LOUISE NEVELSON

A Passionate Life

Laurie Lisle

SUMMIT BOOKS

NEW YORK • LONDON • TORONTO • SYDNEY • TOKYO

SUMMIT BOOKS
Simon & Schuster Building
Rockefeller Center
1230 Avenue of the Americas
New York, New York 10020

Designed by Edith Fowler
Manufactured in the United States of America

10 9 8 7 6 5 4 3 2 1

Library of Congress Cataloging in Publication Data

Lisle, Laurie.
 Louise Nevelson : a passionate life / Laurie Lisle.
 p. cm.
Includes bibliographical references.
ISBN 0-671-67516-8
1. Nevelson, Louise, 1899–1988. 2. Sculptors—
United States—Biography. I. Title.
NB237.N43L5 1990
709'.2—dc20
[B] 89-29639
 CIP

Acknowledgments

Scores of Louise Nevelson's family members and friends agreed to be interviewed for this biography, and my thanks go to each one of them. The book has been immensely enriched by the memories of her schoolmates in Rockland, Maine, especially Florence Flynn Snow; her Nevelson and Berliawsky relatives, particularly Corinne Nevelson and Lillian Mildwoff Berliawsky; her granddaughters, notably Neith Nevelson; artists who knew her at the Art Students League and during the Works Progress Administration, especially Dorothy Dehner; art critics and museum officials, particularly Dorothy Miller; and studio assistants, notably Diana MacKown. Arnold Glimcher of the Pace Gallery provided invaluable assistance. I am most grateful of all to Louise's son, Mike Nevelson, for the many hours he spent with me and for his permission to quote for the first time from his numerous letters to his mother. Special thanks go to her sister, Anita Berliawsky Weinstein, and deep gratitude to Abram Chasins, Alice Neel, Hubert Crehan, and others too

numerous to name. I am indebted to Suzanne Bloch for allowing me to publish extraordinary passages about Louise from the diary of her father, composer Ernest Bloch. I also wish to thank my husband, Daniel Meltzer, and my friend Sherry Huber for their insights into the manuscript and my agent, Charlotte Sheedy, and editor, Anne Freedgood, for their professional dedication to the biography. Finally I wish to thank staff members at the libraries of the Whitney Museum of American Art, the Museum of Modern Art, the YIVO Institute for Jewish Research, the New York Public Library, the Archives of American Art in New York and Washington, D.C., and at the William A. Farnsworth Library and Art Museum in Rockland.

Contents

Introduction

LOUISE NEVELSON's life was the quintessential American success story—an immigrant invents a new identity for herself and achieves fame in the New World. She was uprooted twice, first from tsarist Russia in early childhood, then from Maine in 1920 when she left for New York as a young bride. Her artistic maturity coincided with the blossoming of American art in the mid–twentieth century, and although she was never embraced by any aesthetic movement, by the end of her life she was regarded as integral to the renaissance of American sculpture, and her work was in the collections of the world's major museums.

Throughout her career, her beauty and flamboyance made it difficult for many people to take her seriously as an artist. She was often depressed or enraged as she struggled to exhibit and sell her work. Yet while she attacked the art world for being male-dominated, she saw herself as unique—not a model for other women. In a desperate effort to gain control over her life, she molded the

meaning of femininity to her will. Although she got more gratification from art than from motherhood, she suffered intense, lifelong conflict and guilt about her son.

She never entirely lost her bewildering sense of being simultaneously inferior and superior to everyone around her because of being an outsider in New England of extraordinary beauty, energy, and talent. For years she led a kind of Cinderella existence, making forays into the worlds of the rich and fashionable and returning to her underheated studio and empty refrigerator. Her public face was carefully cultivated to hide the seriousness of her private one, and its glamour helped to promote her career.

The difficulty and demands of an artist's life exaggerated her assumption that others should serve her. And indeed it was only after she had the help of assistants and developed an obsessed absorption in her work that she began to achieve her artistic triumphs. She survived and flourished as an artist because of her "bravado, nerve, charm, shrewdness, and sheer unmitigated ability," observed an old friend. By the end of her life she had reinvented herself through her creative imagination.

I first became aware of Nevelson's work at the 1963 Venice Biennale, where her black, white, and gold palaces seemed to echo the elaborate edifices of the city itself. During the early 1970s, when I walked through Central Park each morning, I enjoyed encountering her towering steel *Night Presence IV* at the southeast corner. The contradiction between her work and her persona interested me—the assertive sculptures that demolished old assumptions about women artists' work, and her lavish, ultrafeminine presentation of herself.

After deciding that I wanted to write her biography, I went to see her on a warm, sunny day in April 1982. I had made an appointment, but when I rang the bell next to the ornate metal door at 29 Spring Street, the main entrance to her establishment of interlocking buildings in SoHo, no one answered. I waited a few minutes, then telephoned her son and her gallery; they both informed me that she was not ill and always kept appointments. As I stood on the doorstep pondering what to do next, a delivery boy told me to try the studio, behind a screen door a few feet away. I knocked, and from a shadowy interior a tall woman with high cheekbones looked up, startled. When I reminded her of our appointment, she consulted with someone else and told me it had been forgotten; she asked me to come back in ten minutes.

When I returned, she had pulled an old knitted cap over her cropped gray hair and thrown on a richly embroidered kimono, which opened to show little wooden finials in the pocket of her denim shirt underneath. A huge stuffed black panther, a black cat, and a number of black sculptures as powerful as fetishes were in the room. There were no false eyelashes or mascara on her glowing dark eyes, and her smile was radiant. She began to talk in a husky voice marked by the flat vowels of Maine and the staccato rhythms of Manhattan in a kind of stream-of-consciousness that abruptly leaped from philosophical pronouncements to intimate, revealing remarks. I became interested in writing a biography that concentrated on the circumstances and forces that motivated her to create art, rather than on the massive oeuvre itself, partly because so much has been written about her widely displayed sculpture and so little about her extraordinary life.

Biographers of artists face special difficulties: their subjects are often inarticulate, and their verbal utterances are apt to be suspect or inadequate. Although Nevelson gave many boxes of her papers to several archives, they contain little written in her own hand except sparse journal entries, checkbook notations, drafts of speeches, and enigmatic poems and essays about art. She wrote relatively few letters during her lifetime—usually only a few misspelled words in a large, childish script on a postcard—because, she explained to me, she "never felt secure enough" to write things down. Her son told me that she deliberately created misinformation, putting down the wrong date or signing her name "Louise Neverlands," because she did not want to be pinned down to the reality of the words. Her mistrust of the written word was so great that she usually picked up the telephone when she wanted to express herself to someone.

In researching her life, I concentrated on her spoken words and unambiguous actions, old photographs, memories and observations of her family and friends, and the way she deliberately placed herself in settings precisely the way she placed a fragment of old wood in an assemblage. I also searched for clues to her character in her drawings, paintings, and sculptures. She painted a few evocative self-portraits in oil, but most self-portraits were in the form of abstract black wooden constructions. She admitted that she was working on her autobiography when in the mid-1950s she constructed *Bride of the Black Moon* from a rough plank and adorned it with a black crown and created *First Personage,* a

double-figure sculpture suggesting highly fragile composure and barely restrained aggressiveness.

I also attempted to understand the objective truth and emotional realities of her life to give significance to what she erased or elaborated. Although she wished to be applauded, she did not want her intimate self to be known. It's significant that she never revealed her original name after she was given a new one in America. She discarded her past for a number of reasons, notably the pain of growing up a poor Jewish girl in an insular Yankee town, and later the difficulty of being a rebellious woman in a patriarchal society. Her dealer and friend Arnold Glimcher wrote: "Through sifting, discarding facts, and rearranging chronology, the collage of her life takes form much like the construction of one of her sculptures." He added that "her life itself is her greatest work of art." The irony is that while she strongly advocated the importance of becoming oneself, she increasingly hid her own self in invented stories and fabricated images.

She was both flattered and anxious about my biography. We were never alone during our interviews; her assistant Diana MacKown and occasionally someone else was always present. Indifferent to my search for factual material, she was uninterested in clearing up misperceptions or mistakes about herself. But she did not attempt to interfere with my research or interviews or to exert any control whatsoever over the manuscript. At times petulant, at others patient, she was always understandably more interested in her work-in-progress than in the details of her personal history. During our last interview, in September 1986, an exhaustive three-hour session, she was alert and lithe in a silver lamé jumpsuit. After I had asked the last question, she eagerly showed me a new creation that suggested to me another veiled self-portrait —a filled box illuminated from within.

I was at last certain that she wanted this biography to be published when, two months before her death on April 17, 1988, she immediately signed and returned to me a permission form for my final visit to her papers at the Archives of American Art in Washington, D.C.

LAURIE LISLE

Sharon, Connecticut
October 1989

Louise Berliawsky

Some of us come on earth seeing,
Some of us come on earth seeing color.

—*LOUISE NEVELSON*

BORN IN TSARIST RUSSIA a few months before the beginning of the twentieth century, Louise Nevelson throughout her life liked to costume herself in elegant velvets, laces, furs, and hats like a Russian aristocrat, or in secondhand ethnic outfits and babushkas with a single jarring ornament, like a crushed-beer-can pendant, around her neck. But whether she was posing as a queen or as a peasant, she displayed surprisingly little curiosity about her homeland, and until she had become famous as a sculptor, she refused to acknowledge that her accident of birth and journey to America had in any way influenced either her temperament or her imagination. "I often hear the remark 'Oh! if I could be a child again,' but somehow, for myself, I am always so busy living in the present that I never look back to relive my childhood but more to search the 'why and wherefore' of things of the present," she declared at the age of thirty-five. Transplanted to the New World when she was five and a half, she chose to regard herself as an original self-creation.

Actually, Louise knew very little of her Russian roots. The family history did not survive the selective amnesia often found among this generation of immigrants, and few written documents and photographs survived the family's persecution in Russia and the flight to America. As an added complication, the names of Russian villages differed, depending upon whether one was speaking Russian or Yiddish, and dates changed if the religious calendar was used instead of the secular. When her mother and father died, she and her siblings could not provide birth dates, birthplaces, or even the names of their grandparents for the obituaries. The month and day of her own birth eluded Louise for years, and sometimes she deliberately varied the year as well. As she matured as an artist, she came to prefer her flights of imagination to the "so-called reality" around her. What was important to her was not what happened, but how she experienced it. And the tapestry of what she revealed or erased from her memory, and what she preferred to imagine or ignore, ultimately found expression in her art, which was animated by the force of the half-forgotten memories.

Nineteenth-century Russia, with its tiny, extravagant nobility, its small number of middle-class shopkeepers, artisans, and professionals, and its huge mass of illiterate, impoverished peasants, was an unlucky place to be born a Jew. Although Jewish villages on the northern shore of the Black Sea were recorded in the first century A.D., and the city of Kiev, founded in the seventh century, included Jews among its first settlers, for as long as anyone could remember Russia's Christians had persecuted the Jews as the murderers of Christ. In the tenth century, Grand Prince Vladimir proclaimed Kiev a Christian city in an attempt to eliminate its Jews and pagans; and in the first half of the nineteenth century, Nicholas I attempted to wipe out Judaism altogether by forced mass conversions, conscription of Jewish children, and censorship of Hebrew and Yiddish books. Jews were expelled from prosperous areas like Kiev, and the Pale of Jewish Settlement, which restricted Jews to hundreds of impoverished villages, became the largest ghetto in the world. By the 1880s it had become home to almost five million Jews, more than half the world's entire Jewish population.

During the more tolerant reign of Alexander II which followed, forty million serfs were liberated, Kiev and other cities were re-opened to wealthy Jews, and Jewish traders were permitted to

travel outside the Pale. Universities began to admit more Jews and to prepare them for the new professional and government positions now open to them, and Russian Jewry experienced a cultural flowering that produced the landscape painter Isaak Levitan and the sculptor Mark Antokôlsky. It was during this time that Louise's great-uncle, Issaye Berliawsky, who lived southeast of Kiev in Dnepropetrovsk, was working as an artisan, painting Christian icons as well as murals in theaters, churches, and other public buildings. Louise later recalled that this uncle won a contest to paint the first star-studded blue ceiling in a Russian church or synagogue. Family legend had it that he was honored by the tsar; in any case, as an artisan, he would have been allowed to live outside the Pale if his passport was approved every year by the police.

A few decades later, a neo-Orthodox movement brought this climate of tolerance to an end, and by the time an educated generation of Jews came of age, opportunities had vanished. Alexander II was assassinated in 1881, and widespread peasant riots broke out across the Ukraine. Jewish shops and homes were looted in the worst outbreak of anti-Semitic violence in more than two centuries. Although laws were passed to protect Jews from pogroms, they were in fact used to justify midnight searches by the police for those without residence papers.

The Jews eventually found ways around the regulations. Since only those in certain occupations—professionals, factory workers, agricultural laborers, servants, and prostitutes—were allowed to live outside the ghetto, a respectable Jewess who wanted to live in Moscow or Kiev would apply for the yellow card of a prostitute. The artist Marc Chagall, who was born Moyshe Shagal in the Pale twelve years before Louise, wanted to study art in St. Petersburg; after being refused papers as a sign painter, he was taken in as a "footman" by a Jewish lawyer. And because of a high birth rate, cleanliness enforced by religious rules, and, for a time, resilience and resignation in the face of suffering, the Jewish population continued to grow.

Louise's father, known as Isaac Berliawsky after his arrival in America, was born in 1871 in Pereyaslav, a day's journey southeast of Kiev, the youngest son of fourteen children, seven of whom died in childhood, in either pogroms or epidemics. His family was literate, well-connected, and relatively comfortable but not a member of either the intelligentsia or the merchant class, both of which educated their sons in Western European capitals. His mother, Ida

Volinsky, was said to be the daughter of a merchant. His father was a dealer in wood; although Louise later liked to believe that her father's family had timberlands in Russia, Jews were forbidden to own land at this time. They were allowed to be woodcutters, however, and so a way was devised around the restrictive laws to enable them to buy trees and sell wood.

One of Isaac's uncles, whose name and position were long ago forgotten by his descendants, presumably had valuable political connections, since he held the highest rank then possible for a Jew. He was called a "governor," Louise remembered, but this may be legend: sometimes the name of the layman in charge of a synagogue was roughly translated as "governor" in English. Others in the family say he could have been a member of the tsar's body guard. At any rate, a large photograph of him in Cossack uniform with a silver star on the chest and a sword was later given a place of honor in Isaac's bedroom in America. Apparently this uncle had no children, and when each of his nephews came of conscription age, he legally adopted him, thus enabling the boy to avoid service in the Russian army. It is indicative of the hopeless plight of Russia's Jews that despite the uncle's influence, many of his nieces and nephews chose to emigrate rather than to try to improve their prospects in their native land.

Emigration had been a topic of conversation among Russian Jews for more than a generation. A few had managed to settle in Palestine, surrendering their Russian citizenship and becoming stateless persons. Then, after the massacres of 1881, thousands fled in one of the largest mass migrations of modern history. A United States congressional commission touring Russia at the time reported that most Russian Jews hoped to begin new lives in America, "toward which their gaze is directed as earnestly as that of their ancestors toward the promised land." In 1891, President Benjamin Harrison expressed alarm to the tsarist government that a million "Hebrews" being forced from their homeland would create difficulties for the United States. Nevertheless, by the time Louise Nevelson left the Ukraine in 1905, a million and a half Russian Jews had already preceded her to America.

The six Berliawsky siblings who emigrated—four sons and two daughters—began to depart in 1881. Most left for Canada and entered the United States in Maine. Nathan, three years older than Isaac, arrived at the age of sixteen and settled in Lisbon Falls, Maine, while his twin brother, Hyman, moved to Waterville. An-

other brother, who married a gentile, lost touch with the family entirely, and his name has been forgotten. A sister, Minna, married to a Russian-trained doctor, ended up in Fall River, Massachusetts. The youngest sister, Sadie, who reached Ellis Island at the age of eighteen, went to live with Minna.

Louise's mother, Zeisel, also called Minna, was born around 1877 into a more humble family on her father's farm near a village called Shusneky on the bank of the Dnieper River. Like other shtetls, Shusneky was a jumbled group of unpainted wooden houses on twisting dirt lanes, gathered around a marketplace where peasants sold fish, black bread, sour pickles, parsnips, onions, and other produce for a few kopeks. Minna's maiden name is uncertain: Louise stated that the family name was Levin on her marriage license in 1920, but afterward she referred to it as Smolerank, although it is probable that Smoleranki was the adopted name of her mother's in-laws. Minna's mother was thought by her neighbors to have spiritual powers; and according to family stories, peasants used to give her a few coins to ensure the health and sex of an unborn child or calf.

Probably partially at least because of the Jews' precarious existence in a hostile country, life within the shtetls was intensely alive and intensely religious. In her nostalgic memoirs, Bella Chagall, wife of the artist, has described an emotionally rich, self-absorbed, intimate family life, highlighted by holiday meals, evenings of stories and fiddle music, winter sleigh rides to the steaming bathhouse, and summer days picking wildflowers in the forest. The dignity, warmth, and humor of Jewish life, despite the fact that people were packed "as closely as herring in a barrel," has been memorialized by the legendary Yiddish writer Sholom Aleichem. Minna, the middle daughter and next-to-youngest child in a family of three daughters and three sons, was cherished by an extended family so large, family legend has it, that at one time it made up an entire village.

Louise's version of her parents' courtship was a highly romantic and fatalistic one: One day her father, a tall and extremely thin young man with pale blue eyes, a brown moustache, and fair skin, was riding a white horse through Shusneky, which was near some of his father's trees, when he glimpsed a tall, dark-eyed, dark-haired young girl in the marketplace. She "took her face from Heaven," according to Sholom Aleichem, who met her shortly afterward. Although Isaac had never before wanted to marry, he

instantly fell in love with her, according to Louise's story, and pursued her with an intensity that frightened her. She did not want to leave home and marry, so she planned to escape across the Dnieper as soon as it froze and stay with her older sister, who lived on the opposite bank. Fatefully, the river did not freeze that winter for the first time in a century, and by the time the snow melted in the spring, Minna's resistance had also thawed. She and Isaac were married around 1897, when Minna was about twenty and Isaac, twenty-six.

After the wedding, they moved to Isaac's birthplace, Perey-aslav, fifty miles southeast of Kiev, with a population of 18,600 people (including a large Jewish minority), wide cobblestone streets, wooden sidewalks, houses with green, blue, and red shutters, and brick shops with tin roofs and iron doors. Their first child, a son, was delivered by a midwife in early November 1898, on the second night of Hanukkah, and was named Nachman. The second child, a daughter, was born less than a year later, in the early autumn of 1899. At the time of her birth she was given the Hebrew name of Leah and called by the diminutive Leike; she would come to be called Louise in America.

Louise was born with her mother's dark brown hair and eyes. Later she would insist she did not resemble one parent more than the other; in fact, she was indelibly stamped by both. When Sholom Aleichem came to call—his sister lived next door—he declared that the baby was "built for greatness," potent words Minna never let her daughter forget. Russian bureaucrats did not record Jewish births, but Louise's mother, who lived by the Jewish calendar, remembered that the infant was born during the seven-day Succoth harvest festival, on the nineteenth day of the month of Tishri. However, when Louise entered school in Maine and was asked by her teacher for her birth date, neither she nor her parents could give one. The date changed every year, since Succoth fell on a different day each fall. To compound the confusion, the Julian calendar, used in Russia, was thirteen days behind the Gregorian calendar, used in America. At first the family decided on December 23 as Louise's birthday; by third grade it had become September 22, and in fourth grade it was October 2. When she was in high school, Louise finally settled on October 16. Years later, after she had become interested in astrology, she asked a rabbi for a conclusive determination of when Succoth had occurred in 1899; she was told September 23, and from then on celebrated her birthday on that

date. But it seems likely that her lifelong irreverence for factual reality was strengthened by her youthful inability to resolve her fluctuating birth date.

As the youngest son, Isaac Berliawsky was expected to remain in Russia to care for his parents. Not until after his father died of cancer was he free to follow his brothers to North America. Having moved his wife and children to Minna's parents' cottage in Shusneky to await their passage to America, he left in the late spring of 1902, accompanied by his elderly mother, who would live for a number of years with an older daughter in Massachusetts. Nachman was three and a half, Leah not yet three, and Minna was pregnant again. Seven months after Isaac's departure, she gave birth to a blue-eyed daughter, who was named Chaya and nicknamed Chanti.

Isaac's three-year absence was a profound psychological trauma for his children. For the rest of his life, Nachman had an intense closeness with and protectiveness toward his mother, and he did not marry until after her death, a few months before his fiftieth birthday. Leah, too young to understand her father's disappearance, experienced a violent sense of desertion, which was intensified when her mother turned her attention toward the new infant. For half a year after Isaac's departure, Leah refused to speak, and her mother feared that she had suddenly become deaf and dumb. This was the first of many periods of numbing depression and withdrawal that would afflict her throughout her life. While she remained mute, her powers of observation were strengthened, since she had to grasp things by watching rather than by asking. Her memories from that time were later expressed as heightened visual ones, like the vibrant hues of the vegetable colors with which her grandmother dyed wool. Other recollections would not emerge until she had blossomed as a sculptor in the 1950s, like her creation of *Forgotten Village*, a sculpture that seemed to evoke a half-remembered Russian shtetl.

When Isaac eventually sent money and steamship tickets in 1905, Minna knew that once she left Russia, she would never see her mother and father again. Unlike Isaac's, her siblings had chosen to stay in Russia; two brothers reportedly became engineers in Kiev. Furthermore, she faced a dangerous ocean journey, like the one that Isaac later called the worst experience of his life because of his violent seasickness. As a young mother of twenty-eight,

Minna had no appetite for adventure; unwillingly swept up in the Jews' exodus from Russia, she never recovered from the anguishing experience of being uprooted.

The strength of tradition alone would have made Minna follow her husband, but violence against Jews was also accelerating, and she must have feared for her children's lives if they remained in Russia. For two days at Easter time in 1903, there were riots in Kishinev. Scores of Jews were killed, hundreds injured, their homes and shops destroyed. Two years later, in 1905, anti-Semitic violence broke out in more than six hundred villages and towns during one week as the first Russian revolution got underway. Most frightening of all, the massacres were again sanctioned by army officers and courts and promoted by local authorities, creating a still greater sense of hopelessness among Jews, even those who had previously resisted emigration—the wealthy who held positions of influence, the socialists who promoted indigenous revolution, and the religious who feared the dissipation of the Diaspora.

Louise was always reluctant to recall a few frightening incidents she vaguely remembered. Yet sixty years later she created *Homage to Six Million I*, a massive black curved wall of immense dignity and grief, a sculptural kaddish, in memory of a subsequent slaughter of Jews. She dedicated a second *Homage* at the Israel Museum, a collection of shining white pavilions on the crest of the Judean Hills in Jerusalem. In words she wrote for the ceremonies, she expressed the hope that her wall would be "a living presence of a people who have triumphed. They rose far and above the greatest that was inflicted upon them. I hear all over this earth a livingness and a presence of these peoples. . . . There is a song I hear and that song rings in my ears and that song is here. . . . We will be with them side by side forever and forever. . . . They have given us a livingness." Habitually reticent on the subject of her own Jewishness, she declared: "The depth of what I feel must remain private. I cannot speak of it out loud."

Early in 1905, despite her misgivings, Minna packed her embroidered linens, dressed herself and her children in their best clothes, and began the long, arduous journey to America by cart, train, and steamship. For observant little Leah, the slow-moving train was an opportunity to see and record in her mind the cities and countryside of her homeland—the fifteen golden onion-shaped domes of Kiev's Cathedral of St. Sophia, marketplaces swarming

with animals and uniformed men, vast gloomy forests, fields with peasants toiling in traditional red shirts, women wearing petti- coats over trousers and colorful babushkas on their heads. The Russian government made it difficult for Jews to get passports; but bribed officials customarily looked the other way as thousands of emigrants crossed the border. The cost of the journey from the Ukraine to America was about fifty dollars an adult, thirty-five for the ocean passage and the rest for bribes at the border and trans- portation to port. Ukrainian Jews usually left Russia over what was then the Austro-Hungarian border and traveled to a German port; Minna and the children eventually boarded a boat to England at Hamburg. In Liverpool, representatives of steamship lines met the third-class passengers, gave each a medical examination, and placed the "Hebrews" in separate dormitories, serving them kosher meals in mass dining halls until their ship's departure.

There was an outbreak of measles in Liverpool that year which led to a six-week quarantine layover, during which Leah listened closely and curiously to the clamor and cacophony of foreign lan- guages spoken all around her. She had no Yiddish words for the astonishing new sights. Other immigrants have observed that los- ing one's language emphasizes the relative unimportance of the spoken or written word, leading to a skewed and detached sense of reality. Again her strongest memories were visual: the rows of bright-colored candies in glass jars she saw glittering under the artificial illumination in an English sweet shop; the doll with eyes that magically opened when it was picked up and closed when put down—a spectacle that gave her such a powerful sense of wonder that she later claimed it was crucial to her becoming an artist.

The family finally left Liverpool on March 16, bound for Bos- ton. Their steamship, the *Cymric*, was owned by the White Star Line, a company that transported immigrants every week from Liverpool and Mediterranean ports to Boston and New York. The vessel carried a handful of first-class passengers and thirteen hundred steerage ticket holders, most of whom were Irish, along with a few hundred English and Scots and 243 Jews. Steerage passengers slept on wooden bunks in dark quarters directly over the ship's engines; seasickness was common, space cramped, smells foul, and the soup ladled from huge kettles into dinner pails was thin and distasteful. But there was also a barrel of water biscuits from which children were allowed to help themselves freely, an abundance that Louise never forgot.

After twelve days the *Cymric* arrived in Boston on March 28, 1905, a year when Theodore Roosevelt presided over an optimistic people who believed wholeheartedly in their land's natural riches, opportunities for the ambitious, and an emerging American culture. It was a progressive era of crusades for social justice—western states, for example, had begun to grant women the right to vote. Leah, five and a half, arrived with vivid visual memories of tsarist Russia and a wondrous three-month land-and-sea voyage. She had already experienced the momentous importance of seeing, and in years to come her glowing dark eyes would be compared by friends to powerful lasers absorbing visual information. "The eye, of all the senses, is most intelligent, and in one fleeting second you look and you are moved by the essence of great splendor," she explained much later. As her visual powers became highly developed, she came to regard them as the essence of her being, pointing out that phonetically the words "eye" and "I" are identical in English.

The family was met in Boston by Joseph Dondis, a young Russian-born relative who had emigrated at the age of six and now spoke fluent English. It was he who bestowed new American names on the Berliawsky children and helped them spell out the strange words in a new language: Nachman became Nathan; Leah, Louise; and Chaya, Annie. Joseph also helped them board a smaller steamship for the overnight trip to Rockland, Maine, where they would at last be reunited with Isaac.

When Isaac first arrived in America, he joined his older brother, Nathan, in Waterville, Maine. Louise remembered hearing her father recall those years as a time when his brother attempted "to enslave him in labor." But others in the family declared that Isaac would have had difficulty working for anyone because of his restless, dissatisfied, independent nature. He had a way of speaking his mind and never forgiving a wrong done him; as a result, he was usually in conflict with one person or another. Family legend has it that after he learned a little English and saved some money, he bought a train ticket for as far away from his brother as his savings would take him, but actually he took an indirect southeast route to Rockland, only about sixty miles away on the seacoast, where he also had relatives.

Rockland was on the rocky northern New England shore, studded with dark green pines and clumps of white birches. The first European settlers had arrived in 1769 and established a fishing

village on the western curve of island-dotted Penobscot Bay. A century later, thanks to its deep harbor on the edge of the inland forest, the settlement had grown into a prosperous shipbuilding town. Construction of wooden sailing ships reached its peak in 1855; during that year Rockland's shipyards celebrated the launching of three barks, six brigs, and four schooners. When the Berliawsky family arrived more than two generations later, the townspeople still liked to recall the glorious days when the harbor was full of graceful clipper ships which had sailed around the world. But by 1900, the sailing ships had given way to steamships, and Rockland's population had dwindled to some eight thousand people whose state of mind was generally nostalgic, cautious, and provincial.

Cobblestoned Main Street was traveled by horse-drawn wagons and streetcars. There were stately white colonial homes, an opera house and a few blocks of two- and three-story brick buildings with offices and shops. There were dressmakers and milliners; fish, oyster, and lobster dealers; and lime manufacturers whose smoking kilns along the harbor melted down the native limestone to use in plaster and concrete. Rockland's industry had shifted from handsome, swift, wind-borne ships to plebeian, earthbound mining and smelting works. Immigrants, mostly from Finland, Ireland, and Italy, had been drawn to the area to work twelve-hour shifts in the quarries. These laborers, largely Roman Catholic, were regarded as so insignificant by the reigning Protestant families that when a worker was killed in a quarry accident, the *Rockland Courier-Gazette* typically identified him only by nationality, not by name. Tourism had grown, and groups of wealthy summer vacationers—including, in 1910, President William Howard Taft—arrived by private yacht or overnight steamer from Boston and New York. They breakfasted in the elegant dining room of the Thorndike Hotel before setting out for luxury resort hotels, like the Samoset, which offered sailing, billiards, and ballroom dancing. Louise's lifelong infatuation with aristocracy, an emotion also tinged with resentment, undoubtedly originated with her observations of the blue-blooded Yankees who vacationed near Penobscot Bay.

It had taken Isaac two and a half years to save enough money to send for his family. When his wife and children finally arrived, he met them at the wharf and took them to rented rooms on nearby Sea Street, a rough waterfront strip popularly called "the Point,"

known for its bars and brothels, which were frequented by fishermen. Five years later, the 1910 United States census revealed that the family was still living at 51 Sea Street—a humble rooming house filled with immigrants and working-class people, including servants, an Irish seaman, an English mason, a steamboat waiter from North Carolina, a rabbi named Max Israel, and a sprinkling of other Jews. There were only about two dozen Jewish families in town, most of whom had arrived around the turn of the century. Some of them ran small grocery, clothing, and dry-goods shops; others were itinerant peddlers who traveled for months at a time through New England, lodging with families known to be hospitable to Jews. Most Russian Jews who had emigrated to North America had settled on the Lower East Side of New York City, so when the Berliawskys joined a small number of New England Jews, they were virtually severed from their Old Country roots.

Rockland society was dominated by a few prominent Protestant families who lived in colonial mansions dating from the golden era of clipper ships. They were descended from the old shipbuilding families, like the Snows, whose shipyard now repaired more ships than it built, although it would launch its last four-master as late as 1919. The Snows and other members of the small-town establishment organized their social activities around the nine Protestant churches to the extent that, according to a 1907 issue of the *Maine Magazine*, daily "devotional exercises" were held in the public schools, and there was little social life outside of the church or the family. One of Louise's classmates, Lucile Hary, the daughter of a banker, remembered that Friday-night suppers at the Congregational church were one of the few places where newcomers were greeted.

Rockland's Jewish community was growing at a time when millions of immigrants were arriving in America every year, and New England Brahmins were increasingly afraid that the foreigners would threaten their political power and cultural dominance. In 1894 a group of Bostonians had formed the Immigration Restriction League, and in subsequent years the United States Congress voted to exclude immigrants of "low moral tendency and unsavory reputation" and those unable to read or write their own language—a bill that would have excluded Minna Berliawsky if it had not been vetoed by President Grover Cleveland. In an insular town like Rockland, where the farthest most natives had traveled was to Boston, there was uneasiness about outsiders of any kind,

partictlarly those who looked, talked, or acted different than the tight-knit Yankee majority. "If you tried to break in, you would not be successful—even if you just came from the offshore islands," admitted Captain William Ralph Kalloch, who attended grade school with the Berliawsky children. "Rockland society was completely closed, even to a person from Massachusetts." There was great ignorance about Jews, and a picture of Moses with horns is said to have hung in a Rockland building. Many Jews felt compelled to anglicize their surnames—the Waterville relatives changed "Berliawsky" to "Berkley"—but Isaac, in a typical display of stubborn, feisty pride, refused to do so, even though the family name was mispronounced "Belowski" and casually misspelled "Belofski" in the Rockland city directory for years and "Beliawsky" on school records until Louise was a teenager.

The prejudice in Rockland was benign compared with the massacres in the Ukraine; but because Jews and gentiles alike usually denied the discrimination, it was difficult to root out. "Although nothing had been done against [Rockland's Jews], their crime was being different. They were made aware of it. And they were merely excluded," explained a Jew who visited Rockland at the time. "They sensed a kind of antagonism that was kept under temporary control. They never knew when this indifference, this freezing contempt, would break out in violence. I remember saying, 'But what is there to fear?' But I was very young at the time and also a New Yorker."

The discrimination was overwhelmingly social and not shared by schoolteachers or by such enlightened individuals as the Roman Catholic priest Father James Flynn, who had been born in Portland, Maine, but educated in Paris. After Father Flynn moved to Rockland as pastor of St. Bernard's Church in 1907, he discovered that the Jews had only a rented room on Main Street for their worship services. A few years later, Rockland members of the Christian Advent Society announced that the world was about to end, packed their possessions, put their small frame church on Willow Street up for sale, and went to a Rhode Island hilltop to await Armageddon. Even though the Jewish community in Rockland was small and struggling, Father Flynn persuaded an elderly Jewish fruit vendor, Simon Higman, to try to raise the six thousand dollars needed to buy the building for a synagogue. It was, however, Father Flynn's letter to the Jewish philanthropist Nathan Straus, a founder of the Abraham and Straus department store in New York,

that brought a check for four thousand dollars toward the purchase price. The Willow Street building was bought in 1912 and named Adas Yeshuron, Congregation of the People of Israel. The Jews in the vicinity—thirty-five families in all—now numbered one hundred and forty.

Shortly after Minna and the children arrived, Isaac had a psychological crisis and lay in bed for months. The exact cause of his depression is unknown, but Minna's disappointment at their impoverishment, her persistent homesickness for Russia, and, since she immediately became pregnant again, the increasing burden of family responsibilities must all have played a part. Family lore has it that in his wife's absence Isaac had become involved with a woman known only as Mrs. Bloom, who had introduced him to Rockland's immigrant community, and now he had to give her up. Whatever the reason, Isaac's paralysis eventually ended, and his children remembered him as an energetic provider who earned money in a variety of ways.

When he first arrived in America, he worked as a woodcutter and a laborer in the lime industry. By the time his family arrived, he was running a small grocery store on Sea Street, next door to where the family lodged. In 1910, when he was around forty, the national census described him as a "junk dealer." In Rockland, where he was described as a peddler in the city directory, he used to walk door-to-door and to the town dump with a hemp grain bag, scavenging bottles, paper, scrap metal, wheels, rags, old clothes, used furniture, and other discarded items to sell from a junkyard near his home and, in time, from a warehouse on Walnut Street. Later, during World War I, he reportedly made bullets from scrap metal. Thus, during the highly impressionable years of her early childhood, Louise lived in abject poverty as the daughter of an immigrant junk dealer—circumstances that apparently embarrassed her. In 1908, when she was in the fourth grade, she told her teacher her father was a "storekeeper," and in 1910 she called him a "merchant," according to the school records. Even in adulthood she never mentioned her father's junk business, alluding only to a warehouse of "antiques."

Louise claimed that she could not remember her reunion with her father in America, and the two seem to have kept a wary distance ever after. Probably she never completely trusted him again after her traumatic reaction to his apparent abandonment of his

family when he left Russia. Once he frightened her badly by throwing her in the ocean to try to make her learn to swim. But in general his relentless struggle for survival left little time for family life. He habitually arose before dawn, ate breakfast with his children, then dined alone late in the evening after the rest of the family had finished. When he was home, Louise found his presence intimidating; he was so high-strung he would jump at a sudden sound, and his children always tried to avoid arousing his fierce temper. "When he came home, it was like an engine," Louise said. "I always felt like it was a furnace downstairs going *chuga-chuga-chug.*"

Although his two older brothers were naturalized in 1890, Isaac, described as a "Russian-Yiddish" alien in the 1910 census, was denied American citizenship in 1916 for reasons that remain unclear. An elderly Knox County clerk thought it had something to do with accusations of drunkenness or bootlegging, which is quite possible, since Isaac's family was supposedly involved in producing vodka in Russia. There is a family story about a police raid when Louise as a young girl is said to have quickly emptied liquor bottles, explaining to the police that they contained rancid vinegar, thus making herself a heroine in her parents' eyes.

Minna gave birth to her fourth child, Lillian, on January 13, 1906, and thereafter was constantly ill. Many of her complaints were gynecological, which American doctors apparently attributed to clumsy deliveries by Russian midwives. At the age of thirty, her sexual relationship with her husband seems to have ended; they began to sleep in separate beds, and they had no more children. Minna's fear of more pregnancies apparently drove her husband to other women. Louise remembered hearing women gossip to her mother about Isaac's involvements, and Minna's proud reply that she trusted her husband. Yet a grandson later recalled that in the privacy of her home she used to curse her husband for his lady friends.

The Berliawsky children were uncomfortably aware of their parents' misery together, which they attributed to their being impoverished immigrants as well as temperamental opposites. Where their mother was slow, calm, cautious, and rarely spoke above a whisper, their father was impatient, tense, and daring, with a hair-trigger temper. Although Louise admired her father and thought him very handsome, she regarded him as "too exciting," hotheaded and excessive in his infatuations, even as an elderly man. But he never deserted his family, and as he became more affluent, he

generously provided expensive clothing for his wife and a piano and private music lessons for his daughters. In time his support-iveness gave Louise a sense of security, and when she recorded her dreams in the spring of 1936, she revealed that one had been about her father being killed and the family living in fear. His liaisons did not, however, reassure her about male loyalty, and kept alive her earlier feeling of having been deserted by him herself.

Early on, Isaac began to buy and sell property. In 1907 he bought a lot in his wife's name on Linden Street in the south end of town near the lime kilns and the shipyards. The ability to buy land, prohibited to Jews in Russia, seems to have given him an insatiable appetite for ownership: between 1910 and 1920, he ac-quired fifty-one parcels of property in Rockland. He got his start through private loans from other Jews and from a lady called Mrs. Brown, whom family members described as a wealthy widow and shrewd businesswoman. Late in 1910 the Berliawskys began to board at 4 Linden Street, a house owned by Laforrest Brown, a milkman, and occupied by his mother, Zelma, and about two years later Isaac built a simple, solid home for his family on the property he owned next door. Initially without indoor plumbing or glass in the windows, it was here that Louise lived until she was married, and its rooms became the subjects of some of her earliest drawings and paintings. Isaac began advertising his expanding real-estate business in the Rockland City Directory in 1914, and building houses and dealing in highly mortgaged property eventually be-came his full-time occupations.

Louise respected her father's achievements immensely—in her eyes, he was a survivor, even "a piece of genius," having pulled himself and his family up from virtual destitution to comfortable respectability in a hostile community. She remembered that he used to take the children in his wagon, drawn by a horse named Blackie, to look at houses for sale while explaining to them how to judge their quality. Like her father, Louise admired the squared-off Greek revival houses, with their front doors classically balanced in the middle of the facade, and she shared his interest in their construction. Sometimes he sent her out by herself to look at a building, and afterward he listened intently as she described it to him. Although she shared his feelings for neoclassic architecture, she was wary of his ambition to live in an old New England house. When she was sixteen, Isaac wanted to move into a colonial house on Middle Street which was on the market for a bargain price; but Louise, either in an unexpected reflection of her mother's timidity

and financial caution, or for fear of appearing presumptuous, announced that she lacked the courage to walk into the fine house.

Although Louise felt closer to her mother than to her father, Isaac and his eldest daughter were alike in many ways. Isaac had "a fire in his eye," an intensity that made others move out of his way, that was not unlike a smoldering quality people observed in his daughter. Father and daughter also shared a high level of nervous energy: he was too impatient to wait for a streetcar in Rockland; she later complained that the New York subways were not rapid enough for her. And her simmering anger, aggressive ambition, stubborn doggedness, and feisty independence were all reflections of her father. Most significantly, her scavenging instincts derived directly from his example. Even as a child she gathered pebbles, sticks, marbles, and other trinkets to display in little boxes. Later, as an artist, she transformed pieces of old wood into coherent, inspired artistic expressions, as if to vindicate and elevate her father's early occupation. In his avid constructing and purchasing of houses, her father built a personal realm of rental properties in Rockland; and after his death Louise created what she called an "empire of aesthetics" and described herself as a builder of environments as well as an architect of shadow and light. "While I loved my mother, I took a great deal from him," she once acknowledged.

America was a bitter disappointment to Minna. The family's poverty forced her to dig edible greens from meadows in the spring, according to one of Louise's schoolmates. After the warm intimacy of shtetl life in Shusneky, the indifference, strangeness, and isolation she encountered in Maine were severe shocks. Although she learned to speak heavily accented English, her illiteracy, which accentuated the enormous cultural difference between her and her neighbors, cut her off from many of them, particularly after the family moved from Sea Street. She also lost her name: she became known as Annie for reasons no one can remember; and when she died forty years later, her tombstone was inscribed "Anna Small Berliawsky." From the first day of her arrival in America, she was misplaced and maladusted. Any outward indication of her socialist sympathies would have shocked the Rockland establishment; her alien religion and tongue were vaguely threatening to them; and her notion of how to be a lady was entirely inappropriate in the Yankee milieu.

When she planned a rare excursion out of her home to Main

Street, she spent hours dressing for the occasion, as if to fortify herself against the barely concealed condescension of the New Englanders. After Isaac achieved a measure of prosperity, she made careful shopping expeditions to Fuller Cobb, the town's most expensive and exclusive department store, where the Morgans, the Vanderbilts, and other summer vacationers shopped. With what Louise called her natural sense of style and unerring good taste, Annie would deftly select the highest-quality fabrics and most elegant fashions for herself and her three daughters. Over the years, she paraded in a matching coat and hat of black Persian lamb or sealskin, while Isaac wore his black suit and greatcoat, black being a sign of respectability in Europe. Isaac was immensely proud of the fashionable appearance of his wife and daughters, and his daughters remembered that he never questioned the amount of money they lavished on clothes. Townspeople would stop and stare as Mrs. Berliawsky passed by—in their eyes she was a large, over-dressed Jewess with flamboyant feathers on her hat and a daring amount of rouge on her cheeks. Louise liked to say later that people called her mother the handsomest woman ever seen in Rockland, and she always described her as a gorgeous creature, sometimes even as "the most beautiful woman on earth." But the Rocklanders' compliments must have contained a touch of derision; they were people who respected modesty, understatement, and Puritan propriety above all.

Despite her admiration for her mother's beauty, Louise was often acutely embarrassed by her mother's elaborate appearance, understanding that in a provincial New England town people did not "dress." To make matters worse, one of her mother's few pleasures was dressing up her pretty daughters—"That was her art, her pride, and her job," Louise explained. "My mother wanted us to dress like queens." Feeling acute sympathy for her mother, Louise did not want to disillusion her by expressing discomfort at being overdressed. Fortunately, since the shirtwaists and dresses were in good taste, their quality and cost were usually not obvious, and Louise's classmates do not recall that the Berliawsky sisters dressed differently than the rest of them. Although Louise was discomforted by her mother's ostentation, she absorbed the lesson that extravagant display was a form of feminine self-expression. Disliking the tight-fitting, restrictive fashions of the day, and too inventive and impatient to sew from a pattern or wait for a dress-maker to stitch a garment, she often created outfits by arranging

and pinning fabrics, tying white embroidered aprons around herself like blouses and angling store-bought hats in unusual ways. When she was about fourteen, she bought a piece of linen and a brimmed hat frame at Woolworth's and attached the linen in pleats to the frame. She then stenciled and painted butterflies, sewed them onto the hat, and wore her handmade creation to school every day until she tired of it.

Like many immigrant families, the Berliawskys made room for relatives from time to time. In 1910, an in-law of Annie's by the name of Smolerank, who had taken the name William Small in America, lived with them while working as a blacksmith in the lime quarry. In 1912, his place was taken by Isaac's brother Hyman, who held an office job. Isaac's younger sister, Sadie, widowed with four young children at the age of thirty-two, made buttonholes in a Waterville shirt factory while her mother cared for the children. When Sadie moved to Rockland and remarried a few years later, her mother went to live with Isaac and his family. Bubba (the Yiddish name for grandmother) was a tiny old woman with a beautiful, chiseled face who had an old-fashioned knack for making curd cheese in a cloth bag. Her daughter-in-law Annie resented her, because she believed Bubba favored her other grandchildren; and perhaps the presence of Isaac's mother reminded her of the absence of her own. One day in April 1919, when Bubba was about eighty-seven, still hale and only slightly senile, she asked to be washed by the woman who came to bathe her daughter-in-law, and to be provided with fresh nightclothes. Then she got into bed, kissed her grandchildren, turned over, and, to the astonishment of the family, quietly died of heart disease.

Annie's misery found expression in persistent psychosomatic ailments—migraine headaches, severe backaches, and other complaints for which doctors could find no physical origin. She took to her bed for as long as six weeks at a time with mysterious symptoms that were eventually attributed to neurosis. She called her doctors constantly, and when they became bored by her apparent hypochondria, she found other doctors in Boston and New York who gave her attention. As the years went by, she became increasingly bitter, morose, suspicious, hostile, and so reclusive that she refused to enter a gentile house. Not surprisingly, she had no close friends; occasionally another woman visited on religious holidays. Her isolation was aggravated by the fact that most of Rockland's Jewish families lived on the north side of town, while

the Berliawskys' house was in the south end. When Louise was fourteen, a bereaved widower in Rockland killed his four children and himself; after she saw the five black hearses pulled by black horses pass silently by, she ran home and wept hysterically as she experienced an outpouring of sublimated grief for her own family.

Annie used her unhappiness as a powerful weapon within the family, alternately arousing their guilt toward her as a victim and imperiously ruling them with a scornful and sardonic sense of humor. Her decisions about the children went unchallenged by her husband, who, in Louise's memory, placed his wife on a pedestal. A compulsively meticulous housekeeper, Annie cared scrupulously for her fine wardrobe, disdainfully rejected old furniture from Isaac's warehouse, and insisted that their grass be impeccably planted and clipped. When her daughters came home from school, they would occasionally find her lying on the couch crying for her own mother, and at these times they did the housework and prepared meals; it often fell to Louise to do the cleaning. "My mother was sickly, and I was strong," Louise once explained. "I was my mother's mother."

Annie's deep frustrations instilled a sense of obligation in her children, and she knew how to bind them closely to her. Thus she actively encouraged her eldest daughter's adolescent dreams, indicating, as other immigrant parents did, that she wanted a place, a kind of grandeur, for Louise that she was unable to attain for herself. She repeated the remark of Sholom Aleichem, who had come to America with great fanfare in 1916, that her tall, lovely daughter was destined for greatness. The form of greatness was not defined, but for many years the family hoped that Louise would become a star of the stage or screen. For her part, Louise claimed never to have disobeyed her mother, who was her "heart and soul." She even went so far as to say that she had dedicated her life to her mother—not by staying at her side or emulating her way of life but by identifying with the older woman's frustrated yearnings. This identification with her mother's feelings was often painful: although Louise idealized her personal qualities, she pitied her unhappiness and her passive victimization, and early on she resolved to take charge of her own life. Often over the course of her life she attempted, perhaps unconsciously, to recover her mother's intriguing lost world through her art. After her youngest sister was born, when she was seven, Louise stopped playing with dolls and chose instead to play with toy monkeys. From that point on, as her

mother decided to have no more children, Louise appeared never to want to become a mother. She empathized so intimately with her mother—a woman, she said, who should have lived like a queen in a palace—that "I was determined to open every front door . . . and to walk right through the door [and] I didn't care if I had to build the house myself."

During the first summer that Louise and Nathan spent in Rockland, they learned enough English to enter the first grade at the McLain elementary school in September. This put Louise with children of her own age, but Nathan was a year older, and both were ill prepared for an American school. There were no private schools in Rockland, so everyone sent their children to public school, where the teachers were almost entirely educated, high-minded, dedicated, single women. Throughout her life, Louise praised their personal dignity and the quality of their teaching. Even in elementary school, learning was rigorous; lessons included writing exercises, word drills, penmanship, and oral recitation. The wisdom and character of the high-school principal, Anna Coughlin, a poet and ardent suffragette, were revealed by the way in which she reprimanded Benjamin Cohen, one of the few Jewish pupils. "I have such a high opinion of you, Benjamin," she used to begin, suggesting that any but the highest standards in behavior and scholarship from him would surprise her.

Despite the fine teachers, Louise felt alienated, shy, tongue-tied, and self-conscious throughout her school years; she habitually sat in the back of the classroom and rarely raised her hand. The other pupils, who reflected the community's conformist attitudes, ostracized the Berliawsky children, and one of them maliciously spread the story that she had seen bedbugs crawling up Louise's back. Classmates remembered that oral recitation in front of the class was particularly painful for the two eldest Berliawskys because of their lack of fluency in English. Many of the other children learned to recite poetry by heart at home, but after school Louise and Nathan spoke their mother tongue, Yiddish. Losing both their language and their given names undermined their sense of confidence in their cultural origins and in themselves. They spoke Yiddish, a language rich in emotional expressions characterized by humor and hyperbole, only in the privacy of their home. As Yiddish became for Louise a hidden tongue, she became accustomed to using an intimate private language and a more formal public one,

which laid the groundwork for both her sense of secrecy and her eventual reliance upon a personal aesthetic vocabulary.

In 1906–07, when Louise and Nathan were second-graders, they were photographed with the thirty-six other schoolchildren. Louise, wearing a plaid dress and a large ribbon in her dark bobbed hair, has an alert expression on her small, round face with its pointed chin. She and Nathan had been absent with scarlet fever most of that autumn. Records show that when they returned after the Christmas holiday, Louise made a diligent effort to catch up with the class. In January her grades were all C's, except for a D in reading; by June she was a B student, except for C's in reading and grammar. Her highest mark—a B + —was in the fifty-minute weekly drawing class. A gradual improvement in her schoolwork over the year, with her lowest marks in reading and highest ones in art, became her academic pattern.

Short in stature, with black hair and brown eyes, Nathan, now known as Nate, was more outgoing than his sister and ingratiated himself with almost everyone he met. He had immediately gone to work as a newspaper delivery boy and as a messenger for a local telegraph company; and in later years he became a good-natured hustler who liked to describe the way he would sell a box of candy to a sailor for a dollar to give to a prostitute and then, after the sailor left the girl, buy the candy back for fifty cents to sell to the next sailor for another dollar. He watched over his sisters in a protective way, and he and Louise were especially close. In school he consistently did worse than Louise in all subjects; when he was kept back in the fifth grade while she went on to the sixth, he developed a rebellious attitude, and in the 1910–11 academic year he received a C in application and a D in conduct. Since Isaac's sisters had been well-educated, and Annie had high expectations for her eldest daughter, they did not discourage Louise from overshadowing her older brother. She was already much taller than he was—at twelve she was five feet seven, while at twenty-one he was only five-three—and her sense of her own potential was undoubtedly enhanced by surpassing him.

When Nathan was a sixth grader, his little sister Annie, aged nine, was already a fifth grader, getting almost straight A's. She had learned English more easily than her older siblings because she was younger when she arrived in Maine. Although Nathan enrolled in seventh grade in 1912, he left school for good after a few months, just before his fourteenth birthday. With another

younger sister about to surpass him, he gave up on his education. Annie went on to skip a grade and graduate from high school with an A average in 1919, only a year after Louise. Nate's generous nature made him proud of his sisters, and he had his own accomplishments. Besides helping to support the family, he was a good boxer and eventually became a quick, light-footed bantamweight amateur contender. In 1915, when he was seventeen, he lied about his age and enlisted in the Navy; during World War I he served on a gunboat in the Mediterranean.

Because of her difficulty with the subject, Louise avoided reading outside of school, explaining that she had always been more interested in her own fantasies than in fairy tales. Her reading was agonizingly slower than her visual associations, and her drive for understanding expressed itself through different channels—she learned much more from experiencing life emotionally than from "dogmatic teaching," she claimed. One exception to her indifference to literature was her excitement over particular passages in Shakespeare's plays. "I wasn't a great reader," she said later, "but when I got to Shakespeare, it was as if I had created him. I see it today as a red line, telling me exactly what the meaning was." She often recited lines from *Hamlet* that could be interpreted as anticipating the fragment-filled boxes she created as a mature artist: "O God, I could be bounded in a nutshell and count myself a king of infinite space, were it not that I have bad dreams." She empathized with Hamlet's plight because her own unhappiness in a provincial New England town was so great that even her imagination could not console her.

Her father, who loved music, acquired one of the early Victrolas to play the latest Caruso and Galli-Curci records and offered to pay for private music lessons for Louise. She first had to overcome her shyness in approaching teachers at a time when few of their private pupils were immigrants. She passed the home of the tiny, white-haired voice teacher Margaret Ruggles almost every day for two years before she summoned up the courage to ask for lessons in high school, which she then took for several years. She was equally awed by Madeline Bird, the high-school music teacher, who gave piano lessons. Miss Bird came from the highest society in Rockland, and Louise remembered her as being as imposing as Eleanor Roosevelt. More than six feet tall, elegant, aristocratic, and a gifted pianist, she lived in an imposing white-columned mansion on Middle Street, a fact that contributed to Louise's associ-

ation of achievement in the arts with the attainment of high social status. Eventually the Berliawsky girls became accomplished enough to perform in her recitals, playing on her Steinway grand piano; in the spring of 1914, when she was fourteen, Louise played a solo, "School March," and a duet with her sister Annie.

The Berliawskys had settled in a town where exposure to the New England upper classes and pressure to assimilate into the prevailing Protestant culture were far more intense than they would have been on the Lower East Side of New York. Independent Yankee women inevitably became Louise's role models, particularly because of her mother's maladjustment, and their encouragement of her gifts underscored her mother's message that she was "built for greatness." Certainly Louise must have realized that her abilities might win her a degree of acceptance and acclaim in the new country that her heritage could not. Although the Berliawskys were Orthodox Jews who observed religious holidays, her isolation from a vibrant Jewish cultural tradition was another factor that threw her back on her imagination and inner resources for a sense of identity and self-esteem, a turning inward that was critical to her development as an artist. "In some ways, all my life I didn't feel quite that I belonged here," she said in 1964. "I didn't really, in my closer being, identify too much on any level, so I just had to fulfill something in myself, and there was that great hunger, great search." Her involuntary introversion also fed her developing grandiose sense of herself. "If you *have* a grandiose concept, and if you can work with it, I don't see why not," she said, somewhat defensively, years later.

Louise always acknowledged that it was her schoolgirl A's in drawing—often the only A on her report card—that encouraged her to become an artist. When she was in second grade, the art teacher showed the class a picture of a sunflower and instructed them to draw it from memory. Without being able to articulate why, Louise exaggerated the size of the flower's brown center and made its yellow petals very tiny. "Because already I must have felt the brown and the yellow—without thinking much I was feeling it out," she suggested later. When she brought her drawing to class the following week, the teacher held it up and praised it as "original" because she had imaginatively changed the sunflower's proportions. Although Louise did not understand the word "original" at the time, she was immensely pleased by the novelty of being singled out in class and took the praise to heart.

In contrast, she wrote English words in a formal, standardized, schoolgirl penmanship—tall and slightly slanted to the right—that suggested her lingering discomfort with the language. "Her handwriting is commonplace, stereotyped," the composer Ernest Bloch observed in 1933. "Clear, legible, flat, without salt or pepper, like beautiful but expressionless hands, with well groomed nails! . . . It is a mask. Unless the mask be the person."

Louise's most memorable drawing teacher in Rockland was Lena Cleveland, who had studied at Pratt Institute in Brooklyn and boasted a "real" artist for a sister. By all accounts, she was a charming, outgoing person, who appeared in Louise's eyes to be more gracious, genuine, and alive than her other teachers. Louise was enormously impressed by her unconventional purple coat and hat, and when she complimented her on them, she learned that Miss Cleveland had impulsively bought the little hat and then found the coat to match. Louise never forgot this story, perhaps because her teacher's spontaneity was so unlike her mother's methodical way of dressing. At first Louise had to convince Miss Cleveland that her drawings were freehand, not copied from a book; but when she did, her teacher became her staunchest ally, even predicting that she would "make a name for herself" as an artist.

Later in life Louise wondered aloud whether her teachers had responded to the intensity, sensitivity, and originality she projected, or whether she had merely reacted to their praise. In either case, she was eternally grateful to them for calling her "the artist," selecting her for painting projects, and awarding her art prizes. Although she suffered in the cold temperatures of northern New England, she claimed that she was never chilly in the school art room because there her excitement generated its own heat. Besides giving her an identity and self-confidence, art became her escape from the gloom and tension at home, and on days when there was no school, she often withdrew to paint and draw by herself. Forced to curb her natural gregariousness because of her social isolation—as if she were indeed "bounded in a nutshell"—she began to express her restless energy and rich imagination through art.

Looking back over her life, Louise liked to recall evidence proving that she was born an artist—beginning at the age of four when she carved bars of yellow laundry soap. As a little girl she used to visit Rockland's graceful stone library, built in 1903 by the philanthropist Andrew Carnegie, where a larger-than-life, heroic white plaster sculpture of Joan of Arc glowed with a subtle patina. The fact that she intuitively understood and identified with this

nineteenth-century representation of a large-limbed girl saint in peasant clothes and a kerchief who exuded a sense of presence and power indicated that she was already an artist, she said. One day when she was about nine, the librarian asked what she and another little girl wanted to be when they grew up. After Louise's friend stated that she was going to be a bookkeeper, the librarian turned to Louise. She was going to be an artist, Louise said; then suddenly, as if the sculpture were speaking to her, she added "a sculptor," because she didn't want color to help her. In her retelling of the story years later, she said she was so confused and frightened by her prescient words that she ran home weeping. Although the story may sound improbable, its importance lies in the fact that she claimed to have *felt* like an artist from earliest childhood, a perception that helped her to persevere. Certainly at an early age her visual mind informed her intelligently and rapidly. "It's the quickest way of communicating, and I think it's the most joyous," she once explained.

Probably the earliest surviving Nevelson is a yellow watercolor of 1905, signed Louise Berliawsky, of a girl sitting on a big chair at a dining-room table surrounded by penciled stick figures. As a teenager Louise dutifully copied reproductions of paintings by Rubens and Dürer. Her rendition of the Mona Lisa was a subtle self-portrait. In her juvenile work, as often happens, her own image played a central role, but it was a habit she never entirely abandoned. She was also interested early on in spatial relationships and interiors devoid of human beings. Schoolgirl drawings and watercolors her family saved include both vivid renditions of empty rooms in the Berliawsky home and pictures of formal parlors filled with carefully observed antique furniture, with similar arms, legs, and carved motifs she later used in her sculpture. *Interiors* (1918), a study in perspective, depicts antiques, a trophy rug, and architectural columns. Her mother allowed her to rearrange the furniture in the Linden Street house continuously, a compulsion that continued during summer visits after her marriage.

One of Louise's high-school watercolors of a room contains a portrait over the mantelpiece of a Karl Marx look-alike instead of the typical Yankee sea captain. Louise was not the only one among the first generation of Jews to become professional artists in the West to find it essential to forge her own identity. Art critic Harold Rosenberg once wrote that "to be engaged with the esthetics of self has liberated the Jew as an artist." Historically, Judaism in-

hibited artistic expression. The Old Testament banned "graven images," linking figurative art to idol worship, and "in this sense, the Second Commandment was the manifesto of Jewish art," according to Rosenberg: "Jews were literally crushed by art while they were in Egypt, and the notion of sculpture must have induced tribal nightmares." The ancient Hebrews discovered rather than created art, and that art consisted of imaginative, surrealistic images—Joseph's coat, the burning bush, Balaam's ass, Aaron's rod. Other observers believe that it was no coincidence that Jewish artists emerged as the authority of the image was broken and non-representational art took hold in the twentieth century. In fact, the more avant-garde the art, the more respectful it would be of ancient Jewish law.

Gradually, Louise was able through her art to transform her complicated feelings about Maine. When the thick green foliage suddenly burst out overhead every spring and created deep patches of shade, the leafy limbs of old trees seemed to hang ominously and oppressively low, like great "umbrellas" over her head, she said, and she was afraid that the heavy branches would fall on her. She had been strongly affected by "the moving grove" image in Shakespeare's *Macbeth,* and the sudden blockage of the sky induced terror in her, which actually may have been a reaction to the subtly threatening environment around her. When she came to understand light and shade in art class, "I could see the shade in one place and the light in another, and I made order for myself." She added that in this way, unbridled nature could be controlled "through awareness." In her teenage years, as she painted miniature, realistic oils and watercolors of the natural world, she learned to translate her turbulent feelings into artistic form, and her anxiety over the phenomenon of spring diminished. Yet even in old age, she complained that Maine had "too many leaves."

After Louise left home, she never lived in Maine again for any extended period of time, but she acknowledged that the state's fierce, harsh beauty—the pine forests, dramatic ocean tides, jagged granite outcroppings, glittering phosphorus, and northern lights— had deeply impressed her. She identified with the energy and restlessness of the sea, she later declared. Beyond the Owl's Head light of Rockland harbor, hundreds of islands dotted Penobscot Bay, part of nature's great abundance or, as she put it, "richness." She also experienced nature as intelligent and virginal. Her native Yiddish, the abundantly allusive language of a landless people, had

few words to describe nature, and in her mind images registered instead. She was fascinated, too, by the sight of lobsters in lobster pots, by the tar-blackened, battered piers and timbers and the dark hulks of sunken ships that suddenly loomed up out of the sea when the tide swept out, among them the four-masted *Castine*, wrecked close to the Rockland coast in 1909. She became intimately familiar with the neoclassical, columned, squared-off New England architecture,with colonial silver and lace patterns, and with the earliest American sculpture—granite gravestones, iron weathervanes, and ships' figureheads. A few Pemaquid Indians from nearby reservations were still seen in Rockland from time to time, and Louise felt a sense of kinship with these despised outcasts and their artifacts.

When Louise entered Rockland High School in the autumn of 1914, she was the only "foreigner" in a class of almost seventy students. Most of the others had been born in Rockland, even the two other Jews. Few immigrant children ever attempted high school. Like the majority of girls in her class, Louise was enrolled in the commercial course, directed toward office jobs rather than higher education; she learned bookkeeping, stenography, penmanship, and typing along with the usual algebra, French, geography, and so on. The classical course, which her academically gifted sister Annie elected, required such subjects as Latin. Louise later belittled her B + high-school record because it was mediocre compared with Annie's. "Now I didn't say I was intelligent, but I had a lot of courage and a lot of energy," she once explained, in an effort to describe her tendency to activity and experimentation in her search for emotional richness.

What those who knew Louise in Rockland remember best about her was her extravagant dark beauty, like a Spanish princess's. A pretty child in elementary school, she passed through an awkward stage as she attained her full height at the age of twelve, becoming the tallest girl in her class. She was big-boned, with sloping, narrow shoulders and a well-developed figure, and even in old age she would boast that she had an unblemished body. When she was a teenager, classmates and relatives alike remarked on her glossy dark brown hair, which hung below her waist, her sparkling black eyes, straight white teeth, and olive complexion heightened by a rare cherry coloring that deepened with her frequent self-conscious blushes. Her high flush was so exquisite and

so unusual in a brunette that one day an envious neighbor with less attractive children, suspecting that Louise used her mother's rouge, suddenly rubbed the girl's face to see if the color came off. Her beauty intrigued one younger girl so much that she used to wait shyly on a corner for Louise to pass on the way to school, fascinated by her swinging arms, straight, long-legged stride, and the inexplicable, different quality about her, and the two would walk along together.

One of the Puritan values that Louise encountered in New England was "Beauty is as beauty does;" she also knew the Yiddish shibboleth "The bride can be too beautiful." She later argued that, on the contrary, "the physical is the geography of the being," but at the time her dark, exotic beauty added to her discomfort. Sir Walter Scott's *Ivanhoe*, which was very popular at the time, had a Jewish heroine who bore a strong physical resemblance to Louise; those who read the novel could easily have blurred the identities of the two. Rebecca the Jewess was the voluptuous, black-eyed daughter of Isaac of York, who spoke a strange tongue and wore lavish and peculiar clothes. "Scoffed and sneered at by the proud dames . . . but secretly envied," Rebecca was accused of "sorcery, seduction and other damnable practices" and imprisoned in a turret, although she alone had the power to heal Ivanhoe.

Like the fictional Rebecca, Louise carried herself with "proud humility as if submitting to the evil circumstances in which she was placed as the daughter of a despised race, while she felt in her mind the consciousness that she was entitled to hold a higher rank from her merit." The social ringleaders in her class—Lucy Fuller, whose father owned the Fuller Cobb department store, and Helen Snow, the descendant of a line of sea captains—pointedly excluded Louise, the daughter of a junk dealer and neither a Christian nor an American, from their activities. In contrast to those of her Yankee classmates, her family was assiduously trying to forget its history. Florence Flynn, another child of a seafaring family, who was in Louise's class and lived near the Berliawskys, sometimes walked to school with her. But an unspoken barrier existed between them, and despite their friendliness they never entered each other's homes. Louise was never invited to the summer house parties at hunting and fishing camps or on sailing outings to the islands for picnics and swimming. "We all kind of looked up to her, but we didn't take her in," Florence Flynn admitted. "She wasn't in a group." Louise usually had one best friend at a time; Theresa Lor-

raine, a tall, plain, dark-haired French-Canadian girl, three years older than she, who lived around the corner on Mechanic Street, was a close friend during high school.

In the ninth grade, however, Louise was elected captain of the girls' basketball team, an honor she later played down by explaining that popular girls did not try out for basketball, and she had been chosen merely because she was tall and possessed an abundance of physical energy. But it was as an athlete, not as an artist, that she was memorialized in the class history, for the bruised eye she received while "showing her prowess as a basketball player." Although she admitted that being captain made her less shy, one of her most painful memories was of Helen Snow's party for the team before she left for boarding school in Massachusetts. Louise overheard someone ask Helen in the locker room if Louise would be invited, and Helen's grudging response that she had to be because she was team captain. Louise was so nervous by the time she arrived at the party that she actually wet her pants. Then, in her sophomore year, she was asked to be vice-president of the music club by its president, Doris Black, a delicate, beautifully dressed girl from one of the wealthiest families in town, who apparently felt socially confident enough to choose a talented Jewish girl from a humble background.

Some of the schoolgirls had best beaux, but despite her allure Louise did not. When, around the time of the senior class dance, Louise was paired off by a teacher with the captain of the boys' basketball team, he complained loudly about having to take "that Jew" to the dance. But the boys left boxes of candy for her youngest sister, Lillian, who was petite and feminine. In later years Louise proudly explained that she had been too mature for boys her age and never wanted their attentions. In reality, few eligible young men remained in Rockland, especially then when going to war was added to the local tradition of "going seafarin'" at as young an age as fourteen; Louise's graduating class contained eleven boys and thirty-two girls.

From earliest childhood, Louise was torn between her turbulent and conflicting feelings of inferiority and superiority. During her teenage years these were especially confusing. Although she privately thought of herself as the most attractive girl in Rockland, she became acutely embarrassed when she was complimented. "If you make people understand the irony of a terribly shy person who is absolutely sure of herself, you'll make them understand me,"

she later told an interviewer. Her fragile pride and raw sensitivity were in constant conflict with her natural gregariousness and intense need for recognition. In adolescence she continued to nurture her childhood daydreams of becoming a movie star, but every year she felt an overwhelming sense of rejection at never being chosen queen of the Rockland February carnival.

Within her family, Louise had a natural dominance. Physically she towered over everyone, with the exception of her father, whose height she matched. Furthermore, her mother had anointed her to carry her own thwarted aspirations. Once Louise, attempting to deny she was the family favorite, actually underscored her privileged position: "I never even wanted that. I was *ahead* of it. I was sort of running the show." This early sense of superiority over her older brother and younger sisters contributed to her feeling of specialness and her belief that she possessed "a certain power." The day when a huge workhorse bolted on a street near her house and began to run away, she ran alongside it for a while, thrilled by its speed and grace and by the sight of its black body against the green foliage. "And while the horse wasn't like a race horse with *long* legs, yet it had the *energy* of all of nature and had *symmetry* in its body. It had a *movement* no machine could match."

Louise's wartime high-school graduation ceremonies in the Park Theatre in June 1918 were infused with patriotism. Diplomas were tied with red, white, and blue ribbons; a large American flag decorated the stage; and a graduate recited Rupert Brooke's "The Great Lover," about the death of a soldier. When the graduates posed for their class photograph, most of the girls were in conventional middy blouses with black bow ties, but Louise Berliawsky posed in an elegant dark dress with a white collar and had tied a black ribbon dramatically across her forehead.

From time to time during her school years, Louise had taken part-time jobs, and the summer after her graduation she was a ticket taker at a movie house. But she was increasingly impatient with the kind of job for which her studies in stenography, bookkeeping, and typing had prepared her, and in her senior year her lowest grades were in these subjects. Theresa Lorraine had become a lawyer's secretary, and after Louise saw how frugally her friend lived—saving for weeks to afford a plain cloth winter coat—she rejected that way of life for herself. Years later she expressed an attitude identical to her father's, who preferred struggling for in-

dependence in Rockland to taking a job elsewhere, and declared that a life of crime was preferable to the slavery of working for someone else. "I'd rather steal than beg," she insisted. In order to graduate from high school, however, she was required to have office experience, so in the spring of her senior year she worked for six weeks as a legal stenographer for Arthur Littlefield, a lawyer.

War had filled Rockland harbor once again with boats being built, repaired, and camouflaged for the war effort. One day while Louise was working for Mr. Littlefield, a tall, slim, balding man from New York came into the office. When Louise was eleven, she had blushed and become speechless when she met an attractive man from New York at Miss Bird's house during a piano lesson. Now, at a more confident eighteen, taking the New Yorker to be Jewish, she boldly spoke to him in Yiddish. He introduced himself as Bernard Nevelson, president of Nevelson Brothers Company, a shipping business, who was in Rockland to arrange repairs for one of his steamships. In later years Louise was unable to recall the exact sequence of events, but Nevelson made inquiries about her family and invited her to dine with him and a French sea captain at the Thorndike Hotel. At first she was hesitant about accepting the invitation—she had never dined in a hotel, and her active imagination caused her to fear that she would somehow be swept away on Nevelson's boat. But she was also curious, so she accepted and asked her brother to walk her to the hotel. It's unclear whether she and her parents knew at the time that the New Yorker was married and thirty years older than Louise. Whether they did or not, they apparently decided that it was more important to encourage the prosperous gentleman's interest in Louise than to stand on strict propriety.

Although that evening she was intimidated by the French sea captain, she clearly charmed Bernard Nevelson. When the Nevelsons dined with their old friends the Chasinses in New York shortly afterward, Bernard spent the entire evening talking about the Berliawskys and raving about Louise. "He spoke of her being beautiful, handsome, intelligent—a born artist," the Chasinses' son Abram recalled. "When he spoke about Louise, he looked and sounded like a man deeply in love." He explained that the Berliawskys were unhappy in Rockland, and he concluded that he must invite Louise to New York soon. As he praised Louise, his wife, Lily, an émigrée from Vilna who was habitually tactful, bit her lip and said nothing. He also wrote letters to Louise, apparently

revealing that Lily, a nurse, in her early forties, was pregnant. Louise did not answer his letters, because she did not want to become the young mistress of a wealthy older man, she later explained.

Her silence did not, however, keep Nevelson from looking her up when he returned to Rockland in the summer of 1918, arriving with the pregnant Lily and fifteen-year-old Abe Chasins in their dark green chauffeured Pierce Arrow. They stayed with the Margolis family, New Yorkers connected with the shipping business who were living in Maine, and they invited the Berliawskys to call on them. Isaac and Annie arrived with Louise, not yet nineteen. Abe never forgot his first impression of her—a girl with full breasts and large limbs, whose dark eyes flashed from a round face—and the two of them talked about basketball and music. On an earlier visit to Maine the boy, a piano student at the Ethical Culture School in New York City, had performed for Miss Bird, who served him his first waffles and maple syrup. When Abe spoke about New York, Louise became very curious and clearly envious. Abe sensed that she was being made to feel socially inferior in Rockland and that it was wearing her down. "She *knew* she was made for other places and other things, and she wanted them."

Although he liked Louise enormously, he also felt a little afraid of her because of her statuesque height and emotional intensity: "She was striking. She was exciting. She was very tense and smoldering. I sensed power in her." He had met dynamic women who were officials of important organizations, but he had never met such "latent power" in a teenage girl. "She really took over, and she didn't take over by imposing herself on anyone, not forcefully. She took over by that innate inner strength. She always had it," he said later.

Bernard Nevelson had become very wealthy and powerful through his shipping activities during the war. He traveled to Washington often and referred to Woodrow Wilson so casually that Louise thought he knew the President personally. She would gradually learn that he was a German-speaking Lithuanian Jew who was born in Riga in Latvia, where his father, Meyer, had a timber business. In contrast to Ukrainian Jews, "Litvak" Jews were considered more reserved and sharp-witted but emotionally dry. Bernard was an intense man, refined in his manners and fastidious in his tastes; he was "almost Prussian" in character, according to his daughter Corinne—"humorless, very formal, very rigid, and very

intellectual with a brilliant mathematical mind." He had emigrated to America at the age of sixteen, followed by the rest of the family in 1891. By the end of 1915, he had entered the shipping business with his youngest brother, Charles, and in 1917 another brother, Harry, joined them. The brothers formed several companies: along with Nevelson Brothers Company, their North American Steamship Company helped supply the United States with ships during the war. Bernard was the dominant personality in the family and did not tolerate disagreements with his younger brothers; it was his tough, aggressive drive that was responsible for the family's early business success.

Before long, Bernard sent Louise a letter saying that Charles, treasurer of Nevelson Brothers Company, would be going to Rockland on business. Charles was a bachelor of thirty-seven, although he represented himself as younger. He embroidered the truth in other ways as well. He later told his son that he had been orphaned at the age of four and raised by foster parents in Philadelphia, that he had lived in the Plaza Hotel in New York City and gone to work for Sir Thomas Lipton of the Lipton Tea Company. But a 1910 census taker reported that not only was Charles's widowed mother, Chaye Kreine, still alive but Charles and his brothers were living with her in the Bronx. The census described Charles as a cutter for a cloak manufacturer in the garment industry. Many people found Charles the most appealing of the attractive Nevelson brothers. Although he was only about five feet four and plumpish, he was a dapper dresser with fine manners and a refined accent; his "whole ambition in life was to aspire to be genteel, civilized and educated," according to his son. Almost everyone considered him a decent, amiable man with a certain warm charm.

The way Louise told it, her first meeting with Charles Nevelson was a fateful one. When he arrived in Rockland, he telephoned to invite her to dinner, but she was at the movies with her sister, and her mother took the message. When Louise heard about the invitation, she immediately took her mother aside and confided in her. Although she had not yet laid eyes on Charles, she was so certain of her appeal and her influence with Bernard that she predicted that his youngest brother would ask her to marry him. Furthermore, she told her mother, she would accept his proposal. The evening went exactly as she had predicted, and she agreed to marry Charles. Years later she admitted coolly that to escape Maine she had married herself off to a man she liked to refer to as a Wall Street millionaire.

Louise and others said later that the betrothal had been prearranged by Bernard; that Charles, a ladies' man with a taste for tall women, had merely played a compliant role. Indeed, in 1920, the year of their wedding, Charles signed over his power of attorney to his eldest brother. According to Abe Chasins, "Bernard had an enormous influence over Charles, and he didn't have to coerce Charles to marry Louise. To my mind, Charles was incapable of great love, of emotional intensity at all ... and it didn't matter much to him whether he married Louise or not." After the initial proposal, he probably had some doubts, Louise admitted; but she concluded that he was too much of a gentleman to go back on his offer.

Soon after their first meeting Charles invited Louise and her mother to New York, offering to put them up at the Martha Washington Hotel for women on East Twenty-ninth Street. The purpose of the visit was to give the young couple a chance to get to know each other better and to see if Louise felt comfortable among the Nevelsons' Russian intelligentsia and Ethical Culture Society friends, who were more worldly than the people she knew in Rockland. Louise eagerly accepted the invitation as an opportunity to see New York, the distant metropolis she had read about so avidly in magazines and dreamed of for so long.

Charles showed her the city at its most appealing. First they were invited to the impressive Nevelson home at 300 Central Park West near Ninetieth Street; then Charles escorted them around town: they viewed Manhattan from roof gardens, saw the controversial new Flatiron Building and the Statue of Liberty. "I was overwhelmed," Louise said many years later about her first glimpse of the famous statue. "The water and the sky and this wonderful oversized thing. It looked like she reached to heaven." They dined at the St. Regis Hotel, attended *The Merry Widow,* and went to nightclubs every evening. After Mrs. Berliawsky returned to Rockland, Louise remained in the city alone for a few more days. She found in Manhattan's pace, excitement, and astonishing sights the milieu that she believed had been meant for her. She also understood she was living out a family aspiration: "I had made up my mind to come to New York because my father and mother had intended to come to New York." In the beginning Isaac had indeed planned to stay in Maine only long enough to bring over his family before moving to the big city, but he made his uneasy peace with Rockland instead.

□

Despite her passionate nature, Louise was still a virgin, ignorant of and disinterested in sex; she later called her upbringing a repressive one and confessed to her son that almost until the time she married, she believed that if a male put his hand on her breast, she would have a baby. A Navy man stationed in Rockland had courted her for a while, but she became cautious when she heard he was also calling on a married woman in town. "The other girls would sleep with the sailors, then go to confession," she explained, but she never allowed herself to get seriously involved with anyone who might keep her in Rockland or cause her to be sent away in shame, like the daughter of a prominent family who got pregnant. When neighbors asked her mother how she was able to grant her pretty daughters so much freedom, Annie would proudly say that she trusted her girls. "I would have *died* before I would disappoint her," Louise said.

While Louise was in New York, the Chasins family invited her to visit because Abe wanted his three Upper West Side friends, with whom he played music and pursued show girls, to meet the exciting young woman from Maine. George Gershwin was already composing songs for Broadway shows, and Lorenz Hart had just begun to write lyrics to Richard Rodgers's music. Although the young men admired Louise's beauty and liveliness, they did not keep up with her afterward because, despite her sexual attractiveness, she "wasn't that kind of gal," meaning seductive. "So much of her energy and her thought and her desire was not to make it as a woman but to get the hell out of her environment, to get a secure place where she could start to operate," Abe explained. As a result, nineteen-year-old Louise was evidently more drawn to her wealthy, older suitor than to the talented young musicians closer to her age, although they were undoubtedly closer to her spiritually than her fiancé.

First-generation immigrant girls, particularly Jewish ones, often turned restless and rebellious in America. When Louise was a child and her parents, in the Russian-Jewish tradition, expected her to give up crayons and clay as play, Louise stood her ground. Before she met the Nevelson brothers, she had declared she would never marry; instead, she hoped to emulate Miss Cleveland and prepare at Pratt Institute to become an art teacher. Isaac and Annie Berliawsky were permissive parents, who understood that their offspring, although all but Lillian were still Russian nationals,

belonged to another culture. "My mother and father were very sympathetic," Louise said. "They felt that this was a new country, and that it was a free country. So they supported me in everything." But although her mother ultimately came to trust her eldest daughter's judgment, she also warned her that a career in art would be very difficult and provide few material comforts.

In Louise's memory, her mother did not influence her to marry Charles, but she indicated that she liked Charles "very much," knowing that her daughter respected her "great quiet wisdom" about people. Others believed that Annie did in fact persuade her beautiful daughter to marry the eminently eligible young man. "Her mother thought of the marriage as a wonderful opportunity for her to have a grand life," Louise's first cousin Celia Scheidlinger recalled. Arranged marriages between families were commonplace in her mother's European tradition; and, as it turned out, Louise married at the same age as her mother had and, like her mother, without love. During the period of Louise's formal year-long engagement, she spent her time preparing for her new life in New York, which included visiting the Nevelsons at least once more. Apparently her mother did not feel it was necessary or even appropriate for a bride-to-be to take a job, even though Louise's younger sister Annie, who now called herself Anita, was enrolled in Rockland Commercial College to prepare to earn her own living.

When Louise was asked in later life why she abruptly changed her mind about marriage, she gave various vague replies. It's clear that her courage failed her, for a number of reasons. In 1920 it was not easy for a young woman from a poor background to achieve a realistic degree of independence outside of marriage; the 1919 issue of *Whims*, the Rockland High School yearbook, reported that many recent female graduates had married; a few were in college or nursing school; others were teachers, salesgirls, clerks, and secretaries. When Louise thought about it realistically, the prospect of working her way through art school had many unappealing aspects. It was highly unusual for a woman artist to emerge from a nonartistic background at that time; she knew no professional artists, and her only role models were her art teachers, about whom she felt ambivalent, once describing them as "dried-up old maids." Furthermore, the symbol of the virginal bride on the threshold of marriage, a moment when a woman held great feminine power, was an extremely appealing one for her, even as a mature artist.

Most important, she believed that marriage was not the end of her dreams; during their engagement she believed that Charles was sympathetic to her ambitions and her unwillingness to have children.

One must also remember that the best families in Rockland were descended from shipowners, so Charles's position as a shipping broker and steamship owner must have been quite irresistible. Louise was also somewhat intimidated by her first visit to Manhattan, she later admitted; therefore the idea of companionship with a worldly husband was appealing, especially since she had grown up with a protective older brother. In addition, Charles had become a naturalized American citizen in 1906, so the marriage would immediately give her citizenship, making her the first of the foreign-born members of her family to achieve it. And she was very strongly attracted to the world of influence, power, culture, and wealth that the Nevelsons represented. In 1915 Charles had been a broker for the Aetna Explosives Company, and after suing the company in early 1916 for $1.8 million, an out-of-court settlement had been reached which presumably left him with considerable wealth. It's also likely that her sophisticated New York suitor enormously impressed her, particularly after he (untruthfully) told her he had once courted President Wilson's daughter Margaret. "I obviously recognized that he had quality which no one else in Rockland had," she explained.

Even during their engagement it was evident that Louise and Charles had strikingly different values. When Charles bought her a conventional, one-carat diamond engagement ring from a well-known Maiden Lane jeweler, Louise was disappointed, because it didn't seem to go with the Nevelsons' style of living. She later explained that Charles could have afforded a bigger stone, but he considered a large diamond vulgar, which she did not. Abe Chasins, who knew Charles well because his older sister had once wanted to marry him, found Charles "stuffy, pompous, and mannered: Charles was not cultured, Charles was cultivated. But he had polish. His speech was polished—his look, his manner, his dress, his manners were all polished. But to me they were quite phony."

Charles had attended public schools in Philadelphia and New York, and his education was "not in any sense scholarly," according to his niece Corinne, who considered him an essentially foolish

person. Louise later said she had sincerely believed that Charles would respect her interests in the arts and allow her a nontraditional measure of freedom: "I probably gave him more credit than he deserved for really being an intellectual."

But the Nevelson family's growing wealth and prestige overshadowed Louise's doubts. In 1919, after the Armistice, the brothers formed yet another company, the Polish American Navigation Company, which was incorporated with an initial investment of $3.5 million—$3 million from thousands of Polish-American stockholders and very little from the Nevelsons. Charles petitioned the United States Shipping Board for permission to buy five surplus government ships in which his company would carry cargo between New York and Danzig. The board recommended that his offer of $6.7 million be accepted because of the "apparent good faith revealed in conversations with Mr. Nevelson." The Nevelsons began to take possession of the ships the year that Charles and Louise were engaged, and even in old age Louise liked to recall how the Nevelsons had been "celebrated" for building a fleet of ships for the Polish government, and how some of her sculpture eventually ended up in an office building in lower Manhattan from which the Nevelsons had once operated. The president of the Polish American Navigation Company was the stepson of Ignace Paderewski, the famous pianist who became prime minister of Poland in 1919; Bernard Nevelson was treasurer, and Charles Nevelson, secretary. Bigoted whispers about the Nevelsons being non-Poles as well as Jews were overcome by the brothers' support within the Polish government (Paderewski was an outspoken foe of anti-Semitism), and the fledgling firm was granted exclusive shipping rights in Danzig.

A wedding date of Saturday, June 12, 1920, was set, a few months before Louise's twenty-first birthday. On the preceding Memorial Day weekend, she was the guest of Charles, Bernard, and Lily Nevelson at the Copley Plaza Hotel in Boston, an occasion that was reported in the social column of the *Rockland Courier-Gazette*. Louise proudly insisted that her father pay for her trousseau, even though her fiancé had offered to, and she demanded that the wedding take place in Boston because "I thought he could go halfway, and I could go halfway." The nuptials of his eldest daughter were such an important family event that Isaac broke years of hostile silence and invited his Waterville relatives to the ceremony. The Berliawskys also sent out expensive, engraved wed-

ding announcements which were elegantly scripted in the best upper-class Yankee taste.

A few days before the ceremony, the engaged couple applied for a marriage license in Boston, and a judge waived the five-day waiting period, presumably because they were from out of town. Charles wrote on the license that he was in the steamship business, and Louise indicated that she had no occupation. On her wedding day, Louise wore a lace gown with the hem a few inches above her ankles in the fashion of the time, and a large, elaborate, pink-and-white lace hat that had cost a hundred dollars. Louise looked so "gorgeous" on her wedding day that her sister Anita marveled about it all her life. She was married in the Copley Plaza by Rabbi Harry Levi of Temple Israel in Boston, and a wedding dinner followed for the immediate family. But she had married with misgivings, not trusting but not fully forgetting her earlier instinct to stay single, which was the true dictate of her inner being: "I thought of myself as not being too bright—very attractive, but not too bright. I had not lived, I had no experience, because in the country I didn't even have dates. . . . I thought, There's a world, they get married, and who am I to think this?" Afterward, Mr. and Mrs. Charles S. Nevelson headed off for wedding trips to New Orleans and Cuba, where Charles had shipping business, including taking possession of a fifth steamship.

Growing up in northern New England had marked Louise in ways far more important than the length of her vowels. She ultimately came to recognize that the tension between her Russian roots and her New England upbringing gave vitality and inspiration to her mature artistic expression. She found that being raised as an outsider "was probably good—the toughness and the contrasts probably did something," forcing her to forge a firm and independent identity of her own. Certainly, Louise's development as an artist could have been only enhanced by her Christian education in a gentile milieu. The discrimination and indignities she experienced led to a powerful sense of outrage about the injustice of the social order: "It was only because I had so little confidence in the world that I wanted to build my own world, not *the* world, *my* world." She also entertained the thought that if she had been "fulfilled" too young by social acceptance, or overshadowed by more talented youngsters, she might not have flowered fully as an artist. Being labeled "the artist" in Rockland was important; the

first step in becoming an artist, the psychologist Otto Rank has written, is when one calls oneself an artist. And she believed that if she had not been raised in "the country," as she liked to call Maine, she might not have seen Manhattan with what she described as "vision." Sometimes, she said, one has "to spend time in an antiworld to become conscious, free and powerful in the chosen one."

Young Mrs. Nevelson

Oh, did it take too long to know myself
did it take t world, t whole wide world
to make me see my self, t self of me

—LOUISE NEVELSON

AFTER RETURNING from a second wedding trip, to Havana, the newlyweds moved to a twelfth-floor apartment at 790 Riverside Drive, near 155th Street in Washington Heights, and settled into the life of affluent New Yorkers. During the summer the Nineteenth Amendment to the Constitution, granting all American woman the right to vote, had been ratified, and after Louise turned twenty-one that autumn, she voted in the presidential race that elected Republican Warren G. Harding, an event that must have made her feel an empowered member of the American mainstream. Around that time she posed for a portrait photographer in an elegant fur-trimmed cape tossed over a lace evening gown, with pearls around her neck and a diamond on her finger; she has a little smile on her lips, and her dark eyes sparkle. In the evenings, the couple usually went out—to the Metropolitan Opera, the New York Philharmonic, the theater, nightclubs, or lectures, often with acquaintances from the intelligentsia, many of whom, Louise later emphasized, were musicians and doctors, never mere businessmen.

On the day that she had arrived in America in 1905, a Paderewski recital had made headlines in the Boston newspapers. By the late fall of 1922, when the famous pianist performed at Carnegie Hall to a standing ovation, he had become an acquaintance of the Nevelsons, and they all went out together. There were also business trips with Charles to Savannah, Georgia, and other places, as well as summer visits by chauffeured car to her family in Maine. She was immediately fascinated by the wealthy elite of New York—"the ladies who wore white gloves"—and by their mansions, which dwarfed the colonial homes of Rockland's first families. Although the move to Manhattan into a largely Jewish milieu must have felt to her like an emancipation, it also allowed for an occasional discriminatory incident. Once, when Louise became as deeply tanned as "a mulatto" in the summer sun, she was ignored by saleswomen at Bergdorf Goodman.

For the most part, however, life in New York in the postwar era was characterized by gaiety and prosperity as people enjoyed radio shows, movie palaces, and automobiles. The fat, fun-loving third Nevelson brother, W. Murray, typified the giddiness of the time. He called himself Billy Murray, after a Broadway vaudeville performer whom he resembled. Since he sometimes signed the performer's name, Charles had to back up a number of bad checks. Needless to say, Billy was not in the family business. A number of years later, family memory has it, when Billy was surrounded by chorus girls in a restaurant, he was told that Diamond Jim Brady could eat six dozen oysters at a time. Billy boasted that he could eat seven dozen, which he proceeded to do, downing them with beer. He then excused himself, went to the men's room, and dropped dead of a massive cerebral hemorrhage. He was so large that it was only with great difficulty that undertakers were able to extricate his body.

Entranced by Manhattan, Louise described herself at the time as excitable, distracted, without direction, unsure how to use her abundant energies and heightened imagination. To friends and relatives she appeared to be a beautiful young society woman interested in becoming a singer or an actress. She talked very little about painting and never about sculpture. She did not enroll at Pratt Institute; and when asked in old age why she had not, she gave no convincing answer. Enrolling in a teachers college may have seemed too rigorous, or beneath her dignity when she had a husband able to pay for private lessons; but, more important, she was perhaps not ready for a sustained effort. The young matron

and her friends would "get through the day" by shopping, attending luncheons and teas. "I even played a little bridge and a little mah-jongg once in a while," Louise admitted. Unable to lose herself in the popular entertainment of the era, like Charlie Chaplin or Buster Keaton films, or to be vicariously satisfied by museum visits or cultural events, she observed years later that performing artists often appeared to her like trained animals, and that it had always been difficult for her to identify with what "another mind has left." Sometimes in a frenzied display of undirected creative energy, she undertook decorating projects, like varnishing the covers of all the books on the bookshelves.

Exactly a year after her wedding, Louise inadvertently became pregnant because, she later explained, she was just too healthy. When she went to the doctor's office to confirm her suspicions, she began to hyperventilate with anxiety and dread to such a degree that the doctor told her she would harm herself if she did not relax. Her panic was undoubtedly caused by her fear of being entrapped by her impending motherhood and of following the pattern of her own mother's life. The following winter, when it came time for the delivery, the baby was born by cesarean section; Louise was convinced that she needed the surgery because she had not wanted the baby to be born. In later years she angrily suggested that there was something revoltingly animalistic about spreading one's legs and giving birth.

Myron Irving Nevelson was born at four in the afternoon on February 23, 1922, at Flower Hospital on upper Fifth Avenue. He was never told for whom he was named, and he later speculated that it might have been Myron McCormick, a popular entertainer at the time. However, his cousin Corinne thought that Myron was the Americanized form of Meyer, the name of their paternal grandfather. Louise carefully wrote in a baby book the names of the doctor and the two nurses who had attended her as well as the names of the infant and his parents. Unsure of how to spell the words "cesarean" and even "birth," she wrote, in her conventional script, much lighter than her husband's very dark, stylized signature, that "it was a C burth." She left the hospital with her son on March 9, after a stay of two weeks.

Charles had happily anticipated the birth of the baby, hoping, in Abe Chasins's opinion, that it would make his wife happier and solidify the marriage; he took out a life-insurance policy naming his son as beneficiary. Instead of settling Louise, however, the birth

drove her—a woman who had stopped playing with dolls when her youngest sister was born and who disparaged her own bosomy figure as "the mother body"—into a deep depression. "I wasn't equipped, and I've never been equipped [to be a mother]," she explained. The baby "was very handsome, so I was pleased. But I couldn't help but feel a great responsibility for his life." Louise liked to think that Mike, as he came to be called, took after Charles. Certainly he resembled his father's family physically, being blond and hazel-eyed, and Louise described his personality as gentle and civilized like his father's. "They are, I think, kinder than I, and I think sweeter, maybe, but then maybe their desires aren't like mine."

It was customary among the Nevelson set to bestow a piece of jewelry on a wife who had given birth, and Charles presented Louise with a diamond bracelet. Although she later claimed that she disliked the idea of the gift, she accepted it nonetheless, in keeping with her lifelong ambivalence about the value of conventional tokens of wealth. Being given money or luxuries by a man was a persistent symbol of feminine worth to her, an idea she found simultaneously attractive and repellent. Stories of pawning or giving away precious stones in gestures of independence, then reclaiming them, run like a leitmotif through her life. One day she drove Charles's car to the Bronx to play cards with a friend. When she arrived, she noticed that her bracelet was missing, ran down to the car and found it lying in full sight, where it had fallen, on the dashboard. She snatched it up with great relief, and remarked later that finding it had been far more important than owning it.

She was immediately beset by the restrictions of motherhood, even though her baby had one nanny after another. Mike was acutely sensitive to his mother's feelings; at the age of about three, when Charles prepared to leave for work in the morning, the boy would cling to his father's feet and plead with him not to go. "I dreaded it," he recalled. "I didn't want to be alone with my mother." Although his mother was always kind to him, she was vague and detached. "I don't think I gave him any particular attention," she admitted once. "I don't even think I understood what being a mother meant, as such."

When Lily Nevelson dropped off her daughter at Louise and Charles's apartment, Corinne often discovered a whimpering Mike lying in his crib in soiled diapers while Louise "was practicing on the floor with a tablecloth on her knees or over her head, doing a

scene from something." When the child was slow to speak, his parents took him to doctors, fearing he was retarded; Mike later explained that he had learned only a few words because his father was away at work all day, his mother did not talk to him, and the maid spoke only German.

At times Louise's conflicting feelings about her son terrified her. When the boy was two or three, she was backing up the car when she saw Mike in her path, playing with his dog. As she went to put her foot on the brake, it hit the accelerator instead, and the car lunged backward, narrowly missing the child. Mike said that Louise was so shaken by the incident that she never drove again. At other times she would push him away violently. Over the years she told him more than once that she had not wanted him to be born, that the doctors had had to cut him out of her body. Yet such cruel outbursts were often in the context of an otherwise unusually close and, for a number of years, mutually dependent adult relationship. A surprising number of tender mother-and-child paintings and sculptures, including a rendition of a pregnant woman in the terra cotta *Maternity* of 1950, appear in her work. Still, her feelings of inadequacy as a mother gave her a great, often crippling lifetime guilt, which fostered neurosis, as she realized. She often expressed astonishment that any intelligent woman would choose to have a child. "Hcw can anyone bring another human being on the earth?" she asked.

The baby did not deflect her ambition for long; when Mike was four months old, she began to study voice with Estelle Liebling, a former opera singer. Liebling had made her debut at the Metropolitan Opera in 1902 and, after a European tour, had been decorated by Edward VII of England. Louise loved studying with the famous teacher, who was undoubtedly a role model: after she married and became the mother of a son, she had continued her career with the John Philip Sousa band. Estelle Liebling believed radio offered great opportunities for singers, since the microphone could successfully enhance many small but beautiful voices, and she groomed her students for the air. Besides breathing, diction, and other vocal skills, her instruction emphasized the importance of charm, presence, and poise before a vast, invisible listening audience, and she encouraged her singers to have utter confidence in themselves. She was one of the most gifted voice teachers in New York, and she charged her pupils—including the young Mrs. Nevelson—fifty dollars a lesson, an enormous fee at the time. Louise

used to linger in the long narrow waiting room of Liebling's studio, its walls covered with photographs of her famous pupils and family (her father had studied piano with Franz Liszt), to meet such Metropolitan Opera stars as Amelita Galli-Curci, whose records her father had played, and whom Liebling coached in new roles.

Louise auditioned unsuccessfully for singing jobs at radio stations. She found soprano roles in amateur theatricals and operas, however, and sang in the chorus of a studio performance of *La Traviata* in which she also played a tambourine. Abe Chasins, who accompanied her on the piano from time to time, admired her intensity but did not believe she was musically gifted. "I saw her as a girl who wanted to sing but was never going to make it because she had no voice. It was a sort of screechy soprano to me . . . a voice with a permanent wave." When she was asked in old age about her ambition for a singing career, she appeared to have forgotten that she had ever performed in public, and in fact denied that she had wanted to be a singer.

Little of Louise's art work from this time exists, although she was drawing models on boards as early as 1922. In the autumn of 1924 and the next April, she enrolled in Anne Goldthwaite's Saturday-afternoon drawing classes at the Art Students League. The only female instructor at the League, Goldthwaite was a charming, well-bred, middle-aged southern woman who taught drawing from antique casts or still lifes. She was a respected landscape painter and had been an organizer of the Academie Moderne in Paris. But her class was for beginners; the League's serious art students were in the weekday classes, taught by such prominent American artists as George Bellows, Thomas Eakins, Charles Dana Gibson, and Max Weber. The Goldthwaite class clearly did not give Louise the inspiration she needed at the time, and again she wiped it from her memory. Like other American art students in the early 1920s, she had a narrow knowledge of modern art; examples of avant-garde European paintings were relatively scarce in New York, and only a few American artists, such as Arthur Dove, consistently painted abstractly.

Through acquaintances, Louise met two young married artists, Theresa Bernstein and William Meyerwitz, and began taking weekly drawing lessons in their studio in the Hotel des Artistes on West Sixty-seventh Street. Meyerwitz, a Russian émigré who was an excellent draftsman, had exhibited at the National Academy of Design, the Society of Independent Artists, and the Whitney Studio

Club. Bernstein, who had worked for women's suffrage, was outraged that juries for the major exhibitions accepted very few paintings by women artists. She signed her paintings with only her last name to conceal her sex, and one of Louise's paintings from this period, an awkward rendition of an Oriental teapot, is signed "L. Nevelson."

When Louise and a friend arrived for their lesson, Bernstein would explain why certain objects, such as peaches and a brightly patterned flower vase in front of a heavy drapery, had been selected for a still life. She taught them to paint the darker tones to establish the form of the painting, and as the compositions got under way, Meyerwitz critiqued them. Both of them helped to inspire and encourage Louise, who, Bernstein perceived, had an innate confidence but was uneasy in her environment. "I think that the single element that we gave her was the feeling that the language of art was the prime language of a human relationship with life," she observed many years later.

Bernstein remembered that Louise used to scrape the mounds of oil paint off her palette with her knife in such an assured, controlled way that she told her that she must sculpt someday. The couple never forgot her; she had appeared to them as "a column of vibrating development" who was "very animated and very outgoing [and] seemed to immediately come forward and express herself," in Bernstein's words. It was a mutual admiration. In later years when their former pupil achieved a success greater than their own, she continued to list them in her exhibition catalogs and graciously introduced them at openings as her first teachers.

In the summer of 1920, immediately after Louise's wedding, the Nevelson shipping business began to deteriorate as a result of bad luck and a severe shipping depression. That summer two of the Nevelson steamships, the *Poznan* and the *Krakow*, were chartered to take cargo to Cuba, but the port at Havana was so overcrowded it was impossible for them to unload; one ship returned to New York without unloading, the other accidentally burned at sea. The value of the Polish American Navigation Company's ships fell from more than six million dollars to less than one million in a year. Meanwhile, Paderewski had withdrawn from politics amid criticisms that he relied too heavily upon American financial experts and that his wife meddled in affairs of state.

By July 1921 the United States Shipping Board had taken back

the last of the five ships it had sold the Nevelsons because they had failed to meet the payments on them. Five years later, when a bill that would have made the government withdraw its claims and return the ships was unsuccessfully introduced in a House of Representatives subcommittee, it was charged that the brothers had paid themselves a dividend before making a debt payment to the Shipping Board and had concealed from the Poles the illegality of selling an interest in American ships to a foreign country without United States government approval. For a while, other Nevelson steamships shipped mahogany logs and bananas from the 150,000 acres of land the family owned in Blue Hills, Nicaragua, to Galveston, Texas; but the business languished, and in the mid-1920s the brothers were forced to sell at a loss to the large and expanding United Fruit Company.

Even before the impact of these changes in fortune was fully felt on the Nevelsons' way of life, tensions had arisen between Louise and Charles. In 1924 they moved from their Riverside Drive apartment to a small, new pseudo-Spanish house in a large upper-middle-class Jewish neighborhood in Mount Vernon where the Bernard Nevelsons also lived. For the ambitious young woman from Maine who had dreamed of a life in New York, the move to Mount Vernon, where she was isolated in a domestic milieu, brought paralyzing unhappiness. She gradually withdrew into depression and psychosomatic illness, exactly as her mother had done, suffering frequent attacks of sciatica, which confined her to her bed for almost the entirety of 1925. She suffered from boils and abscesses and said she felt that her blood was boiling as if on a stove.

She had already learned that there was a great difference between a bride-to-be and a wife, and she later suggested that Charles had broken promises made to her during their engagement. She had discovered that underneath her husband's sophisticated veneer lay conventional bourgeois values. Mike, who described his father as a kindly, old-fashioned gentleman, acknowledged that he was naive: "He was of the nineteenth century, and he had an idea of a man's place and a woman's place." When Charles dogmatically attempted to impart his beliefs to his son, Louise became irritated. "Charles was always talking to me about building character, honesty, discipline, leading a disciplined life—'We were not put in this life for fun, for pleasure. We're here to serve a higher purpose,'" Mike remembered. "He was always preaching. My mother, of course, couldn't stand it." Her husband came to represent a culture

and set of values against which to rebel. Charles "tried to restrain her," according to her sister Anita. "He strangled her with her ambition and her emotions." Early on in the marriage, Abe Chasins began to see "her frustration and her loss—her definite loss—of vitality and vivacity, which had *always* characterized her." Louise later acknowledged that she had recognized very early in her marriage that she had little in common with her husband: "I was never married in the true soul sense."

Charles was dismayed by his wife's impulsive acquisition of objects she found beautiful, which resulted in overloaded trips between Maine and New York and, once, the purchase of two silver bowls from an antique shop when out for a drive with Mike and his nurse. Louise avidly read antique dealers' brochures about upcoming auctions at a time when treasures were turning up from postwar Europe. She used to park Mike in a baby carriage outside an auction house while she went inside to see who was buying and what was of value. "She had a blotting-paper memory and soaked up everything," Corinne Nevelson observed. And over the years, as she trained her eye, she developed an unerring instinct for objects of quality.

While Charles dressed conservatively, Louise liked to create flamboyant outfits for herself, like a dress decorated with a dickie made from a wedding napkin. He often insisted she return purchased outfits that he disliked, and he began to be embarrassed to walk down the street with her. So, later, was Mike, who would trail several paces behind his mother, hoping to dissociate himself from the comments of passersby about the striking woman wearing strange clothing. It was like her own mother's promenades along Rockland's Main Street—only in this case Louise lacked her husband's approval. "There's so much of you that has to compromise with another person," she observed in later years when discussing her marriage, and she angrily recalled the power a spouse has "to love, to *kill*, to anger, to this, to that." She said another time: "I learned that marriage wasn't the romance that I had sought but a partnership, and I didn't want a partner."

Within two or three years of their wedding, Charles became fearful of losing his wife's affection and even of losing Louise herself. This was particularly disturbing because divorce was unthinkable in the Nevelsons' circle. "My father was insecure," Mike explained. "My mother was a very beautiful woman, and my father was a stocky man with glasses who was balding and combed his hair over the top of his head." Abe Chasins thought Charles was

"very proud" of Louise but also "a little afraid of her," and others
saw that her growing cultural interests, which outdistanced his,
intensified his possessiveness. Louise confided to a woman friend
that Charles would start an argument every time they prepared to
go out, suggesting that he was anxious about her flirtatiousness
with other men. In time her despair became so deep that when she
read in the newspaper about the trial of a woman who had pushed
her husband out the window for refusing to let her go to a party,
she worried that she might do something equally desperate if she
did not find a way to leave her marriage. In the privacy of their
home, the couple fought loudly and often about sex and money.
Charles would accuse Louise of being unfaithful because she would
not sleep with him; the development of reliable forms of birth
control had made many men in that generation worry about their
wives' freedom to have love affairs without fear of pregnancy, and
Louise years later quietly indicated that Charles had grounds for
his suspicions. He grew so jealous he hired detectives to follow her.
He telephoned the house dozens of times a day until the maid
begged him to stop because she was unable to do her work. "I had
no freedom," Louise said. "All of this made me terribly nervous."

The Nevelsons indicated clearly to Louise that she was not
meeting their expectations in any way. They criticized her for being
irresponsible and neglecting her domestic duties. From time to
time an incident would confirm this accusation. She once took Mike
to the beach at Coney Island, put on his red rubber beach shoes,
and told him to wait on the shore while she went into the water.
After she disappeared, he wandered into the ocean to find his
mother and was dragged under by a wave. When Louise glimpsed
a red rubber shoe floating by, she grabbed at it and discovered
that it was still on her son's foot.

Lily Nevelson humiliated her young sister-in-law by suggest-
ing that she was their social and cultural inferior and by frequently
remarking, "Well, she's from the country—what does she know?"
More than twenty years older than Louise, Lily was short, square,
and plain, and her criticisms probably had an edge of envy to them.
Bernard Nevelson gave Louise stern lectures, but Lily maintained
icy silences, which chilled her as much as any cruel remarks. Ac-
customed to being a dominant personality in her own family, com-
pletely understood and indulged by her mother, Louise found the
change an unnerving shock: "I was kept in a highly nervous state—
and if I ever had an inferiority complex, that was the time."

Abe Chasins realized that Louise's despair was deepening.

"Her eagerness, her glowing enthusiasm, had all but been extinguished. Those sparkling eyes had always flashed with excitement, but as she participated less and less—as she regressed socially—it was obvious she was trying to conceal her bitterness, her disillusionment, her dissatisfaction with everything and everyone starting with herself. . . . She once confided a little bit to me that she was less sure of herself than she had ever been before." He was afraid to hear more, because he saw no way for her to divorce; she had no money of her own, and the Nevelsons had neither the inclination nor the ability to finance her independence. "And she knew I knew. And I think I was one of the few people she liked a little, because she thought we had great understanding without my intruding into her confidence or world." Unable to help her himself, Chasins, who had recently become interested in the ideas of Sigmund Freud, quietly advised her to seek psychiatric help. Corinne Nevelson does not believe that she did, because the Nevelsons would have strongly disapproved.

As a result of the Nevelsons' business failures, Charles left Nevelson Brothers Company in 1926, gave up the house in Mount Vernon, and moved his family to Brooklyn. As their standard of living was steadily reduced, there was no more live-in household help. Tensions between Charles and Louise accelerated when she declined to perform the domestic chores that her maids used to do, declaring that she was "not for that." That summer they lived in a house on the beach in Far Rockaway, where they drew the shades against the heat. The landlord, a retired bachelor who lived in the adjoining house, recently had been tricked into selling his stocks for fake replicas of the Russian crown jewels. Soon afterward he hanged himself, and Louise discovered the body. "I remember that she was screaming, and then we moved from that house" is the way Mike recalls the event.

In the following weeks Louise apparently packed her bags and left with four-year-old Mike for Maine, where she enrolled in a landscape-painting class at the summer art school in Boothbay Harbor. A few days after classes began, the director took Louise aside, informed her that she was far behind the others and not ready for the school, and offered to refund her tuition. Louise refused to give up and stayed on. Each day after the class ended, she took Mike on rowing and sketching outings; in the evenings she left him alone in the boarding house where they were staying while

she went out with friends. She stubbornly worked at her painting and after a few weeks won praise from the director. One of her landscapes was an oil painting of a sailboat rendered in strong, vivid colors, conveying a sense of motion by rough, violent, angry slashes with the brush. At the end of six weeks she was the best in the class, she claimed, which reinforced her belief in the importance of persisting and ignoring others' initial judgments. When Abe Chasins saw her around this time, he sensed "a new determination in her, a kind of courage and the desire to get out from under somehow taking place within her." And he told himself, "This time she's really going to take off."

After her marriage, Louise had encouraged her family to rally around her like an admiring court. Her younger sister Anita lived with Louise and Charles in Mount Vernon while she attended Columbia University Teachers College in New York for one semester. After Anita married drapery salesman S. Stanley Goldfarb in 1927, she moved with him to Brooklyn near the Nevelsons' next apartment, on Woodruff Avenue. At this point the youngest sister, Lillian, moved in with the Nevelsons. She had attended a teachers college in Maine, and in the winter of 1927–28 she taught kindergarten at the private nursery school Mike attended; the next year she worked as Charles's stenographer at his midtown Manhattan office. Nate Berliawsky also left Maine to live with his sister and brother-in-law while he worked in a metal-stamping business specializing in auto bumpers which Charles had established in Brooklyn's Bush Terminal. After his honorable discharge from the Navy, Nate had returned to Rockland to work in construction and real estate with his father and then had tried his fortune in Florida during the land boom. Uneducated but intelligent and with a fine sense of humor, Nate "played the game of being a roué from a small town," according to Mike. He wore loud striped suits, which Charles complained made him look like an Italian gangster. Louise's siblings gave their sister companionship, moral support in disputes with Charles, and help with her domestic responsibilities at a time when she felt undermined by the Nevelson family. "We were sympathetic with her because she was so unhappy," Anita explained.

Her sisters always thought that Louise would have gone on the stage if her husband had permitted it; indeed, a few years later she dreamed about going home with the actress Katharine Cornell. In 1926, she saw a newspaper advertisement for the International

Theater Arts Institute, housed in a Brooklyn brownstone, and that October she began to take acting lessons. In later years she would insist that she took the lessons merely to overcome her timidity and to learn to express her emotions, not with any intention of becoming a professional actress; at another time she explained she was preparing herself for fame. One of the group's founders was Princess Norina Matchabelli, an Italian actress who had played the Madonna many years before in Max Reinhardt's 1911–12 London production of *The Miracle.* Her second husband, Prince Georges Matchabelli, had been Russian ambassador to Italy before the Russian Revolution. The impoverished prince and princess came to the United States so that Norina could star in a 1924 revival of *The Miracle.* It was a disaster, and after a few months the princess left the stage forever and began to teach acting, expression, improvisation, and pantomime in an attempt "to waken the authority of instinct and intuition" as well as other aspects of creativity. Louise immensely admired and carefully observed this "gorgeous" actress's Italian vivacity and expressiveness, her large hats, her sense of style, and the way she walked and spoke.

The princess had a deep interest in metaphysics and spiritualism, and Louise's gradual awareness of these subjects was stimulated; she began to study metaphysics, keeping "copious notebooks" and reading books about the nature of reality in which she underlined paragraphs and wrote marginal notes. It was through the princess that she first heard about the "fourth dimension," which the actress defined as "a purely subjective thing to be thrown out as radio waves;" the cubists depicted it as the normally unseen fourth side of an object. Afterward, referring to herself as "a seeker," Louise became interested in Meher Baba, a Parsee spiritual leader, whom she had learned about from Princess Matchabelli, and went on to examine a wide variety of philosophies and religions, searching earnestly and sometimes desperately for contentment, or, as she put it, "peace between the storms."

It was through Princess Matchabelli, who had known him at Max Reinhardt's theater in Berlin, that she met Frederick Kiesler, co-founder of the Theater Arts Institute, a dapper, dynamic, diminutive Viennese in his thirties. Kiesler had a reputation as one of the most innovative architects and designers in Europe. In the early 1920s he had developed radical ideas, such as theater-in-the-round, and in Eugene O'Neill's play *The Emperor Jones* he introduced what he called the space stage, where continuous movement of scenery was coordinated with the acting and lighting. Kiesler

had arrived in America for the International Theatre Exposition in 1926 with models, photographs, and drawings of modern set concepts by Picasso and other leading European artists and designers. Louise was fascinated by the exhibition and went to see it at least three times.

Few critics, galleries, or museums in New York were interested in avant-garde ideas at the time; and in this cautious intellectual milieu the articulate and gregarious Kiesler became even more outspoken about his theories and the latest European ideas. Members of the American metaphysical movement, which included devotées of the theosophy sect and followers of the mystic George Gurdjieff, rallied around him. Readily drawn to speculation about paranormal phenomena, trance states and new forms of consciousness, Louise became one of his first students. Despite his small stature and the fact that he was married, Kiesler was often surrounded by famous beauties; he "just *loved* beautiful women," Louise recalled. She and her sister Anita were invited to a banquet he held at the Plaza Hotel on Easter Sunday in 1926, where he found that he and Louise had "electric affinities" for each other; he became a lifelong admirer of her beauty, extravagances, and eventual artistic radicalism. Although she never asked either one directly, Kiesler's second wife, Lillian, believed that Louise and her husband were occasional lovers for many years.

In the spring of 1928, Jiddu Krishnamurti, the theosophists' "new Messiah," spoke at Town Hall. Louise, who had bought an aisle-seat ticket, never forgot the elegant, graceful, "beautiful young man" in his shining white clothing with his *"piercing"* large dark eyes. Krishnamurti's message, delivered in an upper-class British accent, was that each individual should strive to free himself from self-imposed limitations in order to claim his "total being." Louise ardently adopted his views, which she interpreted to mean that she did not have to justify her behavior or existence to anyone else. At the time she was searching for the courage and rationale to devote herself to one form of self-expression or another. Her response to his presence was so strong that she had a mental image throughout the lecture of his voice coming from his heart, not his lips: "I saw a vision of moving lips superimposed on his heart, which was a visual projection outside of him but placed in front of his heart."

Louise's imagination produced at least two other similar visions in her life. When she saw the young Jack Benny on stage playing the violin, she visualized "steam," or what she interpreted

as a form of energy, emanating from him to the audience. And the first time she saw Greta Garbo, who fascinated her, in the flesh on Fifth Avenue, a halo of light seemed to ring the actress's head. This ability to dissociate herself from objective reality and enter completely into the emotional truth of an experience proved to be essential to her development as an artist. Some years later, she elaborated upon her ability to transport herself into a heightened state when she described how she had once reacted when standing in front of Henri Rousseau's painting *The Sleeping Gypsy*, which she mistakenly assumed to be a female figure: "You're moved, you're transformed from the object that you see, into a dimension. You don't look, if you are really transformed, and say, 'oh, she's got a dress—candy stripes' . . . you're just lifted, like a great singer would lift you."

Charles's income, as he tried to make a success of various kinds of enterprises, continued to fluctuate. In the fall of 1928 he left Brooklyn and rented an apartment in a new building at 108 East Ninety-first Street between Park and Lexington avenues. Although the building did not meet Louise's aspirations, she was undoubtedly glad to be back in Manhattan, where she would live for the rest of her life. But she continued to be resentful of her husband's financial difficulties and contemptuous of his poor judgment. A small oil, *The Lady That Sank 1,000 Ships*, which she painted in 1928, is revealing. It is a close-up of the head and shoulders of an apparent nude, her head in the sky, while in the distance a fleet of ships is slowly sinking. The lady stares directly and boldly at the viewer, as if such worldly disasters are of no consequence and somehow beneath her.

Conflicts with Charles were more frequent because Louise was unable to budget money; when he criticized her for having meat delivered from fancy Madison Avenue grocery stores instead of shopping herself at less expensive Third Avenue markets, she replied that she did not wish to walk around with a grocery cart in a place where servants shopped. Charles had by then invested the last of his money in the stock market; after the crash of 1929, he used to take his son down to the basement of the building to inspect his "big trunks of stock certificates of companies that didn't exist anymore." This was during prohibition, and Charles cultivated a friendship with a doctor on the ground floor who wrote him apparently very welcome prescriptions for whisky.

One day in the winter of 1928–29, Louise walked over to the Metropolitan Museum of Art and went to the balcony where a group of Noh kimonos, worn by actors in the classical Japanese theater, were on display. Her eye was caught by the finely woven gold cloth embellished with golden medallions and stitched with the sheerest gilt threads. Recently she had been paralyzed by misery, but suddenly she was overcome by the beauty of the robes, and she began to weep copiously. "And then I knew and I said, oh my God, life is worth living if a civilization can give us this great weave of gold and pattern." She saw that the extravagant fabrics were refined and elegant, not at all vulgar, as the Nevelsons might have labeled them. "Her contempt for conventional taste grows out of the vision—always before her—of a kind of magnificence," art critic Dorothy Seckler later observed. The experience connected her again to another realm of existence, one based on aesthetics and exquisite feeling. "I went home, and it gave me a whole new life," she said.

Louise began a serious, full-time study of art at the Art Students League on West Fifty-Seventh Street in the autumn of 1929. Her decision provoked Charles's skepticism and exasperation; but Mike, now a second-grader, was at school most of the day. Previously she had been too distracted by other interests and various personal difficulties to pursue seriously her girlhood ambition to be an artist. As if by a process of elimination, she was "pushed into it because the other things didn't add up. There was nothing else to do." Yet in many ways art was the most demanding. It implied a rejection of an interpretive or performing role with a long-established female tradition, like singing or acting, and signaled her determination to become an original creator—a risky path. She also understood that no one else was going to fulfill her dreams for her, and later wrote:

> No longer am I waiting
> For someone else
> To take me out
> of that dark place
> The self of you is the prime mover

The League, a remarkably democratic art school, described itself in its 1929–30 catalog as "an association 'of Artists and Students who intend to make Art a profession.' Its objects are: first,

'the maintenance of an Academic School of Art, which shall give a thorough course of instruction in drawing, painting and sculpture,' and second, 'the cultivation of a spirit of fraternity among Art Students.' As such it is a cooperative society run by students for students." It had a warm, supportive, liberating atmosphere, and young artists proudly declared that it was the only American art school where avant-garde ideas were tolerated and artistic freedom was encouraged.

When Louise enrolled at the age of thirty, she joined the mainstream of her generation of artists at a time when modern art was just taking hold in America. That autumn the Museum of Modern Art opened its doors in a brownstone a few blocks down the street from the League, at the corner of Fifth Avenue and Fifty-seventh Street. When it exhibited its first Picassos in January 1930, in an exhibition of French painting that also included works by Matisse, Derain, Bonnard, Braque, and Rouault, thousands of Americans got their first look at a substantial body of contemporary European art. Louise was particularly affected by Picasso's cubist paintings. "I had always identified with cubism from its earliest stages," she once told Diana MacKown, and she found the Cézannes, early Braques, and early Picassos "complicated and sophisticated and remarkable." The intense tensions in the American art world between traditionalists and modernists were keenly felt even at the League, where the abstract work of painter Stuart Davis was first shown in 1930. When the young artists Dorothy Dehner and David Smith enrolled in the painting class of Czech artist Jan Matulka in 1929–30, "everybody called us communists—not political communists but aesthetic," Dehner recalled. "We were breaking off from even the advancement of the League itself, which was already a breakoff from the Academy."

The League's "spirit of fraternity" gave Louise such a strong sense of camaraderie with the other art students that she later said its atmosphere had been more important than its teaching. "There's a certain kind of energy they're all pouring out, and it gives you confidence," she explained. The school's emphasis on a collective spirit among artists was especially significant at the time. American artists had often felt isolated during the 1920s because only a handful of galleries would exhibit their work and few collectors were buying it. A young woman seriously interested in becoming a professional artist was still regarded as "a freak," like Rosa Bonheur, because, according to Louise, such ambition

revealed "too independent a spirit." Consequently, the radical, ex-
citable, ebullient milieu of the League was exactly what she needed,
and she became a member within months.

Louise mingled so easily with the other young artists that
although she was ten years older than most of them as well as
married and a mother, many of her classmates remained unaware
of this, even though she occasionally left Mike with a Chinese art
student, who also served as the League's cloakroom attendant,
while she went to class. She was "smiling and full of laughter—a
handsome, luscious person," recalled Ivan Donovetsky, who was
in many of the same classes with her. Another student remembered
that she used to wear an eccentrically long black coat, in which
she wrapped herself to take late-afternoon naps in the second-floor
art gallery. One young woman was struck by the large diamond
ring Louise wore, which at first seemed ostentatious in the egali-
tarian atmosphere of the League, but which eventually fit perfectly
with her personal flair. When, at about this time, Louise and
Charles attended the eighteenth birthday party of a young family
friend in Brooklyn, Louise wore a "marvelous beige outfit" with a
fur around her neck and "was beautiful and exciting, very excit-
ing," in the eyes of the young woman.

Louise made friends with an art student named Dora Lust, a
divorcée who lived near the Metropolitan Museum of Art, where
Louise often sketched. She and Dora liked to sit up late at night
talking about art. It was Dora who introduced her to a group of
semireligious, very rich individuals in Greenwich Village, includ-
ing a mystic known as Countess Nadine Tolstoy, who was married
to the second son of Count Leo Tolstoy. Louise "fit right in," Dora's
daughter, Elenore, remembered—and she also gave everyone the
impression that she had a wealthy husband.

Her first semester at the League, Louise signed up for Kenneth
Hays Miller's Life Drawing and Painting. An erudite, austere, and
introspective New Englander, Miller had a reputation as an im-
portant artist and the most distinguished teacher at the League,
although by the late 1920s his class was considered a bit dull—a
place to go only "to tighten up," according to Dorothy Dehner.
Miller taught the classical techniques of Renaissance painting
while encouraging the use of modern subject matter. He instructed
each of his pupils to cover the canvas with a transparent veil, draw
the composition in charcoal, apply fixative to it, then proceed with
oil paint. White highlights always came first, then umber, brown,

and other colors. Throughout, he lectured about the meaning of art in a lofty philosophical manner that many students found intellectually and emotionally demanding. He was inspirational because he was totally devoted to art as a way of life, and he always had a group of worshipers who lived for his lectures and attended the Wednesday afternoon teas at his Fourteenth Street studio.

According to another League student, Frances Avery, Louise learned Kenneth Hays Miller's underpainting technique thoroughly, and the professor "admired her tremendously" and enjoyed critiquing her work during his Tuesday and Friday analyses. But during the two years Louise was in his class she grew impatient with the limitations of the technique, and in a true test of the League's spirit of freedom she began to apply paint directly onto her canvas in direct opposition to what Miller taught. She painted in the style of Cézanne or Gauguin, using brilliant colors, large forms, very bold outlines, and flesh tones in almost any hue. Once Miller was convinced that a student knew his method, he permitted experimentation, particularly if he thought highly of him or her. This was obviously the case with Louise; she established a rapport with him that lasted throughout the 1930s.

Miller, in his fifties, was known for his efforts to charm his female students by taking their aspirations seriously. After he had "a little affair" with the artist Isabel Bishop, "I became his pet. . . . He was wonderful to me, so I was fine," Louise confessed. He used to escort her to the Metropolitan Museum, and on such excursions he offered her esoteric conversation and an approving, flattering friendship that must have encouraged her most serious ambitions as an artist. When he was ill in the winter of 1931, she brought him a bunch of grapes, a fruit that frequently appeared in his classroom still lifes. He thanked her for the "magnificent grapes" in a letter, saying that he had hung them where he could observe them and had tasted them "where the symetry [sic] could not be spoilt." He continued: "I thought you remembered, perhaps, my admiration for their form in nature; I often refer to it as a kind of guide in the persuit [sic] of the ideal fulness [sic], both in detail and in mass, a sculptural form in the art of painting." Almost certainly, Louise had remembered.

A month after she first enrolled at the League, she also signed up for Kimon Nicolaides's Antique Drawing and Composition. In an informal working arrangement, Miller used to send students to the popular class if he thought they needed more instruction in

drawing. Nicolaides, a modest man whom Miller praised as "a brilliant teacher," emphasized finding one's own style by intense observation "that utilizes as many of the five senses as can reach through the eye at one time." He taught by asking for rapid gesture and slower contour drawings, done from memory or by not looking away from the object, in a certain number of minutes. He advised his students to wear eyeshades, eschew erasers, and use pencils with fine, sandpaper-sharpened points on cream-colored manila wrapping paper. When students advanced to "modeled" or three-dimensional drawings, he instructed them to draw "exactly as if you were a sculptor modeling with clay." Louise later praised his teaching, which emphasized intuitive feeling, and recalled that the first drawing she did for him he picked up, praised, and displayed on the wall as "the best" of all.

Nicolaides, like Matisse who had recently had a retrospective at the Valentine Dudensing Gallery, was a strong influence on Nevelson. From Nicolaides's quick gesture drawings, she realized how much she enjoyed techniques that allowed speed, spontaneity, and prolific output. "I didn't have to measure," she explained. "It would offend me to think I would have to measure something, because I *feel* it." It was a time when she became "a marvelous draftsman," she said, using lead or ink with the utmost sensitivity to make firm or faint strokes. "When I used a line, it was like a violin." Her drawing became so fluid that it was an essential emotional outlet for her: "I might have been bottled up in other things, but I was free to let my hand go." Drawing the female figure was particularly important because it "gave me a kind of strength," and indeed the headless, heavy-limbed forms contained an element of self-portraiture. She began to draw compulsively, sometimes doing forty or fifty drawings of a female nude a day. "The sooner you make your first five thousand mistakes, the sooner you will be able to correct them," Nicolaides taught, and from 1928 to 1934 Louise executed "about ten thousand drawings that gave me an enormous background." Later, the semirepresentational drawings gave her the authority "to break an image or create one" as she moved closer toward abstraction. In later years, her awareness of line inspired her to draw, in effect, with light as she allowed edges, cracks, and holes to admit daylight into her black constructions.

A 1928 untitled pencil drawing on sketch paper of a contorted female figure, drawn before Louise entered the League, is full of radical artistic ideas—its archetypical, monumental qualities are

reminiscent of a Henry Moore sculpture, and testament to her exposure to modern art. With extremely simple, wire-like lines— a curve for a belly and a straight line for shoulder blades—she evoked the feeling of a fleshy female body. Her figures are not anatomical ones such as sculptors often make; they are "exaggerated, but all the joints and glands are there," as art critic Maude Riley observed in *Art Digest*. By 1934 Louise was making drawings of powerful female nudes in one confident stroke or in a series of strong, sure, uninhibited lines. When some of them were included in a show of sculptors' drawings three decades later, along with those of David Smith, Ibram Lassaw, and Alexander Calder, the old student drawings held their own.

In 1929, the ideas of German painter Hans Hofmann were adding to the excitement at the Art Students League. His disciples considered him the most inspiring art teacher in the world, the only one able to unravel the mysteries in the cubist paintings of Picasso and other modern masters. One student claimed that Hofmann was the only professor with satisfying answers for someone searching for an aesthetic of painting or a philosophy of art, since he regarded "cubism as a kind of basic grammar which was related to classicism." After studying in Paris, Hofmann had returned to Munich and in 1915 founded the Schule für Moderne Kunst, for many years the only art school anywhere devoted to avant-garde ideas. Like Princess Matchabelli, he also became interested in the fourth dimension, which he defined in the August 1930 issue of *Art Digest:*

> With the acceptance of the Theory of Relativity by Einstein, the fourth dimension has come into the realm of natural science. The first and second dimension include the world of appearance, the third holds reality within it, [and] the fourth dimension is the realm of the spirit and imagination, of feeling and sensibility. . . . The effect of reality in a picture is found not by copying nature but through the spiritual contact of the artist with nature expressed through a medium in its own language.

Among those spreading Hofmann's name in New York that winter was one of his first American pupils, Vaclav Vytlacil, a painter of colorful, geometric abstractions. When Vytlacil returned from Europe in 1928 and began to lecture at the League about his

teacher's interpretations of the radical new art, many of the students "went wild" about these ideas. The artist George McNeil, for one, attributed his initial excitement over modern art to Vytlacil's lectures. Vytlacil also encountered Louise and never forgot her vivid personality and openness to his theories. "She was receptive to new ideas. It was a pure pleasure to talk to her."

Although Hofmann had begun to teach in California during the summers, it was easier for many Americans to study with him in Munich. In 1930 his class at the summer school of the University of California at Berkeley was in such demand that two hundred students were turned away. It was common at the time for American artists to study in Europe for more advanced training and to be in a sympathetic milieu. "Everyone was talking about this great teacher in Germany who taught the subtleties of cubism," Louise explained. "I knew then that I had to go to Germany."

After two years at the Art Students League, she had rediscovered an avenue for her creative energy—art—and now she wanted to live and work as a visual artist. She had a bedrock faith in herself, based in part on her emotional needs, her awareness of her artistic sensibility, and her sense of her own enormous psychic and physical energy. "I knew I had it, and I felt that through this special perception I could live a meaningful life," she said. She had regained confidence in herself, and she felt entitled to study with the greatest teacher in the world in the same way that she had sought out the best instructors in Rockland and New York. "But there is a world, and I wasn't ready to face all these things," she explained in 1983. "Then I was a mother. Then I was sympathetic with my husband too." She went through a confusing period of "emotional struggle, the struggle to confront"—in short, a pyschological struggle between her own needs and those of her husband and son.

In 1930, probably through Frederick Kiesler or a member of his circle, Louise met and took a few private painting lessons from Baroness Hildegard Rebay von Ehrenwiesen, a member of the lesser German nobility and an avant-garde painter, who recently had emigrated to America. She was a heavy woman with flaming red hair, eccentric, enthusiastic, and volatile, who held dogmatic views about modern art; she made a distinction between "nonobjective" painting, which she claimed was based on intuition, and abstract art, which she said derived from the forms of nature. While Louise sketched skulls in the baroness's small Carnegie Hall studio, hung with works by Wassily Kandinsky, Paul Klee, and

Rudolf Bauer, her teacher worked in collage for a show of her own work. Over the years the baroness encouraged many young artists to paint in the modern genre; she bought the first painting that Louise Nevelson ever sold. The baroness also introduced her to several important people, including Solomon Guggenheim, whose portrait she had painted; Louise and Charles attended a social function in the Guggenheims' gigantic suite at the Plaza Hotel. It is likely that the baroness encouraged Louise to study in Germany, since she had little regard for the no-nonsense cultural milieu of New York.

Louise was receptive to the idea of going to Europe for a number of reasons. As the Depression settled over the United States, she became even more irritated by her husband's economic hardships. The marriage came under greater strain when she enrolled in Nicolaides's evening class in the spring of 1931: it lasted from seven to ten o'clock at night, and she refused to be home for dinner. "I soon realized that within the [Nevelsons'] circle you could know Beethoven, but God forbid if you *were* Beethoven," Louise observed in her seventies. She began to separate herself from her husband symbolically by signing her paintings "Louise Berliawsky," but she soon stopped because "I decided not to break the bond of Nevelson with my son;" by 1932 her signature was identical to the one she would use for the rest of her life. As she began to dress in an even more uninhibited manner, Charles criticized her more harshly. "Remember 1931 when you went to the Art Students League, wore a burlap bag for a dress, and were daily reminded that you were crazy?" Mike asked his mother years later. It was around 1931 that she apparently moved out of the family's current apartment temporarily; she wrote her address as 216 East Thirteenth Street on the back of a painting.

When she talked about studying in Munich, the Nevelsons strongly disapproved. Since Charles, who had no understanding of modern art, was unwilling and unable to give his wife money to study abroad, she turned to her family. Annie, who long had held the moral authority in the family, recognized the depths of Louise's misery—so similar to her own—and finally made the trip possible.

Handsome and overpowering, with her gray hair arranged in an elaborate coiffure, Annie now seemed larger than her "unprepossessing" husband, in the eyes of Corinne Nevelson. She did not depend upon her eldest daughter for care and companionship the way she relied on her second daughter, Anita, whom she periodi-

cally summoned back from New York to help with the housework. Louise had been released years earlier to live vicariously for her mother, and the prospect of her daughter returning to Europe seemed to satisfy her own long-standing desire to do so, even though it was for a completely different reason. "So she said to me, 'You've always wanted to be an artist, you said you were going to Europe—why don't you go? We'll take care of Mike, and you go and study,' " Louise recalled. "I said, 'But you're sick, and who knows what will happen?' She said, 'If I'm going to die, it makes no difference whether you're here or not. Go and finish your studies.' " Louise was deeply grateful, and in testimony to her mother's immense authority over her, remarked more than once that if her mother had asked her to jump out a window, she would have done so. She also intimated in a poem that it was a great feminine force, inherited from her mother, that was driving her:

> The Great Beyond is calling me
> The more aware I am of her
> The more aware I am of there.

Even though it was the depths of the Depression, the Berliaw-skys found the money to finance Louise's trip. During the past decade, the family's real-estate dealings had expanded until Isaac was said to control much of the real estate in Rockland, along with Mrs. Brown and a partner named Blaisdell, and a good deal of forested land outside town as well. Charles, deeply upset at the turn of events, went to Maine. When his mother-in-law wept about how sad she was over Louise's imminent departure, he realized, he later told his son, that her tears were insincere—that in fact she had made the trip possible. Although the Berliawskys were very fond of Charles, they were more sympathetic to Louise. He "wanted a wife but he got an artist," Anita remarked in 1982, expressing the family viewpoint.

Almost instinctively, Louise had begun to imitate her mother's life by marrying young and giving birth to a child soon afterward. But when misery and psychosomatic illnesses made her bedridden at the age of twenty-six, she gradually rejected her mother's way of suffering and even the rudiments of domesticity. Instead of giving birth to another child, as her mother had done—that child being herself—she struggled to give birth to herself as an artist. According to Otto Rank's *The Artist*, an artist becomes his or her own mother psychologically, a theory that partially accounts for

Louise's immense difficulty in feeling and acting maternal toward someone else. Nonetheless, she claimed to have experienced a sharp sense of guilt at the prospect of leaving her son, probably intensified by the fact that her own mother had been so steadfast; she later explained that she would have left the marriage sooner if she had been able to imagine her son having separated parents.

In September of 1931, Louise took Mike, now nine and a half, to Rockland to leave him in the Berliawsky household, which contained Annie and Isaac, Nate, Anita, now divorced, and her three-and-a-half-year-old son, George. (The youngest sister, Lillian, had met an artist, Ben Mildwoff, who had studied in Paris and at the Art Students League. When Ben left for California in 1930, she followed him; they married and later returned to New York together.) Louise lacked the courage to tell Mike face-to-face that she was about to leave for Germany. It was not until she returned to New York that she telephoned to say goodbye. *"Mother, don't go!"* Mike cried in such an anguished voice that Louise was never able to erase the moment from her memory.

A few months later, when Abe Chasins heard that Louise had gone to Europe alone, without a lover, he was astonished, because he had not fully appreciated her fierce sense of independence and overriding ambition. Leaving for Europe was a watershed decision, a rebellious social offense that the Nevelsons and their friends would never forgive. She later implied that she was surprised and dismayed at being cast out of her former circle of friends, but it seems likely that she intended her trip to make such an impact, since it released her from the conventional expectations of a wife and defined her to others as an artist.

In the autumn of 1931 Louise crossed the Atlantic Ocean for a second time, a quarter-century after her childhood passage to America. This time she sailed eastward on a small, single-class Norddeutscher Lloyd steamship, the *Stuttgart*, which took just under five days to reach Germany. She traveled by train from the port to Munich, which in 1931 still retained its medieval appearance, with old Gothic squares, dark, narrow, twisting streets, baroque façades, and rococo palaces. Its population of 750,000 included an elegant Anglo-American set who gathered in the ornate Vier Jahreszeiten and other old hotels along the formal avenues and attended performances of Wagner operas. The city was "a place of prodigious eating and drinking, of vast shouted laughter," ac-

cording to one American traveler, where white sausages with sweet mustard and dark beer were served in beer houses to the sentimental tunes of Bavarian bands. It was also a university town, where youths animatedly discussed the radical new theories of Sigmund Freud and Albert Einstein and the merits of Klee and Kandinsky, artists who themselves had lived and painted in Munich.

But the city had another side as well. It was a hotbed of bitter German veterans, supporters of Adolf Hitler, who had made Munich his home since the end of World War I. Germany, like America, was in the throes of an economic depression, and Hitler had just begun to win backing from his country's industrialists as well as widespread support from Munich itself, which, Eugen Diesel reported, saw "in Pan-Germanism the saviour of its Bavarian essence." Foreign journalists flocked to Munich that winter to write about the rapidly rising Hitler and his Nazi party, which had now become the second-largest political party in Germany. Alfred Barr, director of the Museum of Modern Art in New York, visited Germany in 1932 and was shocked at how easily Hitler's followers were able to bully German museums into taking down their "degenerate" Klees and Kandinskys. Hofmann's students were issued identification cards with their photographs on them, and Hofmann discouraged talk about politics, fearing it would be dangerous. Although Louise may have thrilled to the melodramatic rallies and sense of dangerous excitement generated by the Nazi brownshirts, as her son later suggested, what she heard and observed about their anti-Semitism instilled fear in her. "I had to pass Hitler's house every day from the pensione to the school," she remembered, "and it was always busy." When she received official notification to report to a government office on some minor matter, she was afraid she was being ordered to Hitler's headquarters. "Whatever it was, I went, and it wasn't that at all." A little more than a year later, in January 1933, Hitler was named Reich Chancellor and acquired absolute power in Germany.

Louise was, however, essentially apolitical; she had come to Munich in search of herself as an artist. When she arrived in October 1931, she began to attend a daily drawing class with a dozen other pupils, mostly Americans, at Hofmann's art school in Schwabing, Munich's open-minded bohemian district. The students worked in charcoal from a live model in the mornings and afternoons; there was also an optional evening sketch class. Hof-

mann, a Bavarian, was fifty-one that year. Dignified, handsome, and something of a bon vivant, he was considered intellectually open and enthusiastic about new ideas. Although very much the authoritarian Teutonic master in style, he taught that the artist must infuse techniques and interpretation with his or her own intuitive and imaginative feeling. Because of the emphasis he placed on originality, he never showed his students his own work or even reproductions of the masters. Influenced by German idealism, he considered creativity and art spiritual forces, and used the word "artist" as a synonym for the *"creativ,"* a word he used constantly. With his "absolute faith in art as the revelation of spiritual and universal reality," the German master taught "with powerful conviction," which deeply impressed his pupils, according to Ludwig Sander, a student in Louise's class.

Several years earlier, Hofmann and his wife, Maria (Miz), also an artist, had hosted for his students evenings in cafés, weekends in the nearby Bavarian Alps, or Sunday afternoons in one of Munich's art museums, such as the Alte Pinakothek, which displayed works by Dürer, Rembrandt, Rubens, and contemporary masters. Only two years before, Hofmann had been "carefully and exhaustively specific" in his daily critiques of student drawings; he would sketch vivid "graphic/analytical" explanations on each student's charcoal paper. But by the autumn of 1931, he was preoccupied with getting out of Germany; the Nazis' hostility toward intellectuals and modern artists had already become distressingly apparent. He had turned over most of the teaching to an assistant and visited the school no more than once a week. Louise recalled angrily that he had been interested in cultivating friendships only with students who could help him get to the United States, such as the son of a wealthy American diplomat, or Ludwig Sander, an American who was fluent in German. In fact, Sander spent most of that winter helping Hofmann translate his writings into English, presumably to help Hofmann get teaching offers in America. As it turned out, Louise had enrolled in the last class that Hofmann ran in Germany—six months after her arrival, he closed the doors of his school and prepared to emigrate to America.

Louise was deeply disappointed at getting so little from the Munich school, especially after her elevated expectations. She intimated later that Hofmann had been sexually attracted to her and that she found his interest unwelcome because of her distress over her separation from her child and her family. Accustomed to close

family ties, she had never before been so entirely alone; and by departing for Europe, she had flagrantly violated the rules by which she had been raised. Her mother, despite her dreams, had remained a traditional woman whose life was intimately connected to her children. Louise, who had suffered terribly as a child when her father left for America, had now similarly abandoned her own child. She was beginning a long and anguishing process of neutralizing and sublimating her maternal drive with another form of creativity. Emotionally exhausted by her inner conflicts, she admitted that she was unable to concentrate fully on art.

Furthermore, she had never studied German, and the art students who were fluent in that language benefited the most from Hofmann's teaching: he was slightly deaf, spoke English haltingly, and even in his native tongue he had difficulty expressing his ideas verbally about *Spannung* (tension), *Fläche* (plane), and *Bewegung* (movement). Louise, who was older than the others, disliked the obsequious way they addressed him as "Herr Doktor." Nevertheless, as she later conceded, it was at this time that she deepened her understanding of cubism as more than a revolutionary way to break up and rearrange form on a canvas. She absorbed Hofmann's idea that cubism was "the push and pull" of organic tensions: "Positive and negative. Cubism gives you a *block* of space for light. A *block* of space for shadow. Light and shade are in the universe, but the cube transcends and translates nature into a structure." Nevertheless, she dropped out of Hofmann's school after about three months, left Munich, and began traveling around Europe.

She later said that her maternal guilt then was the worst she ever experienced. "You are depriving another human being of so many things, and the other party also knows it," she explained to Diana MacKown in the 1970s. "And when I got to Europe, I just wanted to kill myself," she told another interviewer around the same time, and remembered wanting "desperately" to see her son. By mid-December, she had sent him several postcards and at least one letter. The boy responded on his grandfather's business stationery, signing his first letter "Two-gun Mike" beside a drawing of a branding mark. Most of his letters were full of cowboys, Indians, guns, and a partially hidden anger toward her. Louise sent him a necktie, a Bavarian hat, stamps, and a book about Germany, all of which Mike wrote were too young for him. He also relayed messages to her from the Berliawskys—Nate will soon send money, save money for paints and do not send gifts "because times are

hard," and after she sent photographs of herself: "Grandma thinks you look crazy, but she is old and don't know much. I think you look just like a great artist."

By December, Charles had retrieved his son from his in-laws and moved him and an English housekeeper, a Catholic missionary recently returned from Tokyo, into a new apartment at 230 East Seventy-first Street. At the bottom of the boy's December letter his father wrote: "Dear Lou—I brought Myron back to our home, and hired an intellectual woman who has had many years experience in teaching, she also keeps the house and prepares meals for Myron, this is the only proper thing to do under the circumstances. Surely Rockland was not the right environment for Myron. Chas." Mike happily wrote his mother that he liked the housekeeper, who helped him with his schoolwork and piano lessons. The woman abruptly left, however, probably because of Charles's unwelcome sexual interest in her, and six weeks later the boy was back in Rockland.

Although the Berliawskys tried to make Mike happy—Nate, for example, bought him a sled and skis—he was miserable. His home had been broken up, his mother was far away for an indefinite length of time, and he was unable to live with his father in New York. He strongly disliked living in the Berliawsky household. "To me it was a tragic house," he recalled, which because of his grandmother's illnesses "smelled of death already." Although Annie was kind to Mike, she was often in a paranoid rage toward others. When the gentile vegetable farmer arrived at the back door, she would stand with her hands behind her back placing a curse on him. She advised the boy that if he ever got into difficulties, he should avoid respectable people and ask society's underdogs for help, because only they truly understood trouble. Dubbed "the general" by her grandsons, she used to don her fur coat and march down Main Street without acknowledging anyone, ignoring even the policeman when he politely greeted her.

By spring, Mike was again living with his father and going to school in Manhattan. At the end of April he wrote sadly to his mother: "I hope you come back soon as I'm getting lonesome," a theme that was becoming more and more insistent. Worried about the details of the ten-year-old's daily life, Louise repeatedly asked him who took him to his fourth-grade classes; he replied at the end of May that sometimes his father took him, but usually he went to school and returned home alone.

□

During her months in Munich, her fellow students found Louise intense and outspoken as well as very beautiful. They also "adored her," according to Maude Cabot Morgan, an aspiring artist from Boston. Louise herself imagined that she must have seemed diffident and quiet because of her preoccupation with her personal problems: "I had nothing. I was trying to find myself." But her natural gregariousness drew her to cabarets like the small, smoky Café Sempl, frequented by students and decorated with photos of singers and celebrities who had appeared on its tiny stage. During those years Germans were very fond of American jazz, spirituals, and folk songs, and they were often sung in Munich cabarets. Louise would occasionally sing along or even perform a solo, and she became known as a handsome, dramatic American girl with a trained soprano voice. She clearly exaggerated her unhappiness, because that winter she attracted a wide variety of well-known men. Among the acquaintances and admirers she later talked about were Clement Wilenchick, a painter who went on to play gangsters in Hollywood movies; Lion Feuchtwanger, a member of the German literary avant-garde; and Max Schmeling, the world heavyweight boxing champion, who was subsequently defeated by Joe Louis.

She also met a number of people in the German film industry, filmmakers associated with Universum Film Aktien Gesellschaft, or UFA, which in 1930 had made the movie *The Blue Angel*. The 1920s had been the golden age of German cinema, but by the end of the decade UFA had fallen into financial difficulties and began to produce Nazi political propaganda films. Most German films of the early 1930s, however, were escapist musicals or melancholy romances. One of Louise's friends in the film business managed to get her a cameo part in a picture being shot outside of Munich. Although foreigners were not allowed to work in the German film industry, her friends also smuggled her in as an extra in a movie being filmed in Vienna. She herself placed no importance on her bit roles; she forgot the names of the films and did not even bother to go see them when they were shown in Paris. Her commitment now was to art, and she was not diverted by the possibility of becoming a film actress; she disliked the passivity of being directed. But the process of filmmaking—the lights, the sets, the camera tecniques—obviously appealed to her. In later years, movie-set techniques, such as staging, professional lighting, and the creation

of a dramatic experience, would characterize the sculptural environments she brought into existence.

After her film appearances, she continued to travel around Europe, sometimes by herself but more often in the company of friends. She returned to Munich for another month at Hofmann's school in March 1932, around the time of the annual pre-Lenten outbursts of Fasching, the bawdy Bavarian Mardi Gras. She visited the resort of Garmisch in the Bavarian Alps but turned down invitations to visit movie people in Berlin and a countess in England. "I was too serious to want to do that," she declared in 1986. "I felt I made a great sacrifice going to Europe." In April, she traveled to Salzburg, Austria, a region of glaciers, lakes, narrow gorges, caves, and roaring waterfalls. One day as she was walking alone through a mountain pass in the falling snow, she felt a sudden urge to vocalize out loud in the clear Alpine air. Despite her disappointment in Hofmann and her anxiety about her son, she could still experience a sense of exhilaration. "All of a sudden I was singing opera," she remembered. "It echoed. I kept on and on."

After visiting Italy, where she saw works by Giotto that she had studied in Kenneth Hays Miller's class, she went to Paris with Miz Hofmann, who introduced her to a number of people in the art world. At first she stayed at a small Left Bank hotel and drank her morning coffee with the artists and writers at the Café du Dôme; then she moved to the expensive rue du Bois-de-Boulogne. It is unclear how she was able to afford a fashionable Right Bank hotel at this time. Perhaps it was a result of meeting the eldest Wildenstein brother, Georges, "a tall, attractive man," who was an art dealer, collector, editor of the scholarly *Gazette des Beaux-Arts*, and member of a family who had had an art gallery in Paris since 1875. She visited the Wildenstein family home in Paris, which she later described as "a palace" full of treasures, such as a piece of Marie Antoinette's petit-point embroidery. Georges graciously praised the student work she showed him from the Hofmann class and several years afterward invited her to the opening reception of the Wildenstein gallery on Fifth Avenue in New York.

It was probably he who escorted her to the exhibition of African masks and carved figures at the newly created Musée de l'Homme, of which he was a sponsor. The museum had a growing collection of primitive art works from Indonesia, Mexico, America, and Africa and had just acquired objects from the Congo, Ivory coast, Niger, and other West African countries. One of the African pieces was a

carving of a leopard, and she instantly and intuitively understood its primal form and recognized its animalistic energy. "I immediately identified with the power," she wrote in *ARTnews* years later, adding that the African sculptures appealed to her more than most of the Western European art at the Louvre. A predisposition to primitivism had already appeared in her work. In a terra-cotta-colored crayon drawing done four years earlier, *Untitled, 1928,* she had depicted three elongated headless female nudes with accentuated breasts, similar to the exaggerations in African carvings, before she could have seen much, if any, of this kind of work first-hand. So the recognition must have resonated as she stood in front of the evocative leopard.

The first Picassos she saw in New York had made her aware of the force of cubism; and when she was in Paris, she was offered the opportunity to meet the artist himself. Uncharacteristically, she declined. "When I was a student I had such reverence for a man like Picasso, I just didn't have the nerve to meet him," she explained unconvincingly. "I didn't want to intrude on his time." Although she claimed to have been, even then, unafraid of being influenced by him, it's possible that the cause of her unusual reticence was that she feared being overwhelmed by the man personally. If so, her attitude indicated her recent understanding that "the self of you is the prime mover," that she could not fulfill her aspirations through another, not even through a man like Picasso. But her lifelong admiration for his genius remained unbounded. She came to feel that Picasso gave to art what Einstein gave to science, and she concluded that through his development of the cube he had altered the consciousness of the world. She believed that she had easily understood the principles of cubism because of her early exposure to metaphysics: "Now, according to metaphysics, thinking is circular. The circle is the mechanics of the mind. It is a mind that turns and turns. It doesn't solve anything really. But when you square the circle, you are in the place of wisdom." Thus the cube eventually gave her her aesthetic law: "When I found cubism, it was like when some people find God, and I have never left it."

On June 14, 1932, Mike enclosed photographs in a letter and wrote accusingly: "You state that you expect to leave for America soon but don't say when." Not long afterward, she left Paris and boarded a ship for New York. After her arrival, she went straight to Mike in Rockland. After deciding that her family was taking

good care of him, she left him there and returned to New York. It is unclear how long she subsequently lived with Charles at the East Seventy-first Street apartment; but after a few months, rather suddenly and with her mother's encouragement, she apparently decided to return to Paris, although the exact date remains unclear. She later said that she pawned her diamond bracelet to pay for her ticket; but her brother-in-law Ben Mildwoff remembered Louise telephoning one day and stating, without explanation, that she needed two hundred and fifty dollars. He managed to get the money to her by that afternoon, even though it was the most crippling period of the Depression. A few hours later she was on a boat to Europe.

In Paris Louise stayed at the first-class Hôtel Scribe on the corner of the boulevard des Capucines. She had imagined that relieved of her anxiety over her son, she would be better able to appreciate Europe. Although what actually happened after she arrived in France is unclear, there are suggestions that she was badly disappointed romantically. One night she wrote on the pale turquoise Hôtel Scribe stationery adorned with a green crest many long, desperate poetic lines and incoherent fragments filled with soul-searching, loneliness, self-doubt, guilt, and a quest for her own "reality." Writing in a large, strong, conventionally right-tilting script, she blotted and smudged some of the black-inked letters with tears. She later revealed that she had contemplated suicide and was restrained only by thoughts of her son and her parents. She was suffering intense psychic labor pains, far worse than physical ones, she later insisted, as she began to understand the dangers inherent in the creative life.

She was cold ("Must it always be cold for me?"), afraid ("I have fright in the soul of night"), doubtful ("Why am I always at sea"), deeply depressed ("Yet its [sic] always dark for me God must have chosen it to be"), and self-pitying ("Some unseen power apparently feels I must learn more before I can flee"). She had fantasies of ecstasy ("I can conceive even flying to a heaven"), felt absolutely lost ("Oh dear me what can it be that I remain so long at sea . . . The sea of the soul is much to [sic] foggy for me"), then defiant ("No I will not die I will try to clear the fog"). She considered trying to be a better wife and worried about the broken trust with her son. She feared her own destructiveness, realizing she had chosen to live life dangerously. As the night wore on, she doubted her strength for the personal journey she had undertaken. She

wondered if morning would ever arrive, then finally emerged from her panicky depression at dawn ("Oh oh oh hurrah the dawn the dawn the dawn is far but I see light and I have no more fright").

Afterward, she understood that her solitary psychological crisis in Paris had been the acceleration of a process that taught her to look to herself instead of to others for personal happiness or creative fulfillment. It also seemed to be the begining of her ability to project a personal world through art that eclipsed the everyday one around her. About six weeks later, after visiting many museums, the cathedral at Chartres, and the palace at Versailles, she went to the French Riviera and then to Genoa, where she boarded a ship for New York. On arrival, she resumed living with Charles, who had moved to a small apartment in a brownstone at 39 East Sixty-fifth Street, a few doors away from the elegant town house of Sara Roosevelt, whose son had just been elected President; young Mike ran errands for Mrs. Roosevelt, who kindly showed him Franklin's model ship collection.

On one of her summer trips to Europe during the early 1930s, Louise booked passage on the *Liberté*, a small, single-class ship with one dining room. Fellow passengers included the physician and novelist Louis-Ferdinand Destouches, who wrote under the name Céline, returning to France after Hollywood declined to make a movie based on his *Journey to the End of Night* because of his Nazi sympathies. Céline, who had a strong appetite for spirited and athletic American women, left his table to speak to Louise, who was dining with several men. A rumpled man with deep-set piercing blue eyes, Céline had what he considered a large peasant head. Louise was fascinated and excited by his fame, brilliance, nervousness, and an element of danger that he exuded. "I liked him because he was neurotic," she admitted. Céline and Nevelson seem to have recognized a congruence of their intensity, strength, and drives. "Nothing on earth would appease him," she told Diana MacKown in the 1970s. "And that's why I think he might have understood me a little." As he expounded to her his theories on the origins of humanity, she was excited by his racing mind and turbulent passions. But she discovered that he hated Jews. She did not reveal herself but later theorized that fanatic anti-Semites are often inexplicably attracted to Jewesses.

After their arrival, Céline pursued Louise with postcards to Paris: "By now you must have been married over and over again.

What possession will be left for me?" he wrote teasingly on one of them. But despite her feeling of deep rapport with him, Louise recoiled from a lasting liaison. Later he looked her up in New York and suddenly, perhaps in the hope of remaining in the United States, proposed marriage. This was only a half-serious offer, since they had never been intimate, and he was involved with a number of other women; when he finally did marry in 1943, it was for reasons of convenience. "I think that at that moment, as much as Céline might appeal to me, I wasn't ready," Louise observed, referring to her dissatisfaction with her achievements as an artist. But she also had no desire to marry anyone else. By then she had read in *Life* magazine that Céline was a Nazi, and she answered his proposal by stating somewhat obliquely that he was worth more to her dead than alive. He understood, she said, and departed, and she never saw him again. In later years she sometimes seemed wistful that it had been impossible for them to overcome their differences.

After his arrival from Europe in 1932, Hans Hofmann became a guest instructor at the Art Students League. Despite Louise's disappointment with him in Munich, she still respected his judgment and undoubtedly wished for his patronage. In October 1932 she signed up for his crowded evening drawing and painting class, and she took it again in November and in February and March of 1933. George McNeil, who also enrolled, remembered that Louise—in his eyes a striking beauty, older, sophisticated, accomplished—was "already doing what Hofmann was talking about" ahead of anyone else (although it was McNeil's painting that was reproduced in the 1933–34 League catalog). In fact, her drawings were pure Hans Hofmann, McNeil recalled—"planes, semiabstract, and, though a figure was evident, cubistic." One evening Hofmann hung all the student work on the wall and graded it, giving a Nevelson drawing of "the nude figure broken up" a high rating of eighty-five and holding it up before the group to remark that it was "bigger than life."

When Hofmann left the League to start his own art school the next year, Louise did not follow him and was soon outside his circle altogether. Over the next few summers, she visited Cape Cod, Massachusetts, where he conducted a summer school, but there is no evidence that she enrolled in his classes. One of the reasons their paths diverged was Louise's growing interest in sculpture. Hof-

mann was not impressed by one of her early sculptural efforts and asked one of his students to return to her a creation in three or four wooden pieces, including a staircase rail, painted dusty red and blue. But although they went their separate ways, Hofmann remained respectfully aware of her developing work.

One of Louise's classmates in the Hofmann class at the Art Students League was Marjorie Eaton, who came from a wealthy San Francisco family and had been on her way to Europe when Hitler came to power. Intensely aware of Louise's presence in the classroom and impressed by her deep concentration, Marjorie resolved to get to know her. As she turned to go over to her at the end of the second week, she saw Louise walking toward her. They introduced themselves, and Louise invited Marjorie to join a group of students for tea at her apartment on East Sixty-fifth Street. Marjorie remembered that after Louise unlocked the door "she pulled up the shades, sorted and put away her husband's laundry. She was still taking care of him. There was a sense of recognition— of saying goodbye—as if she was saying, 'This is where I was, and this is what I'm leaving.' She was a ghost in her own house."

Charles was struggling to earn a living in any way he could. He spent hours in a patent library trying to develop his own inventions, and he set up the short-lived Electric Specialty Manufacturing Company. In 1930 he successfully brought charges against a Honduran who had been hired to develop a working model for attempting to steal his most promising invention, a sewing-machine attachment to mend runs in hosiery and underwear. In October 1933 Charles patented the device, which he reportedly sold to the Singer Sewing Machine Company. Yet for all his efforts he made only a bare living. Sometimes, when he had a little money, he would visit Bernard Nevelson and his family, who were also impoverished, and after dinner give his older brother a check.

When the Sixty-fifth Street apartment became too expensive, Charles found an even smaller apartment around the corner on the east side of Madison Avenue. Louise, Charles, and Mike all shared the one bedroom, and since there was no kitchen, Louise washed dishes in the bathroom sink. The large living room, however, contained both a player piano and a grand piano covered with a paisley shawl. Much to Louise's annoyance, Charles would relax in the evenings by playing the same tune on the player piano over and over, or sometimes he would sing along or accompany the music

on the mandolin. Finally, in the winter of 1932–33, leaving Mike
with Charles, Louise moved into a basement apartment at 1237
York Avenue, which she shared with a dancer named Rose David-
son. It's unclear how she came up with the funds to do so. For a
brief time during this period, she and Lillian ran a tiny antique
jewelry shop in Greenwich Village, but it never made money. It's
possible that Charles gave her small amounts of cash or that her
family did. This began a period in which she visited or lived with
one friend or another or even stayed in vacated and unfurnished
apartments until she could find a place of her own.

The winter after Louise returned from Europe, Mike at ten and
a half had been sent to Kohut, a boarding school for Jewish boys
in Harrison, New York. He disliked it very much, and he misbe-
haved in some way when Charles and Louise visited on Parents
Day in May 1933. When he came home for the summer, an elevator
man in a nearby building, a German World War I veteran, sold
him a small automatic pistol. One day he loaded it and fired into
the apartment fireplace; the bullet ricocheted into the kitchen,
nearly hitting Louise, who became hysterical. The next winter Mike
was again packed off to live with the Berliawskys. Over the next
few years he was passed from one relative to another. Late one
night after his parents' separation, the police found a "very frail,
poetic-looking blond child," in the words of his cousin Corinne,
sitting on a curb near his father's lodgings; he explained to a pass-
ing policeman that he had nowhere to go because his father had
company and his mother was having a party.

In the hope that his wife would return, Charles took Louise
for drives around Manhattan on Sundays, and then out to dinner.
Sometimes she invited Marjorie Eaton to join them. Marjorie re-
called Charles's efforts to ingratiate himself as "very painful."
"Louise just took it passively," she said. Marjorie believed that
Louise tolerated the Sunday ritual only because Charles was giving
her ten dollars a week. Meanwhile, Charles pretended to have a
romantic interest in Marjorie in an unsuccessful attempt to make
his wife jealous. Charles had begun to posture like Benito Mus-
solini, and "the thrill of his life was to go someplace where they
said he looked like Mussolini," Mike remembered. When Ernest
Bloch, who met Louise in the summer of '33, inquired whether she
loved her husband, she shrugged off the question. "Never loved,
she says," Bloch wrote in his diary. "Does not care!" Nonetheless,
from time to time Louise would wrap a towel around her head and

clean Charles's room in the Knickerbocker Hotel, where he had moved after giving up the apartment.

Marjorie felt Charles was convinced that his wife could never survive on her own, but she was certain that Louise would not return to him: "She was coming out of her shell, and nothing would stop her. He was a good man, but he had married this genius."

One evening Charles got drunk at a party in his hotel room and started to sing "Home Sweet Home," then wept at the thought of having no home of his own. Mike, who was temporarily staying with his father, tried to comfort him, but Charles "felt he was a failure as a lover, as a husband, as a father, and a failure in business." At times Charles was so hard up, he had to borrow from his brother-in-law Ben Mildwoff, a struggling commercial artist. One winter night he was locked out of his hotel room for nonpayment of his bill. Both Charles and Bernard now "lived on the dream of past glory," according to Corinne Nevelson, and ran up large debts in the expectation that the ship-insurance money would eventually come in. They kept trying new schemes—one of them was to make European-style bread inexpensively. Charles's hotel room became a laboratory of test tubes, and a factory, Bakers Malt Products, was opened on Eleventh Avenue with two employees and several vats of ingredients. They became involved in making a drink called Malticola but reportedly were forced out by the Mafia, who controlled soft-drink bottling and distribution. In December 1937, certain by now that his marriage had ended and in debt for $9,300, Charles took a train from Grand Central Station to Galveston, Texas, where his brother Harry lived, and got a job selling yet another new invention—air conditioners.

Louise never asked Charles for a divorce; she explained years later that she had been too intimidated to take the necessary legal steps. The couple were not legally divorced until 1941 when Louise was forty, after Charles had moved to California and met a woman he wanted to marry. When he initiated the proceedings on grounds of abandonment (it was agreed that adultery charges would not be brought), Louise remarked indignantly that "gentlemen do not divorce ladies," but she did not contest the action. Long afterward Charles told his son that he considered Louise a very beautiful woman and had always loved her. And in later life Louise was usually gracious about Charles, remembering him as kind and a gentleman, even forgiving his faults by pointing out that it had been his first marriage, too. Sometimes, in flights of fancy, she

described him to those she wished to impress as a millionaire or even as an elegant Englishman. Once, however, long after the divorce, she flashed with anger when she remembered that somehow or other he had taken back the diamond bracelet he had once given her, as if he had deeply disappointed her expectation that she was marrying a rich man. "I'm the type that if I'm going to have art, I want, well, all of it, and if I'm going to have wealth, I'd like to have a lot of wealth," she said.

Louise always saw the decision to leave Charles as an inevitable one. "The world is built for one / Two is a jungle / The world is built for one," she wrote in an undated poem. "I wanted freedom," she explained to an interviewer in 1983. "I wanted twenty-four hours a day to do my work. And also I think it's a state of mind. A feeling you're your own person." It was evident by now that she could attract attention from gifted and important people. Frustration and unhappiness with her marital "imprisonment," as she called it, had made her gather together her inner resources and defy both convention and the economic circumstances around her to achieve personal autonomy. "For me, life couldn't be a complement of master and slave," she wrote in *ARTnews*. "And so I gave myself the greatest gift I could have, my own life."

The Depression Years

I saw but looking does not mean I was seen

—*LOUISE NEVELSON*

THE DEPRESSION ERA of the early 1930s was, paradoxically, a time of raised expectations for American artists. The Museum of Modern Art, the Whitney Museum of American Art, and a growing number of galleries began to exhibit the work of contemporary American painters and sculptors. During the winter of 1932–33, close to three thousand artists, hoping for a chance to exhibit or sell, sent examples of their work to the Museum of Modern Art. When director Alfred Barr returned from his leave in Europe, he asked Dorothy Miller, who was helping out at the museum, "to get the artists off my neck." She dutifully looked at each submission despite the facts that the young museum lacked acquisition funds and its directors remained basically cautious in their tastes; from 1929 to 1934 the museum collected very few American artists, and even those worked primarily in the representational vein: John Marin, Edward Hopper, Charles Sheeler, Charles Burchfield. After Louise's return from Europe, she often visited the museums and galleries

that now extended three long blocks along Fifty-seventh Street on either side of Fifth Avenue. She was excited and stimulated by what she saw: "I was always high. I used to hear people say 'She's drunk again' "—although Louise claimed she drank very little.

Mural painting was gaining importance in America. After a retrospective of his work at the Museum of Modern Art had set attendance records, Nelson Rockefeller commissioned the Mexican muralist Diego Rivera to paint a fresco for the new Radio City Music Hall in Rockefeller Center. Rivera began the mural in March 1933, and groups of idolators, who believed that he was a new Giotto, sat daily on the nearby scaffolding to watch him work. Part of the activity around Rivera was created by his unusually large number of assistants, who prepared and plastered walls, ground colors, and stenciled sketches onto damp plaster before the master did the actual watercolor painting himself. All went well until Rivera, a Trotskyite who believed that mural painting was art for the masses, portrayed a labor leader with an unmistakable resemblance to Lenin. The portrait caused an uproar, and Rivera's capitalist patron ordered all work stopped; the mural was eventually chiseled off the wall in the middle of the night. Undaunted, he set to work on another mural on movable walls in the rented quarters of the New Workers School, a dirty, dilapidated old building on West Fourteenth Street, and set up a visitor's cash box to collect for the communist cause. In mid-July he began a group of twenty-one large frescoes called *Portrait of America*, and paid for the materials himself; his assistants worked for nothing or for nominal wages. He later recalled that "at the top of a steel staircase as steep as those of the pyramids of Urmal or Teotihuacán, I found myself in what was for me the best place in the city."

Marjorie Eaton, who had studied with Rivera for three years in Mexico, looked him up; and when he invited her to lunch, she asked if she could bring along "a beautiful woman," knowing he would readily agree: Rivera was a notorious ladies' man. At the luncheon, he and Louise got along splendidly. Rivera "absolutely fell in love with Louise," Marjorie said. "He used to say to me, 'I *love* Louise!' " For her part, Louise was interested in the middle-aged, frog-faced artist, who was at the pinnacle of his fame. "If a man's a genius, I don't care what he looks like," she remarked to a friend. Before long she had painted several oil portraits of Rivera.

After Rivera heard that Louise was sleeping on a friend's couch, he told her about a vacant studio in his Greenwich Village building,

and soon afterward, Marjorie and Louise moved into it. They furnished the one large room with a couch, a cot, a card table, and empty wooden apple boxes found on street corners. On the walls they hung pictures by Paul Klee, themselves, and their friends. Marjorie's western background, her independence and self-confidence intrigued Louise. Her father, a noted surgeon, owned a cattle ranch, and her stepmother ran her own dress shop in San Francisco. Marjorie had studied art in Paris and Florence and for five years had lived among the Indians in Taos, New Mexico. Despite their radically different backgrounds, the two young women soon felt "as if we'd known each other in another life," according to Marjorie. "It was an absolute recognition of each other."

One evening before they rented the West Thirteenth Street studio together, Louise had asked Marjorie, who was visiting, to stay overnight so they could continue to talk. Even though her attraction to Louise was "psychological," Marjorie felt for the first time the possibility of becoming physically drawn to her "gorgeous" female friend. "It was a strong pull," she said. "I've never felt anything stronger for a woman. We had to sleep together in a narrow bed, and I feared I would fall in love with her, but we went off like logs." Louise was apparently aware of her own ambivalent sexual feelings. That summer she revealed to Ernest Bloch that she was attracted to both Rivera and his wife, the petite and exotic Frida Kahlo, who had confessed to taking female lovers.

Marjorie's strongest memory of Louise during that spring and summer was her continual stream of talk. "She would get up early in the morning and start working, and as soon as I was awake, she would start talking. And she would talk all the time she was painting. And I was grounded. I did no work at all. I sat there, mouth open, grounded, listening to her." Most of Louise's monologue was about whether or not she had the right to break up her family, something that wives from her traditional European background rarely did. "She had a very bad conscience about it, [and she was] justifying that she should take her own life and use it," according to Marjorie, who was sympathetic to her friend's desire to free herself from her marital restrictions.

Louise had a wide circle of companions with whom she usually spent evenings—artists Boris Margo and Arshile Gorky, writer and educator Will Durant—and she introduced Marjorie to a number of them. When Mike occasionally visited, he used to ask his mother's friends for autographs; and his 1933 leather autograph book

contains signatures and calling cards of a number of her teachers and more accomplished friends and acquaintances, such as writer Franz Werfel and novelist W. Somerset Maugham. By summer, the two young women were spending a great deal of time with the Riveras; they often joined the nightly gatherings at Diego's favorite Italian restaurant on Fourteenth Street. The Rivera entourage included everyone from the wealthy to laborers—and to Louise's astonishment, everyone was treated with equal respect.

Rivera recently had met a husky, black-haired Russian artist in his early twenties, David Margolis, who had been raised in an artistic Jewish family near Odessa before coming to America. He appeared to Rivera—who had visited the Soviet Union a few years earlier—the ideal Soviet youth, and before long he asked David to be his bodyguard. Thereafter, if Diego did not wish to talk to someone, he would say a few words in Russian to David, who would send the person away. Through Rivera, David met Louise and found her desirable and very aggressive, and soon they became lovers. "I was young, and I just gave in," Margolis admitted later. He ended their physical relationship "very shortly" because of his discomfort with their age difference, but they remained friends for years.

Many of Louise's friends noticed that she relished excitement and increasingly exercised her sexual whims matter-of-factly. "I never liked the confines of marriage," she told an interviewer. "I love romances, and I like to have affairs." She was always meeting new people, especially attractive men, who actually meant little to her. One of her lovers, Tony Pollet, whom she met in Yorktown in the early 1930s and who became a kind of protector, had an element of danger about him that she relished in men. A very tall, muscular, Italian-Swiss prizefighter who never made the big time, he was a passionate opera lover as well as a bootlegger. She implied in later years that she sometimes had several lovers at once, like a queen with a court. Although in her later years she admitted that she had been quite free, she hastened to explain, "It isn't promiscuous. I threw myself into life, I wanted to know what life was about. . . . I had the courage to move into areas instead of negating." Clearly this was also a strategy to avoid emotional entanglements that might have interfered with her developing sense of herself as an artist.

Before long Rivera asked Marjorie and Louise to become his assistants; Marjorie agreed, eager to return to fresco painting, and

she helped his Mexican plasterer cover a wall with two coats of marble dust. Louise's emerging egocentricity made it difficult for her to be anyone's helper, and she admitted that she did "very little" for Rivera, although she was often at the New Workers School, sometimes with Mike. Meanwhile, Rivera's hard-pressed assistants worked every day, except for their rebellion over the Fourth of July holiday, when they all left for Truro, Massachusetts, among them one of the most talented of the group, Ben Shahn, who had already painted his revolutionary mural *The Passion of Sacco and Vanzetti*. Despite the marginal nature of her professional relationship with Rivera, Louise let it be assumed for the rest of her life that she had "worked and studied with Diego Rivera," as the *New York Evening Journal* put it two years later.

Soon Rivera's assistants became aware that he was spending a great deal of time with Louise. In July 1933 one of them, Ernest Bloch's daughter, Lucienne Bloch, wrote in her diary that Diego did not appear all day; and when it happened a second time, Diego's plasterer explained that he was with Louise Nevelson again. Louise never denied that they had an affair. The assistants began to resent her bitterly, as did Frida, who no longer watched from the scaffold every day, saying that her injuries from a childhood streetcar accident, which had caused her to limp, were painful. Rivera tried to persuade Frida to paint, but she was desperate to return to Mexico. A gifted painter in a surrealistic, mock-primitive style, Frida, who was deeply in love with her husband, had already depicted scenes from her stormy marriage. She was jealous as she endured his infidelities; and that summer, as he frequently did not return home until dawn, her eyes were often red from crying.

When Louise and Diego walked down the street together, he often would buy a bag of cherries, and as he began to eat them, he would generously offer them to laborers who recognized him. One day he took Louise to Fred Leighton's Mexican jewelry shop in Greenwich Village. "And when I got there," she recalled, "he said, 'Take what you want,' and he offered to give me the store. I didn't want it, because I was a friend of Frida's, and I hadn't had too much experience like that, so I took a bracelet." A few weeks later Louise was deeply embarrassed when Diego asked her in front of his wife why she had not worn the jewelry. She tried to smooth over the incident by giving one of her necklaces to Frida, who carefully costumed herself each day in elaborate native Mexican dress—hair combs, jewelry, long ruffled skirts, brilliantly colored

ribbons, and embroidererd shawls. Ernest Bloch visited Frida and Diego around this time and noted in his diary that Diego looked older and exhausted. Frida "gets out a cigar, cuts it, puts it in his mouth, lights it. He, tired, sad, childlike, caresses her arm with his cheek." When Bloch described this gesture, which he had found immensely touching, to Louise, she replied that she could never do that, prompting Bloch to confess to his diary that he preferred the primitive woman he observed in Frida to the modern one he recognized in Louise. Perhaps to defuse the tension between Louise and Frida, the Riveras moved in September 1933 from West Thirteenth Street to the Hotel Brevoort, five blocks away; and after the frescoes were finished in November, they left for Mexico.

When Louise spoke of her encounter with Rivera many years later, she talked about the impressive scope of his mind and imagination. "He didn't live in the present. His life span was sort of beyond and back. So he wasn't caught in the conventions of our time." He evidently encouraged her already-awakened interest in Mayan and pre-Columbian art, and many years later her own working methods suggested that she had been influenced by both his dependence upon assistants and the gigantic scale of his frescoes, which ideally suited modernistic steel, concrete, and glass buildings. But, unlike Louise, Rivera was no longer interested in cubism or abstraction. "I thought he might have found the expression of a new communication," Louise later remembered. "There was grandeur there, honest thinking, and generosity, but his feeling for illustration prevailed, and I had to seek my own way of communicating." She admitted that she had felt competitive with the great Mexican muralist. "I thought I could be as good an artist as Diego, so why should I play second fiddle to him? I had my future in front of me, and I was very confident that I could fulfill it."

In 1933 Ernest Bloch, then fifty-three, had come to the United States from Switzerland to discuss his latest composition, the *Sacred Service*, with conductors and music publishers. One summer day when he dropped in at the New Workers School to talk to Lucienne, Louise was visiting. She made an immediate impression on Bloch, who described her in his diary as "a very beautiful girl with a little cocked hat—reminds me of Raphael's self-portrait. She looks at me with intense eyes, but I am not introduced to her." Ernest Bloch was not tall, but he had magnetism, warmth, and large, expressive eyes; he returned her glances. "The beautiful girl

is still looking at me intensely," he recorded. Ten days later, when he returned to the school in the midst of difficulties with his publisher, he found Louise there again, and this time he introduced himself: "I tell her my troubles, how tired I am, how distraught," he wrote in his diary. " 'You seem to take this *too* seriously!' she says. 'I, I do not take anything seriously!'—'I envy you!'—'So do I! It's *terrible* not to be able to take anything seriously. Let us make an exchange . . . I shall teach you, and you shall teach me!!' I laugh. 'What a musical comedy,' I say to her. 'And if at the end, *you* take things seriously, and *I* do not, what will happen?' . . . 'Can I not help you?' she says. 'Yes. Let us go,' " he replied.

As they left the building together, Ernest invited Louise to lunch. She responded by asking him to come to her studio first for ten minutes so that she could paint his portrait. "Quickly the 'beauty' wants me to pose," Bloch wrote. "She picks up palette and brushes. Sets up an easel, makes me sit down. Impossible to sit still with a beautiful woman in front of one! What eyes! What an olive complexion! . . . The young painter is getting impatient. I am moving, changing. She fiddles with me. And I look at her, the woman who does not take anything seriously. I am attracted to her. An immense desire to make her know her 'seriousness' invades me. Always attracted by the difficult, the impossible! But her eyes! And behind these *fluchtig* eyes, there is something else. Not yet born." Bloch observed that Louise's eyes were oddly expressionless, and "her mouth at times has a little crease, unexpected, teasing, turned up, neither gay, sad, nor bitter, nor anything. Mechanical little movement. Meaningless yet characteristic."

Bloch had expected to be alone with Louise at her studio, but Marjorie Eaton was there, and soon others arrived, a bitter-looking writer and Louise's sister Lillian. Lunch, served at a small card table, consisted of salads, celery, and salami. The conversation was about the serious and the not serious, during which Bloch facetiously remarked that he was going to change his whole life because seriousness had not done him any good. His diary continues: "Suddenly Louise says to me in a detached 'matter of fact' tone: 'Don't you *ever* put your hands *under* the table?' " He replied that sometimes he did and obediently put them in his lap. "She then presses my hands, passionately. I feel myself going under." At about four in the afternoon, Bloch remembered that he had business matters to take care of and got up to leave. Louise went with him to the elevator and wrote her name and telephone number in his address

book, then rode down with him. They shook hands, and she gazed at him deeply. " 'All will be very fine between us' she says like a promise."

When Bloch decided to go to Boston on business for a few days, he telephoned Louise to invite her to go with him; she was not home, so he left a message asking her to meet him at the steamship. She never appeared. When he returned to New York, he telephoned her again and invited her to dinner. When she told him Marjorie had left for a vacation in Maine, he rushed over to her studio. His diary contains a vivid description of the evening:

> She changes practically in front of me. Puts on another blouse. Open. I think that I then take a good look at her, put my hand on her shoulders. Her face impassive. And under the loose blouse, with both hands I feel her whole skin, fresh and satin-like. Strange impression. She does not excite me sexually. Neither by her smell, nor her look nor her skin. Yet I am very attracted by the unknown, the mystery of this strange Louise (How badly the name suits her!) who does not take *anything* seriously.

They dined at the Brevoort Hotel. He was astonished to learn that she, like himself, was Jewish, and that she was thirty-one (actually she was almost thirty-four) and had an eleven-year-old son. She would have gone to Boston with him if she had received his invitation, she told him. By now, however, he was beginning to be skeptical about her sincerity and confused by his own feelings.

As they returned to her studio after dinner, he found Louise more and more beautiful.

> What a world though in this amazing face. Those mysterious eyes. This enigma of a smile which suddenly swerves and from gentle, tender, becomes a twisted pained expression! We go out on the iron balcony. The night is superb. We do not even hold hands. *"I am shy"* she says. Me too. Take a woman, like this? No. It makes no sense to me. It is not her body that I desire. I would like to awaken her soul, asleep or not yet born.
>
> Louise is too tall for me. Physically. Half a head taller. I don't like that. She must be very beautiful nude. What a mystery within her. She is unaware of it herself. She plays "scherzando." It is an error in *tempo* and character. She is off. It is the *adagio* appassionato which I am seeking in her. . . . I come closer. I look into her eyes. She laughs, giggles. I would like to get *this out* of her. She expected

something else, probably, the opposite. . . . Her lips, which she does not even keep from me (how I would have liked a rebellion, a struggle, anything rather than this impassive indifference), are cold. She does not open them. She is still as ice, expressionless. Horrid! I don't understand anything any more. Center of the room. I get exasperated! I throw my arms around her. I kiss her. Same passivity. *I* move back, with violence! It's sheer America! All over again! *All warped.* Or is she simply a *"vamp."* She gets annoyed at my anger. "You want loyalty" she says slyly! Does she want to protect me from herself? Or is she *nothing, nothing,* less than *nothing!* Am I again the victim of my own creative imagination?

Then Louise's sister Anita arrived, and the three talked until twelve-thirty at night, when Bloch got up to leave. It was raining hard, and he had no umbrella, so the sisters insisted he sleep on the cot while they slept on the big couch. "No! If I stay, I will sleep with them, in the bed! I am too tired and beat to take them both. It will be ludicrous. Why I am not thirty still, or even forty, or even forty-eight, or even fifty!" he confided to his diary.

As Louise waited for the elevator with him, she said: "I hope you do not keep a bad memory of this evening?" In late summer he mailed her a postcard from San Francisco, saying he had telephoned her three times the day before he left New York and been very disappointed to miss her. He added that he hoped to see her again, but he never did. More than three decades later Louise remarked to a Boston interviewer that Ernest Bloch "knew my harmony was different, but he appreciated it."

During the first quarter of the twentieth century, indigenous American sculpture was dominated by "realistic sentiment and expressionistic mannerism," according to art historian Sam Hunter. The public had little exposure to European sculptural innovations; in 1927, Constantin Brancusi had a widely publicized fight with U.S. customs officials, who did not regard his sculpture as art—and therefore duty-free. Although the Museum of Modern Art acquired a Gaston Lachaise torso in the early 1930s, art students had to depend upon *Cahiers d'Art, Minotaure,* and other foreign magazines to see examples of the latest European sculpture. David Smith, after seeing photographs of the welded metal sculpture of Picasso and Julio González, began to work in metal in 1932. Alexander Calder, influenced by constructivism, which challenged

the idea of sculpture as solid mass surrounded by empty space, was spending little time in his native land. But not until the last years of the decade, long after Picasso had cast his first surrealist bronze, did the American art establishment begin to accept American modern sculpture.

The most highly respected sculptors at the time were neo-classicists like Robert Laurent and William Zorach, both of whom taught at the Art Students League. Louise never studied with either one, and she said later she was glad of it; she added that she had never studied sculpture with anyone, which was not entirely true. Until she saw the African carvings in Paris, she had shown little interest in working in plastic form. After she returned to America, she became inexplicably excited by certain man-made functional environments—a recluse's driftwood shack on a Maine island, the "black islands" of steel beams in New York subway stations. Like the futurists, who were concerned with mechanization and dynamic movement, she found subway girders as "grand and glorious" as any masterpieces in the museums of Europe. "I would go in the subways and see the black supporting columns and recognize their power and strength. It isn't that I only looked, it was as if they were feeding me energy like the primitive sculpture did."

Sometime in 1933 Louise met Chaim Gross, an intense, handsome young sculptor, and his wife at a party in the Mildwoffs' Greenwich Village apartment. Gross was already regarded as a promising wood carver who combined classicism with expressionism; although he was five years younger than Louise, he already had had one-man shows, and reproductions of his wooden figures had been published in art magazines. Louise visited his Greenwich Village studio and admired his technically brilliant work. Gross found Louise, whom he knew as a painter, charming, soft-spoken, and warm. One evening at the Mildwoffs, Louise told Chaim she wanted to join the sculpture class he taught at the Educational Alliance, a settlement house on the Lower East Side, where he had gone the day after his arrival in America from Austria a decade earlier, because the tuition was nominal and the teaching was in Yiddish.

From her first session, Chaim knew that Louise was "terrifically talented," and he soon learned that she was also an "ambitious talent." Although most of his pupils worked in stone or wood from the model, Louise "just took clay . . . [and] started to make some little triangles, squares, and some other shapes, all kinds of

shapes, and I didn't interfere with it." He believed it was the first time Louise had worked in clay, but that is questionable; one of her earliest sculptures, the realistic cast stone *Cat of the Night*, has been attributed to 1932, the year before she met Gross. "She would do it like a child," Gross explained. "She would pat it down and play along with the triangles with her fingers." Then she would put three or four of the two- or three-inch shapes together and create other abstract shapes. Once in a while she called him over to ask a technical question or for his opinion—"if this or that looked better"—but she did not need encouragement. In fact, she often stated emphatically after she had become successful that she had never needed *anyone*'s encouragement and, furthermore, was not indebted to anyone. "She just played along with those little, little pieces of shapes and forms," Gross remembered. "Then later she started to do some larger ones, and then she quit the class."

On April 30, 1934, Louise rented a studio of her own for fifteen dollars a month in a rambling, red-brick building at 51 West Tenth Street, built in 1857 to be artists' studios, with high, arched windows and an inner courtyard but without central heating. That spring she invited Chaim to the studio to see her work. She had continued to experiment on her own with various materials—terra cotta, plaster, wood, and stone—from which she created semi-abstract, organic animal and human figures. Her first attempts at sculpture were efforts to translate visual images into three dimensions "to really see what each side said," as she put it many years later. "You can't do it on a flat surface. You're handicapped. It has to be frontal. At that time I felt that once I had form, I wouldn't be floundering." She also showed him a number of drawings and paintings that probably had been done in George Grosz's life drawing and painting class at the Art Students League, in which she was enrolled at the time. (Grosz, a German communist who had been in the forefront of the Dada movement until he fled Berlin just before Hitler seized power, had been a highly controversial appointment at the League.)

Gross realized that she was a very good draftsman when he saw her figure drawings, which he observed were both "very exaggerated and very simple." But he was even more fascinated by her oil paintings, most of them portraits of her family and friends. The paintings were also characterized by extremely exaggerated, even grotesque forms, heavy applications of paint and passionately strong pigments. She applied the paint thickly with a palette knife,

then scraped it away until a shape evolved. "Her painting was very distorted, ugly, horribly ugly," which Gross felt indicated her daring and originality. The caricatures also suggested her impatience with naturalistic images as well as her ambivalent feelings about her subjects. Her bold, spontaneous overpainting, sometimes finished off by layers of a slick glaze, revealed a feeling of confinement by the two-dimensional surface. Others later detected influences of cubist use of space and German expressionism as well as the painters Amedeo Modigliani and Chaim Soutine. During the next several decades, even after she had clearly made a commitment to sculpture, Louise continued to paint portraits, sometimes to attract someone's attention, occasionally to earn a commission, and at other times to repay a debt. Her body of paintings contains evocative self-portraits of the artist alone and a number with a baby or small child, presumably Mike, and more than one with her sisters. Several solitary self-portraits express her grandiose yearnings, such as those with stars around the heads, like the 1938 *Self-Portrait* of an elaborately dressed figure with a disfigured face, and the wistful *Sad Princess*, painted in the 1940s and given to her brother, where the word "Nevelson" is painted between the points of a crown.

In 1953, Louise described her excitement when beginning a painting, which indicates that whether she expressed herself two- or three-dimensionally, the creative impulse was identical:

> The subject is poised and t artist moves into or projects into a further dimension. Here and now is where t fireworks begin. . . . A place where drillions [*sic*] of electric living sparks take form, t being (t creator) starts t battery going at unlimited speed. There is nothing between that that enters but t light that is being captured. Not t physical light. T constant concentration, t way the palette tool is held, t amount of paint—every time, every stroke creates a marriage between t work and t creator, all done in feverish heights. . . . When things like this are taking place, there is no inclination to think about technique. There is no life but what is contained within t work in front of you. The challenge seems insurmountable and taxes every breath taken. One feels as if in mid-ocean, his life depends on every stroke it takes to reach shore—a good swimmer will not waste a single stroke or movement and neither does an artist. The light enters, it falls on

certain areas so there is constant change and many vi-
sions are created and at t same time t creator must hold
to one vision. Artists speak of t 2 dimensional flat surface:
there is no flat surface, t very depths between strokes
seems like infinite space.

After Louise got her own studio, which gave her the privacy
crucial to concentration on her work, she began to make the tran-
sition from art student to professional artist by exhibiting for the
first time. For the next few years she entered the huge nonjuried
group shows or exhibited at one of the new, obscure Greenwich
Village artists' cooperatives and galleries devoted to emerging
young artists, such as the Opportunity, Secession, and Contem-
porary Arts galleries. In the spring of 1934, she showed in the
eighteenth annual exhibition of the Society of Independent Artists;
for a small annual membership fee any artist could hang three
pictures in the show. That spring, under the leadership of artist
John Sloan, the Independent Artists boycotted the free exhibition
space offered in Rockefeller Center to protest the Rockefellers' de-
struction of Rivera's mural and any further censorship of artists.
As it held its show at Grand Central Palace, there were in New
York two simultaneous nonjury exhibitions, the other under the
auspices of the Salons of America in Rockefeller Center, displaying
about five thousand works of art arranged alphabetically by art-
ist—sprawling, democratic free-for-alls that included works de-
voted to avant-garde European ideas, nostalgia for the American
past, and anticapitalist political themes.

Despite Louise's friendship with Rivera, she did not withdraw
from the Rockefeller Center show, revealing both her lack of po-
litical indignation and her eagerness to exhibit her work. In con-
trast, Lucienne Bloch's entry in the alternate exhibit at Grand
Central Palace was a large panel of photographs of the destroyed
mural, entitled *In Memoriam*. A minority of American artists, in-
cluding Louise, felt closer to the European aesthetic movement
that rejected the intrusion of politics into art. Determinedly apo-
litical, Louise once admitted she detested the words "the common
man" because she believed there is greatness in everyone; she also
found talk glorifying the masses distasteful because she had pre-
ferred living luxuriously "on the other side." She liked to say,
somewhat defensively, that the artist, in his search for a new way
of seeing, is essentially a revolutionary. But politics bored her. In
1954 she elaborated on her attitude: "Each of us has only a certain

time on earth. I would not want to spend two minutes, much less months, on an unknown prisoner. I want that time for thinking, for myself." At this time she was bitterly disappointed at not selling any of her submissions, but lack of a sale was not surprising for an unknown, neophyte artist during the depth of the Depression.

In the early 1930s, free-form modern dance excited many visual artists. It was as if "dance was *carrying* America at that time," Louise recalled. She went to dance performances every week and was particularly fascinated by Martha Graham's mythical erotic dance dreams, which explored the archetypal symbols of American Indian and other primal cultures whose carvings and artifacts excited her. Louise often glimpsed the striking dancer-choreographer in Greenwich Village; she never knew Graham personally but idolized her disciplined commitment to her work. She also admired Mary Wigman and Isadora Duncan, and she acquired six Abraham Walkowitz drawings of Duncan performing on stage.

Her interest in Graham was undoubtedly enhanced because contemporary artists often designed costumes and sets for her dances. Sculptor Isamu Noguchi, who first did a Graham set in 1935, created spare, shadowy, provocative backgrounds from nonobjective forms; over the next three decades he designed more than a dozen. Louise had her own ideas for the dance, as evidenced by her 1937 pencil sketch *For Dance Design*, in which the costumes are characterized by their abstract designs and headdresses, but none of them was ever executed. Graham also had composers create scores for her dances, creating a unique setting of sound, sight, and movement, elements that later appeared in Louise's exhibitions. In fact, her later sculptural environments suggested empty Graham stage sets. And, as if Louise were a performer herself, she tended to approach her shows and other events with a sense of reverence and ritual. At a time when she had not yet decided whether to be a painter or a sculptor, the dynamic Graham repertory, which paid tribute to heroic woman, undoubtedly exerted an important influence.

At about this time Louise got to know Ellen Kearns, a dance teacher she met through Diego Rivera. Kearns, who taught sculptor John Flannagan and his wife, invited Louise to join her classes. Louise had a vigorous, swinging stride and a strong, sensual physicality that made dance a natural activity for her as well as a way to attempt to order her feelings. "I felt a body discipline was es-

sential to harmonious creation," she later explained. Before she left for Europe in 1931, she had already begun to take dance lessons to achieve expressiveness because she felt "tight and frightened" inside. Now she turned to Kearns, a plain woman without a dancer's physique, who was also a skillful masseuse and had a reputation as a spiritual healer.

Kearns taught eurythmics—expressive, free-flowing movement to music. Where traditional dance had a distinct form, eurythmics sought to touch what Louise later called "the life force." Like Martha Graham, Kearns believed that movement could express hidden and unarticulated emotion "when the body lets go, when the mind lets go of the body, when emotions and desires let go of the mind, and both mind and body are in a renounced, annihilated, relaxed state." She had her pupils perform very slow, gradual movements, emphasizing waiting and spontaneity: they would hang from their hips, stretch their arms and hold them still for as long as fifteen or twenty minutes, and make descending spirals with their bodies for three-quarters of an hour.

When Kearns first asked Louise to lie on the floor like a daisy or leap up like a frog, she was indignant, because the movements seemed to insult her dignity. But "I went again, and before I knew it I was in leotards leaping around and loving it." Soon she impressed others in the class as a serious student of dance. Mary Farkas, another Kearns disciple, remembered that Louise "had an interesting body, rather like what we used to think of as modern sculpture at that time—very heavy—not fat—sort of an earthy quality," and she was particularly adept at the many movements done deep to the ground in the manner of Mary Wigman, Graham, and other avant-garde dancers. Despite her body's affinity for gravity-weighted movements, Louise had to persist to reap their spiritual benefits. "I didn't get the inner dance as fast as many," she admitted. "I took longer, almost, than anyone. But I had great energy." It was in fact so great that Mike, who also took lessons with Kearns, used to be afraid that his mother would get hurt because she threw herself around so vigorously.

Without her study of eurythmics, Louise believed, she would have been unable to bring into being the intense, focused energy necessary for creative work. Her study of the body in space also helped her understand balance, impulse, inspiration, and other aspects of creativity, particularly in sculpture, even more than studying with Hans Hofmann and other art teachers had done:

"Dance made me realize that air is a solid through which I pass, not a void in which I exist." And dance helped "to solve the plastic problem, as I saw [it] made of both alternative equilibrium and tension." Many of her early sculptures, including *Earth Woman II* of 1933, a semiabstract plastic figure, indicate her profound bodily awareness; and her numerous dancing figures created in future years expressed her zestful interest in energetic movement.

Kearns tried to help her students sublimate their sexual energy. "Isadora Duncan said that the absolute center is the solar plexus, but we studied that the center was in the sex organs," Louise explained. As the discipline of dance helped calm and center her, the disruptions of daily life interfered less with the inner reality from which she increasingly drew ideas and images. Kearns's teaching about the importance of every individual's "divinity" underscored Louise's inclination from childhood to greatly magnify her own importance. Kearns did not perform on the stage, because she believed public performances diluted the dance's personal purpose; similarly, Louise throughout her life kept dance a private ritual that she indulged in only alone or with an intimate friend. She continued with Ellen Kearns for more than twenty years, admiring her teacher's spirituality, sharing her interest in metaphysics, and becoming her assistant and friend.

In late 1933, to try to loosen the economic stranglehold of the Depression on artists, the government began to commission works of art for public buildings. In August 1935 the Works Progress Administration director alloted the Federal Art Project three million dollars. The next month *Art Digest* reported that the Art Project would employ four hundred to five hundred artists then on relief rolls to create murals, easel paintings, watercolors, prints, and sculptures for post offices, court houses, immigration stations, and other public places. Before its ultimate demise during World War II, the Art Project provided about five thousand artists with materials, tools, and stipends, resulting in the creation of roughly 100,000 paintings, 13,000 sculptures, 2,250 murals, and thousands of posters, prints, photographs, and other works of art. This mass government employment of artists had an enormous impact on the development of American art. Government policy stipulated that women artists be treated equally with men, and from the start 40 percent of the artists were female. According to sculptor Ibram Lassaw, who was subsidized by the Federal Art Project from 1933 to 1942, it "saved a whole generation of American artists."

In early 1935 Louise went to the Home Relief Office in Manhattan, a grim place where applicants were required to sign paupers' oaths stating that they had no family to support them, a fabrication so common that one supervisor used to remark that everyone on the project was an orphan. Painter Joseph Solman remembered that when he went to apply, he sat in the waiting area next to "a dark, rather handsome-looking woman with very dark sparkling eyes and a sense of inner vivacity and fire," who "was in a very cheerful mood—even, considering our circumstances, an optimistic mood." The two started talking and joking about both being artists, and the woman introduced herself as Louise Nevelson. She told Solman that she was divorced from a very rich husband and lived in a multi-level studio with one room for sculpture, one for painting, "and another room was for her play time, which she obviously implied was naughty." Solman wondered, among other things, how she could afford so much space and be in need of home relief.

Established artists were more likely to be accepted by the prestigious fine-arts section of the Art Project, where they were subsidized to do their own work; lesser-known artists usually became art teachers. Louise went to work in the art-teaching division on March 15, 1935, earning twenty-four dollars a week according to her WPA employment transcript. Presumably as a result of her association with Rivera, she was assigned to teach mural painting at the Flatbush Boys Club on Bedford Avenue in Brooklyn. She immediately began to promote the class, and less than two weeks later the *New York Evening Journal* announced that the Boys Club was offering free mural classes by Louise Nevelson, who had studied with the famous Diego Rivera. Similar articles, some with her photograph, appeared in other New York and Brooklyn newspapers and magazines during the following weeks; Louise collected them all from Burrell's clipping bureau, carefully pasted them in a scrapbook or sent them to her family in Maine. Perhaps she thought the publicity would keep her job alive, but the class stopped meeting at the end of July 1935. It had consisted of ten boys, close in age to her son, who met daily and in six weeks completed two murals in the second- and third-floor hallways of the club building. In the social-realist style of the era, they depicted the dramatic Manhattan skyline, bridges, and an ocean liner entering port. Louise enthusiastically described what she called her "first job" in *Flatbush Magazine*, describing with some exaggeration her reaction to the way the boys painted. "The greatest sur-

prise of my life has come to me in these six or seven weeks with these children which has opened a new world for me," she wrote, adding that the boys gave her ideas and inspiration. She also revealed her offhand style of instruction:

> I won't call it teaching to let children express themselves in a natural way: to let them expand beyond themselves normally. If a child has been working in dark, somber colors, one fine day I might say, "Isn't it a beautiful light sunny day," that message immediately goes across, and I might and usually do get a lovely light sunny picture. . . . I most assuredly do not remember their names, but can recognize them immediately by their work.

Until Louise's employment was terminated by the WPA on July 29, 1939, when massive layoffs began as Congress cut off funds, she taught classes for children, teenagers, and the deaf at various schools and institutions, including the Educational Alliance and the Young Men's Hebrew Association. (Decades later, Louise completely "forgot" that she had spent four years on the public payroll as a result of misrepresenting her family's financial situation to the government.) In time she also joined the fine-arts division, once as an easel painter and another time as a sculptor, when she was required to devote fifteen hours a week to sculpture to be turned over to her supervisor. She was one of the sculptors regarded for a while as "prima donnas" by New York regional director Audrey McMahon, who in retaliation rejected their sculptures and accepted only their drawings as submissions. Nonetheless, Louise's work evolved rapidly during her time with the Art Project. The mere existence of a massive government program to support the arts must have been encouraging to a novice, let alone the availability of weekly stipends. She also learned about casting and other sculptural techniques from artist Louis Basky, who ran a government foundry and workshop for sculptors, which had facilities for enlarging scale models and firing work.

Even before her sculpture had an opportunity to develop on the Art Project, it was selected for a significant show at the Brooklyn Museum. During the first week in May 1935, six weeks after she began to teach in Brooklyn, her work went on display, along with that of nineteen other sculptors, including Chaim Gross, Hugo Robus, and Minna Harkavy, as part of an exhibition called "Sculpture: A Group Exhibition by Young Sculptors." For the catalog,

she subtracted five years from her age and stated that she was self-taught. Her entry, a 1933 piece entitled *Two Figures*, composed of angular intersecting planes and a little more than two feet tall, was lent by the Gallery Secession, an informal Greenwich Village cooperative for new talent, where her work was also on exhibit. At this time she was working primarily in plaster, clay, and tattistone, a self-hardening material invented by Alexander Tatti, which he sold to her and helped her work. Her sculptures from this period are primarily of running and dancing female figures—some of them stylized self-portraits—well-balanced, bold, and eccentric. She was also making chunky cubist animals and small semiabstract shapes, which were crudely executed but spirited as she "cuts and slashes into her creations as though she were modeling toy houses," in the words of an art critic at the time. Stylistically still uncertain, they were nonetheless powerful and viewed as spiritually akin to works of Picasso and Henri Laurens as well as to Mayan, African, and other primal art forms.

Often she painted each plane of a sculpture a different primary color to define the form, as she explained later; sometimes she outlined limbs and color masses with dark lines. Although a few sculptors, like Elie Nadelman, had already exhibited painted sculpture, she later agreed with sculptor Richard Stankiewicz that it was generally considered "heretical" then. Emily Genauer, a young art critic for the *New York World-Telegram*, singled out Louise's polychromatic abstractions as highly inventive and wrote:

> For example, one arm of a figure is painted blue and another yellow. Or one half of her chest is one color and the other half another. Now the idea sounds startling. But colored sculpture is far from a new thing. The ancients always colored their figures. The figures on the Parthenon frieze were tinted. But Miss Nevelson uses color as it never has been used before. She applies it abstractly, so to speak, even as though she were working on canvas instead of in the round. She uses it plastically and structurally, to emphasize some planes and de-emphasize others, to increase the volume of a certain section as it stands in relationship to another.

In the spring of 1936, the first of a series of annual competitive exhibits was announced by the American Contemporary Art Gallery on West Eighth Street, a well-known Greenwich Village exhibition space, sometimes called "the people's gallery." Sponsored

by the American Artists Congress, the contest was open to young artists, and the first prize was to be a one-artist exhibition. One day when Louise was standing in front of her West Tenth Street building, Abram Schlemowitz, a young sculptor also beginning to gain recognition, drove by in his truck on the way to deliver his entry to the gallery. He stopped and asked her if she was entering her sculpture as well as her paintings and drawings, and she said no, apparently because she was reluctant to enter the traditionally male preserve of sculpture or to submit her sculpture to the fierce competition of almost two hundred other artists. He tried to convince her to change her mind and offered to transport the sculpture in his truck. Finally she agreed. Years later she liked to flatter Schlemowitz for his timely act of kindness by calling him her "sculptural midwife."

Among the runners-up for the prize—some forty paintings and fifteen sculptures—were Louise's painting *The Clown* and her painted plaster *Sculpture Group*. She was the only finalist with entries in both the painting and sculpture sections. The sculpture was of reclining Aztec-like female figures, as Schlemowitz recalled it; Louise remembered that it was "colored white-pink, like a watercolor on top." The eminent jury of respected artists—including Stuart Davis, Yasuo Kuniyoshi, Concetta Scaravaglione, and Max Weber—selected Japanese artist Sakari Suzuki as the winner but awarded Louise and six others honorable mentions and a week-long group show in September. In the fall finalists' show, Louise was represented by twelve drawings and five small sculptures cast in plaster, including caricatures of a duck and a dancer, also tinted with watercolors. In contrast to these apolitical artistic expressions, much of the work in the exhibit was "so social in theme as to be on the borderline of propaganda or cartoon, or even over the line," according to Howard Devree in *The New York Times*. (In this spirit, Alice Neel, another winner of an honorable mention, entered *Demonstration*, a portrayal of an Artists' Union march featuring a large banner prophetically reading "Nazis Murder Jews.") Although Louise's work was accepted by ACA juries during the next few years and exhibited in the gallery's group shows, she failed to win another honorable mention.

Perhaps because of her previous intense absorption in drawing, her feeling for line was particularly apparent in her early sculpture; it inspired her to add lines with paint and with tools. While she continued to do imaginative drawings and paintings, she was in-

creasingly drawn to sculpture, partly because of what she called her "physical energy that wanted to push something into shape." She later suggested that, compared to two-dimensional work, sculpture with its tactile nature was more real, truthful, and earthy: "You weigh it a little bit, you push it a little bit." Imbued with heightened meaning, the semi-realistic shapes and tangible materials of oversized sculptures invaded her dreams: her brief and sketchy 1936 record of her dreams reveals that on April 28 she dreamed that "Zorach did the elephant and some other sculptur [sic] did some other animal all larger than life size"; two days later she was awakened from a dream in which she was "carving a tremendous stone." As she worked by day on large plaster figures, in her dreams at night they moved and glowed as if electrified, suggesting to her that "there was a subterranean world, even if it was a dream world, where these bodies had a life of their own." In 1953 she wrote about the experience:

> My head is in a whirl
> a swing and a dance
> My figures are coming,
> going where?
> Their [sic] light and their [sic] bright
> I love them so there,
> My figures are dancing and going where?

While Louise continued to submit an occasional drawing to a show, she frequently preferred to enter sculpture. The group exhibitions she entered were routinely reviewed by New York's numerous newspapers. Art critics were often interested enough in her entries to mention her by name, and the reviews of the autumn 1936 ACA show went beyond mere description to offer a few words of praise. Emily Genauer wrote that although a lithographer was the most accomplished artist among the honorable mentions, Louise Nevelson was the most interesting. By 1938, when Louise was included in a large summer show of WPA art teachers at the Federal Art Gallery on West Fifty-seventh Street, a critic observed that the name Louise Nevelson was a familiar one.

In the winter of 1934–35, when Mike turned thirteen, he was sent back to his grandparents in Rockland. Occasionally his father and Stanley Goldfarb, his cousin George's father, drove to Maine to visit their sons. But Mike's letters to his mother reveal that he

had little communication with her. While Louise was in Europe, Mike and his father had joined the reform congregation of Temple Emanu-El in New York; the previous winter, with the encouragement of his Berliawsky grandparents, he had begun to prepare for his bar mitzvah by attending Hebrew school every afternoon. He wrote to his mother about the Rockland ceremony, which she had been unable to attend because of the demands of her career in New York. Instead, she sent him a tallis, or prayer shawl, candy, clothes, and, just before she began her first job on the WPA art project, thirty dollars. Mike wrote back that it wasn't necessary for her to send him anything because "you will be doing pretty well to be taking care of yourself," which apparently reflected the family sentiment. In later years Louise sometimes defended the way she had "dragged up" her son, or forced him to grow up without much maternal attention, her theory being that this neglect helped him form his personality early.

In April 1935 Mike wrote to his mother that he wanted to spend his summer vacation with her in New York, and he hoped she was saving money to move into a place big enough for the two of them, which suggests that she had told him she had no room for him in her West Tenth Street studio. Although Louise had told Joseph Solman it consisted of three rooms, another person described two primitive lofts, one over the other, with unpainted floors; she slept in the upper one on a narrow army cot and worked in the lower one. When she received her son's letter, she was absorbed with her class at the Flatbush Boys Club, and she replied that she wanted him to go to camp. He tried to argue that he was too old for camp and begged to live with her; his grandmother had promised to send twenty dollars a month to meet any additional expenses, he wrote. He even attempted to appeal to his mother by taking her side against his father: "Nevelson doesn't deserve any 'sympathy.' He didn't give you any when you lived in a cellar! Then I didn't know much (I admit) and I was influenced by him to do as he bid. But now I realize how he abused you and I am set to defend you." He signed the letter "Your Son and Best Friend Mike Nevelson."

The boy's pleas were in vain, however; and he was packed off to be a junior counselor at a summer camp in Peekskill, New York. When camp ended, he visited his mother for a few weeks in August before being sent to Peekskill Military Academy. At first he enjoyed the novelty of the military procedure, but gradually he became lonely. Louise visited him one Sunday, bringing a wall decoration

for his room and carrying a bag containing a block of wood on which she was carving a primitive figure, perhaps the mahogany, African-inspired relief figure on which she misspelled her name "Nevelon." Finally, in February 1936, Mike ran away from the academy, turned up in Rockland, and was promptly expelled.

The following summer he raked blueberries in Maine until he got a job as a mess boy on a naval ship docked in Rockland harbor. A few weeks later he disembarked in New Jersey, took a bus to New York, and looked up his father. Apparently Charles and Louise conferred, and in August she gave up her West Tenth Street studio and rented a larger one over a delicatessen at 376 Bleecker Street, which had a very small bedroom at the head of a staircase for her fourteen-year-old son. Mike was enrolled at Stuyvesant, an all-boys public high school, and found himself a part-time job. Louise attempted to look after him, but, as always, her performance was erratic. When his uncle Bernard worriedly asked him if his mother cooked for him, Mike replied, "Sometimes." The atmosphere of the household was decidedly bohemian: Louise, often barefoot or in sandals and dressed in colorful felt skirts and off-the-shoulder cotton peasant blouses, frequently hired models and held sketch classes in the studio.

It was a casual life. Mike and any other male who was around were pressed into service to help her in any number of ways, including the heavy lifting involved in casting her life-size figures in plaster. That winter Ben Mildwoff asked David Margolis, who often mixed plaster for Louise, to finish a mural of Rockland she had begun to paint for Nate; David dutifully researched Rockland's history and completed the mural, for which he never was paid. A few years later, Louise invited a group of artists to dinner, then suddenly, before they had arrived, decided to take her visiting father to the world's fair. Mike was forced to cash in his rare-nickel collection to buy spaghetti and wine for the guests, whom he entertained until his mother and grandfather finally appeared.

During the winter of 1936–37 money was tight; the previous March Louise's Art Project salary had been reduced by five dollars a week. It was a bitterly cold winter, and there was scarcely enough money for gas for the heater. Louise, who had low blood pressure, suffered intensely from the cold and used to visit the Metropolitan Museum simply to get warm. Although she worked during the day, she became depressed at night: "I saw graveyards with fire. There was death, again symbolic, and I needed heat so much, I saw fire."

She went to bed night after night with that image in her mind, a state she described as "total death."

As she and Mike searched the streets and demolition sites for pieces of wood to burn in the fireplace, Louise discovered what to her eye were treasures. "A piece of wire run over by a truck would be a marvelous jewel for her," Mike recalled. "She had the sharpest eyes of anyone I ever knew." After she got to know a man in the demolition business, a truckload of wooden trash was dumped on Bleecker Street in front of the delicatessen; traffic was blocked, and the police were called. Mike was ordered to clear the street, so he laboriously dragged all the debris into the backyard and sawed it up for firewood.

Despite Louise's self-conscious attempts to maintain a proper façade in front of her son, Mike knew that his mother had many lovers; he quickly learned never to drop in on her unannounced. He even attempted to "court" her himself the way her male admirers did, taking her out to dinner and, in general, treating her as a friend, not as a parent, the way she did him. But living with her became more and more uncomfortable, and in the early spring of 1937 Mike ran away, intending to go to sea. He got his seaman's papers and joined the crowds of the unemployed at the National Maritime Union and on the Manhattan waterfront. Dressed in one of his uncle Nate's old wool hunting coats, he ate meals for a few cents in vegetarian restaurants and washed in the men's room of a cafeteria until a friend of his father's, Maurice Rapoport, finally located him and sent him back to his mother. Mike's report card in the spring of 1937, signed by "Mrs. C. S. Nevelson," indicated, not surprisingly, fair and poor grades in school. He had begun to drink, smoke, and fight, and in 1938 he was expelled from Stuyvesant for spitting chewing tobacco on a teacher. Louise was told that he could return if she sent him to a psychologist. Apparently she did, and he returned to school, graduating in June 1940, at the age of eighteen.

Since all artists were treated about the same on the WPA Art Project, and few had realistic hopes of selling their work during the Depression, it was a time of strong camaraderie among them. Many first became aware of an art community while submitting their work to supervisors, or picking up free materials, or waiting in line for checks on Friday afternoons at the King Street WPA office in Greenwich Village. This mingling led to gatherings in

nearby bars and cafeterias, visits to one another's studios, and the forging of alliances. The Artists' Union, headed by painter Stuart Davis, was formed in 1934 "to unite artists in the struggle for economic security, and to encourage wider distribution and understanding of art." When, in 1937, it became affiliated with the Congress of Industrial Organizations (CIO) as Local 60, artists joined the American labor movement for the first time. Every May Day, or whenever the Art Project was attacked in Congress as a waste of money and a hotbed of radicals, and government support began to falter, the Artists' Union called mass meetings and held marches for which members created clever floats and effigies; they also carried red banners and waved signs with slogans like "Art for the Masses." Although Louise joined the Artists' Union, she remained bored by politics and was far more likely to appear at its dances and meetings on cultural topics than at its political events. Some activists, like Dorothy Dehner, David Margolis, Alice Neel, and Ben Mildwoff, complained later that she was never seen on a picket line.

In general, Louise was liked personally because of her beauty and her friendliness; she was also vocal and amusing, particularly when she openly and daringly talked about her love affairs. But many of her 1930s acquaintances found her oddly apart from much of the artistic ferment going on around her in Greenwich Village. Despite the camaraderie, there were distinct cliques; the social realists and the emerging "action" painters, for example, did not intermingle. In 1935 a group called "the Ten" was founded by painters, several of whom became abstract expressionists. For five years the members, among them Mark Rothko, Adolph Gottlieb, Joseph Solman, and Irene Rice Pereira, met monthly in each other's studios and exhibited together at the same galleries. A year later, a much larger group, the American Abstract Artists, was established by Ibram Lassaw, Vaclav Vytlacil, Alice Mason, Ad Reinhardt, and David Smith to organize group exhibitions for its members. Although Louise knew most of the artists and was familiar with their work, she was not invited to join because, Lassaw explained, she was not doing abstract work. This is not entirely credible, because she had been working in an experimental and semiabstract mode for several years.

The Sculptors Guild was also formed during this time and held its first members' show in the spring of 1938. Its board included Chaim Gross, Minna Harkavy, Concetta Scaravaglione, and

William Zorach, all of whom knew Louise personally or knew her work, but she was not invited to join until the early 1950s. Sculptor Peter Grippe recalled meeting her around 1938 and seeing the terra-cotta cubistic animals she was making on the Art Project. "On many occasions I tried to discourage her from getting involved with many of us who were then breaking away from what today is considered the social realist," he recalled, because, in his opinion, she was untalented and didn't display enough intellectual interest in nonobjective art. In actuality, she was more temperamentally akin to the European aesthetic movement than to other influences on American art. "When the Sculptors Guild started, I would have been very happy to join them," she later admitted. "I knew a lot of them, but I think they thought I wasn't good enough for them." Their disdain deeply hurt and angered her at first; then she decided that the rebuff "had nothing to do with what I had to do," in much the same way that she had reacted to rejection during her girlhood in Maine. In later years she blamed Chaim Gross for her exclusion because he had been the first president of the Sculptors Guild; but all members were elected by secret ballot, and he later claimed to have been bewildered by her long rejection.

Louise may have appeared to be intellectually uninvolved with the new European aesthetics because of her disinclination and inability to participate in earnest conversations about the meaning of art. As she began to express herself in a more uninhibited manner, she often spoke in non sequiturs. She had great difficulty talking articulately about art because her approach was essentially intuitive. She depended upon what she called "flash thinking"—the rapid assimilation of mental images, inner perceptions, and intuitive leaps—and found logical reasoning limiting, unnatural, and antithetic to creativity. "I hate the word 'intellect' or the word 'logic'—logic is against nature," she later explained. "And 'analysis,' another vulgar word." Nevertheless, she owned numerous books about art, metaphysics, spiritualism, philosophy, and religion in which she underscored passages and wrote comments. "She was intensely interested in every phase of art," her son observed. "She studied for half a century, and nobody knows how much she knew about art because her conversation didn't reveal the extent of her knowledge."

It was difficult for her male contemporaries to accept her as a committed artist because of her aggressively female manner and appearance. Some artists, notably Ahron Ben-Shmuel, denigrated

her at the time as a pushy woman who was trying to become a sculptor. Peter Grippe admitted that because she was flamboyant and flirtatious and a divorcée, "we assumed she was a bourgeois girl getting along on poverty row, and I never took her seriously at that time." During those years an attractive woman "had to have a double life," according to Alice Neel, because women felt they had to hide their seriousness in order to escape ridicule. Louise later admitted that to some degree she was camouflaging herself when she dressed in either the ostentatious original creations she put together or the expensive, fashionable clothes her family and male admirers gave her. But she also enjoyed dramatizing herself; her appearance was so important to her that she even went to movies just to see the fashions. She enjoyed the attention and admiration that her good looks attracted, and she did not wish to appear plain or poor, even if that was how an artist was supposed to look.

At a time when women artists usually dressed simply, like Georgia O'Keeffe, who habitually wore only tailored black and white, Louise might wrap a tablecloth around her waist for a skirt, or dye a sheet, sew lace onto it, tie it with a ribbon, and wear it as a dress. At other times she favored secondhand ethnic clothes, like an eye-catching Greek folk costume. One day Ben Mildwoff was walking down Fifth Avenue when he observed a woman ahead of him wearing a "funny costume"; as he caught up with her, he realized it was his sister-in-law. Her mother, who always had been meticulous about her daughters' clothing, was shocked by some of Louise's outfits. "Gramma just said for you to dress human when you come up here," Mike instructed his mother in early 1934. Unsurprisingly and quite intentionally, Louise soon became easily recognizable in art circles, and her reputation now preceded her. At a meeting of Paris expatriates, when she walked in with great poise wearing a large bright-pink hat and a matching ensemble, David Smith, who had not yet met her, turned to his wife, Dorothy Dehner, and observed, "Oh, that's Louise Nevelson."

To add to her fellow artists' suspicions about her sincerity and despite her son's open jealousy, Louise continued to seek out the socially prominent. "Now that you have a son to support, no more entertaining 'countesses,'" Mike wrote to her in the spring of 1935. "Let them entertain you." Louise took to going alone to the fashionable midtown-Manhattan nightclub El Morocco, where she would sit bare-legged at the bar, a daring bohemian act among its

chic and wealthy uptown crowd. El Morocco was where the so-called smart set gathered to see and be seen by gossip columnists and society photographers. Louise made friends with gossip columnist Lee Leary, who was also from Maine and wrote a column called "Manhattan Merriment" for a magazine devoted to horse racing. Soon the name Louise Nevelson began to appear in print alongside the famous names and titles in café society:

> The other night at El Morocco we saw Gloria Swanson in a fuchsia and scarlet dream dress with gold leaves in her hair, looking lovely, languorous and utterly charming; the Ranee of Sarawak (Lady Brook) in a rose and gold brocade gown with a shawl draped over her hair and shoulders Hindoo fashion; blonde and lovely Honey Johnson; dark and exotic Babs Beckwith; Princess Hohenlohe Schillingfurst; Cobina Wright and Cobina Jr; Louise Nevelson, modernistic sculptress; Dick Merrill, aviator; Mrs. William Atkinson (Natalie Van Vleck), portrait painter, and many other interesting personalities,

Leary wrote in 1937.

Despite such amusing diversions, Louise was actually despondent much of this time about her son, her health, her struggles for artistic recognition, and her finances (on July 11, 1937, her WPA salary had been cut again). Her emotional life had always been punctuated by periods of paralyzing despair, often on the heels of periods of intense creativity. When she was depressed, she habitually turned to popular spiritual panaceas; once she joined a Buddhist study group led by a wealthy man at his Sheridan Square house. In April 1936 she began an attempt to psychoanalyze herself by writing down her dreams. These fragments contain references to her dance teacher, Ellen Kearns; to childhood fears, erotic fantasies, dress fittings, and making sculptures. After she wrote that she had experienced some "grusome [sic]" dreams, the jottings tapered off—the last dream, in late June, was of being a member of a one-hundred-person orchestra—as if she no longer wanted to explore her unconscious, or at least to record verbally what she preferred to experience visually.

Among the names in Mike's autograph book was the elegant and elaborate signature of Louis Eilshemius, whom Louise had met around 1933 through an aged guard at the Museum of Modern Art. The guard told Louise about his lonely friend, praised him as

an artist, and urged her to visit him on nearby East Fifty-seventh Street. Intrigued, she immediately paid him a call at his neglected, gaslit family mansion full of deteriorating paintings, stuffed owls, and various kinds of bric-a-brac. Even before she got to know him, Louise had realized that Eilshemius was what she called "an innocent" who lived in his own world. The year before when she was in the well-known, midtown Valentine Dudensing Gallery, a shabby, bearded old man had entered, walked over to a painting, and ordered one of its female figures to remain on a bench. When Louise realized that the man was the painter himself—Eilshemius—she was fascinated by the way his personal reality was more real to him than the one around him, a quality she increasingly understood in her own development as an artist.

Over time she realized that Eilshemius suffered to an extreme degree from the rejection and neglect that she and other modern artists were experiencing. A prolific painter, he had been rejected by juries for thirty years before finally showing in 1917 with the Society of Independent Artists. Although his work was praised by Marcel Duchamp, Gaston Lachaise, and others, it was not widely accepted, and he abandoned painting a few years later. Recognition finally arrived in 1932 when he was given two solo shows and dozens of paintings were sold, including one to the Metropolitan Museum. Art critic Henry McBride blamed himself and others for having neglected this "genius" and called him a "genuine lyric painter." But Eilshemius was embittered by neglect, and his long-delayed success tasted like "ashes in my mouth," he said. Like a biblical prophet, he ranted bitterly about the evils of the world and the glories of his neglected genius to anyone who would listen and in letters to newspapers—thousands were reportedly sent to the *New York Sun*, and most readers assumed he was a lunatic.

Louise, who was impressed by both his talent and the tattered evidence of his wealthy and aristocratic background, began to visit him frequently, taking along one of her sisters or her son. An unrecognized composer and poet, Eilshemius impressed Louise with his knowledge of music and poetry, inscribed to her a 1904 edition of his poems, and showed her his paintings, which he ranked with those of Rembrandt yet, because he was half-demented, gave away for nothing or sold for five or ten dollars. "Every time she went up there, she went into the room filled with his canvases, stacked from floor to ceiling, and walked out with a dozen under her arm," according to Corinne Nevelson, who sometimes went along to play

his songs on the piano. By 1945 Louise owned 181 of his paintings, which after his death and another round of exhibitions were valued together at an estimated ten thousand dollars.

Louise's admiration for his work lasted all her life. Inspired by Gauguin, Eilshemius had traveled to Samoa at the turn of the century. He was also influenced by the nineteenth-century Hudson River School and did thousands of paintings of voluptuous, long-haired female nudes frolicking in ponds, waterfalls, and woods which conveyed the dreamy, lyrical, naive charm of a lost Eden to Henry McBride and other admirers. "Even his awkwardness contributed to the sense of a youthful world where all emotions were fresh, all desires possible," observed museum official John I. H. Baur. His paintings were often highly erotic, like the protrayal of a black imp standing between the legs of a pink-skinned maiden. Many of the paintings Louise acquired—*The Waterfall, Figures in a Landscape, The Spearman*—had a strong sense of romantic reverie; and an early 1916 Nevelson watercolor of a partially nude woman in a landscaped garden is uncannily like an Eilshemius fantasy. Louise admired his "incomparably elegant" brush strokes, strong colors, vast output, and what she insisted was his sophistication. While others concluded that he was but a minor American master, Louise continued to maintain that he was the greatest painter in America. "I have lived with my Eilshemius paintings my whole adult life," she wrote in January 1961, when his work was shown at the Graham Gallery. "I am still enchanted daily with these wonderments."

Just emerging from a marriage where she was considered "crazy," she clearly identified with this lonely outsider's grandiose feelings about his importance and felt that his example should give other artists the courage to continue even if they were misunderstood. "Eilshemius was born to be a great artist," she wrote, calling him the embodiment of natural creativity. "I would rather have given an American artist my money, because I knew what it was to be an American and not be respected by collectors," she explained when talking about her Eilshemius paintings. When his work was exhibited at the Balin/Traube Gallery in 1963, she put her feelings about him into poetry:

> Always there is a consciousness that is aware
> of what consciousness is.
> Eilshemius was and that is why he was alone.

What creative consciousness is not?
In our time, in our stupidity, we have not given
Eilshemius his true heritage.
Eilshemius must be revaluated and recognized
for what he is . . . A creative being.

In 1939, when Eilshemius had another run of one-artist ex-
hibitions in New York, museum officials, including Alfred Barr of
the Museum of Modern Art, several critics, and a number of col-
lectors, such as Duncan Phillips, attempted to raise money for the
old man, who was again poverty-stricken because his paintings
had sold for such pitiful sums in previous years. Although he had
allowed Louise as well as others to exploit him, she apparently
remained unaware of the irony. Two years later, when his callers
and his money dwindled further, Louise was one of his few visitors
in the psychiatric ward of Bellevue Hospital, where he died pen-
niless in 1941 of pneumonia.

Nate was the only one in the Berliawsky family with cash
during the Depression. For a while he reportedly was involved with
rum runners, and by 1935 he had become manager of the Maine
Vending Machine Company, handling "anything in coin-operated
machines," according to the company's letterhead. Actually, the
company was a cover for illegal slot machines, and for a time Nate
was "the slot-machine king of New England." As a "racketeer,"
Nate possessed a pistol, according to his nephew George, and when
one of the coin machines was broken into, he and a tough named
Charlie would locate and threaten the suspect. Nate regularly paid
off the police, and his illicit activities were never investigated be-
fore he got out of them during World War II. Several decades later,
when the Rockland Jaycees awarded him their fifth annual Dis-
tinguished Service Award, Nate was surprised and deeply moved.
"As one merchant explained to me," Mike wrote his mother, "it
seems that for half a century, Nate has carried a self-imposed bur-
den of inferiority, as being ill-educated, a foreigner, and a Jew who
had engaged for years in illegal business, and this award lifted that
weight off him and at last he feels that he 'made it' as an acceptable
and respected member of the community."
At a sheriff's auction in 1937, Nate acquired the rundown
Thorndike Hotel, an Italianate brick building on the corner of Rock-
land's Main and Sea streets. It once had been a first-class hotel
with a hundred guest rooms; Nate had sold newspapers there as

a boy. After he bought it, it was briefly shut down on a false charge of selling liquor on Sunday, which some family members regarded as an example of local anti-Semitism. When it reopened, Nate ingratiated himself with the community by feeding the poor from the hotel kitchen and putting up islanders when they were stranded on the mainland by storms and high seas. The Thorndike gradually became filled with works of art, which Nate accepted as payment from penniless artists; he also loyally displayed Louise's paintings and sculptures despite the townspeople's bewildered and derisive remarks about them. As the hotel developed an excellent dining room, it became popular with local judges and politicians, whom Nate would advise on political appointments. Anita, who had been secretary of her brother's vending-machine company, worked nights in the Thorndike's basement bar, named the Rainbow Room but dubbed the Passion Pit, which was frequented by fishermen.

While Nate prospered, his father steadily lost money. Isaac, who had taken to wearing long johns, a hat, and a baggy woolen suit with deeds, crackers, whisky, and cans of sardines in the pockets winter and summer, remained a temperamental, stubborn, irascible individual with a strong compassionate streak. Every month he would attempt to collect rents on his properties, but when the tenants told him they were out of work and broke, he would take the pint of whisky out of his pocket, pass it around, and once again tell them to forget about the rent. Gradually Nate took on the financial responsibility for his parents and sisters, which, in line with Jewish tradition, he believed was his duty as the eldest child and only son in the family. His sense of loyalty was underscored because he remained a bachelor who until his mid-forties "really had only one love, Mama (we have to discount the unrequited love for Alice Lymeburner)," Mike once wrote, referring to his uncle's eleven-year engagement to a woman he felt unable to marry because she was a Christian. Nate gave his mother the weekly food money and his nephews dimes and quarters to spend in the candy store. As he became—with Annie's blessing—the man of the family, it was he who made rules for his nephew Mike, forbidding him to go out at night, for example. Nate had the best room in the house— the large front master bedroom, where Mike as a child had slept with him in the double bed. He kept *his* automobile in the garage, while his father's 1928 Oldsmobile, with velvet upholstery and wooden spoke wheels, mildewed from being parked outside under a tree.

During these years Louise began to ask her family and friends to help pay her casting and firing costs; in return, she would paint their portraits or give them pieces of sculpture. Sales of her work were sporadic and rare; notes in Louise's handwriting suggest that in 1939 she may have sold a wooden piece, *Seated Woman*, for ninety dollars and a bronze, *Position*, for seventy-five, to or through the ACA Gallery. Nate impulsively sent periodic gifts of money to her and bought her expensive coats or suits when he visited New York. Even Louise's younger sisters treated her to vacations, gave her clothing, and provided her with other favors despite their own limited circumstances. Yet despite the help from her family, her WPA and other earnings, and an occasional small check from Charles Nevelson to his son, her finances were often desperate. At times Louise, like Nate, skirted the law. "I'd rather steal than work. I have stolen," she admitted afterward, but she gave no details. An artist named Hubert Crehan, whom Louise met a few years later, once heard her remark that if she had the money she would pay for something she needed or wanted, but if she did not have the money, she would simply take it.

During this period, Louise moved to a different studio every year or two, sometimes after only a few months, often because she was unable to pay the rent. When asked years later why she had moved so often, she answered vaguely that it was because of "economics" or "space" or because the studios were "uncomfortable" or "not right." In 1938 she and Mike moved into a large apartment on East Fifteenth Street near Mike's high school. Once when there was no money to pay the rent, Mike reminded his mother that she still had an old check in her jewelry box from Baroness Hilla Rebay, payment for the first painting she had sold, which she had kept for sentimental reasons. After Louise cashed it and paid the rent, the baroness refused to honor the check and threatened to have her sent to prison. A lawyer reassured Louise that she had not committed a crime, so she decided to ignore the baroness's threats. She remarked to her son that if the baroness tried to file charges against her, it would make a sensational newspaper story. There was, however, no suit and no story. The next year, 1939, they moved to a railroad flat on East Twenty-first Street, where Louise let her son have the sunniest room.

Louise capitalized on her good looks; she was "slightly whorish," in the words of one female friend. With Ernest Bloch she had shown herself capable of adopting a nonchalant, jesting, yet sex-

ually aggressive stance, which failed to hide her impassive indifference about whether or not they actually became lovers. In fact, "Louise did everything a woman would do to live," according to artist Peter Busa. She liked to tell friends about the time she was admiring a gown in Bergdorf Goodman's window when a man stopped and remarked that the gown would flatter her; before long, Louise and the stranger went inside, he bought it for her, and they went to Atlantic City for the weekend. Ben Mildwoff, who did illustrations for Saks, was leaving at the end of the day once when he discovered that the department store was being kept open while the son of a wealthy German family of art patrons outfitted Louise for a cruise to Bermuda with him. When Alice Neel asked Louise how she managed to dress so beautifully on the small WPA Art Project stipend, Louise replied blandly: "Fucking, dear, fucking." Neel used to find Louise in the lobby of the Hotel Astor where, Louise admitted, she was waiting to pick up men. "That was one way she survived as an artist," Neel explained. In later years Louise observed that if she revealed all the ways she had survived during those financially difficult years, she would be arrested and put in jail.

A Promising Sculptor

I like our lostness of man in society,
I love the search of completeness of t Self

—*LOUISE NEVELSON*

WITH THE OUTBREAK of World War II, American artists became less politically active. In the spring of 1940, after the left-wing American Artists Congress sanctioned the Soviet invasion of Finland, many members resigned from the group. Led by Mark Rothko (still known then as Marcus Rothkowitz), Adolph Gottlieb, and others, a number of them formed the Federation of Modern Painters and Sculptors, which advocated the artist's personal and artistic freedom from politics—"the noble privilege to create art as art instead of practicing a pictorial form of story telling without aesthetic concept." Shortly thereafter the Federation began to protest the backwardness of the art establishment. When Edward Alden Jewell, *The New York Times*'s art critic, admitted his "befuddlement" about the 1943 members' exhibition, Rothko and Gottlieb attempted to define the new American avant-garde to him, leading him to review the exhibition again. "To us art is an adventure into an unknown world, which can be explored only by those willing

to take the risks," the artists wrote. They rejected such notions as common sense in favor of the irrational, advocated the large canvas "because it has the impact of the unequivocal," and expressed a "spiritual kinship" with primitive art. "It is our function as artists to make the spectator see the world our way—not his way," they declared defiantly. As magazine and newspaper editors began to give the visual arts the same degree of attention that had been traditionally devoted to music and literature, serious art critics emerged, many of them from the old left wing. Harold Rosenberg coined the term "action painting" in *ARTnews*, and Clement Greenberg in his critiques for the *Nation* became a dogmatic advocate of the new American painting.

Even though Louise was sympathetic to the Federation's emphasis on aesthetics and apolitical art, she did not fit easily into such groups for a number of reasons, one of which was that her unusual sculpture was not being applauded. In 1941 Carlyle Burroughs, the art critic for the *New York Herald Tribune*, described her work condescendingly as "well off the beaten track, a little mannered, and cleverly done." Her approach to art remained essentially instinctive, impulsive, and deeply subjective; she favored instant aesthetic judgments, which underscored intuition and downplayed theory, and process rather than a perfectionist goal. To a number of other artists she appeared aloof, isolated, impoverished, and angrily impatient; her work was being neglected at a time when the Museum of Modern Art was acquiring the output of other women artists, such as Loren MacIver, as well as sculptors like Alexander Calder and David Smith. "Somehow she wasn't embraced," the artist Jimmy Ernst remembered. As a result of her alienation, she often felt far lonelier than she had ever expected to be—a feeling that hit her particularly hard one Saturday while she was sitting on a bench in Union Square and observed a group of close male friends passing around a pint of whisky and swapping gossip about their wives and children.

By the time Nazi troops marched into Paris in June 1940, escaping European artists had begun to arrive in New York in large numbers. One afternoon in early September 1942, Emily Genauer observed on "Art Gallery Row"—Fifty-seventh Street from Sixth to Madison avenues—Marc Chagall, Max Ernst, André Masson, and Jacques Lipchitz. Many American artists, struggling to forge an indigenous art of their own, resented the émigrés' assumptions of superiority and greater sophistication, while the émigrés were as-

tounded that an artist could even function in what Chagall de-
scribed as "this Babylon," which, compared with Paris, seemed to
him shockingly indifferent to art.

Louise met many of the exiles through Frederick Kiesler, in-
cluding the aging Dutch painter Piet Mondrian, who took her danc-
ing in the early 1940s. Mondrian was more open-minded about
America than most of the Europeans and found New York "the
essence of the modern age." His asymmetrical grid style of paint-
ing, which influenced the native movement toward geometric ab-
straction, was in turn influenced by the city's jazz rhythms,
primary colors, squares and rectangles; it also demonstrated the
ability of abstract art to express feeling forcefully. Mondrian was
unusually tolerant about various styles of modern art as well as
generous and encouraging to other artists. Louise, who appreciated
his interest in her work, was impressed by his immaculate studio
and his high level of professionalism.

She disagreed with the assertion of her former Art Students
League professor Kenneth Hays Miller that the Europeans were
unable to understand the United States. The émigrés gave America
to us "on a silver platter, and just when we needed it," she declared
many years later. When a European art dealer advised her to move
to Paris to get recognition, she replied that although she had been
born in Europe, she belonged to America. She felt that her own
vitality matched its raw energy. "When you go to Paris you are in
a period piece, it is empty," she explained. "When you're in New
York, you're in perpetual resurrection." She also believed it un-
necessary to emigrate because so many European artists had set-
tled in New York. She was stimulated by her exposure to their
paintings and sculptures—she later testified that this cultural
cross-fertilization had been essential to her development as an
artist—and before long she would benefit greatly from their at-
tention to her work.

Sculpture had been a carving and modeling medium in the
United States until the early 1940s, when kinetic art and open-
form welded metal construction became more commonplace, and
sculptors like David Smith and Richard Stankiewicz began weld-
ing metal scrap into sculpture. As a number of artists learned to
weld in wartime factories, metal became the preferred substance
for sculpture. Yet Louise deliberately rejected it. One of her main
considerations was financial, but she also felt that the noise and
other aspects of the mechanical technique insulted her sensibili-

ties. "The word 'torch' and the performance of the torch just went against my feeling," she explained. In a way she was echoing her father. Isaac Berliawsky was still having his trees felled manually with axes; when his customers urged him to use a chainsaw to increase production, he stubbornly refused on the ground that the noise would disturb uncut trees and retard their growth. Since wood had been the principle source of livelihood for her ancestors at a time when it was rare for Russian Jews to be woodsmen, Louise liked to believe that sensitivity to "the livingness" of wood was in her genes. Increasingly, she began to work in the old-fashioned medium of wood, which she later described as "closer to the feminine." When her use of wood was criticized at an artists' meeting, she defended herself obliquely: "If Rockefeller signs a check, it's a good check. But if a bum signs a check, it's a bum check."

Art museums and galleries were not as evenhanded toward artists as government programs had been, and the artist's sense of his or her self-importance was extremely fragile as each one "warmed himself with his own self-esteem," in Ibram Lassaw's words. Louise was stronger than most. Once she was drinking coffee in the Waldorf Cafeteria on Sixth Avenue with her son and a group of male artists, some of whom were highly regarded at the time. "They were discussing art, and they were very serious," she recalled. "They were kind of laughing about me because I was supposed to be a sculptor." Then one of them turned to her and declared that an artist had to have "balls" to be a sculptor. She felt hurt, but after a moment she quietly declared, "*I've* got balls." In the shocked silence that followed, she knew that these men would not attempt to intimidate her again.

After the dismantlement of the WPA, most artists lived perilously near the edge as their means of survival were drastically reduced. One evening Louise was eating a late dinner with a group of other artists at photographer Francis Lee's loft when an inspector looking for illicit electrical hookups knocked at the door. Lee shouted at him to wait, and quickly disconnected the jumper. They continued to dine in the darkness—relieved only by the reflected light from a huge illuminated billboard on a nearby rooftop displaying the lace-covered breasts of Rita Hayworth—until money was collected, and Jimmy Ernst hurried to Fourteenth Street to buy candles.

Louise had no dependable income; she survived on gifts from family members and friends and from sales of Eilshemius paintings and other items. In the early 1940s she bought a small Milton Avery

watercolor of an opera singer with a fan for a hundred dollars, and a few years later sold it to Ben Mildwoff. One day when she was feeling particularly anguished about her living conditions—Mike had noticed bedbugs in her apartment—during a period when she was working intensely, even desperately, she started to walk up Fifth Avenue and window-shop. Stopping in front of Bonwit Teller's windows, she imaginatively entered a world of elegance and ease. Yet as she stood there, she realized that even if the president of the store offered her a million dollars to give up a lunch hour every day, she would refuse. She already recognized her need for, as she put it, "totality" at all times, in order to create with originality and awareness, and the loss of those hours would destroy her concentration: "I needed my full consciousness to project ideas." Her sudden understanding that she had a real degree of freedom, based on complete control over her life, pulled her out of her depression, and she was able to return to her studio and begin to work again. "I never got caught [up] in making a living," she liked to say, apparently not regarding her teaching as livelihood. "That would have seemed to be a little bit out of order to a creative mind such as mine." For the rest of her life, she deliberately attempted to structure her life so that "no one could claim it but me."

The year 1940 was a particularly difficult one: she exhibited in only two group shows and attracted little favorable notice and no sales. In March, at the United American Sculptors show, an art critic wrote that some pieces in the exhibit were successfully innovative, "which cannot be said, however, for the color piece by Louise Nevelson." But she remained openly ambitious, more so than ever, after receiving a modest measure of encouragement in the late 1930s. She was also compelled by her growing drive to continue to create, remarking to a *New York Post* interviewer that "art is a stream that flows on and on, making you do more and more." On one occasion when she was with a friend, artist Blanche Dombek, whose work was being accepted in museum shows while hers was not, she angrily raised her fist and declared that someday *she* would make it. At first taken aback, Blanche later realized that Louise was hostile toward the art world, not toward her personally. A self-portrait Louise sculpted around this time depicted an angular female figure with a small head, a vigorous, earthbound body, and large raised arms—the left lifted in a balancing gesture and the right pointed at the sky with a clenched fist of rage.

□

By the summer of 1941 Louise, who had not yet shown any of her work that year, was bored, depressed, and impoverished. Her divorce would soon be final, which may have contributed to her mood. She continued to frequent fashionable midtown gathering places, like the bar at the Algonquin Hotel, and by that time she "knew the name, the telephone number, the chauffeur, the license plate of *everybody*, and she made use of them—to join people at dinner, to track them down at El Morocco and join their party, to have fun, to eat, to maintain a connection with the wealthy," according to Corinne Nevelson. She liked to hail a passing limousine, make up a story for the driver about knowing the people he was going to pick up, get in the automobile and ride off to meet them. Often she had to walk home because she had no money for a taxi. "I was desperate," she said. "They wouldn't think that you might need a cup of coffee, and I wasn't the type to beg." Such experiences of high living amid the struggles of her daily life helped foster her attitude of combined awe and resentment toward the members of café society.

In August, a friend of her family, a wealthy businessman originally from Fall River, Massachusetts, whose name has been forgotten, invited her to dinner at the Plaza Hotel. She casually accepted because she had not dined there for a while, and she happened to have an appropriate outfit to wear. After dinner, the man's chauffeur drove them to Montauk on the eastern tip of Long Island, where they stayed for several days. Louise was dazzled by his extravagance: "He thought nothing of spending a thousand or two thousand dollars an evening." On their return to Manhattan, as they lunched at the Plaza, she felt more desperate than ever about her difficulties as an artist, yet buoyed up by having an admirer lavish so much money and attention on her. Instead of pursuing a relationship with him or any other man, however, she was committed to fulfilling her aspirations through art. Even though she had no evidence that her career would ever provide for her material needs, art was the way in which she expressed her most intimate feelings. Even if she at times wanted a wealthy husband, her independence would probably never have allowed it. That day, after another Cinderella-like adventure, she vowed to *demand* an exhibition from the best art gallery in New York.

There were about forty serious art dealers in New York at the time, including Karl Nierendorf, Pierre Matisse, and Curt Valentin at the Buchholtz Gallery. She considered the Nierendorf Gallery,

which exhibited the great European artists, the most prestigious, and Nierendorf himself "a man of taste." Since few American artists made a living from art at that time, even those represented by galleries, she was evidently seeking a form of patronage as well as recognition. Nierendorf, a heavy, short, bald, unprepossessing bachelor of fifty-two, had a reputation as a ladies' man and especially admired large, beautiful women. "It's love that dominates the world," he liked to say. Although Louise later recalled that she might have gone to one or two of his shows but had never met the dealer himself, her memory has been questioned by Nierendorf's secretary, Hildegard Bachert, who remembered seeing them together at the gallery several times during the autumn of 1940. In any event, Louise left the Plaza and walked directly to the Nierendorf Gallery on nearby East Fifty-seventh Street.

Now a statuesque, tanned beauty of almost forty-two, she went up to Karl Nierendorf and bluntly announced that she wanted an exhibition in his gallery. When the dealer protested that he did not know her work, she offered to show it to him; afterward, she liked to say, she perched on his desk and crossed her legs. When Nierendorf, who usually wore an animated, good-natured expression on his face, found that she lived on East Twenty-first Street, near his artist friend Amédée Ozenfant, he agreed to visit her studio very soon. When he arrived, he apparently groped at her body on the stairs leading to the basement, where she stored her sculpture; she told him she would not show him *that*, she would show him her *work*. Nevertheless, they felt an immediate sense of personal rapport. A few weeks later he compared their relationship with that of the film director John Huston and his companion, who "are really good friends . . . of the kind we are, you and me. I mean one does not need much words and explanations, everything is quite simple and natural." Nierendorf, who was known as impulsive and excitable, agreed to exhibit her sculpture and drawings in a few weeks, probably because he had a sudden opening. "He improvised all the time," Hildegard Bachert explained.

He and his brother had been avant-garde art dealers in Germany for fifteen years before Adolf Hitler banned the work of modern artists. A "rare combination of shy scholar and sagacious businessman," according to *Art Digest*, he was a complicated and contradictory individual, highly cultured and with strong personal convictions about art. He was particularly devoted to the paintings and drawings of Paul Klee, whose work had been included in the

Third Reich's infamous "Degenerate Art" exhibit in Munich. The previous spring he had made a point of exhibiting the work of artists on the Nazi blacklist. Emigré musicians, architects, and theatre people gathered at his gallery, and its large 1941 spring exhibition was accompanied by lectures, and performances of both modern and classical music. He had belonged to the League for the Independent Film in Berlin, and he liked to show avant-garde films and experimental color animation by Fernand Léger, Man Ray, and others. He also appreciated antiquities and primitive art—he always pointed out their similarities to modern European art—and his collection of Chinese, Greek, Peruvian, and Mexican sculpture was scattered around the gallery.

Regardless of any romantic relationship between him and Louise, he undoubtedly responded to the quality of her work. Various critics had found that some of it resembled three-dimensional Klees or seemed influenced by Ozenfant, and much of it exuded the power of the primitive art he admired so much; he had a penchant for "the strong, expressive things in life," he once remarked. Furthermore, he took the work of women artists as seriously as any dealer of the era; he had already shown the work of Käthe Kollwitz and Loren MacIver. Still, it was a gamble to give his first American one-artist show to a relatively unknown woman artist. It was rare to make a sale of modern American art at the time—he priced Louise's work in the $250-to-$500 range—and art dealers took on American artists simply to enhance the dealer's reputations. For Louise, it was a stroke of great good fortune, coming after another recent opportunity. When the fine arts division of the WPA had ended a few months earlier, Louise, unlike most other sculptors whose works were destroyed or melted down for scrap, managed to retrieve hers from the government. Now she immediately began to select, clean, and repaint sculptures for her first solo exhibition.

Shortly after pledging to give Louise a show, Nierendorf went to California, leaving the arrangements to J. B. Neumann, a German colleague and an enthusiastic advocate of modern art, who had run the New Art Circle Gallery since the 1920s. After Louise asked to delay the opening of the hastily arranged exhibit a week, Nierendorf wrote her from Hollywood, explaining that it was impossible because the invitations had already been printed and mailed. After a three-week run, he continued, he would throw a party "to bring interesting people in." He also wrote that he wished

she were with him and regretted she had not written him a letter: "Strange enough, I always expected to hear from you a few words. But why should you? I know it myself how much of an effort it needs to say something in written language what would be so simple to express personally—or even on the phone." He politely asked her approval to return to New York a week later than originally planned because of a visit to John Huston's ranch in the "very beautiful" California desert, along with influential people who he hoped might be able to help him open a West Coast gallery. One night he and Louise had talked by telephone from eleven to nearly one in the morning, a conversation he had enjoyed very much, indeed would never forget, he confided in his letter.

The exhibition opened two weeks later on September 22, a Monday afternoon. It included painted and waxed polychrome plaster pieces—solid, massive, blocky, crude, fanciful, cubistic figures—some of which had already been shown at the ACA Gallery. Many were sophisticated and playful, particularly the ones with animal names and *Eagerness*, which, one critic observed, captured the spirit of a James Thurber caricature. "Miss Nevelson injects, about equally, wit and a feeling of the primitive in her work which is stylized almost to the end of pure abstraction—but not quite," wrote Carlyle Burroughs in the *Herald Tribune*. The exhibition received a great deal of comment in the art press—at least ten reviews and articles by the leading critics in New York newspapers, art magazines, and other periodicals—most of it favorable. The final judgment was that this sculptor's work was well worth watching. News of the exhibition spilled over into the general press in October as Agnes Adams, a reporter for the *New York Post*, interviewed Louise for a personality profile, and Lee Leary noted in her gossip column for the *New York Press* that her friend's show had been "acclaimed." Nierendorf, very pleased by the favorable response, issued a mimeographed statement announcing that the show would be extended a week and giving the date of the promised evening reception to meet the artist.

A year later, in October 1942, he gave her another exhibition, featuring a group of masks as well as drawings and sculptures. Despite the small size of the figurative pieces, constructed of plaster or tattistone and painted white or a monochrome dark tone, they expressed a greater feeling of massiveness than those of the year before; she broke down each figure into simplified masses and reassembled it "with a shrewd eye for tensions in equilibrium, for

rhythmic movement, for angles that provide accents and produce convincing strength," according to *Art Digest*. Again, the exhibition was widely and favorably reviewed and extended a week. *ARTnews* reproduced a running figure and described Nevelson as one of two authentic new personalities to arrive on the mid-fall scene. Soon afterward Nierendorf included her work in a large show of the artists he had exhibited since 1922, to herald the opening of his new and bigger gallery space in the handsome quarters of the Brummer Gallery on East Fifty-seventh Street. Louise's cast stone *Mother and Child* and painted clay *Kneeling Woman* were on display alongside works by Picasso, Dufy, Braque, Mondrian, and other important modern European artists.

But despite the publicity generated by her first show at the Nierendorf Gallery, nothing was sold. Louise reacted intensely; her feelings sank from pure exhilaration to utter depression, intensified by her inflated expectations, extreme emotionalism, and sheer exhaustion after her rushed preparations. In her excitement, she had ignored the limitations of her body. "I don't care how strong the body is. It can't sustain itself under this great enthusiasm," she recognized later. In the late autumn of 1941 she lay in bed for weeks, feeling cold, despondent, and hopeless. She even destroyed a lot of the work the gallery had returned to her—her best sculptures and drawings from the past seven years. When she later described those days, she did so in visual terms; "I saw *darkness* for weeks." At last she unexpectedly visualized one, then more than one crack of light in the gloom. "Then I saw *forms* in the light," and she knew she would recover. She eventually realized that blackness and brightness inevitably gave way to each other, and that, in what became a lifetime pattern varying only in intensity, there would be periods of elation, exuberance, and exertion preceding an exhibition, followed by days of depletion, despair, and, increasingly, drinking. A few months after the end of her first Nierendorf show, she had recovered enough to move to a huge loft at 92 East Tenth Street.

Among her anxieties at this time was her concern about Mike. At nineteen he had abandoned his studies at New York University and landed in the alcoholic ward at Bellevue Hospital. Upon his release, he resolved to go to sea again with the merchant marine. After promising to send his mother an allowance from his seaman's

pay, he urged her to work hard and achieve "a great name in the art world" while he was away. Mail was erratic, and she often did not hear from him for months at a time. In the difficult summer of 1941, as her career remained flat and wartime hostilities intensified in Europe, her anxieties reached a fever pitch. When Mike's ship docked at Norfolk, Virginia, in August and he telephoned her, she demanded that he return to New York at once, revealing that she recently had been hospitalized and was suicidal. After trying to reassure her and promising to send fifty dollars, he reiterated his desire to remain at sea. In an angry letter criticizing her "infantile and hysterical attitude," he wrote, "Your dramatic threat to commit suicide was so phoney and pathetic as the feeble attempts of a ham actor." Within two weeks he had shipped out for Panama, and by October he was writing to her about the snow-capped Peruvian Andes.

When Mike's ship returned to California in November 1941, he visited his father in Hollywood, where Charles operated a men's clothing store, Filmtown Sportswear Company. Apparently Louise had told Charles that the seaman's life seemed to agree with their son, and Charles wrote to her that she "did not overestimate a bit about our Myron." During the next few weeks in Los Angeles, Mike happily started writing a novel, courted starlets, met scenario writers, and looked into jobs as a radio announcer, actor, or writer. Then, early on the morning of Sunday, December 7, the Japanese bombed Pearl Harbor, and the next day the United States entered the war. Louise frantically telegraphed Mike to depart at once for Maine, apparently fearing that the West Coast would be the next target. As air-raid sirens sounded in New York, she fled to Rockland herself. After some resistance from Mike, who believed that the shipyards of Maine were as vulnerable to attack as any targets in California, he arrived in Rockland and took a job in the Snow shipyard. He registered for the draft as a defense worker, declaring his mother as a dependent; his weekly ten-dollar money order to his mother wasn't much, he admitted, but "it is a good portion of my forty-one cents an hour." By the following September, he was sending her fifty dollars a month, and in later years Louise attributed her survival during the war to her son.

In May 1942 Mike had his seaman's papers upgraded to electrician, and the next month he was back at sea, this time as part of a large convoy carrying war supplies to the British Isles. He wrote his mother cryptically in order to pass the wartime censors,

unable to say where he was or when he would return. In late
October he wrote that he would not be home "until the war is
won," and a week later he ominously sent what he described as
his last letter for a while. He advised his mother to stop living
alone and to move to Maine to be near her family; Ben and Lillian
Mildwoff had already moved from Greenwich Village to Rockland,
where Ben worked at the Bath Iron Works and Lillian was a wait-
ress in the Thorndike's dining room until, in 1943, the United States
Coast Guard leased the hotel. But Louise's holiday visits with her
family were usually disappointing ones, and she remained in New
York for the duration of the war. Mike did not believe he would
survive the war, he later revealed, because his ship was trans-
porting soldiers from Scotland to Algeria through mine- and sub-
marine-infested seas during the invasion of North Africa. But when
an English city he had stayed in was bombed immediately after
his ship had departed, and a tanker he had just left was torpedoed,
other seamen began to call him "Lucky Mike."

Manhattan remained relatively calm despite nighttime brown-
outs, air-raid-siren tests, food and fuel rationing, and the presence
of uniformed soldiers in the streets. More New Yorkers than ever
crowded the art galleries, instinctively seeking distraction. A num-
ber of artists joined the war effort as draftsmen, artisans, and
skilled metalworkers: Syd Solomon, for example, was assigned to
a camouflage unit in England for which English sculptor Barbara
Hepworth invented inflatable balloon camps to act as decoys in
the North African desert. Many others were rejected as too old,
physically unfit, or mentally unstable (especially after they showed
their abstract paintings to draft-board psychiatrists). The wartime
mood intensified feelings and broke down barriers among the art-
ists who remained, and they frequently threw parties noted for
their abandon and the abundance of food and drink. Whenever
painter Attilio Salemme sold a painting, he bought liquor and hired
jazz musicians, then invited other artists, including Louise, to his
studio, where they drank and danced all night.

When Louise was in Rockland for Christmas of 1942, she ap-
parently had a brief romance with Thomas McPhail, a family friend
and a Maine state official. "It was lovely of you to give me so much
of the short time you had here, but I shall always remember and
be very grateful for every moment," he wrote to her affectionately
in late January after she had returned to New York, thanking her
for a sketch of himself and adding how much he missed her. During

the holiday visit, he had escorted Louise to lunch with the dark, beautiful Russian wife of Governor Sumner Sewall at the official residence, Blaine House, in the state capital, Augusta. Louise charmed both Ellena Sewall and the handsome, wealthy governor, who, McPhail wrote, "demanded" her telephone number from him. "I told him you were my own especial property, and I didn't want him fooling around you, but it just didn't work, so fearing violence I surrendered. He says he is going to take you to dinner the first time he is in New York." Afterward Louise sent Mrs. Sewall a watch for the Russian relief effort, and she responded warmly; but, not surprisingly, a friendship never developed. The last letter from the office of the governor's wife contained a formal portrait of Maine's first family; Louise remarked scornfully to her son that the governor's wife was a peasant and that artists were the only true aristocrats.

During these years Louise began to work in a more protective, interior way, creating small black assemblages, which strongly anticipated her later work. When she was in a state of depression, she often visualized the color black; she also had a tendency to turn inward to more bearable fantasies than the realities around her. She started to make small boxes at a time when she experienced daylight as intensely painful, with black velvet placed across their openings in such a way that the interiors were either completely hidden or only partially visible. "My intention at the time was to enclose a box within a box and then have a stage curtain of velvet," so the observer "would have to unfold it and look and move around," she explained, and added at another time, "I wanted great enclosure, so I thought of black." There is no record of her ever showing these boxes publicly, perhaps because they represented to her a "a place of great secrecy within myself."

She later described the war years as "the drinking period." It was a time when free liquor was readily available at gallery openings and excessive drinking became commonplace among artists. She began to consume a great deal of alcohol in a small bar on the corner of East Tenth Street as well. This sometimes led to binges lasting a couple of days, and by 1943 her son was writing her to "be a good girl and don't drink too much." When she was younger, she used to take one or two drinks at night to relax enough to fall asleep. Now she began to drink for oblivion during episodes of despair, when she would weep and reveal her doubts about her work. "I don't know if what I do is sculpture," she admitted to a

friend at such a moment. Liquor also helped dull the pain caused by her frustrated ambition and maternal guilt, which she once likened to a chronic toothache or headache, and provided a restful release from the sheer intensity of her creativity. She often said afterward that she could not have survived without it. Despite the hangovers, she regarded her binges as a kind of cleansing, "like needles are going through you, and when you come out of it, it is amazing because you become more sensitive." She attributed the eventual depth of feeling in her work to what she called her "sharp exhaustions," before her recuperative powers began working once again.

By the early 1940s New York had become the center of the surrealistic movement as many of its European adherents settled in the city for the duration of the war. Surrealism had been in the air ever since Julien Levy opened his New York gallery in the early thirties and exhibited the work of Salvador Dali, Max Ernst, and Marcel Duchamp. In 1936 the Museum of Modern Art devoted an exhibition to surrealist as well as Dada art. At first many Americans disliked the ironic, irreverent, and irrational aspects of surrealism; Louise initially found its literary and intellectual allusions alien to her, but in time she appreciated several of its aspects, particularly its theatricality, its emphasis on the unconscious, and its reverence for the rich associations of the found object. The surrealists' celebration of the random and the instinctive affirmed her natural inclinations in that direction and profoundly influenced her work. When she was asked in 1967 if there were any surrealistic tendencies in her sculpture, she acknowledged that "in some way my thinking overlaps in that direction—so I would say yes." She liked Giorgio de Chirico's early paintings, which featured stallions and male nudes as well as long, ominous, lonely shadows; and she enjoyed the displays Dali designed for Bonwit Teller's windows in the late 1930s—"Day (Narcissus)" and "Night (Sleep)"—which were so controversial that at one point the artist and a store employee got into a fist fight and crashed through the glass onto the sidewalk along with a fur-lined bathtub. When Bergdorf Goodman's windows displayed mannequins made from sheet music poised on mirrors suggesting water, she described the frankness of the imagery as a revelation to her.

On a dark gray morning in November 1942, as she walked to the corner of East Tenth Street and Broadway near Wanamaker's

department store, she saw a diminutive old man coming toward her with a decorated shoeshine box under his arm. In the winter gloom, the box seemed to glow with a golden light. She stopped him, exclaimed over the glittery object, which was fancifully decorated with dime-store ornaments, and asked if it was for sale. The man replied that it was not but added that nobody had ever admired it so much, and if she returned to the corner a few days later, he would show her an even more beautiful one. She learned that he was a Sicilian named Joe Milone who lived on Delancey Street in Little Italy; he had been a carpenter until he injured his hand, and now he was working as a shirt presser and reluctantly moonlighting as a bootblack. When Louise saw his even more elaborately bedecked five-piece shoeshine stand—chair, plush-covered stool, polish box, large and small footrests—she realized it was an imaginative throne as well as a natural, naive expression of surrealism.

She asked him if she could take it to a museum, and he agreed, signing a statement that granted her "full charge of managing my jeweled shoe box." She immediately telephoned Dorothy Miller at the Museum of Modern Art and announced she was coming up in a taxi. As she entered the museum with Milone and his creation, she ran into the director, Alfred Barr, and guest curator René d'Harnoncourt, who were leaving for lunch. They stopped and admired the curio, which was encrusted with buttons, beads, bells, billiard balls, brass knobs, costume jewelry, ribbon rosettes, glass doorknobs, bicycle reflectors, upholstery nails, a brass cupid wearing a sarong of imitation pearls, and a pair of china bathing beauties labeled "Far Rockaway, New York." In a burst of enthusiasm, Barr offered to exhibit it in the museum lobby during the Christmas season as a cheerful and charming holiday display during wartime; later he called it "festive as a Christmas tree, jubilant as a circus wagon. It is like a lavish wedding cake, a baroque shrine or a super juke-box."

The museum's president and board chairman, Stephen Clark, however, was neither enchanted nor amused by it; and he was offended by the publicity that was generated after more than a thousand press releases were sent out and a press conference called in the spirit of the surrealists, who advocated the artist as performer. Milone told the assembled reporters that the stand was not for sale, not even for a million dollars, and that no one could get a shine on it, except perhaps President Roosevelt; he looked

alarmed as Barr's secretary complied with photographers' requests to pose on it.

Louise relished all the attention. She explained to the nation's media that this joyous symbol of Milone's humble trade represented "subconscious surrealism," and that now it could be said that surrealist art had finally reached America in its pure stage: "It could only have been created by a man such as Joe Milone, whose simplicity, pureness, and integrity, combined with the sensitive inner feelings of the man's soul and heart, inspired him to build out of nothing, both in mind and in matter, this *superbly elegant* work of art." In her opinion, it surpassed the more calculated and sophisticated works of the celebrated surrealists (who recently had exhibited at the museum): "It is the most beautiful object in the world, and there is not the slightest doubt in my mind of this fact." When articles and photographs appeared in *Time, Newsweek,* and several New York newspapers, they all mentioned the stand as the discovery of New York sculptor Louise Nevelson. It appeared that her admiration was genuine, perhaps in part as an expression of her own discomfort with intellectuals and her instinct for unpremeditated art.

As the Nazi armies invaded Paris, heiress Peggy Guggenheim smuggled her art collection of avant-garde paintings out of France and returned to America. Just married to Max Ernst, she took to wearing one earring designed by Alexander Calder and another by Yves Tanguy as a way of declaring her nonpartisan interest in abstract and surreal art. In New York, she hired Frederick Kiesler to create a modern-art gallery for her from two former second-floor tailor shops on West Fifty-seventh Street. Named Art of This Century, it opened in late October 1942 and featured imaginative display techniques, like indirect and adjustable lighting, undulating and movable walls, an electric eye that activated a Paul Klee carousel, and a device that made paintings swing into view one by one, remain suspended in a spotlight for ten seconds, then disappear. Art critic Henry McBride observed in the *New York Sun* that Kiesler, who was called in "to install these amazing pictures and carvings, has made such a startling job of it that these still questionable works of art, that have been disputed at every turn . . . almost escape the question marks that are usually hurled at them, and seem to tie themselves naturally enough to the 'age of demolition.' 'We, the inheritors of chaos,' says Mr. Kiesler, 'must be the architects of a new unity,' and the mere fact that the pictures

escape criticism suggests that something of his goal has been achieved."

It was Marcel Duchamp's idea to exhibit the work of women artists, Peggy Guggenheim recalled in her memoirs. She responded enthusiastically to the idea, largely out of a sense of insecurity about her marriage. "She liked the idea as a personal statement," according to Jimmy Ernst, Max's son, who worked as her secretary. Misogyny was commonplace and open during those years; one of the reviews of Louise's 1941 Nierendorf exhibition contained the astonishing lines, "We learned the artist is a woman, in time to check our enthusiasm. Had it been otherwise, we might have hailed these sculptural expressions as by surely a great figure among moderns." Georgia O'Keeffe, whose first museum retrospective was about to open at the Art Institute of Chicago, responded to Peggy's invitation to participate by showing up at the gallery and firmly announcing that she was not a "woman painter"—a phrase she considered pejorative, unnecessary, and inferior to simply "artist"—before stalking out. Jimmy Ernst, who knew Louise slightly, had described her work to Peggy in his effort to promote his American friends. The blue-ribbon jury included Peggy, Marcel Duchamp, Max Ernst, André Breton, art historian James Johnson Sweeney, and Museum of Modern Art curator James Thrall Soby. It selected Louise's *Column*, a recent wooden piece, which could be dismantled and reassembled again. She had become interested in variability in sculpture; and some pieces in her second Nierendorf show, a few months earlier, had featured movable parts. Viewers were invited to rearrange these as experiments in space, an acknowledgment of the metaphysical idea of the relativity of perceptions and the surrealist idea of spectator participation.

Most of the artists in "Thirty-One Women" were unknown at the time; some were not even professional artists. They ranged from the highly respected Irene Rice Pereira to Peggy's seventeen-year-old daughter, Pegeen Vail, and included Djuna Barnes, Leonora Carrington, Buffie Johnson, Kay Sage, and Hedda Sterne. There was a prevalence of so-called female subjects (Merand Guevara's entry was a still life of a bowl of eggs) and introspective self-portraits, like Dorothea Tanning's *Birthday*, Leonor Fini's *Self-Portrait*, Frida Kahlo's portrayal of herself in a man's suit and haircut, and the collage self-portrait in a shadow box created by Gypsy Rose Lee, the celebrated stripper. When the exhibition opened in January 1943, the press release defiantly stated that the quality of

the women's work proved that "the creative ability of women is by no means restricted to the decorative vein." But the exhibition tended to be dismissed by the critics, so it was not an unqualified victory for either Guggenheim or the artists. In his *New York Times* review, Edward Alden Jewell wondered if the Nevelson entry was sculpture at all, and another critic, who admitted to being baffled by her recent Nierendorf show, simply noted what he believed were her influences. Henry McBride in the *Sun* was sarcastic and sexist in explaining why women were better surrealists than all the men except Salvador Dali:

> This is logical now that one comes to think of it. Surrealism is about 70 per cent hysterics, 20 per cent literature, 5 per cent good painting and 5 per cent is just saying "boo" to the innocent public. There are, we all know, plenty of men among the New York neurotics, but we also know that there are still more women among them. . . . Hysterics insure a show. They may be laughed at, they may be pitied, but always they arouse attention.

Only a year apart in age, Louise and Peggy began to see each other often because of their mutual friendship with Frederick Kiesler, but they never became close friends. Louise admired the way Peggy had criticized the Metropolitan Museum of Art for containing nothing "living," an attitude Louise found "quite refreshing and a revelation to New York." Peggy, in fact, became the first important patron of the most avant-garde art in America, including the paintings of Jackson Pollock, Mark Rothko, Hans Hofmann, and Robert Motherwell. But although Jimmy Ernst remembered that she was impressed by Louise's work, she did not buy any. And when she held a second show for many of the same women artists two and a half years later, Louise was not in it. Apparently Louise did not bear a grudge, for in the spring of 1946, after Peggy's marriage broke up, she offered to rent her two floors in the house where she was living. The arrangement fell through, and the following year Peggy decided to buy a palace in Venice.

During the early months of 1943, Louise's mother became seriously ill, but because of both the wartime shortage of hospital beds and her chronic hypochondria, no hospital in Rockland was willing to admit her. Finally a doctor took her to Lowell General Hospital in Lowell, Massachusetts, where she died two months

later on March 11 of bronchogenic cancer. As far as anyone in the family could determine, she was sixty-five. A rabbi officiated at a funeral in Lowell; the burial was in a private Berliawsky family cemetery in Rockland, created after a feud broke out between Isaac and other Rockland Jews. The obituary in the *Rockland Courier-Gazette* described Annie Berliawsky's eldest daughter as "one of the country's leading women sculptors."

Annie's final illness came when Louise was preparing fever-ishly for two group and two solo exhibitions. Although she may have gone to the funeral service in Lowell, it's unlikely that she went to Maine for the burial, particularly since she later claimed never to have visited her mother's grave. Family members have different recollections about which, if any, memorial service she attended.

Any period of mourning for the person she would always de-scribe as her favorite parent was cut short by her frenetic prepa-rations for her shows. In the years to come she never even acknowledged grief at the loss of her mother, claiming that she actually had been *pleased* that her mother's suffering had ended. It is evident, however, that her anguish went underground and found avenues of expression through her work. She did some of her most innovative sculpture as her mother lay dying, as if she were seeking a new source of comfort. One of the pieces included a tall weeping figure, painted white, with broken-mirror tears, wearing a crown created from a piece of gold-leafed furniture. This was also the time when she used black velvet for sculptures she considered too private to exhibit. She always explained that it had never been her role—or one that her mother would have wanted for her—to be diverted from her life's work by the illness and death of even the person she idealized as "the most beautiful woman on earth." Her mother had freed her many times before to live vicar-iously for her, and Louise's successes were very important to her; once when Ben Mildwoff read her a negative review of Louise's work, she was surprised and hurt until he pointed out to her that to be recognized at all was praise of a sort.

Annie died three days after the opening of an inaugural ex-hibition at the Norlyst Gallery which included Louise's lumber *Napoleon*. The Norlyst had been opened in a rundown loft on West Fifty-sixth Street by Jimmy Ernst and his girlfriend, Elenore Lust, whose mother Louise had befriended at the Art Students League. They had come upon thousands of nineteenth-century circus and

Parisian music-hall posters, including Toulouse-Lautrec lithographs and twentieth-century Ringling Brothers depictions of exotic beasts, carousels, harlequins, human cannonballs, and various kinds of acrobats. Meanwhile, Louise was carving and crafting little wooden acrobats, one standing on top of another, and painting them bright colors. Her fascination with the circus had grown naturally out of the artistic milieu around her. Surrealists commonly used the circus as a metaphor for mankind, and circus themes appeared frequently in the works of Paul Klee, Alexander Calder, Chaim Gross, and Louis Schanker, who once worked for Barnum & Bailey. In the winter of 1942–43, Jimmy and Elenore visited Louise's East Tenth Street loft and saw her circus creatures crafted from elements found in junk shops—a plaster clown's head and tin signs in the shapes of a saw, a key, eyeglasses, and scissors. In her early use of lace, bureau handles, whisky glasses, tacks, hooks, metal tools, scraps of wood, and other odds and ends, she revealed a collector's instinct, an exuberant sense of humor, and an immense sensitivity for secondhand objects, inspired perhaps by the fantastical Joe Milone shoebox. Jimmy, raised among avant-garde artists in Europe, at once recognized these fabrications as exciting and genuine. When he and Elenore decided to exhibit them along with the posters in April 1943, Louise, in a burst of creativity, made about thirty additional pieces.

She later said that she used discarded pieces of wood and other materials for her sculpture during the war because they were free and abundantly available. But working with junk and scraps also satisfied her need to work rapidly, intuitively, and prolifically. In time she realized that her imaginative transformations of found or lost objects gave expression to her old childhood feeling about "the injustices of relationships" between the Yankees and the immigrants in Rockland: "And I suppose I transferred that awareness to material" and began to see "almost anything on the street as art." She also liked to remind observers that the Bible prophesied that the meek would inherit the earth.

She selected refuse for its appearance rather than its former function: "I'd be defeated right away if I had to remember that this is a leg from a chair." One of her first finds was a long, narrow wooden box, measuring about six feet by six inches. "The box at that time was a promise to me. It led me to try the unusual." Before long she had filled it with slender slivers of wood and displayed it in her studio with its hinged door ajar. Similarly, she created *Exotic*

Landscape, dated 1942–45, by filling a carpenter's tool box with wooden elements.

Besides rounding up raw materials from sidewalks and gutters, Louise cajoled bits and pieces from woodworkers in carpentry shops, a nearby lumberyard, and a high-quality furniture factory: "After a while they were giving her everything they had and saving it for her," according to artist Sidney Geist. She even talked city policemen out of confiscating a wooden horse she was dragging home by offering to share a quart of whisky with them. The red-headed Irish janitor in the building next door showed her what a "wedgie" was, helped her hammer and nail when "he saw I didn't know too much about these things," and fascinated her by keeping nesting pigeons in the interior squares of wooden liquor boxes stacked from the floor to ceiling in his rooftop apartment.

Karl Nierendorf disliked Louise's latest sculptures, even though they had antecedents in Picasso's constructions of wooden odds and ends, and described them as "refugees from a lumberyard." When Louise heard this, she stormed over to his gallery and confronted him, fiercely, humorously, and insultingly in turn, as she created what Jimmy Ernst, who happened to be present, described as "a marvelous scene." She accused Nierendorf of preferring her drawings to her sculpture and calling her more interesting than her work. She was, however, obviously insecure about her new work, for she went on to demand that he exhibit her drawings as a way to counterbalance her Norlyst show. After protesting, he finally agreed to show some of her pen and pencil sketches and four or five small sculptures in late April.

The Norlyst show, which opened in April 1943, was, in Jimmy Ernst's opinion, "decidedly a happening." The floor was covered with sand and glass marbles to simulate circus sawdust and was extremely difficult to walk on. Recorded band music played continuously. Some of Louise's sculptures made noises; others had light-bulb eyes that lit up. A *Ferocious Bull,* composed of a bedstead and a chair back, had a moving head and tail; upside-down chair legs represented seals; and a metal tool evoked a tightrope walker. In line with the surrealist ethos, visitors were encouraged to pull the "animals" on furniture casters around the gallery and to arrange other pieces of wood any way they wished. The title of the show, "The Clown as the Center of His World," evoked both the metaphysical idea that the world is a projection of the self and Martha Graham's dance title *Every Soul Is a Circus.* Elenore later

claimed that she came up with the name and the clown represented everyman; Louise, for her part, referred to the clown figure in both the masculine and the feminine gender. She gave fanciful names to her other figures, created for the most part from roughly cut boards and crudely nailed together: *Riders of the Temple of Life; Longest Dog in Captivity; He Walks, He Talks, He's Almost Human.* A grouping of four figures entitled *The Crowd Outside* included the *Lonely Child* and *Forsaken Man*—pursuing the theme of isolation often depicted by the surrealists.

The Norlyst press release made a point of the educational as well as the aesthetic rationale of Nevelson's work, probably bearing in mind the Museum of Modern Art's "Arts in Therapy" competition the previous month. The nationwide competition for artists had been intended to demonstrate the ways in which injured soldiers could make use of crafts in rehabilitation therapy and mental patients could be helped through artistic expression. Louise had submitted a child's wooden seat, which resembled a horse, and the museum's jury selected it as one of fifteen to win a ten-dollar fifth prize. Afterward she mentioned to a friend, who was an art teacher, how abstract wooden toys, which could be taken apart and reassembled in a number of ways, could be instructional for children. This became an abiding interest of hers; and a decade later, in an effort to make money, she unsuccessfully attempted to get manufacturers to produce them and Macy's department store to sell them as educational toys.

Edward Alden Jewell described the Norlyst Gallery floor as "strewn with a strange conglomeration of 'sculptural' forms" or "queer contraptions" which marked "the onset of the 'Silly Season.'" Unknown to Jimmy or Elenore, Louise or someone else apparently protested this, because five days later he re-reviewed the show and to some extent reversed himself. Maude Riley, the reviewer for *Art Digest*, observed that Nevelson was up to "pranks" but "always she offers something fresh, very sincere, often humorous, and always basically good." Other critics were fascinated or amused by the deceptively awkward, offhand, insouciant assemblages, but they were unsure of whether or not to take them seriously and stopped short of calling them art. It was not until several decades later that Dorothy Miller took the show seriously by calling it an early expression of Pop art. As Louise had anticipated, most people at the time considered the drawings at the Nierendorf Gallery her more important work.

Nothing was sold from the Norlyst exhibition, and after the sculpture was returned to her, she fell into a depression. This time she was undoubtedly also experiencing a delayed reaction to her mother's death. Without the money to store her work, she saved a few elements she thought she might use again and then, with the help of Mike, who was temporarily back from the war zone, she hauled the rest to the yard behind her building, smashed it apart, and burned it, along with about two hundred paintings that had been torn from their stretchers. "It was like a psychic operation to take these things apart, and I banged my head physically against the wall and lay down on the floor and decided never to get up until something came, some revelation to myself. . . . It was one day, two days. Finally I did get up and started again. So that tells you the story of the joy I had from that exhibition." After a year and a half of working in wood, she despairingly gave her wood-working tools to her son. The following autumn, Nierendorf exhibited fourteen of her remaining oil portraits, most of which had been painted during the 1930s and saved by being in the possession of their subjects. It would be many years before she publicly showed such daring sculpture again.

Mike took a job on an ore boat in the Great Lakes, where, he reassured his mother, there were no submarines. After setting up a joint bank account for the two of them, he wrote her a stern letter, instructing her to withdraw money only for rent and food, not for entertainment, art materials, or expenses relating to exhibitions. When the war was over, he wanted to use any remaining funds in the account for his education, he explained.

> My money earned from 1941 to date I consider blood money. I earned it at great personal hardship and risk. I tell you these things because I consider you a Bohemian. . . . I have great respect for the bohemians [and] the lumpen proletariat. . . . But I only feel akin to them when I share their pleasures. There is nothing Bohemian in the sweating away of one's life in . . . the engine rooms in the bowels of ships. The heat, the noise, and the moving steel make one very consciously a materialist.

When Mike was home on leave, Louise, perhaps to assuage her guilt, took time off from her work to cook for him and drink beer with him in her favorite bar, on Tenth Street; but one day, she told her friend Dorothy Dehner, he looked so cocky that she

knocked him down, probably after she had been drinking. In October, Mike was admitted to a Detroit hospital for a liver inflammation, an illness he blamed on his nerves. He told his mother not to visit him because she was too "high strung and frantic"; she sent him a pair of slippers instead.

After being discharged as unfit for duty, Mike went to California to recuperate and recruit for the National Maritime Union. He visited his father in Los Angeles and met his father's new wife, Mae, whom he found extremely charming. Charles was uncomfortable, perhaps fearing that Mike and Mae had hit it off too well, and after only one night in their apartment he sent his son to a hotel. Soon afterward Mike left for a union hall near San Pedro. When Louise questioned this, Charles explained that Mike had remained in their apartment eating home-cooked meals for a few days until he looked better. After that, the young man had little time for them except for a "grand" Sunday dinner, when he was in "a joyful mood" about his upcoming voyage to the South Pacific.

At sea again on his twenty-second birthday, Mike wrote his mother in the ten-minute intervals between blackouts descriptions of India, where he had a cobra tattooed on his arm, but made no mention of the fact that his freighter, carrying thousands of tons of bombs and small arms ammunition, had been mistakenly fired on by a British ship in the Bay of Bengal. In Egypt a few months later, he wrote that he had remained too long in a "timeless blue void"; disillusioned with the life of a seaman, he admitted that now a steak and a bottle of wine were far more appealing to him than seeing the world.

Mike returned to New York in the spring of 1945 to find the painter Ralph Rosenborg spending a great deal of time in his mother's company. The affair, which became one of the longest lasting and most emotionally charged of Louise's life, began during the war. Ralph, who was born in Brooklyn, was fourteen years younger than Louise, ruggedly handsome with a strong chin, a puckish smile, a shock of curly hair, and a passionate artistic nature. Close to his widowed mother, he was also boyish, dependent, and in Mike's eyes, a son substitute for Louise, who used to tell him unconvincingly that Ralph was merely a friend. Despite his heavy drinking, Rosenborg had a disciplined commitment to his art, and his small abstract oils and watercolors had led to his acceptance by the Ten and the American Abstract Artists. He had his first one-

man show in 1934, and by the early 1940s the Willard Gallery was exhibiting his work. At the time he became intimate with Louise, he was creating the paintings that later were considered among his finest work.

As she had been with Mondrian, Louise was impressed by his tidy studio and his orderly, perfectionist habits, like carefully placing his paints on wheeled medical tables and putting his brushes and sheets of paper in precise order. The two used to talk about starting an art school as a way of surviving as artists, and although their plans never materialized, they often hired models and held sketch classes for themselves and their friends. Ralph taught Louise a number of practical skills as they undertook such projects as framing her Eilshemius paintings. She respected his knowledge of paint chemistry and his theories about the unifying power of similar color harmonies; at one time Mike observed that Louise's portraits and Ralph's paintings contained a number of common characteristics, particularly after Ralph applied a brown glaze to them.

The two spent a great deal of time together while she was preparing for another exhibition at the Nierendorf Gallery in October 1944. This time, stung by the reactions to her rough-wood constructions in the Norlyst show, she spent hours sanding, smoothing, and polishing pieces of wood—curved furniture legs, newel posts, cornices, a baluster, bedposts, a duck decoy, a hatter's block, a chair rail, and a tenpin—many of which were already machine-finished. Thanks to Ralph, a number of refined woodworking techniques, like the use of dowels and recessed nails, appeared in her work for the first time. Many of the found-wood elements were displayed on horizontal planes, like surrealist dreamscapes. But most of the reviews were again disappointing. Her work reminded Jon Stroup in *Art Digest* of children's blockbuilding efforts and even more of sculptor Alberto Giacometti's *The Palace at 4 A.M.*, a 1932–33 surrealist piece resembling a diminutive environment, but without the former's naïveté and the latter's sophistication.

After more than a decade of living precariously in studios and lofts, Louise decided that she must have a permanent home to give her stability. A summer visit to Maine five months after her mother's death had intensified her loneliness and dissatisfaction; the loss of her mother's comforting presence in her life made the need

for the emotional security of a house even greater. It was Mike, to whom it was evident that his mother should not live alone, who suggested she ask Nate, who was a bachelor, and Anita, who was divorced, to live with her in New York. He himself had no intention of settling in the city. The idea was discussed, and around Christmas of 1944 Nate told Louise to look for a building. Ralph, whose studio was on the corner of East Thirtieth Street and Lexington Avenue in an Irish "lace-curtain" neighborhood, immediately noticed a For Sale sign on a rundown, seventy-year-old brownstone on Thirtieth near Second Avenue. The house was narrow, deep, and dark; but its four floors contained seven marble fireplaces, there was a full basement and a large backyard, and the double parlor had elegant parquet floors, elaborate moldings, and floor-to-ceiling windows. The price was apparently reasonable; it was just before postwar housing shortages began to drive up real-estate prices. Louise was impatient, perhaps worried that her brother might change his mind, so an offer was made, and the sale became final in March 1945.

Money for the down payment and renovations was put up by just about everyone in her family as well as a number of friends. Karl Nierendorf loaned her a thousand dollars, although he was actually struggling himself, and also helped her sell paintings from her Eilshemius collection, which recently had become valuable. Ralph carried out many of the extensive repairs the house needed. Nate and other members of the family insisted, however, that title to the property be placed in Anita's name—which she had recently had legally changed, along with her son's, from Goldfarb to Berliawsky—because of what they perceived as Louise's impractical artistic nature; they were concerned that she would be unable to hold on to the house—a judgment that proved to be not unreasonable. Anita also felt that she deserved the property. As assistant manager of the Thorndike Hotel, she had kept her hard-earned money in a joint account with her brother's, and it was from this that she and Nate would pay the house's mortgage payments, taxes, water and utility bills.

The decision offended Louise and further exacerbated the sisters' difficult and complicated relationship. While Anita was drawn to Louise and ready to help her, she often felt overshadowed, even abused, by her elder sister. In old age she became bitter, declaring, "I was the smart one, but I ended up the dumb one." In the years to come, whenever Anita moved into the Thirtieth Street house or

arrived for an extended visit, Louise invariably made her feel un-welcome. Anita would begin to drink and weep about what she continued to call "my house," while Louise remained silent. At one point Anita had an outburst in the Thorndike dining room: "I want to go to New York, but I'll have to stay in a hotel. Nobody has room for me. Nobody will make room for me. I can't even stay in my own house . . . my *own* house. *She* didn't work for it. *I* worked for that house, and it is mine." Anita's son, George, did not have a key to the house, and on one occasion he broke the front door's beveled French glass and let himself in. When Louise returned and ordered him out, he angrily replied that it was his mother's house and threatened to throw *her* out.

The family decided that the top two floors would be rented, and Louise would live on the rental income. Louise wanted the backyard, basement, and ground floor for her storage, studio, and living space, the parlor floor for entertaining and displaying her art work. She created a couch for the parlor by covering a bed with a carpet, then bought three identical sets of garden furniture to unify the rooms visually, which gave the house a strange, cool atmosphere. She decided to sleep in a small, bare ground-floor room separated from the kitchen by a black curtain. She put her sculptures on the parlor mantelpiece and floor, hung her oil por-traits and remaining Eilshemius paintings, and arranged a group of African carvings against the exposed brick walls.

As she had hoped, she felt more settled now. Her restlessness was eased by being able to see the East River from the steep front stoop and by her discovery that she could work eight months a year on a large stone slab in the backyard, from which she could see both the Empire State Building and Grand Central Station. In the next few years, the amount of work she produced increased greatly. One room of the house was used to store old wood, another for painting, a third for assembling sculpture. She wasted no time on domestic chores; if there was nothing to eat in the house, "she would drink whisky and eat onions," Marjorie Eaton recalled, or go to the Italian bar and restaurant a few doors away. Sometimes she served visitors cold soup from a can, or if she was in the mood, cooked a Russian peasant meal with garlic, onions, sausages, and red cabbage or a leg of lamb. She particularly relished black bread, caviar, sour cream, sardines, clams, cream puffs, and Bulgarian feta cheese. "I've never been fat, but I have a great appetite," she boasted.

In the backyard she let her imagination loose. Over the next decade she splashed orange, blue, white, and pink paint on the flagstone stepping stones, as if to represent flowers, and stuck rows of sharp-edged sculptor's tools, including files and calipers, along with egg beaters, spatulas, and cheap wooden spoons, some of which she painted black, into the soil. In a corner she called "the farm," there was a red barnlike structure to which she nailed sections of driftwood and other old wood. In front of it she put up a white fence with wide pickets. In another part of the yard she placed large wooden blocks in careful sculptural relationship to one another. Most intriguing of all, she put mirrors face-up on the ground to reflect the sky, creating surprising rays of reflected light emanating from the earth. She explained that what interested her about nature was the way the human mind translated and transformed it. The reverence she had felt in her youth for Maine's rocks, pines, and sea had been fundamentally altered by her original and increasingly radical perceptions as an artist.

As always, she found more sustained and dependable psychic rewards from work than from love, and her relationship with Ralph gradually changed. "Having an affair is like a lovely meal—it's delightful—but creation is something else that fascinates me to this day," she explained in 1982. On another occasion she said, "I've had moments in bed so beautiful the world could have stopped right there. But then you get up. You go on." Her *Lovers II* of 1946, a cubistic rendition of one-eyed male and female figures, depicts the lovers looking out into the distance instead of at each other, while their entwined bodies form one mass. A relationship that demanded subservience was impossible for her, and even one with relatively equal give-and-take she found difficult. She admitted in later years that she was unable to handle a relationship in which "all barriers [were] down," suggesting an incapacity for real intimacy. Certainly Ernest Bloch had felt frustrated by her "impassive indifference" in 1933 when he unsuccessfully attempted to arouse genuine feeling in her. She openly admitted that she felt stronger than most men, although she usually chose younger men or those she could easily dominate, and declared that she had never met a man so great that she was tempted to renounce her interests in favor of his. She had, of course, deliberately declined to meet Pablo Picasso, the one man whose talent completely awed her.

Although most men continued to find Louise extremely attractive and to enjoy her amiability and openness, her ambition

and lustiness and, as one man put it, "aura of interesting inner violence" prevented many of them from becoming seriously involved with her. "Like all women artists, she was pretty much of an egotist, and I don't think men like that very much," observed another female sculptor. One summer in the late 1940s, Sidney Geist, a friend of Mike's, arranged to meet Louise at the bar of the Thorndike Hotel. He never forgot the sight of her in a black sleeveless dress, tanned and looking much younger than her age: "We talked very excitedly, and she was very fresh, vulnerable." But he recognized that if someone fell in love with her, he would be "smothered"; "she was so physical and had this gusto. She would burn you up." Another male friend compared her to a tiger with invisible claws who could easily devour a man.

Not surprisingly, Louise's love affair with Ralph was a tempestuous one. Charming when sober, Ralph was unpredictable when drunk. "Every time I see you with Ralph I think to myself that here goes Louise, off on another wild goose chase with that *goose*," Mike told his mother. Among the couple's various stresses seemed to be a conflict between her desire for society and his for seclusion. Ralph did not seem to be living up to his early promise as a painter; he rarely exhibited twice at the same art gallery, in part because of his distrust of dealers, and he had no gallery representation from 1947 to 1952. Louise finally broke off the relationship. Although members of her family have said that Ralph Rosenborg was the only man she ever really loved, it is debatable. Afterward they remained friendly, despite Ralph's initial bitterness at the breakup, his romantic involvement with her sister Anita, and his eventual marriage in 1951. When he needed money, his wife, Margaret, would call on Louise with a painting to sell, and over the next few decades Louise acquired a great many Rosenborgs at extremely modest prices. For the rest of her life, she loyally attended his openings and referred to him as one of the great twentieth-century painters, "a sort of modern Turner, a real painter's painter who is a master of the lyrical approach to landscape."

In February 1946, for the first time, a Nevelson sculpture, *Young Bird*, was included in the prestigious exhibition of new art presented every year by the Whitney Museum of American Art. In a strong sculpture section it was singled out for praise by at least one art critic, along with Isamu Noguchi's sculptural abstractions. Two months later an exhibition of her work in various media—

particularly drawings and bronzes—opened at the Nierendorf Gallery. Around that time she apparently sold a running figure, *Position*, originally sculpted in 1939 and recently cast in bronze, for $175. In May, immediately after her show closed, Karl Nierendorf returned to Europe for the first time since leaving Germany eight years earlier. His assistant Hilde Prytek was put in charge of the gallery. Nierendorf expected to be away for only a short time; he had become an American citizen and used to remark that he preferred life in New York to his old existence in Berlin. But through Nate Berliawsky's friendship with a former governor of Maine, now a U.S. official in occupied Germany, he became involved in helping the American military government restore works of art to their rightful owners. He was still in Europe the following autumn when, after a long silence, he wrote Louise from Switzerland, asking for repayment of his thousand-dollar loan by the end of December. She rounded up the money and repaid the debt.

While her dealer was abroad indefinitely, Louise's father died suddenly on October 10, 1946, of acute congestive heart failure at what was assumed to be the age of seventy-five. The *Rockland Courier-Gazette* reported the death in a front-page news story, and the obituary described the old man who had lived there for more than four decades as "one of Rockland's best known Jewish residents." By then he was said to be among the town's largest taxpayers; his considerable real-estate holdings recently had begun to increase in value. In later years Louise proudly referred to her father's properties as his "empire" and compared them to her own aesthetic domain, for which he used to bring her old furniture parts and other debris from Maine. After his wife's death he had lived with a woman called Daisy, to whom he gave most of the family silverware. He died without a will, and although his son was named administrator of the $3,500 in cash and the properties he left, it fell to the more aggressive Louise to go to Daisy's house after the funeral and retrieve the valuables.

The relationship between Louise and her son remained an intense one. On New Year's Day, 1944, Mike, still at sea, wrote his mother a long, reflective letter revealing his desire for closeness with her in flirtatious and intimate language. "We are both growing older, darling, but rather gracefully," he wrote. He bought his mother jewelry and told her about his sexual and drinking adventures, adding that "so far I haven't found anyone beside you whom I cared letting in." After he left the merchant marine, he returned

to New York, despite his earlier protestations, and moved in with his mother. Before long he was joined by a young painter, Susan Wilson, a tall, slender blonde; within a year they had married and had a daughter, Neith, named by Ibram Lassaw for an Egyptian goddess. Louise observed that she had not been prepared to be a mother at the age of twenty-two and was certainly not ready to be a grandmother at forty-seven. Mike later said that he had been trying to create a buffer between himself and his mother; the marriage lasted only three years.

While Mike was at sea, he had made small carvings to give to prostitutes. When he returned to New York, Louise offered him a place for a workbench at the Thirtieth Street house, and before long he was exhibiting his sculpture at the Roko Gallery. He helped his mother with her work in a number of ways, sometimes carving her name—their shared name—into her wooden sculptures. After he left the house at the end of the day, however, Louise was apt to clean his tools and clear his workbench, and sometimes even work on his sculptures herself, a liberty that deeply affronted him as "a male with my own personality. She must have regarded my work as an extension of herself because she regarded me as an extension of herself."

Sidney Geist, who first met Mike in 1946, recalled his extreme hostility toward Louise: "Just to mention his mother, and he mentioned her all the time, got him into an angry state. He always carried this pain centered on her." Then, in what must have seemed to Louise the third abandonment by an important male in her life within a year, after the departure of Nierendorf and the death of her father, he decided to move to Rockland in June 1947, to try to find a way to support his wife and child while continuing to sculpt. He later revealed that he had also moved in the hope that a more wholesome way of life would bring him more emotional stability after the traumas he had suffered during the war. Nate obligingly placed his nephew on the Thorndike Hotel payroll. Ever loyal, while traveling from Florida back to Maine he stopped in New York to see Louise, probably attuned to his sister's particularly strong need for him at that time.

While Nierendorf was abroad, Louise began to paint again. Among the oil paintings she did in 1946 were portraits of children, one of which, *Untitled,* is of a child, three cats, and a female figure that strongly resembles herself. She also painted a fine *Self Portrait*

with riveting dark eyes, large nose, and clawlike hand. She continued to participate in large group shows, like the Whitney annual in the spring of 1947, which included seventy-six other sculptors. At last, after remaining in Europe for a year and a half, Nierendorf returned in September 1947 with a large collection of Paul Klees he had discovered in Switzerland. Louise, who had been impatiently awaiting his return, immediately made an appointment to show him her latest work and discuss her next show. The night before their scheduled meeting in October, a friend telephoned her to say that Nierendorf, who had had a heart condition for years, had suddenly died. All night long Louise refused to believe the terrible truth, until she read the obituary in the morning newspaper.

For six years Karl Nierendorf had encouraged her, taking her work seriously and persuading leading art critics and others to do the same. Sculptor David Smith, a friend of Ralph Rosenborg's, had first become aware of her work after his wife, Dorothy Dehner, urged him to see one of Louise's Nierendorf shows. "He came back and said, 'She's the best woman sculptor in America,'" Dorothy recalled. Even though Louise was usually disappointed by the tepid, uncomprehending reception of her exhibitions, such reactions were not unusual at the time. It was rare for an American artist, particularly a sculptor, to be represented by a gallery in the 1940s, and Louise would proudly boast afterward that she had been the only American whom the German art dealer had shown with any regularity. She always gave Nierendorf the utmost praise, stressing that he had never refused any of her requests, and remembered him fondly as her "spiritual godfather," who had told her that she possessed the personal qualities of an artist like Picasso and therefore, he predicted, would achieve her highest artistic ambitions.

The line between Nierendorf's personal and professional favors to Louise remained unclear after his death when many German expressionist and Italian futurist paintings from his collection were discovered to be hanging on the walls of her house. He died without a will, and his assistant claimed that the paintings belonged to his huge estate of more than seven hundred works of art. Louise was equally certain that he had given them to her personally (he had always bought her new clothes for her gallery openings), although she had no proof of it. No one understood why he would have given Louise the valuable paintings, but it was apparently typical of him

to loan or give away works of art impulsively without receipts. Louise's lover at the time, Bernard Colefran, who had been an American Army officer in Germany, suggested suing; but nothing was done, and eventualy Hilde Prytek took away the paintings. Nierendorf's entire collection, which surprisingly contained no Nevelson works, was bought several months later by the Guggenheim Museum for a little less than the amount of the dealer's personal debt of eighty thousand dollars.

Lady Lou

*[Art] is a Universal love affair for me
and I'm in love with Art.*

—LOUISE NEVELSON

MANY PROMINENT émigré artists returned to Europe after World
War II, and American artists began to feel free from their influ-
ences. After championing Jackson Pollock in 1948, art critic Clem-
ent Greenberg went on to declare the artistic independence of
America. What came to be known as the New York School emerged
as the paintings of Pollock, Rothko, Hofmann, Willem de Kooning,
Arshile Gorky, Adolph Gottlieb, Ad Reinhardt, and Robert Moth-
erwell were selected by Greenberg and art historian Meyer Shapiro
to be exhibited together at the Samuel Kootz Gallery. *Life* maga-
zine gave national publicity to this provocative new form of paint-
ing, made up of "action" and "color field" styles, which became
widely known as abstract expressionism. Some of the artists who
formerly had gathered at the Waldorf Cafeteria in Greenwich Vil-
lage established a small cooperative school of abstract art, which
in turn led to the formation of the Artists' Club, a group of the
dominant abstract expressionists. In the early years the club was

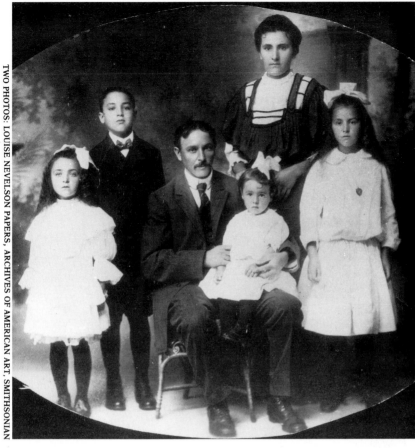

The Berliawskys—Anita, Nathan, Isaac, Lillian (in lap), Minna, and Louise—around 1907

Isaac Berliawsky around 1903–1904

Minna or "Annie" Berliawsky

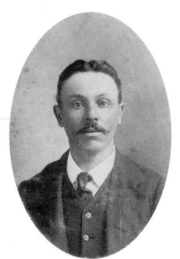

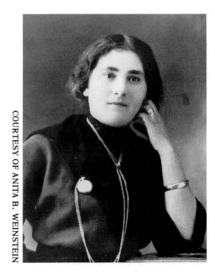

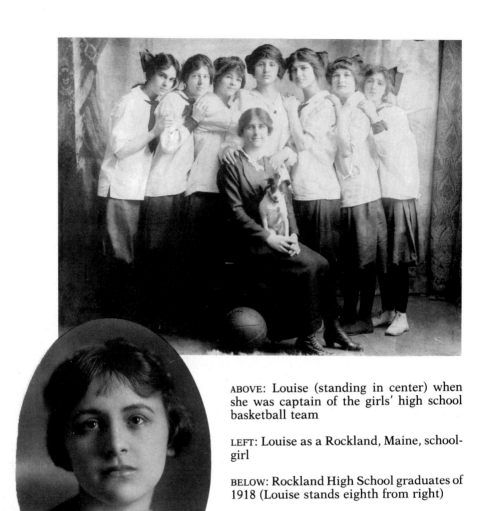

ABOVE: Louise (standing in center) when she was captain of the girls' high school basketball team

LEFT: Louise as a Rockland, Maine, schoolgirl

BELOW: Rockland High School graduates of 1918 (Louise stands eighth from right)

OPPOSITE: Mrs. Charles S. Nevelson around 1922

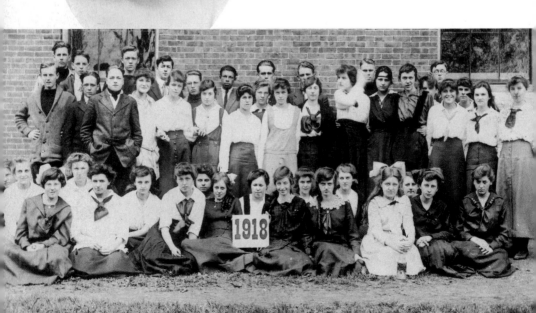

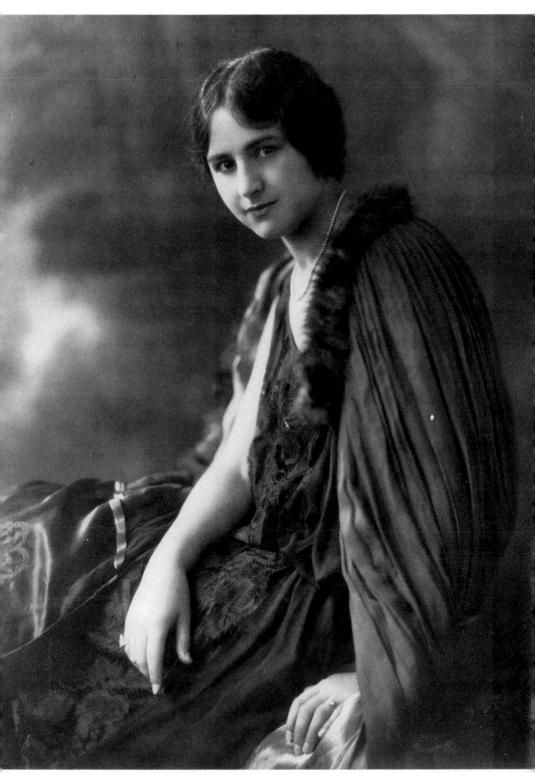

LOTTE JACOBI

LEFT: Louise at forty-four

LEFT BELOW: Anita

BELOW: Nate Berliawsky in 1948

BOTTOM: Lillian in the 1930s

THE *ROCKLAND COURIER-GAZETTE*
COURTESY OF LILLIAN M. BERLIAWSKY

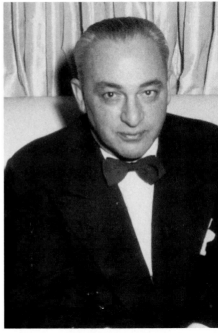

LN PAPERS, ARCHIVES OF
AMERICAN ART, SMITHSONIAN

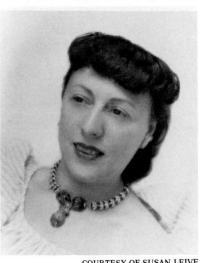

COURTESY OF SUSAN LEIVE

BELOW: Myron Nevelson at age
one-and-a-half

BOTTOM: Mike Nevelson as a
teenager

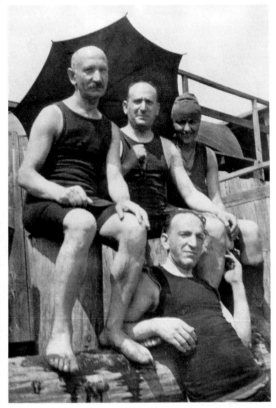

FOUR PHOTOS: LN PAPERS,
ARCHIVES OF AMERICAN ART, SMITHSONIAN

ABOVE: Louise with (left to right)
Bernard, Charles, and Harry Nevelson

BELOW: Charles Nevelson

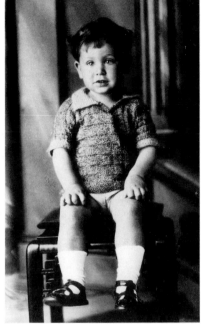

LOTTE JACOBI

LEFT: Karl Nierendorf

LEFT BELOW: Colette Roberts

BELOW: Teddy Haseltine

NEVELSON ARCHIVES
WILLIAM A. FARNSWORTH
LIBRARY AND ART MUSEUM

COURTESY OF RICHARD ROBERTS

OPPOSITE: Louise and her boyfriend Johnny in 1954

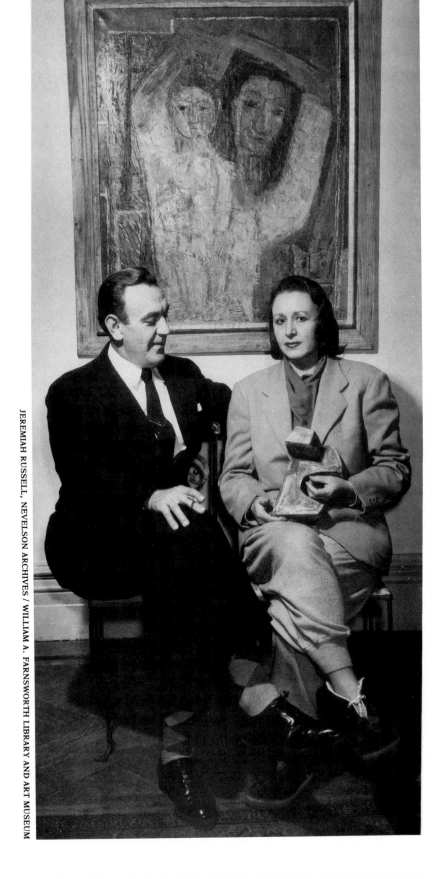

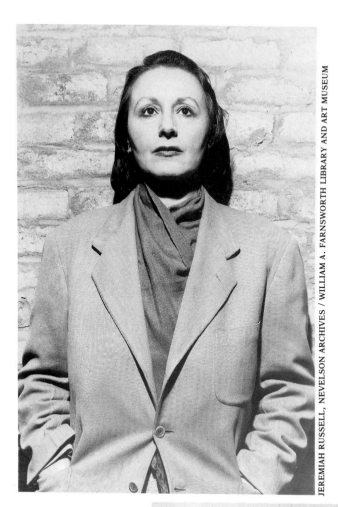

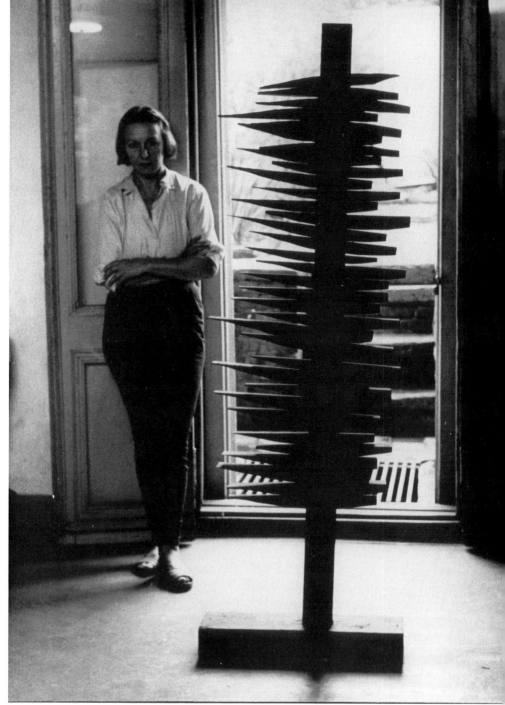

With back section of the sculpture *First Personage,* 1956

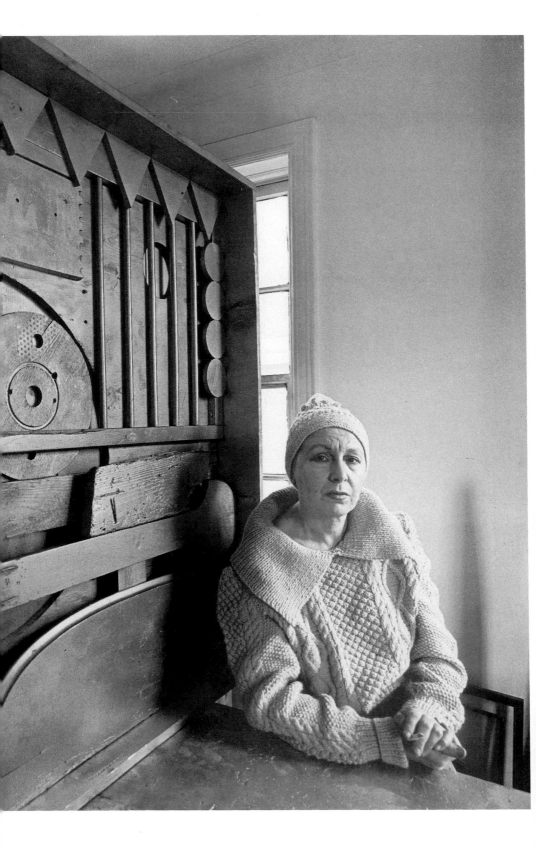

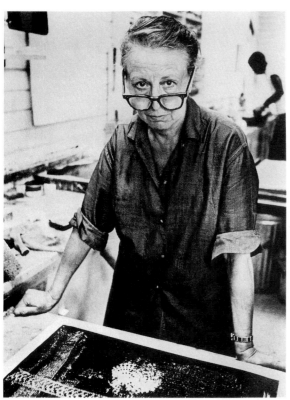

At Tamarind in 1963

With a gold piece in her Spring Street studio, December 1960

LEFT: Louise at fifty-five

RIGHT: Louise's *Self-Portrait* of 1946, oil on canvas (42½″ x 30″)

LEFT BOTTOM: One of Louise's 1932 pencil drawings on paper, *Untitled* (13¼″ x 14″)

BELOW: The parlor of Louise's house at 323 East 30th Street

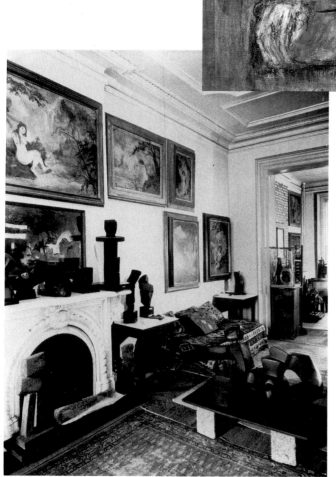

Louise's bedroom, 1972, with one of Mike's sculptures, lower left

Posing with "Dream House" sculptures in 1977

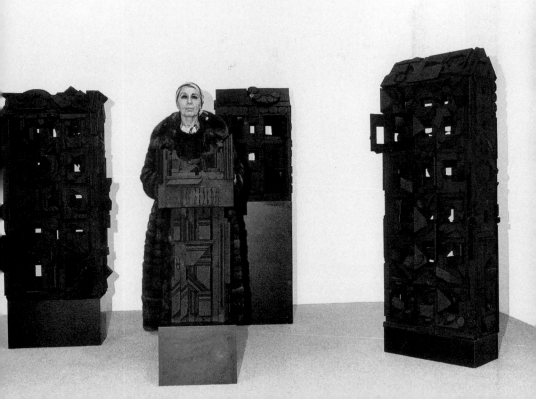

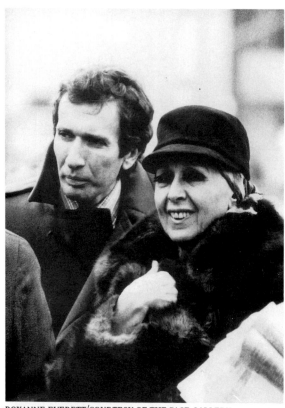

With Arnold Glimcher at a sculpture installation, New York City, 1972

Joking with Merce Cunningham and John Cage

With (left to right) Neith's daughter Issa, Elsbeth, and Neith at the opening of her 1980 Whitney retrospective

Louise and Diana MacKown in 1973

Posing with metal sculpture at Lippincott at the age of eighty

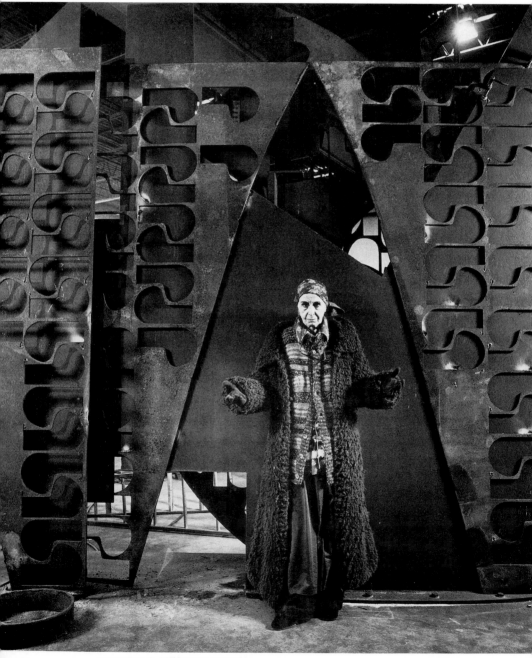

exclusively male, and attendance was strictly limited to members and their guests. Only a few favored female artists—Mercedes Matter, Perle Fine, and Elaine de Kooning—were encouraged to participate in the club's Friday-evening panel discussions. In this male-oriented milieu, painter Grace Hartigan temporarily changed her name to "George" in an attempt to be taken more seriously. "Male artists in America treated us like dogs," artist Lily Ente recalled. De Kooning asked Mike Nevelson to join the club (Mike declined because he was living in Maine), but Louise was not invited, although she was occasionally among the guests who crowded into the meetings in an East Eighth Street loft. Afterward, a number of artists would drift to the Cedar Tavern on University Place near Eighth Street, a noisy, rough saloon, which few women dared to enter alone. Despite Louise's social aggressiveness, she was seen only infrequently inside the Cedar Tavern. Occasionally she entered with one of the male Russian-Jewish artists to whom she felt temperamentally akin, and at such times, she remembered, she used to sing for the men. She maintained a good-natured rapport with this group, even though most of them regarded her as an outsider and dismissed her work.

A prominent member of the so-called Russian mafia was Mark Rothko. Louise, who used to lunch with him in his downtown Third Avenue studio, later described their relationship as "pretty good friends," and the painter himself as a very kind, generous, intelligent person. She was intensely aware of his paintings, which by 1950 had become entirely abstract and very large; the next year he explained that through these large canvases he was attempting to enfold the observer in the mood of the painting, an engulfing experience that Louise eventually achieved through sculpture. The two artists shared a deep resentment of their long, difficult years of struggle, although Rothko believed that "the hostile incomprehension of the public" had, by promising him nothing, actually freed him to turn to "the world of transcendental experience," according to a letter he wrote to *The New York Times* in 1947. Rothko's viewpoint must have underscored Louise's own contempt for bourgeois values and her devotion to the liberating powers of art. He also recognized and respected her creative vitality, declaring that "no matter what she does, she is an artist."

But after Nierendorf's death, most male artists and members of the art establishment were condescending toward her work, and she was excluded from important shows, like the Museum of Mod-

ern Art's "Abstract Painting and Sculpture in America" in 1951. She once remarked to émigré artist Hans Sahl that she felt like an alien too; Sahl remembered that "she was very ambitious and frustrated at the same time." She worked off some of her rage through drinking and the demanding physicality of her work, but on occasion it erupted furiously in other ways. It was possibly on the July 1954 weekend she spent in Provincetown, Massachusetts, with her sister Anita and Ben Mildwoff when she was asked to be on a panel entitled "Why Can't Women Be Good Painters?" that she viciously tongue-lashed the policemen called in to break up a raucous party. Still an episodic alcoholic who passed out at parties and insulted people at openings, she was never reluctant to tell her male colleagues that they were "all full of shit." Her beauty began to suffer as her face became puffy, flushed, middle-aged.

She was also experiencing an extremely painful aspect of creativity: the necessity of repeatedly unearthing and exposing her deepest perceptions in the face of probable neglect. Sometimes after reaching what she called a point of no return, she had what she described as "a little breakdown." One weekend when she was staying at artist Anita Weschler's country house in New Hope, Pennsylvania, a museum director arrived for a scheduled Sunday-morning meeting with her. Louise was not yet up, and after repeatedly knocking on her door, Anita went into her bedroom to find everything—Louise's old velveteen jacket, long flowing skirt, and the bedcovers—in utter disarray and empty bottles of Scotch, gin, and every other liquor that was in the house under the bed. When she finally managed to wake Louise with the news that her visitor had arrived, Louise smiled charmingly and told her to send him away.

After a drinking bout, she would eat raw garlic and onions to cure the hangover. In time it reportedly also took injections of quinine and periods at health spas to bring her back to normal. "I tried too hard and overlooked my grace / Laying down my tools— will wait until / Iternity [sic] for grace to return," she scrawled at one point. When she was sober, she described these episodes airily: "Like a plant, one must have dormant periods in which to store up material for the next flowering."

It was at this time that Louise began to strengthen her friendships with other women artists in an apparent move toward self-preservation against the powerful sexist attitudes around her. Other women respected her intuitive and intelligent mind, her

courageous outspokenness, strength, and seriousness. By her late forties, she emanated such a vital sense of presence that her daughter-in-law addressed her even in letters as "Nevelson." She was "extremely strong, vivid, and dominated everyone," according to Olive Plunkett, an advertising copywriter who, along with a roommate, rented Louise's top-floor apartment in 1949–50 and was invited to Louise's frequent parties, where wine was poured from jugs into jelly glasses, daisies were thrown around haphazardly as a flower arrangement, and jazz records were played from her large collection. For the most part, Louise was kind and gentle to other women, often behaving better toward them than they did toward her. But at times this tolerance seemed to emanate from a subtle sense of superiority, as it did in her relationships with her sisters. Although Louise had an easy empathy and familiarity with a number of women, several of them noticed that she did not offer a real, self-revealing closeness—"With Louise you had to sense intimacy rather than verbalize it," Dorothy Dehner explained. Yet when another woman asked her about the essential goal of an artist at a gathering of women sculptors at Rhys Caparn's studio in February 1954, Louise answered, "To be yourself," and added that too many artists were "hiding under veils." Lily Ente, also a Ukrainian-born sculptor, often spent the day with Louise. She found her witty, unusual, and "very exciting," even "a genius as a person" because her mind worked so quickly and her remarks were "so original, so plain." Lily marveled that if Louise disliked someone, she might say quite naturally and quietly, "Go away, I don't like you." The women talked and laughed together on long walks around the city as they shared their struggles to work and exhibit—and their dreams of doing something new as women. "We consoled each other and cried on each other's shoulders," Lily recalled. "We were comrades-in-arms."

Women artists made repeated attempts to band together in more formal ways. In April 1952 Louise was elected to the National Association of Women Artists. A few years later, a large number of women artists were invited to Ilse Getz's uptown carriagehouse studio to plan a women's exhibition to awaken museums, galleries, and critics to the quality of their work. Only Louise and a few others showed up, including Worden Day, Joan Mitchell, Helen Frankenthaler, and Grace Hartigan. Louise was in high spirits and acted as if the whole thing were a joke, perhaps in an attempt to disguise her underlying feelings of hopelessness and cynicism.

When someone asked her how she had managed to get the attention she had as an artist, she answered, as she had answered a query about her finances years before: "Fucking, of course, what else?" Ilse, who was German and a generation younger than Louise, irritated some of the others by stating that it was actually an advantage for a woman artist to be young and attractive. After a discussion of their common complaints, one of the women suggested that they telephone the more prominent artists who had not appeared, while others disagreed. "Then someone's boyfriend showed up," Worden Day remembered. "He was greeted with laughter and a roar of 'Here's another woman.' When he heard what the meeting was about, he shouted, 'Don't do it—it would be a great mistake!' No one asked why. Somehow it was obvious that the general feeling of 'Don't rock the boat, don't make any waves, don't stick your neck out now' prevailed. The meeting ended, and so did the idea."

In the months after Nierendorf's death, Louise had been despondent, discouraged, and unable to work. In the spring of 1948 she developed fibroid tumors and had a hysterectomy. After two weeks in the hospital, she returned home and spent the next few weeks in bed. Lacking the physical strength to sculpt, she slipped into a deeper depression. As she approached the age of fifty, she was forced to face the reality of menopause. Even though she had firmly rejected a conventional female existence for herself, losing her physical fertility may have caused her to wonder whether she would also be deprived of her artistic creativity, or at least its imperative urgency.

When Louise became disturbed and distraught, her sister Anita, who affected a tough Bette Davis–style manner and appearance, often left Maine and went to her side. "I guess that you need me there to start the ball rolling," she wrote Louise once. "What we need is a few good wisecracks and a few growing doubles." Anita was also in low spirits because Nate, to whom she was very close, had suddenly, at the age of fifty, married Ben Mildwoff's younger sister Lillian, a department-store buyer and designer. Louise, who had first met Lillian at her eighteenth birthday party in 1931, had encouraged the marriage, but now she may have feared the loss of her brother's financial support. By July Anita had become so concerned about Louise's state of mind that she offered to take her to Europe. Louise, who had traveled very little since

the early 1930s, agreed, but later she could recall almost nothing about the brief trip.

She was once again worried about her son. After his divorce, he had begun to reach out to his mother more frequently, particularly during the long, bleak Maine winters. In February 1952, he urged Louise to make an off-season visit to Maine, adding that he did not think artistic, intellectual women like herself made very good mothers. Judging by the surviving letters from this period, mother and son alternately helped each other financially, encouraged each other as artists, informed each other about exhibitions and sculptural techniques, and disagreed about contemporary art. Accusing his mother of merely expressing her emotions rather than communicating with the viewer, Mike was determined to remain a traditional sculptor outside of contemporary "modernism." That same year, in a letter to the sculptor William Zorach, he pointedly praised him for "refusing, at personal cost, to jump on the popular and now-fashionable bandwagon of the makers of toys and fabrications of junk which crowds this already debris-ridden planet."

Mike and Nate's wife, Lillian, had opened a summer antique, art, frame, and refinishing shop in Rockland which also served as his sculpture studio; in time its sign would read: "M. Nevelson, sculptor. Maker of graven images for savages and sophisticates. Builder of objects aesthetic or useful. Lives by miracles but aided by friends and accepted commissions." Mike shared his exhilarations and despairs with his mother as he struggled to exhibit in Maine, Boston, and New York, and Louise openly worried about being "in his way." She wondered if she should step aside while another sculptor named Nevelson attempted to establish himself. "I thought that by negating myself, I would give him a break. It isn't a matter of generosity, but there is such a thing as returning something that you might have taken," she explained. But although she claimed that she stopped exhibiting for a brief time in the late 1940s, she was unable to put her son's interests above her own for very long.

In the spring of 1951, a husky, six-foot longshoreman named Johnny, whose last name has been forgotten, entered her life. She had a habit of meeting men on the nearby East River docks. Corinne Nevelson remembers that one afternoon she walked down the front steps of Louise's house with her just as the stevedore shift was letting out and the men were passing by, "and Louise said, 'I'll say goodbye now—I want that one.' " She reportedly picked up Johnny

in much the same way. When she learned that he had been in prison, it added to his appeal, and he lived with her off and on until the spring of 1954. During that time, he assisted her in many ways, hefting her heavy sculptures when she was having trouble with her back. "John is working hard and is a great help, he is so sweet," Louise wrote to Mike in early 1952. Occasionally he changed from his baggy workman's shirt and pants to a formal blue suit and escorted Louise around town. Mike thought they made an appealing couple, because Johnny was affectionate and "would take almost anything—he wasn't male dominant, but he was very protective." Mike hoped they would stay together and establish some sort of family stability. Unfortunately, Johnny had chronic stomach trouble as a result of gun wounds to the abdomen he had gotten in a brawl with the police. Louise did not want to be bothered with the needs of a sick person, and gradually Johnny came around less and less. When people asked Louise about him, she would vaguely indicate that he had simply disappeared.

The real problem was that Louise was becoming more self-protective as she gave more rein to her creativity, which demanded a surrender to the emotional side of her nature, which in turn rendered her more vulnerable to the abrasions of daily life. "The actual world is too much for me," she admitted. With her impracticality, excitability, and sensitivity, she experienced life's "great shocks on a great scale." Increasingly, she wanted to be cared for, catered to, protected by others.

After a visit to New York, Mike scolded her for smoking cigarettes and ordered her to see a doctor and cure her "horrid gagging cough": "How can you expect to keep a man around the house when you hang over the sink, spitting and making ugly nauseating noises as if you were strangling, suffocating, and puking all at the same time[?]"

The following winter she offered room and board to an elderly Italian man known only as Joe, or "Little Joe." She never hired people in any conventional way; people simply came along and began to work alongside her, she liked to say. "I have moved Joe in, who is taking care of t house and I have practically retired, and hope to for t rest of my life," she wrote to Mike in January 1952. In the same letter she dispensed her own brand of motherly advice: "Mike dear after a terrific struggle all along t line I must say living by grace instead of hard labor is much better and I do not intend to break my balls for anybody or anything and dear don't over due [sic] anything, enjoy each day."

The old man "took care of her like a baby," according to Marjorie Eaton. He shopped and cooked, swept the floors and washed the steps, answered the door and took telephone calls, moved heavy objects and assisted in the studio. Sometimes he fashioned very rough shapes in clay before Louise finished them; then, after they hardened, he might cut them open and hollow them out, helping her to increase her output. Every day he would wash one of the two flannel exercise suits that Louise worked and slept in, so that when she woke she did not have to waste time dressing. When Joe suddenly vanished around 1956, Louise was unable to discuss it, except to say that he had gone back to Brooklyn; others heard that he had married.

Although she was unable to tolerate the needs of others, Louise sometimes betrayed a longing for an affection that might take the edge off her acute loneliness. She had a cedar chest that she treated as a hope chest; it contained a violet-and-lemon-scented trousseau of unused lace-trimmed linen sheets, petticoats, blouses, handkerchiefs, and negligées. Once when she had been drinking, she telephoned Elisabeth Model, a beautiful dark-haired European artist, and asked her to meet her for a drink at a small hotel, explaining that she had something important to ask her. After they had seated themselves, Louise suddenly asked how she had met her husband. Elisabeth was astounded: she was sure that Louise did not want to marry again or need her advice to meet men. "It's a romantic story—why do you want to know?" she inquired. "You were always such a lady that I was curious about you," Louise replied. After forcing the story of her courtship from her, Louise began to weep, saying that she had never had a true romance, and now she never would. Then she pulled herself together and suddenly declared, "In ten years I will be on top!" "What is the top, Louise?" Elisabeth asked. "Valentin," she replied at once, referring to Curt Valentin, one of the most prestigious modern art dealers, who had represented sculptors like Alexander Calder, Henry Moore, and Jacques Lipchitz but who had not yet displayed her work.

While Louise was having difficultly lifting heavy sculptures in the aftermath of her operation, she had become acquainted with a European sculptor who ran the basement kiln at the Clay Club, an informal cooperative workshop; he offered to help her if she joined the group. The club, which was in an old brick stable on West Eighth Street, offered studio space and technical assistance to sculptors working in clay, metal, stone, and bronze, and held

members' exhibits as well. For the next four years Louise worked almost daily in the club's communal studio, which eased her sense of isolation: "I wasn't feeling very well, so I didn't want to stay in [my] studio alone." After her bitter disappointment when her innovative work in wood was misunderstood in the 1940s, she had retreated to more cautious efforts in terra cotta and stone; critic John Canaday later wrote that her sculptures created in the years immediately after Nierendorf's death were derivative of Constantin Brancusi, Paul Klee, and Robert Laurent.

Other club members found her "an amicable person" who adapted easily to group working arrangements. The Clay Club had been founded twenty years earlier by Dorothea Denslow, who now ran it with another sculptor, Sahl Swarz, who helped fire Louise's work in the basement kiln. The domineering Denslow, however, who earned a living making death masks, took a dislike to Louise and announced to the others that Nevelson was finished as an artist. Louise thought she was simply jealous and decided to ignore her: "I always felt, when these people try that, let them have a good time. She was no challenge to me, but I must have been to her, so I let her do what she wanted, and I did what I wanted." Nonetheless, tensions must have heightened after an article in the *Brooklyn Eagle* on October 26, 1950, mistakenly referred to Nevelson instead of Denslow as the director of the workshop.

In fact, Louise was becoming well known for her terra cottas and had joined the New York Society of Ceramic Arts. She laboriously carved cat and bird forms with incised faces from Tennessee marble, but more often she created in clay. Less expensive than stone or metal (firing a clay piece then cost less than five dollars, versus two hundred dollars to cast a piece in bronze), clay was also compatible with her rapid style of composition, "immediately responsive to the creative impulse," as she put it: "If it gets a little too hard, you can soften it; too soft, you can dry it. You can cut away or add on at will." With a good deal of energy, she would bounce a mound of unformed clay, then smack it into shape, spread it flat like dough, cut forms from it, press textiles into it, draw stylized faces on it with a sharp tool, or scoop out a hole for an eye or a mouth.

She began to work prolifically, rarely producing fewer than fifty of anything. To help with the firing, she turned to others, including Alexander Tatti, who allowed her to run up thousands of dollars worth of bills, confident that when she sold a piece, he

would get paid. "You might think it's a mad vitality, but she's not mad, she's a little obsessive," observed Sidney Geist. Geist, who favorably reviewed an exhibition of her ceramics, recalled seeing hundreds of terra-cotta figures, animals and humanoid heads resembling round loaves of bread, lined up along the baseboards and placed in drawers and cabinets of the Thirtieth Street house. In time terra-cotta blocks with craggy pitted surfaces, named *Game Figures* and *Moving-Static-Moving Figures*, were painted black and mounted in three segments on brass rods in order to achieve greater size and movement; the stacked and segmented torsos could be rotated on an axis and even interchanged. Louise described the pivoting totemic pieces as "in the nature of static mobiles in movement and cubes or blocks in substance."

In the spring of 1950, the workshop prepared to move to larger quarters on the Upper East Side, where it was renamed the Sculpture Center. Anita, who had come to live with her sister the previous autumn, offered to treat Louise, who was feeling restless and dissatisfied, to a vacation in Mexico. For years art critics had been comparing Louise's work to ancient American art: she had always felt a kinship with the vitality of primitive works, beginning with the Penobscot Indian artifacts in Maine. Her interest had been revived by Wolfgang Paalen, editor of the surrealist magazine *Dyn*, who was interested in the influence of primal forms on modern art, and had stayed in Louise's house for several months in 1946 when he had a show at the Nierendorf Gallery. So after the Whitney Museum's Lloyd Goodrich visited Louise's studio in early April and selected her semiabstract, reclining *Mountain Woman* for the museum's annual exhibition, the sisters set out for Mexico City.

They called on the ailing Diego Rivera and Frida Kahlo and went on to the Mayan ruins in the Yucatán Peninsula—Uxmal, Chichén Itzá, and the sites of Mitla and Monte Albán near Oaxaca, where they saw the half-hidden remains of abandoned palaces, temples, tombs, columnar structures, and massive ceremonial centers. Louise was tremendously excited by the affinity she felt for the crumbling Mayan sites. She climbed the steep stone steps of a pyramid rising above the jungle into what she felt was "a rare ether." The mysterious undeciphered geometric hieroglyphs, the depiction of Mayan ritual, the portrayal of an ancient indigenous royalty, the deeply appealing aesthetics—which she later described in terms of order, power, balance, bulk, harmony, and rightness—and the grandeur of sculptural forms on an architec-

tural scale, all excited her. "This was a world of forces that at once I felt was mine," she said. The enormous size of the monuments made her immediately want to work on a larger scale. Rivera had flattered her years before by suggesting that she had royal blood; now she felt an identification with the depictions of the Mayan sun god and moon goddess and a powerful kinship with the diminutive, brown-skinned descendants of the Mayans. The ruins exuded the sense of a lost history for her, much as pieces of found wood did. Afterward she resisted labeling the art "primitive," saying that the Mexican jade heads she saw in a museum resembled highly refined Chinese carvings.

Back in New York, she and the elderly artist Max Weber visited the Museum of Natural History, where they saw replicas of two unusually large thirty-foot carved stelae from Guatemala's Quiriguá ruins, a classic Mayan site. Three years earlier, after Weber had complimented her on her Eilshemius collection, she had invited him to see her recent paintings. He was a highly respected artist, art critic, and juror (a member of the 1936 ACA jury that gave her an honorable mention), who had studied with Matisse and Rousseau. After Nierendorf's death, she cultivated his friendship, undoubtedly in the hope that he would help her stalled career. Weber, who was married, enjoyed long talks with her and occasionally took her and Mike out to dinner. Just before she went to Mexico, he had bought a bronze Nevelson *Head* for $110. After visiting the Quiriguá stelae with her, Weber observed that "the great Mexican primitives" had often been more "modern" than the current avant-garde, but he cautioned her that "the primitives *having been—we* can't be primitive! All we can do is to aspire to do our best in the environment and civilization in which we were destined to live." Although it is not known how Louise took this advice, it's likely that it encouraged her aesthetic integration of the primitive and the present.

Louise and Weber shared a number of preferences in art (he had created one of the first pieces of abstract cubist sculpture in 1915), and she had hoped for important help from him, a Russian Jew with a genial, eager, questioning personality. But by early 1951 he had decided not to pass around the photographs of what he called her "splendid work," and he was either unable or unwilling to help her career in any significant way beyond encouraging her. He wrote to her rather formally the next year that he was glad to hear that she was working once again: "I know well

that you are imbued with a desire to create something valid and refreshing. You have already done fine and creditable things, and you will add to these as time goes on."

Louise's great enthusiasm for the reproductions of the Quiriguá stelae inspired her to go see them with her own eyes. By December she and Anita were making plans to return to Central America to view the totems at a small ceremonial site owned by the United Fruit Company in a remote Guatemalan rain forest beside the Motagua River. A United Fruit boat and a small private train took them to the ruins, where they were invited to use a company guest house on a nearby banana plantation. They enjoyed themselves immensely, attending a governor's ball in imaginatively draped and pinned fabrics which Louise had found in the marketplace. She was oddly disappointed, however, by the unprepossessing "brownish" sandstone stelae, some of which had toppled over; they were less impressive, she felt, in the flickering greenish jungle light than the white plaster replicas under artificial lights. Her reaction may also have been affected by her childhood aversion to verdant foliage. "In nature they seemed as if they probably belonged here. Maybe I like the idea that they didn't belong. You see, I reversed it. I'm not so sure that I like sculpture in a romantic way," she explained. Her realization that to her artifice was preferable to actuality supported her affinity for imaginative reality. Most important, her encounter with the aesthetics of Central American art enabled her to move rapidly toward a new personal style that would integrate her deepest instincts and ideas in an original way.

In the late 1940s she had made a brief stab at etchings at Atelier 17, a highly regarded printmaking workshop, which English artist Stanley William Hayter had moved from Paris to New York at the beginning of the war. Although Hayter espoused exploring the unconscious and advocated inventiveness with etching materials, his formal European attitude toward technique made it impossible for Louise to work with him. He suffocated her with attention and instructions about how to use a number of precise etching tools until "every time I took a breath, he was there taking one." Too independent for such pedagogy, Louise found the process mechanical, restrictive, and finally paralyzing.

After Hayter returned to Paris in 1950, the American sculptor Peter Grippe and his wife, Florence, took over the workshop. Peter invited Louise back, but she declined, explaining that she did not

want to master the etching tools. But by then there had been more experimentation in graphics, such as impressing plants and textured papers onto printing plates, and Grippe promised to show her methods that did not require the traditional tools. After she agreed to come, he gave her a can opener and fabrics and let her go to work. She created lavishly with lace and crude tools on large plates with great volumes of black ink in a characteristically unconventional way. While the plate was resting in an acid bath, she used to scratch it with any instrument at hand, "thus disturbing or reaccenting the etch," according to curator Una Johnson. She would throw in more acid, or not let the acid bite into the plate deeply, to allow chance to create unexpected results. "I sort of felt my way—like when you turn a page you know either through the weight or somehow that you have turned two pages—so when you wipe the plate you know what to expect from your print." As she worked directly and rapidly on the plates, her imagination and her intuition were freed, and she created a group of bold and innovative prints.

She could be found at the workshop day and night until it closed in 1955. She enjoyed the communal milieu and made several lifelong friends. Dorothy Dehner, recently divorced from David Smith, admired some Nevelson prints lying on a table, and the two artists introduced themselves and immediately felt an amiable intimacy. "She thought it was kind of wonderful that I had been married to David Smith," Dorothy recalled, adding that they never talked about his work. Louise usually arrived at Atelier 17 in an outlandish outfit, and since she worked without inhibition with total absorption, she found that even the acts of wiping, burnishing, and printing were creative. "My God, what energy!" recalled Alan Gussow, an apprentice at Atelier 17 in the fall and winter of 1952–53. "She revelled in the inks and papers. She threw down textures of fabrics, worked with enormous physicality, literally throwing herself into the work. The most lasting impression was that she got dirty. I mean very dirty. It was as if she enjoyed wallowing in the blackness." The resulting intricate, semiabstract intaglio images were related to memories of Central America—among the titles were *Ancient Sculpture Garden* and *The Stone Figures That Walk at Night*. Most of the prints were entirely composed of tones of gray, white, and black tracery veiled by a shadowy, mysterious, murky half-light; others were darkly inked until the images were in almost total darkness, suggesting a dream state. (In 1939 Louise

had been moved deeply by Picasso's *Guernica* with its inventive cubist forms portrayed in stark grays, whites, and blacks.) These etchings marked the beginning of her nearly exclusive use of black during the next few years.

As her studio filled up with new terra cottas and etchings, Louise began to promote her career energetically once again. In an effort to be noticed, she attended Tuesday-evening gallery openings, made the rounds on Saturday afternoons, and aggressively cultivated art critics. While visiting Anita Weschler, she noticed her friend's card box containing the press contacts of the Sculptors Guild and spent the afternoon laboriously copying down the names and addresses. "I've waited, I've paid my dues, and I want it now," she used to say impatiently. When she was ignored by important critics or bypassed by members of a younger generation, she realized that she was losing face. "I know that your work is sound and exciting," Mike loyally wrote to her when Howard Devree failed to mention her sculpture in a *New York Times* review of a 1951 group exhibition. "Why do you think the critics make such a purposeful effort to give you the 'silent treatment'?"

As part of her strategy, Louise appeared, invited or not, at large parties attended by influential people in the art establishment. She derisively described one of them held on New Year's Day, 1952, to her son—"Most of t men were fags and t other guests were snobs. I guess that's society." She liked to dress to look wealthy and elegant in a wide-brimmed picture hat and a well-tailored black suit with a fur around her shoulders; she had an enormous, slightly out-of-style wardrobe, which she meticulously preserved in garment bags and boxes placed neatly within closets that extended the entire length of the brownstone. Using her charms and social contacts, she made every effort to be seen in the right places. In May she attended the opening of Belmont Park with Mrs. Alfred Gwynne Vanderbilt, Cornelius Vanderbilt Whitney, and Prince Serge Obolensky. At about the same time, a gossip column featured a photograph of her in a chic polka-dot jacket and dramatic black hat, lunching with Mr. John, the milliner of the moment, who designed hats for movie stars and fashionable women, including Greta Garbo and the Duchess of Windsor. Louise often wore his expensive creations, although it is not clear how she paid for them—possibly with art work. One of them, an enormous black velvet hat with a seed pearl sewn in each dimple of its

quilting, was to Corinne Nevelson "the most fantastic, fabulous hat I had ever seen."

She had concluded that, like Picasso, all great artists displayed versatility, produced prolifically, and exhibited widely. Confident of her own energy and stamina, which appeared to intensify in her early fifties after she got over her anxiety about the menopause, she was convinced that "no one [else] could, quite, do what I could do." By her own count, she displayed her sculpture, drawings, and paintings in at least sixty shows during the 1950s, the number of exhibits escalating each year as the decade progressed, and unsuccessfully attempted to enter other shows, such as the huge Whitney annual of 1952. Increasingly, she tried to take rebuffs philsophically: "As for t Audubon, I was rejected to [sic] and I know some students at t Sculpture Center who sent their first piece and were accepted, which shows you that it means nothing," she wrote to her son. "We're in creative work because we want to be and we take it all in our stride."

In her resolve to exhibit as often as possible, she attempted to join virtually every artists' group in New York that sponsored annual shows. In 1952 alone, she paid dues to at least eight local and national arts organizations, some devoted to the work of women, others to ceramics, and several to contemporary art. Finally, twelve years after it was founded, the Federation of Modern Painters and Sculptors voted to accept her in 1952. The Federation's members, presided over by Harold Weston, included pioneers in the modern movement as well as many of Louise's longtime friends and acquaintances. The group had remained bitterly divided over the degree, if any, of its political activities, and the issue heated up again during the early 1950s, the years of the McCarthy hearings, when a new statement of principles against taking any political position was adopted.

Louise was still trying to get into the Sculptors Guild, which had been in existence since 1938. She befriended Lily Landis, an attractive young blond sculptor, who had been admitted at the age of nineteeen. Louise used to invite her to lunch, show her her work, and give her gifts, like embroidered bibs for her baby daughter. She was candid about her overriding ambition—"They will roll out the red carpet at the museum for me," she used to declare, "and I will have a sable-lined coat"—and Lily was eager to help her. In early 1953 the members' committee at last invited her to join and, as if to compensate for fifteen years of neglect, immedi-

ately named her exhibition chairman for the May annual show (in which she entered her own black plaster *Figure from the Distant Lands).* "She did a beautiful job," Lily recalled, and because of her energetic personality and innovative installation she was "kind of a star already for us."

Once she became a member of an organization, Louise offered her brownstone's large double parlor for meetings, auctions, benefits, and parties, and by 1953 the Federation of Modern Painters and Sculptors usually met there. As the hostess, Louise was "very, very beautiful," Lily recalled. "Almost as beautiful as Greta Garbo with that marvelous nose and features—and always very flamboyant in black." For jewelry she might wear a necklace made of a brass door hinge, or an Egyptian scarab. Sometimes she humorously indulged in bizarre effects, such as imitating a Picasso figure by painting one eye green, another blue, and her mouth orange-red. As she widened her circle of acquaintances in the art world, her sculpture on display in the house was seen by important artists, critics, and dealers. She always had preferred working alongside other artists to the isolation of the studio, and she loved the attention that came with the role of hostess—"to be at the center of a moment of largesse," as Sidney Geist put it. Once, when the members of the Federation filed out after a meeting, she positioned herself at the front door to say goodbye. "Every man kissed her! And there were hugs. And she loved it," Geist added, noting that her house had become "a hive full of helpers, lovers, and family."

Antagonized by the exclusiveness of art-world cliques ("I'm beginning to agree with you that the critics and the galleries have nothing to do with ART," Mike wrote), Louise decided it was better to display her prolific output wherever she could than to wait for a prestigious gallery to take her on. To the dismay of some of her friends, the sculptor who had once exhibited beside Picasso in the Nierendorf Gallery began to show her work with amateurish artists in the burgeoning number of vanity and commercial galleries, in business offices, and once even in a beauty parlor. "She was indefatigable. She never refused. No place was too humble or low," Hubert Crehan, a friend from this time, reported. Her belief in herself, her boldness, ambition, and desperation drove her to display her work where another artist would not have dared to risk his or her reputation. In the winter of 1952 she exhibited bronzes, terra cottas, and drawings in a group show at Gallery 99 on

MacDougal Street in Greenwich Village. "As you know I am show-ing with a little tiny gallery in t village," she wrote to her son. "I still don't know whether I did t right thing by so doing but that to [sic] I'll take in my stride. You move up a little and get pulled down and so it goes and so it seems to go with them all." That year her work was on display almost every month somewhere in New York in her attempt to make it impossible to ignore her.

In 1953 she sometimes exhibited in as many as three different shows at one time. Frequently she displayed a well-received piece over and over again. Before long it appeared that her determination and ubiquitous presence were beginning to pay off as her sculpture started to take prizes. In late February 1953 she won an award in an all-female show for her forceful bronze *Archaic Figure with a Star on Her Head,* whose raw vigor was "completely out of place at this polite party," Sidney Geist observed; in May she won several prizes, including the National Association of Women Artists' award for *Ancient Figure.* Besides the routine notices she often received in reviews of group exhibitions, she was mentioned in other pub-lications, like *Interiors,* which displayed a Nevelson sculpture in a room setting in its March 1952 issue. As her name appeared more often in the art press, critics gave her sculpture a few meager words of praise; in October 1952 *Art Digest* singled out her totem *Proud Lady* from the large Federation exhibition, noting that the sculp-ture section was otherwise unimpressive. At the end of the 1953 season, her son wrote prophetically that "in a few years [you] will be universally hailed as the 'Grande Dame' of American sculpture," collectors would begin to compete to buy her work, and, he went on, in 1959 she would sell more than $30,000 worth.

As the tidal wave of abstract expressionism crested in the early 1950s, the art world was engaged in an intense ideological battle, with fanatics on both sides. After Hans Sahl attacked "abstract conformism" in a *Commonweal* article, Jackson Pollock attempted to beat him up at the Cedar Tavern; afterward, Louise, Edward Hopper, and others thanked him for speaking up. Because they felt it was important "to be seen, to talk about ideas, and to be out there among your fellow artists," in 1952 Will Barnet, Peter Busa, Steve Wheeler, and others founded the Four O'Clock Forum to encourage ideas other than abstract expressionism and to lend moral support to one another. Barnet, who belonged to a minority of "hard-edge" painters known as the Indian Space school because of their interest in patterning, Indian iconographic imagery, the

appearance of flatness, and the rejection of illusionism, linear per-
spective, chiaroscuro, and other European influences, struggled not
to be overwhelmed by the popularity of the New York school. He
believed expressionism was mere emotionalism which, like all
tides, would recede. "The question arises whether modern art is
really moving anywhere," the sponsoring artists of the Forum
stated in the spring of 1954. "The manner in which this generation
develops the classic elements of pictorial art will provide the real
answer as to whether it has succeeded in resolving the *crisis of
form* that it faces."

More tolerant toward women artists than the Artists' Club, the
Forum's organizers asked Louise in the spring of 1953 if an April
meeting on the future of abstract art could be held at her house,
and invited her to be on the panel with artists Richard Lippold,
George Constant, and Philip Guston; she enthusiastically agreed.
On that Sunday afternoon and succeeding ones, she appeared to
be interested in the debates, indicating that she had in the past
decade recognized the need to form alliances with other artists and
changed her attitude toward "intellectualizing" art. Soon after-
ward she agreed to become one of the sponsors who moderated
discussions and donated ten dollars every few months to help cover
costs. As the Sunday debates became better known, as many as a
hundred artists attended; a chosen few were invited to remain
afterward for drinks and take-out Chinese food.

In January 1954 Louise moderated a discussion about sculp-
ture, "Changing Concepts of Space in Art Today," with José de
Rivera, Worden Day, and John Ferren. In early December a sym-
posium, "The Synthesis of Idea and Technique in Art Today," was
held at her house with Willem de Kooning among the panelists,
an attempt to create a dialogue with the abstract expressionists.
Even though Barnet and de Kooning got into a bitter argument
about the nature of reality, Louise later proudly recalled that
Elaine de Kooning remarked that her husband had never spoken
better than in the special ambience of Louise's home. (Still, Elaine,
and presumably her circle, continued to recognize Louise more for
her Eilshemius collection than for her own work.) Soon press re-
leases carried the Thirtieth Street address, and Louise was hosting
so many meetings that one of the original founders complained
that the Forum had turned into a Nevelson salon.

After eight years of entering single sculptures in group shows
when her house was bulging with sculpture, Louise finally had

several one-woman exhibitions in 1954. The German photographer Lotte Jacobi, whom Louise had met through Nierendorf, exhibited a large number of recent Nevelson etchings and a half-dozen sculptures in her portrait studio; sculptor Marcia Clapp dedicated the inaugural exhibition of her gallery on East Seventy-fifth Street to Louise and then decided with art dealer Grace Borgenicht to display Louise's work in an insurance agency later that summer. A bemused *New Yorker* writer reported the result:

> [Miss Clapp] led the way into a good-sized bull pen full of girls at typewriters; they were surrounded by filing cabinets and about two dozen of Miss Nevelson's works. "I picked her because her work is strong enough to fight office equipment," said Miss Clapp, pointing out a simplified duck that stood on a pedestal beside a three-tiered green cabinet. "In offices especially, I think it's important to concentrate on the abstract and the semi-abstract, because those styles are very much in tune with the scientific, business way of thinking." She glanced at [chairman Michael H.] Levy, who had followed us out of the office. "Could he look at a pastoral scene in his present tensed-up frame of mind?" she demanded. . . . Mr. Levy said Miss Nevelson's work caught his mood exactly. "She telescoped form," said Miss Clapp. "That's what businessmen are doing today. Art can't lick it, so it should join it."

Despite her successes Louise still managed to survive financially only with the help of Nate and other family members. She must have mentioned her lack of money in a Christmas visit to Rockland in 1952, because after her return to New York her brother sent both cash and checks to her. (In return, she continued to give him some of her work, and she had also painted his portrait three years earlier.)

Nate often loaned money to people in Rockland and rarely pressed for repayment, while he overstaffed the Thorndike Hotel with down-on-their-luck artists and poets. When his nephew Mike installed a time clock, he protested that the hotel was not a prison.

As far as Louise went, Nate was motivated by feelings of kinship rather than any understanding of modern art; he had remarked to Mike a few years earlier that art was "a stupid waste of time." He had even, when visiting Louise in New York and seeing her enormous expenses (she had filled a bowl with unpaid bills totaling thousands of dollars), advised her to give it up since she

was unable to make a living at it. In 1950 she had listed only fifteen owners of her work (drawings, sculptures, and oil paintings); another, undated list of twenty-three owners contained only names of relatives, friends, and art critics, and presumably many of the works had been gifts. Her sales were typically two hundred dollars or less, and her attempts to earn money through portrait commissions were shaky. She lost one when the subject refused to accept the finished product because of its unconventionality. Nevertheless, Louise declared to Nate that she would become to sculpture what Rockland-born poet Edna St. Vincent Millay was to poetry—a presumption that irritated him so much that he abruptly left the house. Louise later acknowledged that she had been unable to vary her course and was in effect wearing blinders like a horse. "I hate the word 'compromise'," she remarked in 1954. "My inner feeling dictates, and I will not change. I am dedicated to what has an intensity for myself."

In spite of his impatience, Nate remained loyal to Louise, displaying her paintings and sculptures in the Thorndike and once paying several thousand dollars for mahogany sculpture pedestals with her signature engraved on oval metal plates. Although he disliked her bohemian way of life, out of affection he stayed with her on occasion when he was in New York. In December 1953, learning that she was exhausted and depressed after a prolific period of working and exhibiting, he sent her a check for $200, as "a little spending money" and warmly invited her to Rockland for "a complete rest." He seemed to consider Mike responsible for her indebtedness, and tensions between them increased in the summer of 1954 when Nate calculated that he was owed about ten thousand dollars for the money, meals, and services he had provided for Mike and his mother and expected Mike tend bar at the Thorndike without salary and give him sculpture while he deducted its value from the debt.

The Mildwoffs also helped Louise. They had moved back to Greenwich Village at the end of the war with their two adopted children, Steven and Susan. Lillian, whom Ernest Bloch had described in 1933 as stylish and good-looking but "more commonplace, more open" than Louise, continued to regard her oldest sister with gentle tolerance. She and Ben again gave large parties for their artist friends, who now included art collectors and critics as Ben began to prosper in the glass business. One evening Louise walked into their brownstone on West Eleventh Street and ex-

claimed, "The whole art world is here!" Besides introducing Louise to many people, the Mildwoffs assisted her in numerous other ways. Lillian provided her with a car or a taxi, depending on her need at the moment, storage space in their attic or basement, sessions with her own psychiatrist, or her charge cards at Fifth Avenue department stores. Both Lillian and Ben apparently loaned her large amounts of money, some or all of which she repaid in $500 and $1,000 installments. Most important of all, the Mildwoffs were early and devoted collectors of Louise's work: by 1950 they owned at least six drawings and six oils as well as a number of terracotta, bronze, aluminum, and black wood sculptures.

Louise's existence during the 1950s was a bizarre contrast of grandiose dreams and unsavory reality, posing in high-society settings one night and drinking in working-class bars the next. She befriended a number of rough characters (a woman friend was shocked to find a prostitute at one of her parties) and boasted that one waterfront tough, "Bobby," carried "a roll of hundred-dollar bills thick enough to choke a horse." (This same Bobby reportedly underwrote the cost of casting a number of her sculptures in bronze.)

Louise also sold items from the trunkloads of drawings and jewelry that she had obtained as gifts, trades, and purchases, but she was characteristically impractical about these sales. When sculptor Louise Bourgeois brought her father, a textile expert, to appraise an old restored tapestry that Louise had somehow acquired and offered her $25,000 for it, at a time when she had no money, Louise laughed and replied, "If it's worth that much, it's worth keeping." Another time, when a male admirer set up a charge account for her, she bought alligator handbags, linens, and silver and impulsively delivered some of them by taxi to Bernard Nevelson's widow, Lily, and her daughter, Corinne, who were struggling to make ends meet.

Mike admitted in September 1953 that he did not understand how his mother survived. "I'll eat my hat if you've earned more than ten thousand out of sculpture and painting in the last ten years, and certainly you live by middle-income group standards. But, as I suspect, woman [sic] have ways of maneuvering in this materialistic world in a manner that baffles most men," he wrote her. He continued to send her small checks until he closed up his shop the next month and sailed to Brazil for the winter, after assuring her that Nate would help by working out a "gimmick," such as having her bill the Thorndike for interior decoration.

Louise's financial desperation finally forced her to decide to teach again. She received a teaching certificate in sculpture from New York state on February 1, 1954, and the following fall began to teach in the adult education program of the Great Neck, Long Island public schools at $40 a week. Max Weber, who lived in Great Neck, and her friend Dido Smith, who wrote flattering articles about her teaching experiences and theories in the June and September issues of *Ceramic Age* magazine, may have helped her get the job. Every Wednesday she took the train to Great Neck to teach an afternoon parent-child class and an evening sculpture workshop. In the latter, her teaching methods were highly unusual, if not blasphemous by 1950s standards. Drawing on her own experience as an art student, she was intent on encouraging rapport with her students, who were mostly suburban housewives and who, she observed, lacked confidence but not creativity. One student left the class after a few months because, she later explained, Mrs. Nevelson taught for only about ten minutes and spent the rest of the two-hour session describing her sex life, which the woman remembered as "definitely varied." Louise also liked to say that it was impossible to have a family and be a great artist at the same time. "Really, the prime thing is to free and remove any inhibitions so that the student can begin to move on his own initiative," she declared.

At the beginning of class, Louise would sit and read, refusing to answer questions or look at her students' efforts. When one of them, who enrolled with her son in the 1954 afternoon class, timidly asked how to begin, Louise cavalierly replied that art could not be taught. She intended to give her class the first push, a few technical tips (such as, when working in clay, to start with the feet), and what she took to be encouragement. After about an hour she might look at their work and demonstrate, usually by creating structural planes on a piece of clay with a knife. At such times she was extremely perceptive, her students recalled. Arnostka Lieberman, who studied with her from the autumn of 1957 to the spring of 1960, felt that Louise had opened her eyes by, for example, making her aware of shadow patterns. "She could have been a great teacher," said another student. "She understood before I knew what I was doing. But she was hard to pin down."

One night as Louise and another artist-teacher were waiting for the train back to Manhattan in the bar next to the station, she remarked that her students had asked her that evening about the meaning of art. Her reply was to dance in front of the class, swirling

her full peasant skirt and crooning that art was "a love affair." This was a perception she repeated many times, writing in 1954 that modern art "adds up to Structure, Technique, Material but & above & beyond all it is a Universal love affair for me and I'm in love with Art." Experiencing creativity as a natural, powerful, life-enhancing urge marked by the feverish imagination, heightened sensitivity, and distorted observations of a person in love, she had difficulty making her erotic, anti-intellectual approach seem thoughtful or serious. At an Artists Equity costume party she remarked to a woman friend that she was wasting her time—she should be either in her studio or in bed with someone. Equating sexual and artistic expression so completely often had little meaning for others and merely served to remind them of the way Louise continued to violate sexual taboos. In the same 1954 statement, she also wrote:

> So very very much has been said & written about Art & yet such a small percentage of people take t time to truly think & feel Art. . . . Today in Modern Art we have freed ourselves totally & completely from t representational, from t literal and dug right down deep into t core, right down to t place where creation is unadulterated, where we have cleaned & scrubbed it to its primordial place. For me this is t place of t beginning-ness. The place of pureness, t first place, t one-ness & there you are. It is t place you [tap] life itself.

Louise had spent Christmas, 1952, in Rockland with Mike, Nate, and Anita, facing the traumatic possibility that the block on which her house stood might be torn down and replaced by a housing project under a plan drawn up by urban planner Robert Moses. On November 8 *The New York Times* had published a front-page story and map of the three targeted blocks and quoted the New York City Committee of Slum Clearance description of the neighborhood as "a run-down area" of tenements, small commercial buildings, garages, and warehouses. In the summer of 1953, impatient with her lack of recognition and upset about the prospect of losing her home, Louise toyed with the idea of moving to London, an idea that became even more appealing when the British sculptor Jacob Epstein was knighted the next year. Still, she did nothing, and in early December 1954 the Committee of Slum Clearance officially notified her that the block had been acquired by New

York University–Bellevue Hospital for apartment towers, which would be designed by I. M. Pei and known as Kips Bay.

That winter she worried constantly about lack of money and the imminent destruction of her house, which simultaneously undermined her sense of stability, threatened her identity as an art-world hostess, and meant the loss of an unusually large working space. Mike wrote from Rio de Janeiro that he would offer his house in Rockland except that he knew his mother would find Maine "a desperate experience, cold and isolated." In early 1955, the new owners of 323 East Thirtieth Street began to collect rent from the top-floor apartment and $100 a month from Louise, leaving her responsible for utilities and upkeep. Despite all this, she had difficulty taking in the reality of her loss. As brownstones and tenements around her fell into disrepair, were emptied out and ultimately razed, she continued to procrastinate, clinging to the illusion, which was encouraged by several politicians, that the demolition might not occur.

During these uncertain years of living on borrowed time Louise began to compose in wood again; her recurrent desire to transform rubble into art seemed to reflect her deep anxiety over the destruction of her home. Even while she was working in terra cotta and etching, she had been collecting the wooden debris that was so abundantly available on the demolition sites in the abandoned blocks around her. She was beginning to find clay unsatisfactory; despite stacking ceramic chunks on rods, it limited the size of her sculptures. In 1956 she wrote Dorothy Adlow, art critic for the *Christian Science Monitor,* that while some people argued that modern forms were determined by their materials, "it seems to be more likely that these in turn may have been chosen to fulfill the need felt by sculptors to explore *Space* in ways not permitted by clay, bronze or stone." She believed that in working with found wood she was especially involved with the fourth dimension, which was essentially what she was interested in; it had become to her "the Great Beyond," a "transcendent spiritual place of refuge." Working with pieces of old wood, "you enhance them, you tap them and you hammer them, and you know you have given them an ultimate life, a spiritual life that surpasses the life they were created for."

Her searches with a wheelbarrow at three or four o'clock in the morning to beat the garbage trucks became more frequent and frenetic; her choice of objects, more audacious. During a visit to Provincetown, she told everyone she was searching for ovals—in

particular, old toilet seats. She returned from her visits to Maine with driftwood, boards, and once a barber's pole. While visiting Marcia Clapp in the Poconos, she bought baseball bats in a country store. Friends and relatives began to haul armfuls of discarded wooden material to her; Lily Landis and her husband brought bushel baskets of horizontal wood cuttings. From time to time Louise telephoned Alfred Van Loen, a Dutch artist who ran a Greenwich Village art gallery, to tell him she had borrowed an old pickup truck and invite him to go to the country with her for a few days to explore secondhand shops. Alfred realized that although she responded to people interested in her sculpture, about which she could talk endlessly, she took no interest in anyone else's work. "We were both artists and were glad to see each other and were both glad to get back to work," he said. She developed a lifelong friendship with a young painter named Mary Shore, who lived in Gloucester, Massachusetts, with her husband and two sons. Mary was a beachcomber, and every few months she loaded her station wagon with sea refuse and took it to Louise in New York; if the weather was good, the two might drive back to Gloucester together or go farther north to Rockland and stay at the Thorndike.

The parlor floor of the Thirtieth Street house was lit by forty-watt bulbs, creating what art critic Hilton Kramer called a "permanent and unrelieved twilight—gray, silvery, and shadowy, without color or sharp contrast." In the basement a Chinese-red refrigerator contrasted dramatically with "neatly arranged stacks of black-stained wood, baroque driftwood, fragments of lumber with delicate edges, or machine-cut ones, forming geometric patterns," according to art dealer Colette Roberts. Louise's tenant Olive Plunkett assumed that she was forgetful or frugal about lighting the stairway and avoided arriving alone after dark, afraid to let herself into the shadowy parlor, which she described as being like a Charles Addams drawing. Whenever she asked Louise to replace a bulb, Louise laughed and did so, but usually not until a few weeks later. By now most of the rooms in the house were full of various kinds of assemblages and larger-than-life figures. The effect was so overwhelming that when Kramer walked outside into the daylight again, he felt disoriented, the way he had felt as a child when leaving a Saturday-afternoon movie.

In December 1952 Colette Roberts, the new director of Grand Central Moderns Gallery, a small nonprofit art gallery on East Fifty-sixth Street, had invited Louise to participate in a sculpture

show of "new talents." Although hardly an unknown artist, Louise entered *Mountain Woman* and *River Woman*, selections described by painter Fairfield Porter in the January 1953 issue of *ARTnews* as the "best of all." Roberts had high, precise critical standards as well as eclectic, unpredictable artistic tastes. A vivid dreamer herself, she became intensely interested in what she interpreted as dream images in Louise's assemblages, which she began to call "sculpture collage." She offered to give her a one-artist guest show with the possibility that the gallery might represent her. Louise later claimed that she had been reluctant to accept because she considered such an association humiliating after being represented by the prestigious Nierendorf Gallery. Since she was at the time exhibiting in every conceivable place, it seems more likely that she disliked or was wary of some aspect of Colette's personality. Colette, born Colette Jacqueline Lévy-Rothschild, was a vivacious, cultured French Catholic intellectual whose formal and elaborate French mannerisms seemed affected to many Americans. After studying art history at the Sorbonne, she had moved to the United States at the beginning of World War II with her American husband and their small son. There she reviewed art exhibits for *France-Amérique* and directed the gallery of the National Association of Women Artists before moving to Grand Central Moderns.

After Colette had courted her for two years, Louise finally agreed to an exhibition from January 8 to 25, 1955. Her darkly inked etchings were mounted on the walls, and her stately sculptures with an unusual degree of emotional depth were widely praised. With a strong sense of satisfaction, Louise dedicated the exhibition to herself. "It is grave, humorous, dramatic, tragic," she wrote, qualities that she believed characterized her life. The show included "tabletop" landscapes composed of wooden squares, balls, blocks, triangles, and rectangles, whose proportions and spatial relationships were sensitively calculated. *Black Majesty*, a series of black vertical elements lined up on a horizontal plane like a surrealist dreamscape, was, the artist whimsically declared, an evocation of Africa. (If pressed, she could always find literal symbols for her abstract forms: she explained that the rectangular base of *Ancient City* symbolized the city; its square pedestal, consciousness; its hollow round form, the sun; its tall object, the cold seasons; its shaft with three rounded forms, the warm seasons; while its pair of menacing carved red-winged griffins, with the bodies of lions and the heads of eagles, flight.) She also exhibited her stone-

like ceramic sculptures stacked on copper tubes, which reminded some observers of Easter Island or Saxon effigies dedicated to pagan gods; others described the blackened clay sculptures as remote, mysterious, provocative, original, and influenced by Mayan art.

The title of the exhibition, "Ancient Games and Ancient Places," was carefully chosen to make a statement. Louise later said that she had searched for a title that would impose a thematic unity on the show: "Not that the thing has to look like it, [but] it becomes a oneness." She selected titles from phrases she had written on scraps of paper, most of which were allusive, suggestive of abundant nature, lost worlds, titled aristocrats, and, above all, the highly romantic side of her nature. At times they also signified motifs in Russian fairy tales, images in the paintings of Marc Chagall, or the titles of modern dances by Martha Graham and Erick Hawkins. The names sometimes "speak to me," she explained, referring to one that alluded to noctural blooms in a moonlit garden before she had conscious knowledge of the Mexican flowers that bloom at night. Some themes, like that of lost civilizations— an unsurprising obsession for an immigrant—were recurrent. Aware that her verbal imagery might have meaning only for herself, Louise admitted, "I have never used language like others have."

The dominant image in the new exhibition was *Bride of the Black Moon*, a roughly carved, unpainted wooden plank adorned with a black crown and a cloth veil; a black sphere on a platform at its side represented the moon. Unlike Chagall's rapturous brides or her own dancing figures, Louise's bridal representations, beginning with 1952's *Bride of the Sea*, were solitary, passive, awkward figures—mournful black virgins—indicating her deeply skeptical feelings about the institution of matrimony. She eventually became convinced that happiness in love was impossible for herself and other creative and independent women, and she reiterated that her own "marriage" was to her work. Nonetheless, as standing at the threshold of marriage became more remote for herself, she seemed to become obsessed with the idea of the bride—the moment when a young woman traditionally holds the most promise and power. When she arrived in Italy a few years later and discovered that her suitcase of Chinese robes was missing, she announced to the Italian officials that she was getting married the next day and her wedding dress was in the lost bag.

Bride of the Black Moon was surrounded by four wooden constructions (*Black Majesty, Forgotten City, Night Scapes,* and *Cloud City*) representing the four corners of the earth the nuptial figure would visit. Louise composed a revelatory poem, which she pasted to the sculpture's pedestal:

> The bride
> of the Black-Moon
> goes to many continents
> She plays games
> She sees the Sphynx [*sic*]
> Prometheus
> The images on the wall are images she remembers
> She is soon to take another voyage
> She will have seen
> more, and more, and more . . .
> And she hopes to communicate to you
> New scenes and new images.

She later said that she got so involved with her imagery and identification with the bride that creating the sculpture was like writing her autobiography. "*Bride of the Black Moon* is me, of course," she laughingly admitted.

Art historian Laurie Wilson has speculated that the black moon unconsciously represented her mother, for whom she had never fully grieved, which explained "phantom images" of death in her work. A few months before the exhibition opened, Louise had delivered the eulogy at a memorial service for the mother of a close friend, painter Anna Walinska. Anna, also a Russian Jew, had, like Louise, been brought from the Ukraine to America at the age of five, but she had devoted herself to caring for her parents. Louise met her in the 1940s when they exhibited together, and became very close to the whole family. At the service, she recalled that her impression of the Walinska household the first time she dined with them was of "a spacious, gracious, harmonious home; wherever my eyes rested they found a fine, strong, direct personal expression in plastic creation." She felt especially close to the mother, a sculptor: "If I may dare to say so, I felt above and beyond all for Rosa Newman Walinska. Her creative work was first and always a love affair and she placed it on a *high Mt. Top.*" Two years later, at a show for ten women artists at the Riverside Museum, Anna Walinska's large painting of a mother and two children in black, grays, and greens was hung at the top of a stairway. Anna found Louise

standing at the bottom with tears running down her face. "How happy your mother would have been to have lived to see this," Louise said, and the two women embraced. Anna perceptively replied, "You're weeping for your own mother, darling."

Louise had already begun to color her wood black, and by the late 1950s she had blackened virtually every piece of sculpture, even figures carved from Ivory soap. She usually saturated all the pores of a piece of wood by taking tongs and dipping the wood in a can or tub of thinned commercial black oil paint, although she once colored a clay cow with crayon and shoe polish. Her matte black paint was described as "dead black," and some pieces were inevitably likened to coffins. "I suspect that her psyche is a witches' brew of fear and trembling about death," said her friend Hubert Crehan. "Her cedar chest looked like one of her coffins. I said, 'Why don't you dip it in the black?' She was indignant." She habitually denied that the black in her work represented death, calling the idea a cultural assumption of the Western world; she liked to point out that in China mourners wore white. Art critic Dore Ashton called her black "romantic, not elegiac," and Hilton Kramer said its primary purpose was sculptural, not the creation of a macabre mood. Nonetheless, Louise's black seems also to have been a subliminal expresson of grief, and her protests, a form of denial. When asked by a *Life* reporter why she painted everything black, she replied evasively that "black creates harmony and doesn't intrude on the emotions." Another time she explained that while Ad Reinhardt came to black consciously and philosophically, she arrived at it intuitively and with unacknowledged impulses: "I just feel *looking* at it is the most satisfying of all things. Emotionally it may have great sorrow, or great joy."

Blackened forms appealed to Nevelson for other reasons. Black represented the darkness of night and the mystery of the unconscious. On a technical level, it created a strong silhouette and alchemized a simple board into something aristocratic, complete and exciting to her. It was a unifying element in her work, although no two blacks were ever exactly alike, as the texture of the wood subtly altered the tones. The color was also a characteristic Berliawsky one—the color Isaac and Annie had worn and that Nate insisted Mike paint his bathroom and the Thorndike's basement barbershop. In years to come, critics would see in Nevelson's blacks tarry Maine piers, rich, rotted jungle vegetation, and defunct cultures with their lives charred away. Louise herself preferred to

describe the color in metaphysical terms: "For me black isn't black anyway, and color isn't color as such. Color is a rainbow and is just as fleeting as anything on earth." She never forgot that a Japanese philosopher had once told her black contained all colors. Hubert Crehan was amused to hear her defiantly insist that her work was "not wood, not black, and had nothing to do with death"; he interpreted her denials as part of her desire to transcend her raw materials.

"Ancient Games and Ancient Places" was widely praised and led to her being invited to become a member of the Grand Central Moderns Gallery, along with Byron Browne, Hugo Robus, Maurice Sterne, and other well-regarded contemporary artists. She agreed to a one-third commission and to donate one piece of work a year to the gallery for the next three years. During that time Colette Roberts acted as her business manager and publicist, putting together a slide lecture called "Nevelson's Elsewhere" and shepherding her wherever she went, "as if they were Gertrude Stein and Alice B. Toklas," according to Sidney Geist. Colette strongly supported and identified with her artists, and according to her son Richard Roberts she regarded Louise as "an extraordinary person and loved her dearly." The two women shared a lively sense of irreverence and a streak of unconventionality and liked to travel together. Colette was sometimes disorganized, the business end of her gallery was often neglected, and she was not known for bringing artists and collectors together; but she returned to France every summer and kept up her ties with influential members of the Paris art world. During the next few years she would bring to Louise's studio Marcel Duchamp, Pierre Soulages, Georges Mathieu, and other French artists and art critics who would turn out to be immensely important to her career.

Queen of the Black Black

Queen of t black black
King of t all all

—*LOUISE NEVELSON*

ALTHOUGH MIKE SUGGESTED that it was unrealistic to think of owning another house, Louise persisted in her search for one. By the autumn of 1955 she had become physically ill from her efforts to subsist on her teaching salary and at the same time look for a house she could afford. Lonely and despondent, she believed that nature, having given her generous amounts of energy and creativity, had also bequeathed her confusing, crippling periods of depression: "You can only conceive of drives when there are great negatives within one's life. It is a night. And then you *have* to fight for the day." From time to time she sought psychiatric help, usually for short, intense periods when she was particularly troubled, often because of difficulty with a close relationship. In general, she was guarded about describing such times, but she hinted at the distress they caused her. "There have been moments in my life when I was under such pressure and in such conflict that my temples seemed to be tightened by pain as if they were being penetrated by screws,"

she said once. "I know damn well what it means to be screwed up."

Once while visiting Mary Shore in Gloucester, she got up in the middle of the night to look for the liquor; Mary heard her and followed her downstairs, where Louise began to reveal her anxieties. In 1961, when Mary heard that Louise had checked into a midtown hotel "to rest," she gave her a copy of *Curable and Incurable Neurotics*, the latest book by the controversial Viennese psychiatrist Edmund Bergler. Bergler believed that creative expression emerged from attempts to resolve neurotic misconceptions and other forms of what he considered psychic masochism. Louise, who regarded her creativity with reverence, was nonetheless impressed, recommended the book to Mike, and consulted Bergler perhaps two dozen times before his sudden death in early February 1962.

After seeing one of her exhibits, Bergler had labeled her a gifted but extremely masochistic artist. Louise later recalled that she had asked, "Look, Dr. Bergler, how on the one hand can you say the show was good and everything and that I lack this, this, and this?" His response was: "The show is good in spite of you." She found this reply very interesting but of little help with what she regarded as the painful side of creativity. "And I thought, well, the nature of creation is masochistic anyway because you have to go inside and dig out. The very nature of creation is not of a performing glory on the outside. It's a painful, difficult search inside."

Although Louise accepted this form of suffering, she intimated to a young woman she had befriended, Clover Vail, that she had persistent psychological problems; she confided that she wished she had had a mental breakdown and subsequent recovery because this might have helped her resolve some of her conflicts. She later observed that psychiatry could give people another view of themselves but could not provide ultimate answers. She tended to use instead psychological denial and absorption with work to escape from personal problems.

She also had faith in metaphysics, spiritualism, and Eastern religions. According to Colette Roberts, serenity meant to Louise "the achievement of Unity," the opposite being a feeling of fragmentation. In her work she was moving from a focus on the object to a concentration on her own personal "elsewhere," as she searched for a "oneness" in herself, a form of psychic integration. Looking for the essential thread that wove through everything, she

often greeted a new idea with "This is the common denominator!"
She tried in turn Christian Science, New Thought, Zen Buddhism,
and Rosicrucianism. In the early 1950s she had become a member
of the Scientology movement, a religious philosophy founded in
the 1940s in California by L. Ron Hubbard and devoted to inner
healing and self-discovery; in the winter of 1956–57, although she
had very little money, she sent the group $225. She also liked to
have her future predicted by fortune-tellers and astrologers, but it
is hard to tell how seriously she took them. When she returned
from one such session in the mid-1950s, she took a beer from the
refrigerator and remarked to a friend that she had been told she
would die wealthy. "Imagine that son of a bitch telling me I'm
going to become rich!" she angrily declared.

During the autumn of 1955 she concentrated on several dozen
black rough-hewn wooden pieces marked by nicks, splits, and
gouges for a February–March show—her first entirely black ex-
hibit—at Grand Central Moderns. She carved them delicately, sub-
tly highlighted them with touches of silver and gold paint, and
carefully organized them into intricately varied relationships. The
one-woman exhibition, "The Royal Voyage," was even bolder than
the previous year's show, as the bride's travels metamorphosed
into a queen's journey. The enormous queen, represented by a
seven-foot beam, was perforated in three places; like the bride, she
had a mate in name only—the royal couple were placed far apart—
and exuded a mysteriously powerful presence. The king was an
even larger, tar-coated hardwood beam, eight feet high, two feet
wide, and one foot thick, which Louise and Marcia Clapp had dis-
covered on one of their searches around Manhattan in Marcia's
station wagon. The two figures were on an imaginative journey by
sea to an abandoned civilization, *Forgotten Village*, bearing gifts
represented by a large pile of abstract terra cottas, and accom-
panied by a personage with a spiked headdress evoking an Indian
chief. In mythology, the psyche's masculine and feminine polari-
ties, which seek to be united, are often represented by a royal
couple. "I'm a queen to myself," Louise later remarked. "I'm prob-
ably even a king to myself." Lacking a protective male mentor or
strong masculine lover at this time, she evidently began to feel the
need to incorporate so-called male qualities into her personality.

The exhibition also included "underwater seascapes" com-
posed of driftwood forms and wooden scraps in hinged glass boxes,
which, Colette Roberts observed, was appropriate since "The Royal

Voyage" was taking place in subterranean waters. Other critics saw the sea as a symbol for the unconscious, the voyage as representing the creative life, and faraway islands as the longing for one's unexplored potential. The next year, when Sidney Geist asked Louise to write about her private myth for a group show at the Tanager Gallery, she sent him a poem about a transcendent spiritual journey which he found incomprehensible. He went to see her about it; she listened, agreed with him, and, to his astonishment, told him to change the words about any way he wished. He refused, and they revised it together:

> Queen of t black black
> In t valley of all all
> With one glance sees t King
> Mountain top
> T climb
> T way
> Restless winds
> Midnight blooms
> Tons of colors
> Tones of water drops
> Crystal reflections
> Painting mirages
> Celestial splendors
> Highest grandeur
> Queen of t black black
> King of t all all

Louise's sources of imagery were, like all artists', derived from what she felt and imagined as well as what she saw around her. She observed everything, eagerly absorbed visual information, and easily made use of what was "in the air," as she put it. She undoubtedly had seen or read about Picasso's revolutionary relief constructions, composed of flat and horizontal elements of found metal, which had been displayed at the Museum of Modern Art in early 1950. The title "The Royal Voyage" was perhaps inspired by Martha Graham's 1953 dance called *Voyage.* The use of royal figures was customary among artists at the time; Henry Moore's monumental *King and Queen* had been exhibited at the Kurt Valentin Gallery in New York the previous November, and Giacometti had exhibited groups of large personages in New York. The color black was also commonplace in Louise's artistic milieu: Louise Bourgeois and Alexander Calder had begun to paint their sculpture

black; Sari Dienes worked with charred objects; and Lily Ente used black marble.

Louise Bourgeois had been a friend of Louise's since the 1940s, when she had first shown her own sculpture informally to friends on her roof. Louise missed the first Bourgeois show in 1949 at the Peridot Gallery in Greenwich Village, which contained abstract standing figures made of found wood, but she had asked Mike about it. She attended the next Bourgeois show in 1950, where the sculptor had created fifteen polelike wooden figures and grouped them in environments, and many observers found Louise's 1955 show heavily influenced by Bourgeois's work. Louise shrugged off such comments, remarking that Bourgeois had absorbed a great deal from her visits to the Thirtieth Street house; and when she stopped teaching in Great Neck in 1960, she recommended Bourgeois for her job. Later she acknowledged that "it is true that you are not isolated, and you might get a fleeting thing that penetrates and you [are not] even aware how much it meant to you." It would be paralyzing to feel you could never absorb an idea from anyone, she continued; creation should be free-flowing and uninhibited by such concerns.

By the time Louise held her third one-artist show, "The Forest," at Grand Central Moderns in January 1957, the gallery had moved to quarters on the top floor of 1018 Madison Avenue at Seventy-ninth Street, where Grace Borgenicht and Samuel Kootz had their galleries. With dim lighting and hanging wall reliefs, the exhibition exuded the unified mood of an ominous black forest enclosing a small seaside village. The abstract wooden sculptures, composed of organically twisted driftwood and geometric lumberyard remnants, were clustered in subtle relationships of rhythmic horizontals and verticals; individual pieces were placed in poses of almost unendurable stress where they barely touched.

The most exciting construction was a self-portrait—the looming, primordial black *First Personage*, which Louise always considered one of her first important sculptures. The piece had precedents: in the summer of 1955 she had exhibited *Personage in the Black Forest* at the Sculptors Guild show. Almost eight feet high, *First Personage* was a solid flat slab imbued with human presence; behind and partly hidden was a shadow figure pierced by dozens of sharpened sticks. With its quiet exterior and agitated interior, the double-figure silhouette exuded a sense of highly frag-

ile composure and barely restrained aggressiveness. "The two sort of make a total being really," Louise explained in an interview with Arlene Jacobowitz in 1965. "The front when you meet a person, and then all the dynamics you don't meet. Certainly not all at once."

Early viewers compared the dominating Personage to a beast of the forest, rather like the image of Louise as a devouring tiger with concealed claws that many men held. Unlike earlier figures, this female Personage lacked a male companion, even though she was originally conceived as a bridal figure. Louise had created several somber nuptial pieces for the exhibition, including an extremely long, thin "wedding bridge," on which she glued a half-inch black velvet ribbon, with symbolic houses on either end. But while she was working on the piece, she became so involved in her private fantasy that when she imaginatively "crossed that bridge," she felt for a terrifying moment that she was falling to her death. And while she was carving Personage's face, a knot surrounded by radiating wood grain where a mouth might be suddenly seemed to move like two lips. Frightened by the surfacing of these fears, which Laurie Wilson has linked to Louise's empathy for her mother's unsuccessful attempt to escape her suitor by fleeing across the frozen Dnieper, Louise became eager to get *First Personage* out of her studio and decided at the last moment to exclude the black wedding cake (a particularly evocative piece) and wedding bridge from the exhibition. This unnerving experience ended her desire to display individual sculptures in the round—outside of an enclosure—and they were among the last to be left what she considered vulnerably exposed for quite some time. "I can't come out in the open anymore," she told Dorothy Seckler seven years later.

Doubtless her fear of losing her house gave her an urgent impulse toward enclosure. She now felt compelled to enclose her small sculptures within wooden boxes, "There's something more private about it for me and gives me a better sense of security," she said frankly to Arlene Jacobowitz. An admirer since the 1930s of Joseph Cornell's objects arranged in boxes, Louise had collected old boxes for years, used them for pedestals, even created sculpture with them, but at this time she began to focus entirely on them. Around Christmastime, 1957, she became fascinated by the crisscross separations of a wooden whisky crate. Before long she was eagerly collecting milk, lettuce, whisky, and orange crates. One spring weekend in Provincetown she talked sculptor Chaim Gross

out of his seedling boxes. "My God, more, more!" she cried to Ben Mildwoff, when he gave her a pile of Japanese tile boxes made from inexpensive knotty wood.

She again began to work compulsively, composing interiors for hundreds of crates. Some of her boxes had false doors or were hinged to open into diptychs or half barricaded to conceal internal chambers, which were sometimes empty but more often full of gemlike sculptures. The filled box is an obvious psychological representation of rich interior depths, or a fertile womb, or sexuality, as in Pandora's box. With its variably protected and penetrable interiors, the box became in Louise's hands a half-hidden device that enabled her to express her female sensibility, maternalism, and sexual energy. "She had this power once it was a box," observed one of her studio assistants.

After she made the aesthetic decision to work within a square or rectangle, she understood that her intense attraction to the box was also based on the appeal of cubism. The philosophical value of the cube represented to her, as she put it, "terra firma," a way to anchor flights of fantasy. The conceptual mind seized upon the geometric box as a logical structure, and the dreaming, demonic imagination created the contents. She always believed that while painting gave the illusion of depth, sculpture expressed it in reality and was therefore more factual, more truthful, and better suited to the portrayal of the cube. "Cubism was really a sculptor's form," she explained. In contrast to painting, sculpture made the cube easier to understand: "When we look at the early paintings of the cubist school we find a paradox. The cube is a solid. In painting it becomes abstract. In sculpture we accept the cube: it has become concrete and consequently has been resolved and become tangible."

She continued to work without T squares, drills, or other woodworking tools or machinery, relying mainly on files, hammers, and scissors. She broke traditional rules, invented her own techniques with pins and glue, and soaked wood in the bathtub to make it pliable. She claimed never to have measured with a ruler or yardstick because they were too mechanical and analytical. "I never know my next move," she told a reporter for *Time* magazine in 1958. "I just let it happen. When I let my inner vision guide my hands, there are no errors." Meanwhile, her house and backyard filled up with growing heaps of black wooden elements, carefully organized by size and shape, "like sinners crowding the antecham-

bers to await the Last Judgment," Colette Roberts observed. These were, Colette explained, Louise's "reserve of forms, ready for use, paints heaped on a painter's palette." While Louise often had difficulty remembering a name, she had a prodigious memory for forms. When a dealer telephoned asking for a missing element from a work made years earlier, she quickly found it among fifty thousand others.

She felt she could imaginatively grasp the earlier existence of a board, table leg, or banister rail marked by daily use, weather, accident, craftsmanship, and tell whether it had been "touched, fondled, caressed, even kicked." She also endowed the item with aliveness, claiming that when it was nailed "some of it screams back, and some is quieter," and that breaking or cutting it had to be done with sensitivity. When a black wooden piece on one of her sculptures was nicked, however, she regarded it as simply part of the piece's continuing evolution and had it painted over. Once she mused about giving an old hat form a new life, pointing out that if people really looked at it "they will see it for what it is, not just for its utilitarian use." Quoting the Bible about the meek inheriting the earth, she asked, "And so why shouldn't these [pieces of discarded wood] inherit the earth? They start on a humble note, and they become as much of a unity as any other law that we understand." For her, the functional object arranged in an abstract design integrated reality and imagination. She considered the art of selection "a sculptural act, and I do not consider the selected 'found form' less mine than the invented form," she wrote in one of her catalogs. Because of the randomness inherent in a piece of wood, she understood that its placement had to be precise; and like a musician with perfect pitch, she had a sure sense of arrangement.

She habitually searched auctions, antique and secondhand shops for old lace, clothing, baubles, beaded bags, objets d'art, and native crafts. For her, collecting was a form of continual visual training, a search for recognition of the image or dimension with which she identified. She glimpsed an Indian pot in a Texas souvenir shop and immediately knew she must own it, "because it had everything that I understood." It was not for sale, but she persuaded the shopkeeper to let her have it. She also was attuned to commonplace objects she handled on a daily basis: "I have never seen anyone open a cord so perfectly," Anna Walinska said. "Not to cut it, but gently taking the time to open the cord, to respect the wrapping with a degree of sensibility that was astonishing."

Louise loved living with beautiful objects and claimed to have learned most of what she knew from them: "A white lace curtain on the window was for me as important as a great work of art. This gossamer quality, the reflection, the form, the movement, I learned more about art from that than in school." Jade, linen, lace, silver, silks, and orchids were as much presences to her as human beings and, in fact, "played as definite a part in my consciousness as people." By the 1960s she was living surrounded by American Indian baskets, African sculpture, pewter, Sheffield silver, Chinese lacquer, early American tools, pre-Columbian figures, New England samplers, and hispanic *santos*, simple carvings of saints.

The interesting interplay between the classical balance of the geometric boxes and her intricate arrangements inside was described by some critics as an integration of cubism and expressionism. "The one establishes the artist's affinities with the Expressionism of our time, with the aspiration for an esthetic emotion which is unbridled and deeply felt; the other reveals a sense of design which is nearly Mondrianesque in precision and discipline," Hilton Kramer wrote in *Arts* in 1958. Her attraction to the contrast between an emotive interior and an ordered exterior, especially circular shapes enclosed by rectangular ones, had inspired a painting of eggs in a carton in the late 1920s and made her receptive to the influence of Mayan hieroglyphs enclosed by geometric forms. "If [Nevelson] had to be placed in a standard textbook classification, you couldn't do it," John Canaday wrote in *The New York Times* in 1969. "You would have to saw her in two and file one half under 'Mystic-romantic' and the other under 'Rational-classical' but all you would prove is that she is in a class by herself." Louise herself liked to say that Picasso had resolved the cube, Mondrian had flattened it, and she had endowed it with poetry.

In December 1954, faced with another Maine winter, Mike moved into Louise's brownstone and stayed through most of January while his mother had her first one-artist show at Grand Central Moderns; but by the end of the month he was back in Maine, broke and disheartened. As he carved a large commercial eagle and contemplated taking a commission for a ship's figurehead, he wrote to his mother that he could no longer call himself an artist. Then, at the end of the summer, a tall, attractive, dark-haired twenty-three-year-old named Florence Klettke, on vacation from her sales-promotion job in Chicago, was intrigued by the sign on

Mike's shop, went in, and met him. A few weeks later he proposed, and they were married shortly afterward. When Flo later admitted to her mother-in-law that she didn't always understand the reviews of her sculpture in art magazines but appreciated the volumes and the spaces in the work, Louise replied, "That's all there is, my dear." Their contact was not always so easy, however; and Flo later characterized it as a cordial but distant relationship.

A year later, on October 6, 1956, a daughter, Elsbeth Louise, was born. After Mike wrote his mother that domestic dullness was the price of emotional security, Louise sent her daughter-in-law a black negligée. She also sent boxes of old clothes, toys for her new granddaughter, support payments for her elder granddaughter, and occasional $50 or $100 checks to Mike. Sometimes the checks were gifts; more often they were payment at New York rates for his assistance with her work. When Charles Nevelson died of congestive heart failure on September 12, 1959, in Los Angeles, he left virtually nothing to his son, although he had claimed that he had moved into the mortgage, real-estate, and investment business and presumably had accumulated some wealth. Louise had last seen Charles a few years earlier, after he had a heart attack as he got off a plane in New York; she and Neith brought him a basket of fruit in the hospital. After his death, she sent Mike an especially large check, either to compensate for the lack of inheritance from his father or to ease her guilt about overshadowing him professionally. Mike wrote her that the money would buy him time to return to sculpture.

In the early 1950s, Louise had met Donald Mavros, a young sculptor who was opening a ceramics studio in her neighborhood, and had invited him and his friend Teddy Haseltine to visit. Before long Mavros began to fire her terra cottas for her. After Joe disappeared around 1956, she asked him to move into her house and become her full-time assistant. Besides needing help in the studio, she wanted a buffer against the world. She was finding it increasingly difficult to deal with people in a realistic way; because it was hard for her to say no, she got into situations that made her uncomfortable, and at times she seemed oddly fragile. Mavros politely refused the invitation, explaining that he did not want his emerging sculpture to be dominated by her powerful work. She then made the same offer to Haseltine, a twenty-eight-year-old ambisexual Peter Pan with a wide grin, sharp beaked nose, pointed ears, and brown hair that grew to a widow's peak on his forehead. Teddy,

inventive and capricious, was the archetype of eternal youth, charming but immature. He had studied to be a monk until the day he was forbidden to go ice skating at prayer time, when he walked out of the monastery and never returned. Now he liked to entertain people by making up elaborate stories about himself. He lived in a fantasy world, drank heavily, and took marijuana and other drugs, yet his friends enjoyed his company. "He might be wildly drunk one day and then hung over the next, but he was always whoever or whatever he was feeling at the time," one of them explained, "so that his whole eyes, body, hands, fingers were always expressing whatever it was he wanted to say."

Teddy, who occasionally worked as an artist's model to support himself, agreed to become Louise's assistant in exchange for free board, an arrangement that offered him stability, security, and discipline. In the autumn of 1956 he moved into one of the little rooms on the top floor of the brownstone, which he decorated in an austere Oriental style. (It was at this time that the new owners of 323 East Thirtieth Street notified her that since she refused to lease the top-floor apartment, her rent would be doubled to $200 a month. After Nate interceded, a compromise rent of $150 was reached, an amount that her brother dutifully sent every month to the New York City Collector's office.) Teddy had adored his foster mother, who, with her husband, had adopted him shortly after his illegitimate birth. Louise, now in her late fifties, apparently replaced her in his affections, and he became totally devoted to her.

Early in their relationship, Teddy teased Louise after a night of heavy drinking together about something she had done, which she could no longer remember. She telephoned Donald Mavros and told him to get Teddy out of the house because he was driving her crazy. Donald told her the teasing would pass, and it did; and during the next few years Teddy was the person closest to her. Besides assisting in the studio, he ordered groceries, cooked, played with her grandchildren, provided companionship at mealtimes, and escorted her to openings and parties. He dissolved sugar in water to give her the energy to keep working; he shared her interest in Zen, mysticism, metaphysics, and Eastern religions and accompanied her to hear Krishnamurti whenever he lectured in New York. Louise provided him with pocket money and occasionally wrote him a small check; from 1956 to 1961 she also gave him a number of drawings and sketches lovingly inscribed to him.

She found Teddy endearing as well as stimulating; he was full

of ideas, inventiveness, and creativity. She also appreciated his wholehearted admiration for her work at a time when the art establishment was cool toward it. She disliked being alone, although, like a cat, she sometimes went off to a corner of the house to be by herself with her own thoughts. Furthermore, Teddy acted out the role of free spirit, allowing her to feel like the more responsible person. "While Teddy was making outrageous statements, she would be sitting at the big glass coffee table with a little smile on her face," Mavros recalled. "She was indulging the little boy." When Teddy became too obstreperous, Louise would tell him in a very quiet but firm manner to go lie down until he felt better. While he regarded himself as an artist, he represented no competition, because he was unable to sustain a creative idea for long; he was merely capable of, in the words of Dorothy Dehner, "whimsical willfulness"—and his work remained at the art-student level. After Louise helped him get a show at the Wittenborn Gallery, she was surprised to discover that he actually disliked exhibiting his work. "I thought everyone wanted a show," she said later, but "he didn't give a damn."

There was an enormous rivalry between Teddy and Mike, even though Teddy seemed much more attached to Louise than she to him. As Mike saw it, Teddy "would have poisoned me to get me out." But as a surrogate son, devoted to her more totally than the married, independent, mature Mike, Teddy provided a substitute relationship that apparently helped free her from any lingering inhibitions about overshadowing her son and a sculptor.

In the studio Teddy handled the handsaw, hammered, hefted, nailed, doweled, and searched for the particular wooden elements she wanted. Her spontaneous composing method actually required two people because, lacking a preliminary drawing, she had to hold a piece in the appointed place while Teddy secured it. At other times, she got up before dawn, created an interior for a box, and struck the first nails; when Teddy joined her a few hours later, he drove in the others. He also ran errands to her suppliers—Dykes Lumber Company for wood scraps and I. Mishurovsky for paints— and delivered or picked up her sculptures from exhibitions. At times, the two of them lay pieces of black wood on the floor of the studio, arranging as many as twenty reliefs at once, with a lot of "give and take," according to Mavros; Louise sometimes agreed that Teddy's way was better than her own.

Dressed in a long bathrobe, perched on a low wheeled stool,

and surrounded by half-a-dozen fruit baskets containing scraps of similar shapes, she would start composing at the far end of the room, move with the stool, start another composition, and gradually move down the row, then make another pass at it. From time to time she got up to drink coffee, rest, and smoke. "What I do, actually, is the judgment," she once explained to *Newsweek*. "I have to decide. 'Does this function for me?' It's a matter of placement and arrangement. I let things lie around sometimes for years before I can use them. They just won't fit in, and then suddenly, they are perfectly right."

Teddy habitually referred to the resulting compositions as "our" creations—once remarking to sculptor Worden Day that "This is the best piece we ever did"—and friends often offered Louise and Teddy joint congratulations. Colette Roberts had two possible explanations for Louise's own frequent use of the word "we" when referring to her work: one was the artist's way of acknowledging that the sculptor and the sculpture were one; the other was her recognition of Teddy and various other helpers.

Around this time Teddy was creating black three-dimensional paintings, collages, and constructions with ebony and black paper. He used to tell his friends that he had created black boxes—small, delicate, filled with beads, spools, and other scavenged oddities—before Louise developed her own. Most people disregarded Teddy's claim, but Donald Mavros believed that Louise and Teddy had forged a mutually dependent working relationship as well as an artistic "collaboration." Another studio assistant, Tom Kendall, came to believe that Louise with her driving ambition, personal force, and capacity for hard work had indeed taken over and developed Teddy's idea. "I don't mean that it was outright theft," he explained. "But there's a way of absorbing, perhaps, the full thing and suddenly, 'Oh, I'd like to try that'—and then suddenly, 'These are more powerful than his. Not more beautiful, but more powerful.' And then, 'They're richer; they're deeper.' " When Louise began to create black boxes "it ate his heart out," but Teddy was incapable of action because "he needed a mother." His work may indeed have been an inspiration to her, but he was only one of several who claimed to have influenced her after her work had become successful. Irene Rice Pereira later swore that Louise had gone through the garbage cans outside her brownstone searching for Pereira's discarded drawings, on which she would later base her boxes.

The brownstone became a very fluid household as Teddy brought his friends around, young helpers described by Colette Roberts as a band of "sorcerer's apprentices." After Teddy left for Maine in a fit of temper during the summer of 1958, Bobby Buecker, an ebullient artist who had met Louise at a Grand Central Moderns opening, knocked on her door and asked for a place to live in exchange for assisting her. That same summer, Georgette Michaud, a pretty young artist, moved into the household and stayed, on and off, for three or four years. Unable to bring herself to ask for a salary because the household seemed so much like a family, Georgette depended on Louise's twenty-five-dollar checks; Louise also gave her at least one small black box. Years later Georgette admitted that she would have starved to stay around. When Louise arose at dawn and went down to her studio, Georgette would join her and be greeted by Louise's words "Well, Sarah Bernhardt, are you up?" Patty Bosse, a young divorcée, also enjoyed the milieu but declined Louise's offer to move in, fearing a loss of independence. Louise used to invite her for lunch, then casually ask her to bring along a red snapper, or her car so they could drive to Jones Beach to look for driftwood. "If you served Louise Nevelson, you were welcome; if not, you went away," Donald Mavros explained.

Strict about a few things, such as maintaining a sense of order, Louise kept the loyalty of her assistants by her personal magnetism, her comforting maturity, and her way of treating them as comrades. Her quiet dominance was tempered by her ability to create a busy, peaceful, purposeful, and exciting atmosphere around her. Life was also informal; Louise and her assistants felt free to drink wine or smoke marijuana or turn the radio to classical or rock stations even in the studio. "There was a certain joy in working with her," Tom Kendall found. " 'Now what is it that you like to do, Tom?' she would ask, or 'Now this is going to take a little time, I understand, so I'm not going to hurry you.' " Kendall had become eager to meet Louise after seeing her black work, and she became interested in his background: he had been raised in Peking and educated at Yale and Columbia, where he had studied with the great art historian Meyer Shapiro, and was related to the artist Childe Hassam.

Louise's productivity and enormous exhibition activity depended on both the use of assistants and a working rhythm that enabled her to create rapidly an abundant, rich, and complicated body of work. She had no telephone in the studio. "Suppose I want

to work today. Someone says something on the phone today that hits me the wrong way. That day is gone," she explained to an interviewer. On days when she felt unable to compose, she painted or arranged and stacked elements. When a day's work was finished, she had the studio swept down and the tools and materials put away in precise order for the next day. When she began work again at dawn, she could count on the fact that "everything is clean, is nice. You are very happy. You start working." She and her assistants worked from early morning to lunchtime and occasionally after lunch if she was eager to complete a sculpture. Sometimes in the afternoons everyone would fumigate for bedbugs or scavenge for old wood. In the evenings they would scrub down, dress up, and go out together to art-world openings and parties.

After delays in the plans for the Kips Bay redevelopment project and promises from the mayor and other politicians that the area would not be razed, Louise was suddenly notified that, beginning the first of November, 1956, she could be asked to vacate the premises on thirty days' notice. She began to get up at three in the morning to rummage for debris near the demolished buildings around her. At times she still refused to accept the reality of the eviction; at others she was in despair over the relatively small amount the city was giving her as compensation, and she hunted with increasing urgency for another home.

In the midst of this uncertainty, her work and imaginative reality became more important to her than ever. She was creating about sixty pieces a year, and near the end of the 1950s there would be some nine hundred sculptures crammed into the brownstone, stacked one on top of the other, occupying every room, even the bathrooms. To make space for them, she put out on the sidewalk the tables, chairs, chests, and other household items she was discarding and did not want to break apart for her work; she sold another twenty pieces of furniture, including a stove and a refrigerator, for $175. "I must be able to see!" she explained, referring to her need to have her heightened visual imagination unimpeded by utilitarian objects. While her January 1957 show was still on display at Grand Central Moderns, she turned away praise by insisting, "This is nothing . . . You should see what I am doing now . . . now it is what I want to say."

Five months later William Zeckendorf, Jr., of Webb and Knapp, Inc., took over the three-block development property and

announced that a $30 million construction project would begin the next year. During the following months, more than a thousand families were relocated, and only 150 households—including Louise's—remained inhabited.

Dorothy Dehner asked Louise if anyone had ever photographed all her work in the house and when she said no, Dorothy offered to do it herself, even paying for the film, as both a chance to experiment with her new camera and a gesture of friendship. "I just thought, This work has got to be recorded," she explained later. She was apparently unaware that the previous year Jeremiah Russell had photographed Louise's work. Instead of paying him for what amounted to three hundred negatives, Louise presented his wife with a number of gifts—"a somewhat worn shawl, a large round shallow basket beginning to fray, a beaded dickey, a glass jar with [a] lid," even a delicate necklace of mother-of-pearl flowers. That summer Dorothy took the bus every morning uptown to Thirtieth Street, buying fruit and eggs for lunch along the way, so as not to impose on Louise: "I brought my lamps, my tripod, and my wonderful camera to her studio, and I photographed everything." She methodically made 450 exposures—three of each view, including the view from the steep stoop toward the river, the basement studio, the garden, and everything on the parlor and upper floors. Besides photographing Louise's sculptures, paintings, and drawings, she shot the Eilshemius paintings and the pre-Columbian sculptures displayed on black shelves. Louise later said she was very grateful that Dorothy had everything on film because not only did she eventually cannibalize most of the sculptures, the entire milieu was destroyed as well. In return, Louise and Teddy gave Dorothy a small box sculpture, and in February 1959 Louise gave a party to celebrate Dorothy's exhibition of bronzes at the Willard Gallery.

During the autumn of 1957, Louise worked on her third January exhibition at Grand Central Moderns in her condemned house with only a couch, a pillow, and a Hudson Bay blanket—"just enough for the sleep of a warrior," Colette Roberts observed. "Often she threw herself down, fully clothed, ready to resume the moment the edge of fatigue was blunted . . . 'Who cares?' is her war cry against anything that stands in the way of her immediate urge to create. For nothing matters to Nevelson except her work, and the endless discoveries of life, all interwoven." Louise readily acknowledged a few years later that "I'd rather work twenty-four hours in

my studio and then come in here and fall down on the bed than do anything I know. It's like pure water; it's living."

In October, the French artist Georges Mathieu visited what he regarded as her mysterious "Kafka-like" home and became the first European to acquire a Nevelson sculpture, which always retained its "magic power" for him. He described the setting:

> There is no place to live; no living room, no entrance hall, no bedroom, no kitchen, no pantry, no dressing-room, no bed, no table, and no tub. Yet, one finds thousands of closets, thousands of cupboards, of chests, of coffins, of boxes, thousands of Nevelsons. . . . Nevelson is there, engrossed in her thoughts, weary of having killed so many lovers for so little joy. They are all lined up, hung: Mediocrity, Bourgeoisie, Egoism, Security, The American Way of Life, Comfort, Stupidity, Opportunism, Self-Indulgence, Vanity, Glory, Health . . . Life.

Louise had now begun an off-and-on affair with Hubert Crehan, the managing editor of *Art Digest*, a burly, red-haired, blue-eyed Irishman from San Francisco almost twenty years younger than she was. They had met while sitting side by side at an Artists' Club meeting where some well-known artists were trying to define the nature of art. Hubert was intrigued by her face, which appeared to be smeared with Vaseline—"She was gleaming in a jellied mask, and looked like some mannequin out of the waxworks"—at a time when her use of a glossy, sepia-brown makeup, heavy eye shadow, and no lipstick made her look wild and bizarre despite her beautiful bone structure. Before long, she abruptly arose and declared, "I thought everyone knew that the purpose of art is to inspire the creation of a beautiful city!" Her non sequitur created an astonished pause in the debate; such outbursts were often incomprehensible, especially if she had been drinking. When the discussion turned to a book on aesthetics that Crehan had just read, Suzanne K. Langer's *Feeling and Form*, he stood up and gave an impromptu lecture about it. Louise, impressed, nudged him and whispered, "You tell 'em." An intellectual as well as a soft-spoken but spellbinding speaker, Crehan reminded her of Céline. A few weeks later, when a participant dropped out of a program Louise was organizing on symbolism in abstract art, she asked Crehan to step in; he obliged, and afterward she invited him to a party, where they become better acquainted.

Typically, it was Louise who walked into Hubert's studio and declared: "I'm ready for a hot romance with you." She called him her bulldog and said she wanted to hold the leash. But she complained that she could not afford him because he could come up with only a few coins for a pitcher of wine or to play her favorite song, Perry Como's "All at Once You Love Her," on the jukebox of their favorite bar, on Third Avenue. Still, the relationship was not without its highly romantic moments. During a period when Hubert was in San Francisco, he was surprised, since he knew that she rarely wrote letters, to receive a large envelope from Louise. Inside was the sheet music to "All at Once You Love Her." Back at his studio, when he made vodka-and-lime cocktails on crushed ice and affectionately put Maurice Chevalier's rendition of "Louise" on the record player, Louise unexpectedly began to weep. And there was the winter night when he heard a knock on his door: "It was Louise with snowflakes in her hair, a shawl over her shoulders, holding a pair of low-heeled golden slippers in one hand." Barefoot, she instructed him to take off his boots and walk with her to the East River to watch the lights of the tugboats and the Brooklyn shore through the falling snow.

Because of his position at *Art Digest*, Louise expected him to write about her sculpture. When he did not, she was offended. "She was interested in the 'line,' in geometric arrangements, while I am more attracted to the 'scribble,' or amorphous, biomorphic forms," Crehan, who was also a second-generation abstract-expressionist painter, explained. At the time, however, he expressed respect and even admiration for her work, and he always assigned critics to review her shows. Like many men before him, he had serious reservations about her personally: "I felt that Louise's ambition and her image of herself as a prima donna was an impossible thing for me to deal with. I decided it would be a bad move to marry a woman as old as she was who was absolutely self-centered in her dedication to her work."

Before the start of an artists' meeting on the subject of collectors, Louise confided to Elisabeth Model that she was in love with "Hub," who was to be one of the panelists. Suddenly Crehan walked in, accompanied by a young girl. Obviously deeply embarrassed to encounter Louise, he praised her work incessantly once the discussion got under way. Louise understood why he was so flattering, but she proudly said nothing. After Hubert married the girl, an Oberlin art-history major named Anne Stoltz, Louise

invited her to lunch. The two got along well, and in the middle of the meal Louise lifted her wineglass and said, "I hand over the torch to you, my dear," and presented her with one of her etchings, *A Wedding in the Heavenly City.*

Louise's fourth exhibition at Grand Central Moderns, in January 1958, was titled "Moon Garden + One." The "One," Colette Roberts explained, was intended to encourage the onlooker's own "nocturnal garden." During the installation, Louise worked on the spot, because she believed spontaneous composing would add "great vitality" to the show. Like a stage director, she ordered a desk, chairs, and other furniture taken out of the gallery, arranged for two walls to be painted black, covered one window with paper and placed a sculpture on the sill of the other. "It was the first time we had no intrusions from anything else," she later told artist Harold Weston. As she attempted to relate each black construction to the next, she envisioned the gallery as one gigantic sculpture or "ensemble." "Everything has to fit together, to flow without effort, and I, too, must fit," she explained to a *Time* reporter. Instead of a sculptor who made objects, Louise had become in her own mind a person who imposed herself on an environment.

The installation was completed in the dusky late afternoon— a dense presentation of 116 matte black boxes of varying sizes stacked along the walls with rather rough, sometimes wildly ragged forms placed on pedestals in the center of the gallery. The show contained *King II* (1957), a personage placed in a constructed coffinlike box, suggesting that the male mate from earlier exhibitions was now definitively buried. Louise realized that she had achieved an artistic breakthrough; she later acknowledged that what she had created was intensely personal imagery, and she rejoiced in it. "Slowly, majestically, she stripped herself of her workshirt, radiant with joy, and slowly, in an incantatory mood, the sculptor started to dance," Colette Roberts wrote. "This hieratic dance in front of the megalithic forms seemed like a part of a druidic festivity, a rite where body and soul merged." Louise, dressed all in black, was soon joined by Teddy Haseltine. In earlier years, she used to perform solitary, sometimes embarrassingly awkward dances late at night at parties; now she and Teddy, who had also studied modern dance, often put on exotic robes and performed bizarre dances together, particularly after they had been drinking. On the day of the installation, however, the dance seemed to be a

formalization of the physical aspects of the sculptor's work as well as, in Roberts's words, "a dance of ecstatic gratitude and joy, an act of grace toward the unknown forces which let her achieve her ultimate aim in life: Creation." In succeeding days Louise was often at the gallery, wrapped in a heavy black wool coat, wearing dark red lipstick. Although the show seemed to many visitors to be a private sculpture garden or a cemetery at night, she had another explanation: "This is the universe, the stars—the moon—and you and I, everyone."

The dimly lit, highly theatrical atmosphere of "Moon Garden + One" was intended to overwhelm viewers, whom the sculptor had deliberately attempted to disorient in order to make them question their own everyday reality and accept her more imaginative one. Obscurity, even partial blindness, was key to this effort. At first Louise rejected the idea of using any light at all; but, the story goes, a few hours before the opening, Erwin Barrie, director of the parent Grand Central Gallery, tossed a blue scarf over a lamp, convincing her to use a few blue bulbs. Frederick Kiesler is also said to have encouraged her to exaggerate shadows with cool bluish light. (Louise, unable to recall whose idea the unusual lighting had actually been, later described it as a collective decision.) Another influence may have been Martha Graham's darkened abstract dance sets and her use of dominant, heavily made-up female dancers.

"On entering the gallery one feels first a breathless, imageless stir, remembers Dylan Thomas' 'seizure of silence,'" Emily Genauer wrote in the *Herald Tribune*. "Gradually the forms become clearer: the rhythmic recurrence of the shapes and lines of curved fragments and jagged ridges densely arranged within confining boxes, the lids one may lift (symbolically?), the play not of light and shade but of shadow and blackness." The jet surfaces absorbed most of the available light, but as the viewers' pupils dilated and slowly adjusted to the darkness, shapes floated into sight; every so often one object was illuminated slightly more than another, effectively evoking the murky, mysterious, subconscious mind.

When she studied at the Art Students League, Louise had not understood that shade was as important as light. Now the shadows and silhouettes took on more significance than the nails and edges that cast them; she had, she told Dorothy Seckler in a 1964 interview, arrested the "fleeting" shadow and given it stability, solidity, and substance—a stronger presence than the actual surface itself.

"I used shadow as if it were made out of stone and gave it a form, and it became mine," she declared in a panel discussion.

In the January 1957 issue of *Arts*, Hilton Kramer reviewed "The Forest" and explained that to the artist, sculpture was "a plastic embodiment of pure shadow to which light is admitted in a subtle and fugitive way. . . . Without grasping the presence of that consciousness and entering into it in some degree, I suspect any viewer would find Mrs. Nevelson's art merely eccentric. . . . One must really enter the shadows before one can *see*." Louise was so pleased with the review that she sent him an etching and began calling herself "an architect of shadow."

Perhaps the most important part of the "Moon Garden" exhibition was Nevelson's first wall, *Sky Cathedral*, a towering accumulation of nearly sixty filled boxes of differing sizes, more than eleven feet high and ten feet long with an uneven silhouette. After she had started to stack her boxes along the walls of her house to make room for them, she liked the effect so much that she decided to display them formally that way in the gallery. To Hubert Crehan, her single coffins were now a wall of sarcophaguses, a mausoleum, or catacombs; to Mike they suggested the wall of stacked boxes for nesting pigeons she had seen in the 1940s. Others saw in each box a letter in an undeciphered alphabet or an echo of Mayan glyphs, where a head might be repeated again and again. Other visual impressions had also been inspirations, conscious or unconscious. One winter day when Louise and Dido Smith passed Bonwit Teller's windows, Louise suddenly stopped, "transfixed" by the sight of black walls made out of irregularly shaped open shoeboxes as a backdrop for black-and-white gowns.

She had been searching for a way to achieve monumentality in her work ever since she had seen the Mayan ruins of Central America, partly as an expression of her vitality. "At that time, if I'd had a city block, it wouldn't have been enough, because I had this energy that was flowing like an ocean into creativity," she once told Diana MacKown. She also complained that her box constructions were "dwarfed" by the huge canvases of the abstract expressionists. With her walls, she became one of the first artists to violate successfully the taboo on large interior sculpture. The scale of *Sky Cathedral* and her later "forests of black boxes" rivaled in size the paintings of Pollock, Reinhardt, Rothko, Barnett Newman, and Clyfford Still, reducing the viewer to a diminutive Alice-Through-the-Looking-Glass amid oversized chess pieces.

Louise also shared the abstract expressionists' fondness for speed of execution and tolerance of accidents in their work. Sidney Tillim in *Arts* called her "an action painter with solids" since her walls showed such painterly qualities as chiaroscuro, frontality, surface composition, and, eventually, rectangular framework. Perhaps most important, she was influenced by the New York school's common use of white with black enamel paint.

Reviewers were excited and astonished by the power of "Moon Garden" to arouse real and confusing fears. Some, however, had reservations, believing it was meretricious to disregard quality in individual pieces for the sake of emphasis on the entirety. Hilton Kramer was among the few critics who found many sculptures more interesting than contemporary painting, and he wrote the first serious critical appraisal of Nevelson's work in the June 1958 issue of *Arts*. "Far from being an eccentric or an off-beat expression, [her work] takes its place in the context of contemporary sculpture with great ease and distinction," he wrote, identifying it with the constructivist tradition that had emerged from the Russian avant-garde in the second decade of the twentieth century. Writing about her walls, he concluded, "They are appalling and marvelous; utterly shocking in the way they violate our received ideas on the limits of sculpture and on the confusion of genres, yet profoundly exhilarating in the way they open an entire realm of possibility." When his article appeared, Louise sent him a telegram which said simply: "I love you."

The "Moon Garden" exhibition caught the attention of the national media, and *Life* promised a feature if the show stayed open for another two weeks. Colette Roberts obliged, and in *Life*'s March 24, 1958 issue there was a greenish photograph of Louise in a black peaked witch's hat crouching over her work. The accompanying article described her as "a sorceress in her den." "Although I don't really think you're a witch, I was delighted to see you get almost as much attention as *South Pacific*," wrote Robert Rosenblum, professor of art at Princeton University. Artists as well as critics recognized that Louise had created "a very new kind of feeling" and "a whole new way of looking at sculpture," in the words of Ibram Lassaw. The *ARTnews* staff voted her exhibition among the ten best of the year. Reveling in her new success, she arranged for Condon Riley, who had a gallery on East Sixty-seventh Street, to promote her work for a percentage if she sold anything as a result of his efforts. She predicted to a group of fellow artists

that she was going to become more famous than Picasso and was sharply reprimanded by the wife of one of them, who reminded her that she was a visual artist, not an actress.

Up to now, Dorothy Miller, the Museum of Modern Art's curator of museum collections, had been unable to persuade museum officials to buy Louise's work or to include it in an important show. "Several times we took a work of Nevelson's to our acquisitions committee and couldn't put it over," she said. Miller had first visited Louise's East Tenth Street studio in the early 1940s to consider her sculpture for one of the Modern's exhibitions of select groups of avant-garde American artists held every four years or so. Louise had been bitterly disappointed when her name was dropped from the list for the 1946 exhibition. Dorothy remembered that Louise was "very hard up" and "absolutely magnificently beautiful," but she was bewildered by her work, particularly "little sort of platforms with objects on them that were a little bit like certain surrealist things of Giacometti. She showed me things that were just absolutely the direct ancestors of what she became famous with later. But it was somehow too soon."

Dorothy and Alfred Barr had gone to her first shows at Grand Central Moderns: "We were careful not to miss them, because somehow we sensed something about Louise." Then, on a visit to Paris, Dorothy was impressed to learn that Louise had a reputation in French art circles. Afterward, sitting in sculptor Helena Simkhovitch's Victorian walled garden on West Tenth Street during a "Sculpture in a Garden" show where Louise's black wood *Sky Image* was boldly set off against a whitewashed brick wall, she declared: "We have to do something about Louise Nevelson!"

Colette Roberts had taken her friend Marcel Duchamp to see the "Moon Garden" in January 1958, and his enthusiasm for the show enabled Dorothy to persuade Barr to see it; the museum officials both found it, in Dorothy's words, "a total surprise" and immediately wanted to include *Sky Cathedral* in an exhibition of the Museum's collection. "Alfred said, 'We *have* to have that wall— we simply have to have it,' " Miller recalled. "We were all just completely bowled over by her work which had come to this marvelous state of fruition." Because of the museum's minimal purchase funds, they asked Colette if she knew of a collector who would donate it to the museum, and soon afterward she telephoned to say that Lillian and Ben Mildwoff would be donors (Louise reportedly agreed to give them the wall for nothing). The Modern's

trustees tentatively approved the acquisition the following month.

The Mildwoffs already had begun to donate Nevelsons to other museums: through the Federation of Modern Painters and Sculptors' tax-deductible gift plan, Ben had given *Black Majesty* to the Whitney Museum in 1956; the next year he gave *Dark Shadows* to the Newark Museum. The Brooklyn Museum acquired *First Personage* in a similar manner from Nate Berliawsky. Louise had joined the gift plan in the 1954–55 season, and her work was among the first to go to permanent museum collections: Alabama's Birmingham Museum of Art, the Museum of Fine Arts in Houston, the Farnsworth Museum in Rockland, and others. In gratitude, she threw a party at her house for Harold Weston, Federation president and creator of the plan, which by 1957 had placed twenty-seven works by various artists.

The following autumn, when the Museum of Modern Art re-opened after a fire, she adapted *Sky Cathedral* for a darkened upstairs corner. After the museum's truck delivered the wall to the museum, she assembled it with the help of Teddy and had the museum workers nail it together. As usual, she added details on the spot, this time placing a vertical pole in front of the wall. French sculptor Jean Arp, who was in New York for a one-man show at the museum, recalled that on the day of his opening, October 8, 1958, Louise and her helpers were installing the gigantic sculpture. He watched with fascination, remarking, "This is America, and I will write a poem to the savage." The poem appeared in the March 1960 issue of the French art magazine *XXe Siècle*, bestowing on Louise a particularly prestigious form of recognition.

Although the number of New York art galleries doubled during the 1950s, Louise had still made few significant sales. The situation was immensely frustrating to her; she had been working as a professional artist for twenty years, her house was overflowing with sculpture, and her work was being accepted by museum collections. The entire "Moon Garden + One" exhibition had been priced at $18,000, but seven individual boxes from it had been sold for as little as $95 each, including one to art dealer Betty Parsons. Some art circles had written Louise off as an artist's artist. At times she blamed her lack of sales on her use of old wood, explaining that collectors wanted to invest in marble or bronze instead. Meanwhile, her financial anxieties grew. She was now almost sixty and needed a steady source of income to pay for assistants, materials,

and other expenses connected with her work. She also needed money to buy a new house and to help her son support his family.

One of the new galleries had been started by Martha Jackson, a Smith College graduate from a wealthy Buffalo family with a passionate interest in art. She had moved to New York after her second divorce and opened her gallery in 1953 at the suggestion of Hans Hofmann. Martha, a stubborn, straightforward business-woman with a flat, nasal voice, exuded the "atmosphere of a loser, a victim, a deep sadness," according to Lillian Kiesler, Frederick Kiesler's second wife. Although the Martha Jackson Gallery spe-cialized in contemporary American and European artists, Martha had an uneven knowledge of art and, Dorothy Miller remembered, made "surprisingly naive remarks." But she also had good instincts and the ability and willingness to promote artists.

She had admired Louise's work since the summer of 1956, when Louise loaned her a sculpture for a garden exhibition. In 1958 she invited her to join her gallery, which had become, along with the Sidney Janis Gallery, one of the city's most prestigious and best-financed. Louise accepted, a decision Colette Roberts understood and supported, since Grand Central Moderns was a showcase gallery without funds to promote or buy an artist's work or even to pay exhibition expenses. "As far as owing anything to anyone, you know damn well I owe you more than you will ever owe me . . . [ellipses hers] things that cannot be measured in money nor in anything else but JOY," Colette wrote Louise two years later. "The world you have created is all your own and roaming around it with you has taught me so much." Martha for her part was glad to have a woman artist in her gallery. "She believed in women and felt they were not treated right," according to her son, David Anderson, the gallery's business manager. Most important, Martha was genuinely enthusiastic about Louise's work, and during the next few years a Nevelson wall would usually be on display in a second-floor space nicknamed "The Enormous Room."

American dealers had begun to follow the European method of giving artists a salary in exchange for works of art, and the first real financial security of Louise's professional life came when Mar-tha offered her a guaranteed income in exchange for sculpture purchased at the standard artist/gallery split of 60/40 percent on signed sales. Martha even agreed to advance money against future sales whenever Louise needed it. On one occasion, after Louise had expressed anxiety about their arrangement, David Anderson re-

assured her by stressing her importance to the gallery and writing, "If you have to have some $ for any reason, just call me, and of course I will send a check immediately." It was agreed that some sculpture in Louise's huge inventory would be sold at the present low price of $60 a square foot, so that a ten-by-fifteen-foot wall would cost $9,000, and some only when the price went up. Other pieces would be sent abroad. As plans for a one-woman exhibition in late 1959 got under way, Mike found Louise "happy and whole" as she anticipated the end of her financial problems and the fulfillment of her artistic aspirations. In August 1959 she sailed for Europe with her two sisters and Lillian's red-headed fourteen-year-old daughter, Susan, who was to attend a boarding school in Switzerland. In Winchester, England, Louise bought a silver-and-crystal necklace and an 1820 crystal ring and immediately had the gallery send her $2,000.

About the same time that Martha Jackson offered to represent her, Louise had seen a building-for-sale advertisement in *The New York Times*. It was at 29 Spring Street in the Little Italy section of lower Manhattan, bordering on Chinatown and the Bowery. She asked Teddy Haseltine to take a look at it, and he described a five-story building with a flower shop, a candy store, and a barbershop on the ground floor, and on the second, small doctors' offices with concrete floors (she later heard rumors that it had been a sanitarium and an abortion mill). At first she refused to look at it after this unpromising report, and when she finally did, she complained that all she could afford was an awful house in the middle of nowhere. Nevertheless, in September 1958, with loans for the down payment from her brother and brother-in-law, she bought it. But even after everything had been moved, she refused to leave Thirtieth Street, so Teddy stayed with her there until he could persuade her to vacate the premises. She finally arrived at Spring Street and, uncharacteristically irritable, demanded that Bobby Buecker take down the Eilshemius paintings he had carefully hung for her. Then she went to bed, where she remained for several days.

Her first show at the Martha Jackson Gallery, "Sky Columns Presence," opened for a month on October 28, 1959. Louise claimed that she had not bothered to change her clothes or the sheets on her bed during the difficult weeks of preparation, when she was simultaneously working on other important exhibitions. She had installed floor-to-ceiling black walls the entire length of the gallery, and there were clusters of four- and five-foot-high totemic columns

tightly and heavily encrusted with small shards of wood, which, like her use of sun and moon emblems, were directly derivative of what she had seen in Central America. An enthusiastic review by Dore Ashton appeared in *The New York Times* the day after the show opened, with a two-column photograph of *Sun*, a roundish encrusted arrangement of wood fragments placed in a box and displayed on a pedestal:

> Once again Louise Nevelson, grand mistress of the marvelous, illuminates her fabled world . . . [and she] surpasses everything she has done before. . . . There are circular compositions with elegant plays of half-moon and angular shapes; long plaques with flutters of small elements sifting into "in between places"; pegs, lattices, dividers, dominoes, wheels, and chevrons. There is even a ghostly structure resembling a pianoforte.

Ashton acknowledged that Nevelson was not the first artist to create an environment, but "never has anyone saturated a room with such ideally idiosyncratic poetry." Martha Jackson had hired a professional lighting expert, Schuyler Watts, to unite and dramatize the sculptures with red and green spotlights that "bled out the blacks into positively lunar shades of silver, greenish silver and reddish silver until the eye no longer knows what black is—if it ever did—and still less what white might be," Ashton wrote in the December *Arts & Architecture*. During the next few years, Louise cultivated Ashton's friendship and traded work with her husband, artist Adja Yunkers. In 1961 she insisted on being godmother to their eldest daughter, and the infant was named Alexandra Louise in honor of the friendship. By the mid-1960s, however, when Ashton developed reservations about Nevelson's work, Louise lost interest in both the friendship and the child.

During the exhibition, the gallery held work valued at $150,000, which, after a 40 percent commission, would if sold earn the artist some $90,000. Louise began to indulge in grandiose financial expectations, remarking to a *Newsweek* reporter that, instead of selling individual pieces for $3,000 or $4,000 each, she intended to sell the entire show intact for "a quarter of a million bucks." She justified the figure by explaining that the show represented a lifetime of work, and "there are a lot of millionaires around." Although this hope did not materialize, there was a growing number of individual sales to astute private collectors; and

after the exhibition ended, Martha gave Louise a one-year contract. One of the collectors, Howard Lipman, a sculptor-turned-collector, had been impressed by Louise's shows at Grand Central Moderns and wanted to meet her. He asked Dorothy Dehner to bring her to dinner at his Murray Hill apartment, which contained sculptures by Smith, Calder, and Noguchi. On the appointed evening, Louise, who had been drinking, took a look around the apartment and said contemptuously, "How can you live with all this crap?" Lipman tactfully replied that he also admired her work and hoped to add it to his collection very soon. True to his word, he bought a black wall, *Sky Cathedral Variant* (1959), from Martha Jackson.

Another early collector was Emily Hall Tremaine, who had bought a 1957 black wood piece, *Moon Garden Reflections*, composed of three shadow boxes, from the "Moon Garden" show. In 1959 she also bought *Moon Garden Series* and several ceramic totemic pieces placed in boxes with hinged doors. "I am very excited to see what you conjure up to support the Greek columns (it always makes me think a little of *Mourning Becomes Electra*)," she wrote to Louise, saying how much she, her husband, Burton Tremaine, and architect Philip Johnson, who had designed their pool and sculpture garden in Connecticut, loved "those pieces that give a sense of the mystic emotionalism of the gothic spirit. The macabre playfulness with grotesque angles, high vaulted shadows, nails, etc."

Louise had exhibited in a group show at the Galerie Jeanne Bûcher in Paris in 1958, and Martha Jackson now began to promote her reputation in Europe. On a trip abroad in June 1960 she called on Daniel Cordier, who recently had established himself as the leading avant-garde dealer in Paris, and told him that Europeans and Asians considered Nevelson "one of the great sculptors of the world." She urged Louise to agree to his terms to represent her in Europe. If Louise signed the two-year contract, she would have to make walls for its duration. "He wants WALLS, he wants wood, and he wants BLACK WOOD," Martha wrote to her. "He will pay as he agreed with David by measurements. He loves the WALLS. He believes this is a unique contribution to the art of the world. He doesn't care what kind of Walls you make. He hopes you will work quietly to develop this theme. He will take thick or thin walls, little or big boxes, reliefs, or however you wish to work. He wants you to be very free to work quietly and not to be rushed."

In spite of this, Martha went on to say that she and Cordier

would each need another wall in the remaining months of 1960 and four apiece the next year. "Louise, this is it," she exulted. "This is what it takes to go into the top ranks. Luckily we all believe you have it. How many Americans have the strength and the will to come up in the international market in this way? But you have it, and I think you will do it, and also I believe your work will expand and grow stronger than ever under these circumstances. But it is up to you to decide."

Recognizing the opportunity, Louise signed the contracts with the Jackson and Cordier galleries, each guaranteeing her $20,000 a year. And on October 28, 1960, she flew with her sister-in-law, Lillian, to the opening of her first one-woman exhibition in Europe at the Galerie Daniel Cordier. It was well received; reports came back to America that even Picasso had been to see it. "Louise! All those who count in Paris now know of Nevelson, and you are there to stay," Colette Roberts wrote her.

While she was in Europe, Louise saw a number of old friends and met some new ones, shopped, and traveled to Brussels, Amsterdam, London, Florence, and other cities. She had gradually learned to avoid the disabling depressions and periods of exhaustion that followed exhibitions by leaving immediately for a vacation, usually to a warm climate where she could sunbathe and swim. After her 1959 exhibition, she had vacationed in Puerto Rico with Martha Jackson; and now, after her exuberant return to New York, she spent Christmas, 1960, with her in Haiti.

But with all the increasing recognition of her work, Louise remained angry about her years of neglect and fearful that her success would prove ephemeral. At one of her openings, she sat at the bar, weeping and repeating over and over again, "It's too late, it's much too late." She also expressed her rage in obscene and often offensive ways. The final event of the 1958–59 exhibition season was a May show, "Recent Sculpture USA," in the walled garden of the Museum of Modern Art. Louise was furious at not being invited to participate, particularly as a number of younger sculptors had been. She got herself an invitation to the opening, dressed for the occasion, and arrived on the arm of Hubert Crehan. After mingling with the guests for a while, she suddenly disappeared. When Hubert asked her later where she had gone, she said she had ducked behind the drapery concealing the cases of liquor and tubs of ice cubes for the portable bar, "squatted over a tub,

and pissed on the cubes, relieving her rage and sense of injustice," he recalled. Both shocked and amused, Crehan suggested they leave the party immediately.

Many museum directors and other members of the art establishment believed that Nevelson's work had not fully matured until the mid-1950s, which was typical of sculptors, owing to the unwieldy nature of their materials; Museum of Modern Art curator William Agee called her a core member of a "second generation." Dorothy Miller, who described her as a late developer, also admitted that "we museum people were guilty of not seeing her early enough." As she remained poised for rejection, she developed a reputation for being tough and arrogant. When Colette Roberts brought James Johnson Sweeney, director of the Guggenheim Museum, to Louise's Thirtieth Street house, he had walked silently— and, Louise assumed, disapprovingly—through the dark rooms crammed with sculpture. Finally, as they went into the garden, Louise abruptly told him to leave, without waiting to learn whether or not he liked her work. Another time, when a member of what she called the "art mafia" apologized to her for being a few minutes late for an appointment to see her work, she told him rudely that it did not matter, because he was, in fact, thirty years late. And when Alfred Barr asked her where she had been all those years, she replied, "Right here in New York working—where the hell have *you* been?" As a young woman approached her with congratulations at a museum opening, Louise, who had been drinking, said loudly, "Fuck these Philistines!" Proud, angry, and capable of holding a grudge for years, she did not reply when Elaine de Kooning left her a note praising one of her Grand Central Moderns exhibitions.

When she was going to be honored at a large cocktail party, Frederick Kiesler remarked that he hoped she would change the flannel workman's shirt she had been wearing for weeks. But when the Kieslers arrived at the party, Louise was still wearing the old shirt. She saw them, swore, and threw off the shirt, exposing the beige athletic brassiere that supported her large breasts. Corinne Nevelson remembered that Louise was at her most outrageous when she threw a huge housewarming party in 1959 at the Spring Street house for hundreds of acquaintances from the worlds of art, music, and society: "Every now and then she would raise her voice and call out to a woman coming up the stairs, 'What the hell are you doing in my house, you bitch? Get out!' To a distinguished

bishop from Chicago in a gray tweed jacket, she said: 'How nice of you to come, Monsignor, but why are you wearing a tweed jacket—do you think this is a whorehouse?' "

Shortly after the incident in the museum garden, Dorothy Miller invited Louise to dinner and tactfully explained that the "American" shows she curated every few years were a mixture of a few established but neglected artists and a number of young unknowns. She timidly invited Louise to enter the upcoming one, diplomatically adding that she would understand if Louise turned her down, since she would be one of the oldest if not the best-known artist in the show. To her amazement, Louise immediately accepted, even though she was frenetically preparing for several one-woman shows that autumn. "She didn't bother to say yes or no, she just said, 'Dear, we'll do a white show.' That was her answer. It just came to her, at that moment. She had never done any white work. She said, 'Don't tell anybody, it will be a surprise.' " (Miller was not entirely accurate; 1957 photographs of Nevelson's studio show sculptures that had been painted white.)

Louise set to work in a nearby space rented from a funeral parlor—a "white studio" because she wanted to be totally immersed in the experience of whiteness. There was little time to talk, and Louise and her assistants worked through the summer under tremendous pressure, painting and repainting pieces of wood white until they were completely blanched. Sculptural components, as usual, were old banister balustrades, bits of molding, finials, newels, slats, knobs, dowels, mitered corners, lintels, studs, porch posts, rough old boards, lion-footed legs, even an old croquet set. As Bobby Buecker described it. "This was here, and that was there, and there was no discussion about why or what or how or anything." Meanwhile, Louise mischievously hinted in public that she was up to something new, half-revealing and half-concealing what she was doing. "People think black is the only mysterious color," she said to a *Newsweek* reporter. "I've been thinking of trying something in white, or perhaps Indian red. Brick red, you know? That's a marvelous color." She was unable to resist showing visitors her emerging albino work-in-progress. "I promised Dorothy Miller I wouldn't show it to anyone, and I've shown it to everyone that's come," she confessed to another interviewer.

It was impossible for Louise to give Dorothy a photograph for the catalog because, due to her spontaneous composing method, the assemblage would not be completed until it was set up in the

museum; instead, a chalky wall and two columns were temporarily assembled for the camera. On the day before the opening, Louise, aided by Teddy and two museum assistants, rapidly installed it in four hours in a white-walled room, instantly and intuitively making visual decisions that had been incubating for months. That evening she dined at Anna Walinska's home and stayed overnight. "What did Kandinsky say—'Black and white are the two most powerful'? I've always felt that too," Louise observed. Anna's admirer at the time, a Greek wholesale florist, had sent her a box of white orchids, which she presented to Louise to wear at the opening.

Dorothy had given Louise the biggest gallery, and the completely white room was a shock to the opening-night guests. Called "Dawn's Wedding Feast," the twelve white pieces included a sixteen-foot-long, intricately patterned altarlike wall, *Dawn's Wedding Chapel*, an extremely uncomfortable-looking nuptial pillow consisting of sharp pointed edges, a wedding chest, and a wedding cake intricately crafted from clustered Victorian finials and antique chair legs. There were wall reliefs and groups of elegant, slender, appliquéd columns, some standing on white bases, others suspended from the ceiling. To Colette Roberts, the columns suggested the statues of kings and queens at Chartres Cathedral; to others, stalagmites and stalactites that cast mysterious, soft-edged afterimages on the walls.

Most of the fifteen other artists in "Sixteen Americans" had been born in the 1920s or -30s. They included painters Frank Stella, who was only twenty-three, Jasper Johns, Ellsworth Kelly, Robert Rauschenberg, and Jack Youngerman, as well as sculptors Julius Schmidt and Richard Stankiewicz. Nevertheless, Louise's imagery fit in, and she was described, along with Johns and Rauschenberg, as an aesthetic descendant of Kurt Schwitters, Max Ernst, and Marcel Duchamp. The next year Jean Arp ended his poem about Louise with the words that she "has a grandfather, probably without knowing it: Kurt Schwitters." Louise, who claimed she had never heard of the German artist until the Arp poem was published, later acknowledged the existence of "parallel thinking." Schwitters's huge, tilting, eccentric construction *Merzbau* was built in his house between 1924 and 1937 from cardboard, furniture parts, metal and wood scraps, and other refuse, and his Dada assemblages were exhibited in New York in 1936 at the Museum of Modern Art.

Louise was also called a "junk artist" akin to the beat gener-

ation of writers, whose defiant use of obscene verbiage was an expression of social protest. "It's appropriate that an artist from the country that has the biggest dumps of discarded objects in the world should out-Schwitter Schwitters," Robert Melville wrote in *Architecture Review*, likening her outlook to "a sort of anti-mescalin vision of the charred remains of paradise." Destroying an antique, annihilating its identity with black paint, and assembling it in a nonfunctional way was clearly an expression of Louise's mockery and anger. Yet, by aesthetically ordering debris, she transformed it into art, rather like the reconstruction of the world from old objects at the end of T. S. Eliot's *The Waste Land.* "The word scavenger is really a resurrection," Louise proclaimed in her later years. Another time she described her environments as "empires" built of "a thousand destructions of the real world."

Two large columns in "Dawn's Wedding Feast" held shields of a female moon and male sun, but the bride, typically, seemed to be gazing at herself in a wedding mirror composed of an oval picture frame and wood fragments all placed in a box. Still the wedding motif was heartfelt, romantic, almost childlike. "The baroque finery—lacy and latticed like a small Victorian town with its wooden houses and daintily fenced gardens—seemed peculiarly American. In fact, New England. And the first thought I had when I saw it was that Emily Dickinson might have described such a place as she peered down from her wooden tower in Massachusetts," Dore Ashton wrote about the whitewashed gingerbread effect. To Thomas Hess in *ARTnews*, Nevelson's albino environment "succumbed to an artist's iron will and velvet eyes" in an effort to recover a lost world "with enormous pain." Other critics used such words as "bizarre," "resplendent," "tranquil," even "humorous," although for the most part there was no jocularity in her work by this time.

The show displayed an atmosphere of expectancy and an unmistakable suggestion of tenderness, and Louise later searched for the right words to try to express her feeling of identifying with "something that was the beginning again" in the months before the show. She liked to use the expression "to break it," meaning to jolt an image into focus or abruptly change a mood. "Maybe sometimes we become too introverted and deliberately want to break it [and] move into another area. . . . So I did and felt satisfied and then we came back to the self," she explained. She began to call herself "an architect of light" who worked in the color of early

dawn—a color that, in contrast to black, implied to her a state of consciousness, worldly activity, and receptiveness. As a nuptial representation of virginity, the show suggested her awareness of never having been married in what she called "the true soul sense": "It was a kind of wish fulfillment, a transition to a marriage with the world," or even an expression of joy—she described white as "more festive"—over her long-awaited acceptance by the art establishment.

In March, while her work was still on display in the Museum of Modern Art exhibit and at several New York galleries, Lucille Beards, who had just bought a black wall and wanted to unveil it at her Sutton Place apartment, gave an extravagant party for the sculptor and invited two hundred friends and people from the art world. That evening Louise "never looked lovelier, and she sparkled like a hundred-carat diamond," according to a gossip columnist. Encouraged by the prizes she had recently won and her representation at the Martha Jackson Gallery, Louise hoped, somewhat unrealistically, that an institution would take the entire "Dawn's Wedding Feast," permanently preserve it intact within glass, and, she added fancifully, place it in a roof garden where people danced all night. She was bitterly disappointed that instead, individual pieces, particularly the iciclelike columns, were sold off separately—to Rufus Foshee, John Horton, the John deMenils, the Nelson Rockefellers, the John D. Rockefeller IIIs, and the Whitney Museum, which through the Howard Lipmans acquired a major section of the wall.

Nevelson

*In the stillness of one's being is t center of Creation
there I am t camera, t image*

—LOUISE NEVELSON

BY THE EARLY 1960s, abstract expressionism had become the new
Academy to rebel against as still later forms of abstract painting
and a wealth of vigorous new sculpture emerged. "One of the most
striking developments in recent years is the resurgence of sculpture
as an art form," *New Yorker* art critic Robert Coates wrote in De-
cember 1960. "Just as everyone was preparing an obituary for it
(it was too cumbersome and too rigid to fit in with our fast-moving,
rapidly changing way of life nowadays . . .), a fresh generation of
artists arose who by their almost passionate interest in exploring
untried possibilities of the medium succeeded in breathing new
life into it." What was surprising was that Louise Nevelson, now
in her early sixties, not only was included in the new wave but
was regarded as the artist who typified this moment in the art
world. Her walls were a synthesis of both modern art's haphazard
tendencies and the recent trend toward more orderly expression.
"Could there be a more dramatic representation of the contem-

porary world?" art critic Stanley Burke asked rhetorically in *ART-news*.

The question was an apt one. The mass media had begun to pay a great deal of attention to artists as colorful personalities, and collecting contemporary art, especially Pop art, had become extremely chic. The art scene gradually took on show-business overtones as dealers and collectors boosted its new manifestations. Louise, who had worked hard to promote herself and her work for years, was in tune with the mood. In late March 1961 she participated in a generally pessimistic panel discussion at the Philadelphia Museum College of Art. Art critic Katherine Kuh declared that twentieth-century artists had a compulsion to smash "time, form, color, light" in revolt against the era's materialism; Marcel Duchamp declared that the increasing popularity and commercialism of art was destroying aesthetic values. Louise, resplendent in fluorescent green eye shadow, a peaked black hat, and a black cape with silver cabalistic patterns on it, immediately reprimanded him for his "rather aristocratic view."

She enjoyed the prospect of art reaching the masses, later explaining that she never liked to dismiss a new aesthetic movement, because each one "leaves a consciousness, an awareness." That day in Philadelphia she said grandly: "I think this is the richest time in creative history. I believe our art is important—more significant than that in Europe. We are in tune with the sun, the moon, and the airplane." She continued: "An artist by his very nature works alone. He spends most of his time by himself, and it is *essential* that he have a public to keep him from going mad. It doesn't have to be the *biggest*," and then, after pondering her remark for a moment, she grinned and added, "but the bigger it is, the more I like it."

In the autumn of 1960 she participated in a show of women artists and asked Tom Kendall what he thought of it, apparently hoping he would say that she was the best. Instead he praised Georgia O'Keeffe. Louise's expectations of fame and success were escalating: the "ART: USA: 59" jury had awarded her the $1,000 first prize for her black wood *Moonscape II*, and her white wood *Dawn Light II* won the $3,000 grand prize in the First Sculpture International of the Torouato di Tella Institute in Buenos Aires, Argentina, in the summer of 1962. That same year, she made her first museum sale. The Whitney Museum's acquisitions committee usually purchased a well-rounded collection of ten or twenty sculp-

tures at relatively low prices. But when Howard Lipman chaired the committee in the 1961–62 season, it bought only her black wall, *Young Shadows* (1959–60), for the unprecedented price of $11,000, along with its first Calder stabile and its first David Smith brushed metal piece.

Her success with white-painted wood led her to search for new ways to vary her work with color. "Out of the studios in the spring of 1960 [was] revealed a tremendous surprise: the pieces were gilded, all in the room was Gold, glittering gold," Colette Roberts wrote. A special gold studio on Mulberry Street contained a pile of bedposts, piano lyres, hat blocks, umbrella handles, jugglers' pins, toilet seats, and antique claw-and-ball legs, all of which, after being heavily lacquered and sprayed with metallic paint, resembled "gigantic wheels and arms to be used by a timeless watchmaker." Nevelson astonished the art world once again as her golden walls were exhibited in the 1960 Whitney annual, at the Galerie Daniel Cordier, in a Museum of Modern Art group show, and along with both black and white walls in a one-artist show at the Martha Jackson Gallery. "An artist who is crystallized in a style is no artist," she declared in a press release, adding that she would never create another black sculpture. The release compared her work in black, white, and gold to a spiritual journey from the gloomy darkness of night through the pale purity of dawn into the bright noonday sun, and the giant gilt honeycombs in the upstairs room received most of the press's attention.

Louise's intoxication with gold derived from her earliest memories. When at the end of her life she was awarded a gold medal from the American Academy of Arts and Letters, she recalled that in Russia people used to say that the streets of America were paved with gold. Another time she suggested that the debris she discovered in the gutters of New York must be precious if indeed the New World's pavements were gilded. In fact, she infused so much value into a chunk of old wood that symbolically it alchemized into a gold nugget in her eyes. The fine gold threads embroidered on Oriental robes had showed her in the late 1920s that bold use of gold was not vulgar, as the Nevelsons had believed, but the epitome of refined taste. Then, during World War II, she had become enamored of Joe Milone's gold shoeshine box. After her hysterectomy of 1948, she had responded so viscerally to the sight of a rich shade of yellow satin on a pair of antique French chairs in the window of a Fifty-seventh Street shop that her melancholy mood suddenly lifted. She had always found allure in symbols of

wealth, and she was enormously impressed by the gold knives, forks, and spoons she had seen on a trip to Texas. Giving battered junk the look of Fort Knox bullion was also an ironic statement about collectors who preferred to invest in sculpture made of precious materials. Her gold assemblages evoking royal diadems also revealed her fascination with aristocracy; indeed, most of her major gold pieces had the word "royal" in their titles. Never given to understatement, she began to appear in gold shoes and gold lamé clothing, and she gilded the wrought-iron doors, floors, and fixtures in her house.

Museum of Modern Art curator William Seitz thought her eighteen open cubes composing the eight-foot-high *Royal Tide I*, which were part of the museum's "The Art of Assemblage," projected the opulence of Versailles. Kenneth Sawyer wrote of her work in the 1961 Martha Jackson exhibition catalog that "curiously, there is no vulgarity here (an achievement in itself); instead, there is that quality which recalls High Baroque." Other critics, however, found the golden throne room in the Jackson exhibition "vulgar," "grandiose," "bizarre." Even Dorothy Miller thought that the inferior quality of the gold paint degraded the sculpture, and loyal Colette Roberts acknowledged that the gleaming assemblages had a "a touch of brassiness." Another critic wished that Nevelson would "recover from her gilt-complex and get on with exploring those sweet mysteries of death and transfiguration."

Sales of the gold work were disappointing at first, even though a number were eventually acquired by private collectors. The Albright Art Gallery in Buffalo had expressed interest in buying a wall, undoubtedly through the encouragement of Martha Jackson, one of its founders; they finally compromised on a gold assemblage—the relatively small *Royal Game I* (1961), for which they paid $6,000—but only because patron Seymour Knox would not accept a black wall, and Gordon Smith, the museum director, would not agree to a white one. Louise, angered that they had not chosen a larger piece, bluntly declined Knox's invitation that she install it. "When you acquire a big wall—the present price is $100,000—it will be my pleasure to come up to your Buffalo . . . to install my great big beautiful wall," she wrote. Instead, she ended up presenting gold walls to the Whitney and the Tate Gallery in London, the latter getting the huge altarlike *An American Tribute to the British People* (1960–65), which she decided was appropriate for a nation with a royal family.

Despite negative reviews, she continued to exhibit her gold

work, sending a piece to Lady Bird Johnson's White House Festival of the Arts in the spring of 1965. But the almost unanimous coolness toward her new work put her on the defensive. She felt the need to explain to her critics that gold, a natural element mined from the veins of the earth, was not merely an ancient symbol of wealth but also one of optimism and splendor. Gold reminded her of the sun, she added, and she always loved the sun's heat, since she often felt cold.

It may have been thanks to the psychotherapy she had recently undergone with Dr. Bergler that the tepid critical response to her gold walls did not throw her off balance as it might have in the past. Colette Roberts observed that the work, which she thought was seeking more order and balance through a greater use of circles and ovals—picture frames and toilet seats, for example—conformed to Louise's new air of maturity, calmness, and acceptance. Her use of metallic gilt would soon end, however, even though she had not explored all its possibilities.

Meanwhile, tensions had arisen between Louise and Martha—not over the controversial gold work, which Martha defended vigorously, but over Louise's increasing need and appetite for wealth; it was as if she suddenly expected everything she touched to turn to gold. In March 1961 she had bought the building next door at 31 Spring Street, for $33,000 with the help of Lillian Mildwoff, who signed the contract of sale and assigned the title to Louise. In 1962 her payroll included studio assistants, a housekeeper, an accountant, and an attorney. In addition, she was sending Mike gifts and wages of several thousand dollars a year. His wife had given birth to a second daughter, Maria Isak, in the spring of 1960, and he happily wrote his mother, "I'd rather have a living child than one more piece of sculpture."

Martha was having difficulty making sales of large constructions to private collectors. An inventory dated February 16, 1960, listed seven sales, ranging from a $40 etching to a twenty-four-unit untitled wall for $5,500, which netted the artist only $7,315.50, although by the next year her sales, priced now from $500 to $25,000, grossed about $80,000. Cordier was able to interest European museums in her work, and in 1961 she had her first exhibitions in West Germany, at the Staatliche Kunsthalle in Baden-Baden, and in England, at London's Hanover Gallery. The collector Joseph Hirshhorn, who had had an easy, teasing rapport with Louise for a number of years, acquired his first Nevelson from

Martha Jackson in 1962, but it was the small figurative *Mountain Woman*, made in the 1940s. For most collectors, it was difficult, if not impossible, to visualize a Nevelson wall in their homes. And, as Robert Coates put it in *The New Yorker*, the sculptor's symbolism often seemed "too intuitive, too personal, and too impulsively metaphysical for easy understanding."

There were other problems as well. Louise and Martha were "constantly fighting," according to Martha's son, David Anderson. Louise began to find Martha's twanging, persistent voice irritating and felt she visited the studio too often and took too many sculptures to cover the gallery's outlays of cash to her. Apparently she assumed Martha was wealthier than she actually was and resented having to pay her own way on their Caribbean vacations together. But Martha had to make the gallery break even, and from time to time she even sold family furniture and silver to raise money. More significantly, Louise complained that Martha was so eager to make a sale that she would break up a wall and sell a section of it without the sculptor's permission. Louise, who did not always bother to inspect a wall before it was shipped to a buyer, would complain to studio assistant Tom Kendall, "How did you let Martha do that?"

To compound the confusion, Louise often dismantled and rearranged walls the gallery sent back to her after a show, to save on storage costs. As their creator, she felt she had a perfect right to cannibalize her own works, whether or not they technically belonged to her. She was completely unconcerned about using one of the boxes actually owned by Martha in another wall she was creating for someone else, and one entire wall the gallery owned was "lost" in this way. Although Martha and her son pressured Louise "to try to resolve some pieces and make them permanent," she never did, aside from screwing together some gold walls. Consequently the gallery never had dependable photographs to show to clients and was confused about who owned what.

To ease the problem, Tom Kendall was hired to help Louise date her prints, record sales, and keep track of the hundreds of boxes by noting each one on a card with a sketch, number, name, price, and location. Louise paid him $25 a week for part-time work, and after he was hospitalized for malnutrition, Martha began to pay him another $50. Ironically, Martha ended up paying more to him in wages than she would have paid for storage. During the three years Tom worked for Louise, he sometimes scratched her

signature on the backs of boxes with a nail when Louise got tired of doing it herself. She also taught him how to stack the boxes (pulling out the bottom one a little so that gravity acted as the mortar) and arrange them (varying the surfaces by depth, for example) until he learned "to put up a pretty good wall—and in fact, she didn't bother to do them after a while," he reported. He was probably pressed into assembling a number of walls because of the heavy demands on Louise from both the Jackson and Cordier galleries and her resentment about these demands. "I seemed to be on auction between the two of them," she recalled. "Can you imagine anyone trying to boss me—that way of life was over for me in the 1930s."

Martha Jackson had been poorly prepared to handle a prolific sculptor. After drawing up the usual painter's contract with Louise, she experienced enormous, unanticipated transportation and exhibition expenses. Moreover, several important sales originated directly from Louise's studio, resulting in lower commissions for the gallery. As early as spring 1961, the gallery had developed a substantial negative cash flow, since Louise's sculpture never earned in sales what she withdrew in advances. The contract, negotiated by Louise's attorney, Elliot Sachs, could not be easily renegotiated. Since the gallery was unable to head off unforeseen problems, by November 1961 it was evident that the two-year contract would not be renewed when it expired at the end of the year. In March 1962, two weeks after Louise's accountant discovered that the gallery owed her a substantial sum of money, Elliot Sachs demanded that Martha return the remainder of her work, which she was holding on consignment. A week later, in a letter written by Tom Kendall, Louise declared that the "spirit" of the contract had been broken. The gallery ended up taking a substantial amount of sculpture to cover its financial outlays on her behalf.

Despite the difficulties, Louise's work remained a permanent and important part of Martha Jackson's personal collection, and in the years to come, she always spoke admiringly of Louise's "high level of accomplishment." Louise on her part said she appreciated Martha's "great deal of feeling for [an] artist's creativity." In retrospect, Louise acknowledged that Martha had finally let her have her own way in everything—which, ironically, had led to an impossibly complicated business relationship. Martha's efforts had, however, firmly established Louise in the commercial art market both in America and abroad. The tension between the two women

eventually dissipated, their friendship survived, and they contin-
ued to weekend together in East Hampton and vacation in Mexico
until Martha's death by drowning in the summer of 1969.

When one of Louise's acquaintances, art dealer Rufus Foshee,
realized that she needed someone to straighten out her complicated
problems with Martha, he approached Sam Kurzman, an attorney
with a reputation for helping artists with their business affairs.
Kurzman called on Louise, who was impressed by his powerful
manner and tall, broad-shouldered appearance; he reminded her
of Abraham Lincoln, she told Tom Kendall, adding inexplicably
that "although he was Jewish, he was so American-minded." With
neither the inclination nor the ability to deal with the business
side of her career, she was happy to abdicate that responsibility
to an apparent rescuer. In May 1962 Kurzman became not only
her lawyer but her "advisor and spiritual comforter," according
to another attorney she later hired. Kurzman also represented the
Sidney Janis Gallery, which had handled some of the most im-
portant painters in America. After establishing himself as a busi-
nessman and art collector, Janis opened his gallery in 1948
expressly to exhibit avant-grade art and demonstrated great skill
in promoting and selling the work of artists with established rep-
utations. A few months after Jackson Pollock's death in the summer
of 1956, he had sold the painter's *Autumn Rhythm* to the Metro-
politan Museum of Art for $30,000, a record-breaking amount of
money at the time. By 1960 Pollock canvases were expected to pass
the $100,000 mark soon.

It soon became evident that Nevelson was eager to join the
Janis Gallery. But she did not want to risk approaching Sidney
Janis herself: she gave Kurzman a print and, associates reported,
promised him a wall valued at $50,000 if he managed to get her
into the gallery, which represented neither women artists nor
American sculptors. Janis had first seen her work at the Nierendorf
Gallery in the 1940s, but he was not excited by it until the ap-
pearance of the walls a decade later. He had met her socially at
various gallery and museum openings during the intervening
years. When the two got together to discuss a contract, at a meeting
presumably set up by Kurzman, Louise told the dealer with typical
overstatement that being represented by his gallery would fulfill
a lifetime desire. She claimed later that he assured her, or at least
implied, that her annual sales from his gallery would reach as high

as $200,000, giving her an income of more than $100,000 a year. A woman who admittedly liked men to spend money on her, she also liked to be paid handsomely for her work, and her ego had a vengeful edge. "I'm going to make a million, and I'm going to shove it down the throats of all those dealers," she used to tell Tom Kendall. Then she would pause and add, "I'm fighting for artists!"

Sidney Janis had a reputation as a shrewd and unsentimental art dealer who used tough but fair business practices with collectors and artists alike. But Louise's desire for commercial success overshadowed any concern she might have had about her ability to get along with him personally, and she ignored a warning against going to the gallery from Willem de Kooning, who was now exhibiting elsewhere. In fact, the gallery was losing some of its most important artists at the time Kurzman approached Janis about Nevelson. When Hilton Kramer heard about it, he was astonished, because he regarded Janis and Nevelson as "people who didn't speak the same language at all." Nonetheless, they reached an informal agreement in late May 1962; their association became publicly known that summer,when her gold walls were on display in New York, and *Time* magazine predicted that the sculptor's "future looks golden."

Kurzman offered to sell Louise a turn-of-the-century clapboard house next to his in Westport, Connecticut. He priced the property at $45,500 and offered to finance the mortgage himself. Louise liked the idea of owning a country house, and she hoped Mike and his family would move there from Rockland. At a time when there was a growing demand for her walls, Teddy Haseltine's personal problems had made him increasingly unreliable. Mike, on the other hand, gave her emotional support, located furniture parts for her, provided her with his wood fragments, and kept up an ongoing dialogue about art with her. Sometimes she felt her son was older, maturer, and wiser than she was. The lines "Sun Son Sun Son / To [sic] bright the light so bright . . . Sparkling brilliant and delight / My Sun My Son My Sun My Son" in an undated poem from this period clearly express her love for him. In spring of 1962 she signed some documents and made a down payment of $2,500 on the Westport property. She said later that she had not understood the significance of the papers she signed, notably a promise to pay off the $20,800 mortgage within a year.

At the same time, Dorothy Miller invited Louise to be one of four American exhibitors that summer at the thirty-first Biennale

in Venice, one of the largest and most important international exhibitions of contemporary art. (Other Museum of Modern Art officials selected the painter Loren MacIver, deceased expressionist painter Jan Muller, and the sculptor Dimitri Hadzi to complete the American group.) The two women had recently traveled together to Chicago to judge a large exhibition at the Art Institute of Chicago; perhaps because Louise expected her traveling companions to make all the arrangements, Dorothy found her a "completely amenable" one.

The Biennale had a reputation as a marketplace where genuine appreciation of art was secondary to making deals and attending parties. But since exhibiting artists were treated like "starlets at Cannes," according to John Ashbery in the *International Herald Tribune*, it was a milieu that appealed to the gregarious side of Louise's personality. It was also, of course, an honor to be selected. She had no time to create a new exhibition for Venice, and the Modern lacked funds to ship her sculpture overseas, but Dorothy Miller persuaded Daniel Cordier to let her "commandeer" an entire show of Nevelson's work which was touring Europe. As Louise boarded a jet for Italy with Dorothy, three weeks before the Biennale's June 1962 opening, her friends fully expected that she would win the sculpture prize for America.

She was given three galleries in the small American pavilion modeled after Monticello and several weeks in which to transform the small circular entranceway into a gold environment and the rectangular galleries to the right and the left into white and black ones, respectively. Early each morning Louise and Dorothy took a vaporetto from their borrowed apartment on the island of San Marco to the exhibition site and worked until the daylight faded. They were assisted by two Italian workmen, using a primitive ladder held together by string, who "had no language except Italian, but they understood everything," Dorothy recalled. Louise "would say from the floor pointing upward, 'Put it there, dear, over there, this way, this way.' Then she'd say, 'Okay.' And they'd say, 'Okay.' " Unused to Louise's working pace, Dorothy was soon walking on sore, bandaged feet, and both women suffered from the unseasonable cold. As crates of her constructions arrived, Louise dismantled them and recreated twelve completely new black, white, and gold environments. On the first morning she impulsively seized a simple wooden shape one of the Italian workmen had taken from a pavilion archway, sprayed it gold, and incorporated it into

an assemblage. To dim the intense Mediterranean light and create a stronger sense of envelopment, she ordered the glass ceiling in the gold room covered with gold gauze and used black and white cloth to cover skylights in the other galleries.

Not until after the opening ceremony, when a flotilla of gondolas and other boats glided down the Grand Canal to the Public Gardens, did Louise take time to shop for fabrics and European eye makeup, to visit cafés and attend parties, including one at Peggy Guggenheim's palazzo on the Grand Canal. Returning by vaporetto one morning at dawn, she experienced a mystical sense of pleasure as she saw the silhouette of Venice against the pale sky—a sight she later declared was as wonderful as anything she had ever seen on earth.

Her constructions worked well in Venice: there was a natural affinity between her encrusted gold concave wall and the ornate Venetian façades in nearby Piazza San Marco. Some people observed, however, that the white construction seemed scanty in its large space. Still, the bold environments astonished viewers, and Louise became popular with members of the press. The judges were less enthusiastic. Every sculpture prize went to Europeans—particularly, and perhaps not surprisingly, to Italians. First prize was awarded to the Swiss-Italian Alberto Giacometti, who according to Dorothy was "wonderfully appreciative" of Louise's work, and with whom she had developed an easy camaraderie over drinks during the installation. Her congratulations were so effusive that she almost fell out of her gondola in an attempt to embrace him.

As soon as she returned from Italy, Louise went to Rockland. She presented her granddaughters with expensive silk dresses (orangy-red for blond Elsbeth and dusty blue for brunet Maria) and Mike with an Italian silk bathrobe and a check for $5,000 (money she had just received from Sam Kurzman). She also urged him to move into the Westport house, which had become hers on the first of July.

Mike seemed as happy as he had ever been. At the age of forty, he was grateful to have a secure family life, and he had become optimistic again about his future as a sculptor. For the past few years he had been creating large, blond, laminated-pine anthropomorphic furniture personages characterized by superb craftsmanship, wit, and imagination. He had had several exhibitions, including a well-received one at the Staempfli Gallery in New York,

where a critic detected a somewhat menacing, Rabelaisian quality to his work. There were superficial similarities between his sculpture and his mother's, like the use of wood and the development of interior spaces; but each was highly individual. After exhibiting together in a group show in 1961, Mike wrote to her how important their "mother-son sculpture relationship" was to him; another time he fancifully suggested that she was the moon and he the sun. Despite the fact that he was happily settled in Rockland, his wife's eagerness to move and his own sense of filial obligation persuaded him to uproot himself. By the end of September, he had made plans to sell his house and studio and move to what he called the "fancy house" in Westport.

Meanwhile, Louise was rapidly becoming unsure of her ability to achieve rapport and influence with Sidney Janis, who was unwilling or unable to provide her with the level of reassurance she needed from a dealer. After the Venice Biennale, he had outlined their two-year agreement whereby he would be her exclusive worldwide agent in exchange for the standard 60/40 commission; significantly, the agreement contained nothing about guaranteed minimum payments to her. Almost immediately they had a number of misunderstandings and disagreements. Louise wanted him to ask $100,000 for large walls, twice what he thought they could bring in the marketplace. After he forwarded her thousands of dollars, she went on a shopping spree, buying clothes, pewter, baskets, and antiques and visiting a masseur and a beauty salon. She paid a bill from Plaza Paint Supply Company for $1,272, gave her son several thousand dollars more, and repaid a debt to Ben Mildwoff. The money was soon spent because she was "not clear as to the relationship of her expenses to her income," Mike explained at the time. As she begged her friend Rufus Foshee to persuade Janis to advance her more money against sales, it looked as if she were forcing him to ask her price for the walls.

A date of January 1, 1963, was set for her inaugural exhibition at the Sidney Janis Gallery. At the same time, both Kurzman and Foshee were asking her to make good on her promises to give them walls, pledges that she now disclaimed, not unlike a coquette who hints at favors she later withholds. She stayed at the Westport house during the summer, but she felt imprisoned by Kurzman, who wanted her to prepare for the upcoming show. She began to drink heavily and was reluctant and unable to concentrate on her work. She told Mike she was "desperate" for him to come to Con-

necticut. Meanwhile, in late October she flew to Miami Beach with her sister Anita, who had been staying at the Spring Street house with Teddy and his friend Al Gentiere. From Florida they began traveling haphazardly—to Nassau a week later, then to Puerto Rico and on to St. John in the Virgin Islands.

It became evident soon after Mike and his family arrived that the Westport property had no clear title. Suspecting dishonesty on the part of his mother's attorney, Mike flew to her defense and had a heated confrontation with Kurzman. When he realized that he would have to leave Westport, he took the proceeds from the sale of his house in Maine and bought three and a half acres of meadowland with a sheep barn in New Fairfield, Connecticut, which he immediately began to renovate. Until now Mike had tried to calm his mother; but by late December, after becoming increasingly alarmed about Janis and Kurzman, he concluded that the time had come for her to defend herself.

The opening of Louise's January show at the Sidney Janis Gallery was planned for midnight on New Year's Eve. It was a bitterly cold night with a strong wind, and only her closest relatives, most loyal friends, one or two critics (a newspaper strike was on), and a handful of important collectors came. Among the collectors were Vera and Albert List, who expressed interest in a black wall, *Night Garden*, priced around $25,000. A second gallery contained a golden *Dawn* grouping, featuring broken baseball bats and upside-down rifle butts; and a third, a white triangular-shaped *New Continent*, apparently hastily assembled from repainted black boxes. Guests whispered that the work in the exhibition was inferior to Nevelson's usual innovative display; it was inappropriate for a first exhibition with a new gallery, they claimed, and therefore an insult to Sidney Janis. They speculated that because she disliked and distrusted her dealer, she had deliberately and masochistically put together a mediocre exhibition.

After the subdued opening, Louise and a group of intimates— Mike, Hubert Crehan, Rufus Foshee, Mary Shore, and a few others—went to the nearby apartment of another friend, Lucille Beards, to make scrambled eggs and talk for the rest of the night. After first declining the invitation to the gathering, the Lists arrived, explaining that they had been unable to wake the doorman at their apartment building. Recollections differ about what precisely happened that night between sculptor and collector, but the

next morning Mrs. List telephoned Janis to say that she was no longer interested in the black wall. Years later Janis angrily complained that Louise had somehow sabotaged its sale, and that the other assemblages in the show had proved difficult to sell because they were "a little on the crude side" and shabbily constructed. In any event, he was able to sell virtually nothing.

Janis's reservations about Louise's work were echoed by even the devoted Colette Roberts, who admitted that the show was "not an excursion into a Nevelson 'Elsewhere.' " Hilton Kramer called the Janis installation "rather sparse and sedate" compared with Louise's lavish past environments and criticized her white and gold walls. White paint, he wrote, reduced shadows, flattened the images, and minimized the intricacy of her work; gilding did not deliver enough definition, while degrading the sculpture with "an air of artificiality and specious glamour." He concluded that "the use of white and gold has proved to be sculpturally ineffective, and nothing new in the realm of form and scale has been created to compensate for the loss in expressiveness." He praised the black *Night Garden*, however, as demonstrating that the artist had mastered and transformed the complex constructivist tradition. Sidney Tillim wrote in the February issue of *Arts* that whereas in earlier work Louise had been spontaneous and without concept, she was now trying to be profound, which made her work indecisive because she was "being more reasonable, perhaps, against her will." He suggested that black was psychologically consistent with her use of junk, whereas white and gold were too "virginal and sacred, respectively." His conclusion was the most damaging of all: "In her gilded pieces, structure, never vigorous to begin with, seems positively ramshackle, and the pieces themselves take on a flimsiness that permits one to question her oeuvre entirely."

Immediately after the opening, before most of the reviews were out, Martha Jackson wired Louise that she had been told a letter was in the mail asking her to hold the Nevelson walls in the gallery for Sam Kurzman. (After Louise had refused to give Kurzman a black wall, he took possession of a $25,000 gold wall, *Dawn Light I*, which had been at the Seattle world's fair.) Two days later, Elliot Sachs, acting on Louise's behalf, instructed Martha not to turn over any sculpture to either Kurzman or Janis; the next week he revoked Janis's right, which Louise had previously granted him, to pay Kurzman for the Westport house out of her earnings. Before the end of January, Louise had hired Harris Steinberg, a well-

known criminal lawyer who specialized in defending people accused of embezzlement and other kinds of white-collar crime. He was, as it happened, an avid art collector and evidently agreed to represent her in exchange for gifts of sculpture.

Two months later, Steinberg wrote the Art Dealers Association of America, laying out Louise's grievances against Sidney Janis, who was a member of its board of directors, and trying to mediate the dispute in order to avoid a lawsuit. He accused Kurzman of unethically representing both the artist and her gallery simultaneously, drawing up a contract that was "completely unfair" to her and selling her a house while concealing vital title information. Now, Steinberg continued, Kurzman was withholding sculpture from her while demanding excessive fees, while Janis was refusing to let her out of the contract unless she agreed to pay him between $17,500 and $22,000 over the sums advanced to her. In short, the contract procured by Kurzman had placed Nevelson in a position "where her professional future and economic welfare are seriously threatened."

By this time Louise had little money to live on, and since she was still under contract to the Janis gallery, she feared that she would be unable to sell her existing or future work either privately or through another dealer. To make matters worse, Martha Jackson and Daniel Cordier already owned much of her sculpture. As tensions with Kurzman heightened, Mike defended his possession of a licensed .38 revolver as necessary to protect his family. He had always owned a gun; now he let it be known. Louise, unaware that she could break a contract, became so deeply depressed that she was, in Mike's eyes, "practically incapable of functioning." She had never been involved in a legal battle before, not even during her divorce, and now she was forced to confront the kind of abrasive reality she had erected elaborate edifices against. She found dealing with the legal mentality as stressful as the issues themselves. Furthermore, she had no confidence that she could win a case against an important dealer like Sidney Janis. She was despondent, distraught, and drinking so heavily that some of her friends were afraid she might attempt suicide. "I just wanted to die," she recalled later. "I just couldn't face it."

Her lawyers decided that the most effective way for her to raise funds was to sell her New York properties, an excruciating choice that brought back memories of the loss of the Thirtieth Street brownstone five years earlier. Fortunately, a temporary di-

version presented itself, and she took off for California, leaving her lawyers and her son to untangle her problems. Two years before, June Wayne, director of the Tamarind Lithography Workshop in Los Angeles, had offered her a guest-artist fellowship financed by the Ford Foundation, and Martha Jackson encouraged her to take it now. Louise flew to Los Angeles in late April with her sister Anita, and they moved into a small furnished apartment at the Havenhurst Lanai in West Hollywood. Soon after she arrived, she wrote a brief note in a shaky hand to Elliot Sachs, giving him authority over the Spring Street houses. Arrangements were made to sell them to a friendly lawyer, Mortimer Goodstein, who would rent number 29 to her for $650 a month. Still deeply depressed, Louise spent a good deal of time drinking, lying motionless on a couch or sunbathing beside the swimming pool.

Despite her state of mind, she completed her first lithograph in early May and became extremely prolific for the next five weeks, using direct, inventive methods, like pressing erasers, crayons, and lace she had brought with her onto the large stones—much the way she had done at Atelier 17 a decade earlier. She worked collaboratively with assistants "to accomplish finishes she could not have produced alone," according to June Wayne, who called her an "image-maker." By the end of her stay, she had created twenty-six untitled series: nineteen in shadowy black and white, the rest with a single, muted color. Una Johnson later described them as "the most abstract and perhaps the most powerful of her entire graphic works. . . . They are great night landscapes with clusters of glittering lights and piercing white lines that stab into the depths of space. Here appear lacy patterns and sudden visions seen from great heights. . . . These large, mysterious black-and-white visions [have] something of the strange fantasies of Poe and the vivid imagery that floods the poetry of Whitman."

At the end of her fellowship, when the five hundred lithographs were insured for $10,000 and given a market value of close to $150,000, Louise's confidence in herself was restored. "I went to the telephone and called New York and said to my lawyer, 'Go on with the case. If I'm worth that in six weeks, what in the hell are you worried about?' " The trip to California brought her back to life, she often declared afterward.

When she did not pay the $20,800 note on the Westport property by July 1, 1963, Kurzman served a legal complaint against her. She countersued, asking $200,000 for the damage done to her

reputation, peace of mind, and ability to work. The case was heard before the New York State Supreme Court, and after about six months of arbitration—testimony was being given the day President Kennedy was assassinated—a judge invalidated Kurzman's claims. Louise felt she had been vindicated. The relationship with Janis was formally terminated in late September, about a year after it had offically begun. Louise agreed to pay him $18,920 in three installments over the next year; until he was repaid, he would hold five pieces of her work from the disappointing exhibition as collateral. Louise always said later that going to the Sidney Janis Gallery was one of the two worst mistakes of her life—the other one, also entered into for wealth and position, was getting married.

As her stature in the art world grew, Louise rose to leadership positions in numerous artists' groups. In January 1959 she was president of the New York chapter of Artists Equity. After a period out of office, she was re-elected in the spring of 1962 and represented the group at Governor Nelson Rockefeller's home in Pocantico Hills to hear a report from the New York State Council on the Arts. A year later she was elected the first woman president of Artists Equity, the largest group of professional painters and sculptors in the country. The board had intended her to be a figurehead president, since they, and particularly secretary Bella Schaeffer, did the necessary organizational work and Louise was involved in her dispute with Sidney Janis at the time, but if they asked her advice on any specific matter, "she was very intelligent and fair."

She was also expected to be a peacemaker; the New York chapter had been holding its dues in escrow for two years in an attempt to win more influence with the national office, which it felt, among other things, did not return enough dues to run its large five-hundred-member chapter. She immediately stated that her goals as president were unity and a larger membership, especially of younger and avant-garde artists, so the organization could become "a Living Force." Stressing the common cause of all creative people, she argued for a national conciliatory convention and persuaded the New York chapter to release $3,000 to finance it. She presided over the convention in Denver that spring, where New York members were permitted to vote and their chapter president, Hy Cohen, set forth his grievances "in a forthright and amicable manner." The convention passed a number of unification bylaws, one of which named chapter presidents to the national

executive committee. Louise spoke optimistically at the banquet about the future of art; she had replaced her inhibitions about speaking in public with a sense of defiance—"So I'm an idiot. So what!" One artist observed that despite her spontaneous style, she was actually organized, purposeful, and well controlled about "where to speak out and where to tone down"; and although she had assiduously avoided political activities in earlier years, she now found her leadership efforts on behalf of other artists very gratifying.

In the spring of 1961 Arnold Glimcher, the twenty-three-year-old head of Pace Gallery in Boston, who had recently caused a local stir with a Pop art show, offered to exhibit Nevelson's sculpture. When he approached Martha Jackson about the possibility, she surprised him by immediately agreeing; she had an urgent financial need to sell Louise's work. Glimcher, who was still a graduate student in art history at Boston University, had barely enough money to keep his gallery open, and a Nevelson show would be a big financial gamble. Nevertheless he telephoned Louise for her permission and offered to put her up at the Ritz-Carlton Hotel and throw a large party for her if she came to Boston for the opening. "I'd love to come to Boston," Louise replied, adding that she had been married there. It was the spring when her gold work was being tepidly received, and the night before the opening she was so depressed she drank a great deal of Scotch. The next day, wearing a large fur hat despite the warm late-May weather, she made her way to the Newbury Street gallery.

She admired the installation, and she and Glimcher had an immediate understanding. In the next few weeks he sold almost the entire show—totaling $70,000 to $80,000 worth of sales—to young Boston collectors, the first significant amount of money his gallery had ever made. He came close to selling a large wall to a collector who intended to donate it to the Boston Museum of Fine Arts, but the museum's director, Perry Rathbone, rejected the idea because of its size, observing that the museum's treasured Braque was much smaller.

After this, whenever Glimcher was in New York, he visited Louise, sometimes with his wife, Milly, who had majored in art history at Wellesley, and his young sons. Louise also got to know his mother, Eva, who like herself had been born in the Ukraine at the turn of the century and brought to America at an early age.

Although the recently widowed Eva was more conventional than Louise, the two shared the emotional Russian temperament and a taste for extravagance, and before long they were close friends. Glimcher's instant rapport with Louise was indeed due, in part at least, to her resemblance to his mother. As Louise's relationship with the Martha Jackson Gallery deteriorated, he offered to represent her, even though he had been warned that she was "difficult," and in the spring of 1962 he ran advertisements showing her work at his gallery. During the Venice Biennale, he lunched with her in the rooftop restaurant of the Danieli Hotel. After he heard about her arrangement with Sidney Janis, he "was a bit depressed, and she said, 'Don't worry—I'll be with you someday.' " Before her Janis opening six months later, he wrote a warm note to "my favorite sculptor," enclosing a gift from his wife, mother, and himself "to say we love you even when we don't see you."

After her relationship with Janis had broken up, Glimcher visited her in Los Angeles. He and a partner, collector Frederic Mueller, were planning to move the Pace Gallery to West Fifty-seventh Street in New York, and he again offered to represent her. Although friends advised Louise against moving to an unknown gallery with no important artists, she agreed to go, predicting that Glimcher would become "king of the art world" and the vehicle for her creative fulfillment. The Marlborough Gallery opened at the same time with a list of well-known artists, so Nevelson's decision to go to Pace was to Glimcher "the most important thing that happened to my gallery." Harris Steinberg negotiated the terms whereby Pace would sell Louise's sculpture in the United States and, in conjunction with the Hanover Gallery in London, in Europe. There would be the usual gallery commission and a minimum guaranteed income of nearly $20,000 a year against sales. Glimcher paid off her debt to Janis and saw that all her work in Janis's possession was returned to her studio. "I did not take a single piece, so she would feel secure and trust me," he explained. During the first months that Pace represented her in the autumn of 1963, it did not sell enough of her work to cover its outlay, but Glimcher did not press her to give them new sculpture.

He stayed in close touch, however, telephoning her several times a week, and gradually the encouragement he provided enabled her to cut back on her drinking. He also found a way to resolve the problem that had beleaguered Martha Jackson—Louise's continual dismantling and rebuilding of her work whether

it belonged to her or not. Glimcher never referred to the contract with her, realizing that she considered all the sculptures essentially hers. He readily understood and empathized with her point of view: at the Biennale he had watched Giacometti impulsively paint dark-bronze sculptures (on loan from collectors) flesh-colored with blue eyes because he disliked the way they looked in the huge white space of the Italian pavilion. So he worked out an arrangement with Louise whereby she would give the gallery another wall of the same size as one she had taken apart. These trades created great confusion for Pace's registrar at the end of the year, but Louise's equanimity was more important to Glimcher.

"[Glimcher] fits me like a glove," she said; "he was born for me. Look, I have a wonderful son. Could he do it for me? I have a brother. They can't do a thing for me." Glimcher flattered her feminine needs, buying her flowers and extravagant gifts. ("You're just my little lover boy too," she cried after he gave her a fur coat.) He served as her escort on important occasions, like the time she was invited to dine at the White House on November 12, 1974 by President and Mrs. Ford. For her part, she introduced him to Mark Rothko, and after the artist's suicide in 1970, Glimcher ended up representing the huge and tangled Rothko estate. She also took him to see Willem de Kooning in East Hampton; undeterred by an accident getting on the Long Island Expressway that totaled his new Mercedes, she insisted they keep their appointment and hire a taxi to drive them—a round trip of more than two hundred miles. Their business association was extremely lucrative for both of them and lasted for the rest of her life. Glimcher described their relationship as "perfect" even though Louise "sometimes played as if she didn't understand things because she didn't want to deal with them, and I knew she understood them."

In 1964 he gave a party for her at the Hotel Pierre to celebrate her first Pace exhibition in New York. While he and Louise sat at the head table, her son and other relatives were seated at the other end of the room, which infuriated Mike. He remembered thinking, "I'm a partner of Louise Nevelson. I'm not a *son*. We never had a mother-son relationship. I've been working for her for years." He had indeed. He had cut shapes and constructed boxes for her, even locating a lacquer to spray a dull satin surface on her sculptures. He looked over and saw Sidney Janis, who had been invited by Glimcher as a magnanimous gesture, sitting at the next table. "I'd had a few drinks, and I got up, and I walked over to him, and I

said, 'Mr. Janis, I think you've got some nerve showing up here.' "
Replying that he had been invited, Janis attempted to brush Mike
off, but the younger man grabbed his lapels, pulled him out of his
chair, and refused to let go. As the art dealer's face began to turn
purple, other guests forcibly separated them. When Louise accused
her son of spoiling her party and ruining his reputation in the art
world, he cursed and left abruptly with his wife. Coincidentally or
not, after this incident he received a letter from the Staempfli
Gallery severing their relationship.

The Pace presentation of Nevelson's work was a dimly lit in-
stallation entitled "Silent Music." The catalog, which Glimcher
had designed himself, was a dazzling display of graphics, using
cutouts and silver, transparent and black-felt paper. The sculpture
was smaller and more abstract, severe, and elegant than in the
past. It was also full of innovations, suggesting that Louise's new-
found security with Pace had already paid dividends. This was
acknowledged by *The New Yorker*'s Robert Coates, who observed
that "of late her artistic development has been enormous." Among
her new ideas were mirrored backgrounds, which magnified a box's
size, drew in light, and incorporated the spectator's broken image.
"I took the back out of the box, then I used glass for reflection,
then I used a mirror or a glass to get more reflection," she ex-
plained. In her first use of plastic, she placed Plexiglas shields
around black sculptures, creating another complex play of gleam-
ing light. With the use of mirrors and reflective plastic, she was
once again attempting to involve the spectator.

In 1961 Emily Genauer had suggested that Nevelson could no
longer go on presenting fragment-filled boxes; her work, albeit in
new colors, had become repetitious. After the innovative 1964 ex-
hibition at Pace, Genauer rejoiced that the sculptor showed signs
of "tearing down that imprisoning wall of her own: mannerism."
The New York Times's art critic, John Canaday, stated that she had
reached the epitome of her career: "Only yesterday, Louise Nev-
elson was the star debutante of the art season, and now here she
is, the grande dame of contemporary sculpture." He called it her
best exhibition to date, which "should establish her position for
anyone who has had any lingering doubts. . . . Her work has had
flair, spirit, and the inexplicable quality called 'presence,' but it
has never before been in addition so controlled, so disciplined,"
with "a sensation of absolute completeness." At the opening Louise
told the story of Isadora Duncan's last performance, when she

raised one arm in a simple gesture and said, "Dears, that's what it's all about." Nevelson, wrote Canaday, "can certainly point to this [show] and say, 'Dears, that's what it's all about.' "

As demand for her work accelerated, carpenters and others began making boxes for her. In time, her use of square, hard-edged boxes gave a more classic, orderly appearance to her walls, particularly the outside perimeters. It also conformed to the new minimalist aesthetic, which emphasized clarity and simplification. Before long she turned to children's toys like Lincoln Logs and Playskool blocks. In her frequent use of factory-made forms, her assemblages emphasized reasoning over romanticism, structure over detail, craft over chance, and deliberate design over inspired improvisation. Instead of found wood that expressed the mystery of lost civilizations, the tooled elements suggested the machinery of the modern era.

By the late 1960s *The New York Times* was calling the Pace Gallery "one of the hottest young dealer partnerships in town." It put on lavish, thoughtful exhibitions for its carefully nurtured artists, and Glimcher continued to sell Nevelson's work at a rapid rate. He considered that his main accomplishment in this respect was overcoming collectors' resistance to living with large, iconoclastic walls, which he did by both his enthusiasm for the work and his willingness to go to collectors' homes and set up walls experimentally. In the last six months of 1966 alone, Pace sold more than $200,000 worth of her work. As her prices escalated, the gallery advanced her more money each month, and by the next year she had become financially secure for life. As she approached the age of seventy, she relished her wealth, not only because it met her personal and professional needs but also as a measure of her worth. "I enjoy the fact that a woman artist in America can collect wooden scraps from the street, put them together, and sell them to the Rockefellers for $100,000," she remarked to a *Houston Chronicle* reporter in 1969.

By the mid-1960s Teddy Haseltine was seriously ill. Once when he insisted on visiting Dorothy Dehner at two or three o'clock in the morning, she was deeply disturbed to see his pupils so widely dilated that his normally brown eyes were completely black, a phenomenon she associated with drug use. In the summer of 1964 he was operated on at St. Vincent's Hospital, reportedly for complications caused by alcoholism. After leaving the hospital, he

spent a day at Jones Beach with his old friend Donald Mavros, and they made plans to return to the beach two days later. But, when Teddy got up that day, he apparently felt poorly and stumbled down the hall to Louise's bedroom. Louise, who was still in bed, asked what the matter was; he said nothing but collapsed onto the bed. When she realized he was dead, she telephoned the police, then Mavros, telling him in a tight voice to come to the house immediately but unable to explain why. Mavros rushed down and found a distraught, tear-stained Louise. "Ted?" he asked, and she replied, "Yes, he's up in the bedroom." Mavros found the body of his friend face down on the floor beside Nevelson's bed; he later heard that Teddy, at the age of thirty-six, had died from a cerebral blood clot.

When Donald came downstairs, Louise asked him to buy her a quart of whisky and some beer. When he returned with the liquor, she went off by herself and drank until she passed out. "She felt really alone and deserted at that moment," Mavros observed. In the same way that she had refused to acknowledge grief at her mother's death, she did not allow herself to mourn openly for Teddy and, in fact, assiduously attempted to banish him from her consciousness. Mavros had the task of telephoning Teddy's friends and relatives and arranging to have the body shipped to Hudson Falls for burial. He and two of Teddy's close friends, Patty Bosse and Al Gentiere, traveled upstate for the funeral, where they convinced a Roman Catholic priest to perform the last rites and bury him next to his adoptive mother, who had recently died. Louise stayed behind in New York, unable to talk about the death except in the most elliptical and coarse way, which was deeply disturbing to some of Teddy's friends. She had always disliked funerals, explaining that they held no meaning for her, and she dealt with her grief by throwing herself into her work with renewed vigor. "She cast him out," Tom Kendall said bitterly, because "death to her was a very fearsome thing." Mavros noted, however, that after the loss of Teddy she stopped dancing. In the months to come, she donated a group of her works on paper, including some affectionately inscribed to Teddy, to the Brooklyn Museum in his memory.

At the time of Teddy's death, Diana MacKown, a young woman of twenty-eight, was living in the Spring Street house. Two years earlier, after Louise's assistant Georgette Michaud had left to get married, Teddy had brought Diana, who bore a strong physical resemblance to Georgette, to the house. He had met her through

a Hungarian sculptor who was a friend of her family. She was the younger of two daughters in a family of musicians in Rochester, New York; her mother was a pianist who taught at the Eastman School of Music, and her father was first cellist with the Rochester Philharmonic. Trained to be a violinist, Diana had rebelled against practicing so she could "go in the corner and draw." After studying at the University of Rochester, she won a scholarship to the Yale art school, spent a year in Italy after graduating, and when she returned to New York, telephoned Teddy. He introduced her to Lillian Mildwoff and then to Louise, whose work she had seen while at Yale.

Before long, whenever Louise traveled, she asked Diana to stay in the house with the increasingly unreliable Teddy, to look after the household, which included a black cat named Dahlia that Louise had brought home from a party in her pocket. After Teddy's death, it became evident that Diana was ready to take his place in the studio. At first Louise resisted the idea, but when she saw the sure way Diana handled a hammer and nails, she changed her mind; she explained that although Diana had no knowledge of carpentry, she understood the rhythm of the work because of her musical training. "When it started, it seemed so natural that it was easy to fall right into it," Diana recalled. Like other assistants before her, she enjoyed the studio atmosphere, which she described as "very open and free and fun" as well as "good hard work." Louise told her she was worth her weight in gold and began to pay her a salary, at first $25 a week. For the next twenty-five years, until Nevelson's death in 1988, Louise and Diana lived, worked, and partied together in an extremely close, mutually supportive relationship.

In 1964, when Neith Nevelson, now seventeen, suddenly arrived alone in New York from Florence, Italy, where she had been living with her mother, she went straight to her grandmother's house. Louise had been helping to support her for several years, and Neith later described her grandmother, whom she had last seen at the Biennale, as her "'fairy godmother." Seeing a young girl standing at Louise's door, Diana ran from across the street into the house by another entrance and locked the door, presumably intent on protecting Nevelson's privacy. "I'm not receiving today," Louise called out from inside the studio. "But I'm your granddaughter—I'm Neith. You *have* to let me in," Neith cried. Louise handed the keys and a ten-dollar bill out to her, explaining

that she was unable to see her at the moment because she was working. Neith bought some food, let herself into the house, and found a place to take a nap until Louise was finished in the studio. She stayed for several weeks before leaving for California, where she took jobs as a waitress and a burlesque dancer, and then she telephoned her grandmother and asked to return. After promising earlier to help Neith in every way, Louise told her bluntly she was unable to take care of her. Nevertheless, in January 1965, Neith arrived in New York via a Greyhound bus and showed up at the Spring Street house. She was wearing purple sneakers, she remembered, which she considered significant, since the stairwell and other parts of the house were at the time being painted a rich royal purple. After promising her grandmother that she would not be any trouble, she was taken in and given Teddy's old bedroom.

Although Diana immediately resented Neith's intrusion— Neith recalled that she ordered her in a threatening manner not to touch her big butcher knife—Neith lived off and on at Spring Street for the next three years, helping in the studio, attending art school, and going to art-world parties. In 1948, when Neith and her mother had moved to the Lower East Side of Manhattan, Louise first had taken an interest in her little granddaughter. Neith used to visit her on Saturdays and play in the cellar of the Thirtieth Street house, slide down its long banister, and accompany Louise to gallery openings and the corner bar. Louise liked to bite the child's flesh affectionately, but Neith remembered that the bites hurt and left teeth marks and saliva on her arm. Sometimes she napped in her grandmother's bed, and although Louise tried to be discreet, Neith sensed her sexuality. When the child thought that a man had recently been in the bed, or when Louise had washed in olive oil, a practice she regarded as beneficial for her skin, the child insisted on sleeping on the floor. When Neith was about eight, Louise bought her an expensive FAO Schwartz doll resembling Brigitte Bardot and took her to the Bardot film *And God Created Woman*. Ten years later, perhaps with a sense of vicarious pleasure, she encouraged her spirited granddaughter to be uninhibited; she went to see her perform as a go-go dancer and bragged to her friends about it.

When Louise had first moved to Spring Street, neighbors had dumped garbage on the doorstep. They believed she was running a brothel, probably because of her exotic appearance and the young women and men who came and went in seemingly inexplicable

ways. Even after they learned she was an artist, the local police persisted in calling her establishment "a cathouse." Describing herself as the original hippie, Louise shared the politically liberal and socially rebellious attitudes of her young helpers, hailing social protesters for seeing through repressiveness and phoniness. But she insisted that her granddaughter visit a psychiatrist after she became involved in angry and violent episodes. Neith enjoyed going to the Apollo Theater in Harlem, and sometimes Louise went along. When Neith married a black actor and gave birth to a daughter, Issa, Louise bought a house on East Seventh Street, where Neith and her family lived until the marriage broke up a few years later. Neith later explained that, as the daughter and granddaughter of artists, she felt "displaced in a formal society."

As Louise's fame as an artist spread, she increasingly needed a buffer against a mounting wave of abrasions and obligations, which she found mentally disorienting and emotionally depleting. Although she had long hidden her most private self behind outspoken and aggressive behavior, she remained vulnerable to criticism and rarely ventured out to openings or other social or professional events alone. She believed that people's ambivalence toward her derived from their admiration and envy. Visiting Mary Shore in Gloucester, she met Charles Olson, a poet who had been a member of the avant-garde faculty of Black Mountain College in North Carolina in the 1950s. Apparently, after an evening of drinking when she described her accomplishments, Louise sensed his jealousy, and indeed, he attacked her success. Afterward he wrote her apologetic notes, but she refused ever to see him again.

Being constantly surrounded by compliant young assistants seemed to lessen her desire to keep up with old friends. She usually moved gradually out of friendships, but she was also capable of ruthlessly rejecting one. In the 1940s she had met the sculptor Helena Simkhovitch, and they became, in Helena's view, as close as sisters. By the 1960s Louise was apparently irritated by the demands of the relationship. "She would call me in the morning and waste my time talking about everything," Louise remembered. One day Helena telephoned to discuss a commission to sculpt a head, and Louise responded with an impatient and denigrating remark, which reduced her friend to tears. "I must have said something that hurt her," Louise continued. "I never knew what it was." Helena's husband, Frank Didisheim, got on the telephone and reprimanded Louise, who then and there ended the friendship. "After

twenty years to start this nonsense! I had no time for it—and I still don't," she declared. Helena, deeply hurt by this intense vengeance, wrote Louise several times but never received a reply. Years later she got Louise's unlisted telephone number from a mutual friend, called, and asked a question about a matter now forgotten and received a polite reply. Then Louise asked in a slow, gentle voice, "And now, dear, will you tell me where you got this telephone number?" It was around this time that Louise announced she had time only for ongoing relationships, not longtime ones which "tend to clutter and become outgrown."

In her sixties, Louise's personality and presence became more powerful than ever, and she was regarded as more "masculine," or driven and dominant, than most men, albeit in her own soft-spoken manner. But she was still titillated by dangerous men, like an important Mafia mobster in Little Italy, who entered local restaurants surrounded by an entourage of followers. "He's got it," Louise said to her son. "He's power." The admiration was apparently mutual; she boasted to Mike that he had sent her a bouquet of roses. When the wheels of a friend's Bentley parked outside her house disappeared one night, Louise quietly got word to "the man," and the wheels quickly reappeared.

While she had increasingly distanced herself from the possibility of serious romantic relationships with men, she often encouraged other women to have them. In 1963, when she realized that her old friend Frederick Kiesler planned to marry Lillian O'Linsey, Louise seemed both resentful of their happiness and amused that they would actually marry. She began to take an intense interest in Lillian, who was younger than Louise, and invited her to go to Ingmar Bergman's *Smiles of a Summer Night*. At the film, Louise "smiled like a goddess placing a benediction on us," Lillian recalled, believing that Louise's invitation was a generous act of erotic instruction as well as an unspoken acknowledgment that Louise and Frederick had once been lovers. A male acquaintance, Will Barnet, suggested that Louise tended to make up exaggerated stories about herself and male admirers, and he wondered how much contact she actually had with men. In the presence of other females, she often expressed hostility toward the whole sex. "They think they're so big because they have a prick—cut it off!" she exclaimed to Neith. For many years she had feared the price exacted by marriage, and certainly the experiences of many other women artists, whose careers had withered while liv-

ing with men, justified her anxieties. When she was in her eighties she once remarked that men had little to offer in the way of real communication or intimacy.

Socially, Louise and Diana were for many years regarded as a couple—"To My Valentines," John Canaday wrote on an Alexander Calder drawing of a male nude holding two hearts in his hands. Artist and stage designer William Katz, who saw a lot of them during the last two decades of Louise's life, described her attitude toward Diana as maternal, and their relationship as having elements of both friendship and romance. But at the age of eighty-two, Nevelson hotly and unhesitatingly denied the inevitable rumors. "I couldn't live with myself if I was a lesbian," Louise declared. "I've never had that experience." According to Diana, she and Louise were simply "good friends."

In the early 1960s Dorothy Miller had tentatively suggested that the Museum of Modern Art might give Louise a retrospective, but no date was set. In December 1964 Lloyd Goodrich, director of the Whitney Museum, offered to present her first museum retrospective on the fourth floor of the Whitney's new Marcel Breuer building on Madison Avenue. After discussing the invitation with friends, including Whitney benefactors Howard and Jean Lipman, who had brought Nevelson and other sculptors to the attention of the museum officials, she accepted the offer. The exhibition, planned for early 1967, would include more than a hundred works, ranging from 1930s drawings to her most recent constructions. Darkened and theatrically illuminated by blue spotlights, it would be her biggest environment ever—but first there was a skirmish over the installation.

After curator Jack Gordon had expressed his ideas for the installation, Louise complained to Arnold Glimcher, and in January 1967 Glimcher wrote a carefully worded letter to Gordon which Louise signed. Composed in her style, it was an attempt to both charm and bully Gordon into doing what she wanted: "I have given long and careful consideration to the installation of the exhibit, which you know is as important to me as the work itself. As I am, and will always be, an environmental artist so this must be a retrospective environment of my total composition." She was particularly concerned about the placement of her latest creation, *Tropical Rain Forest*, a narrow walkway of open black boxes and suspended sheets of reflective Plexiglas. "My reason for the placement of the passageway and its housing of the tropical rain garden

is to allow a fluid and light movement from the present into other periods of my work, and then a direct route back to the present and the crescendo of the enormous new metal sculpture as people leave my environment. This is my particular pride and joy. . . . So, dear Jack, you see this is why *Rain Forest* must be separated by physical distance from the new enormous metal sculpture."

She got her way about that, and she took care of an early piece Gordon wanted in the show but she did not—a stylized running figure, *Earth Woman* (1933)—by having it destroyed in an "accident." On the Sunday morning before the opening, while Glimcher and Fred Mueller were inspecting the installation, Glimcher remarked that the piece did not look good in its location. Nevelson agreed and suggested they move it. As the men picked it up, she remarked that she had never liked it. "She said, 'Why don't you drop it right there,' " Glimcher recalled. "We said, 'What?' and she said, 'Drop it!' " The dealers obediently dropped the plaster piece, breaking it, and the three began to laugh hysterically. Afterward, Louise wrote Gordon a note explaining that she and Diana had broken it again while attempting to mend it. The struggle between the curator and the sculptor was actually no contest at all because "she was so much more vigorous a character" than Gordon, according to Howard Lipman.

On opening night, Louise pinned on her shoulders two deep purple silk Japanese tapestries, each embroidered with an enormous white crane, gray branches, and pink cherry blossoms. Underneath she wore a starched white embroidered peasant blouse and a long black ruffled Mexican skirt. She had begun to cover her cropped, thinning gray hair with a bandanna, not unlike a Russian babushka, and that evening she wore a headdress created from a turquoise damask napkin. As final touches she added a necklace of boar's teeth and a large brooch she had made from black wood and sheet gold. She had disliked her witchlike photograph in *Life* in 1958, and photographs of her in a recent issue of *Art in America* were equally unflattering. Fascinated by the way actress Jayne Mansfield glamorized what Louise considered ordinary features, Louise, as she approached the age of seventy, spent a great deal of time and thought on her appearance. In earlier years she had been accustomed to the easy attention and power a strikingly beautiful woman commands. She now began to experiment with false eyelashes, which threw her eyes into dense shadow. In time, the lashes became exaggerated caterpillarlike fur fringes, reminiscent of the

stiff doll's eyelashes that had fascinated her so long ago in Liverpool. She realized that she presented herself better if she created a striking image. Once, when she attended a bar association party, she decided to tone down her appearance for the attorneys; she discovered, to her acute discomfort, that it made her unaccountably shy and inarticulate. "I never underestimate one's appearance because you project something," she commented.

She made greater efforts than ever to create a public persona, which, although based on genuine, innate dramatic impulses, diverged more and more from her innermost feelings. "Louise has a person in her mind who is Nevelson," observed Donald Mavros. Disheveled or distraught in the studio, Louise could transform herself, Glimcher declared, into a "bird of paradise" to accompany him to an opening a few hours later. The persona was closely connected to the work itself; at times an art critic's description of a black assemblage seemed to portray Nevelson the woman. At the same time, many of the artist's deepest and most private feelings and perceptions bypassed the persona to find expression in the sculpture. In 1964 she named a curved wall *Self-Portrait*. "Nevelson is the work," Glimcher once observed, and, indeed, a few years earlier she had described her relationship to her sculpture as "like a mirror"; her forms reflected her image back to herself, and in the process she drew closer to what she dubbed "the so-called truth." She found it deeply satisfying to give the public this reflection of herself, particularly as it was by now so highly praised and desired in the art marketplace.

The opening of the Whitney retrospective was crowded, and as flashbulbs popped around her, she was encircled by admirers. She was buoyed by the fact that Andrew Wyeth's paintings were displayed on the floors below, and a show of Henry Moore's sculpture had opened the same night at the Brooklyn Museum. But reviewers had widely differing reactions to the highlights of her oeuvre. As old charges of mannerism and lack of an overall concept were repeated, the artist seemed curiously detached. She was fully aware that the retrospective's prestige and publicity would give her more opportunities to fulfill her aesthetic ambitions. "I feel this is the first time in my life I can do what I want," she said to a *New York Times* reporter. "Hell's going to break loose. I'm just beginning."

With her market firmly established, she bought back the Spring Street houses. Unwilling to condemn commercialism in the

art world because it enabled artists to take their rightful place in society, she explained during a panel discussion that the "romantic concept that an artist can't make a living" resulted from a false sense of superiority. She undoubtedly took satisfaction in the fact that achieving financial independence through creative accomplishment was a rare and difficult feat for a woman. The following year, her success in the marketplace was matched by professional recognition when she was elected to the National Institute of Arts and Letters. She claimed afterward that even without the financial rewards, the gratification inherent in her work would have sustained her: "If someone asked me what part of success meant the most to me, I would say that success means I can have a loft big enough to work in, I can have help with my work, and I can have all the materials I need, whatever they are, to express that work."

Throughout the 1960s, Nevelson continued to experiment with new materials, encouraged by Pace's policy of advancing funds to its artists for expensive new plastics, processes, and technologies. Although her readiness to put wood aside was unexpected, she had expressed curiosity about technological innovations as early as 1939, when she sent away for a speech about commercial television. Now she echoed the minimalists and declared that artists should embrace science, automation, and technology. To those who argued that the slick products of technology were devoid of feeling, she pointed out people's strong attachments for automobiles and motorcycles. In 1960, before astronaut John Glenn orbited the earth, she remarked to artist Ilya Bolotowsky that modern art should encompass consciousness of outer space; artists should be like lassos thrown out into space, "able to grasp anything and not limit themselves." "I love horses and carriages with those wonderful wheels, but I can't get where I want with them," she remarked during a panel discussion in 1967, adding that she supported anything that "opens mankind to more awareness."

In the spring of 1966, her exhibition at the Pace Gallery included glossy enameled aluminim shapes—mathematical cylinders, rectangles, double funnels—in black or white grids. Although she had made several trips the previous year to a fabricator in St. Louis, she reportedly first saw the finished sculptures, made from miniature scale models, when they were installed in the gallery. Several critics at first expressed concern at the apparent loss of the sculptor's own touch in her work. Dorothy Seckler in *Art in*

America found that the show, in its use of smooth industrial materials, "revealed a new Nevelson who seemed to have been swept from the 'elsewhere' of her shadow cells to the 'here and now' of sleek, impersonal forms in a rash, overnight flirtation with technology." However, the exhibit brought Louise her largest sale to date as *Atmosphere and Environment I* (1966), a twelve-foot-long assemblage of geometric black metal industrial forms, went to the Museum of Modern Art.

Although in earlier wooden works she had used some glass, she now began to compose entirely in transparent materials. Aware that the greatest scientific minds had developed modern plastic as far as possible before it was manufactured by industry for profit, she enjoyed exploring its aesthetic potential. Going from shadowy, black boxes to open, luminous sculpture was like turning the box inside out and sculpting with light instead of shadow. She became fascinated by translucent plastic's potential for revealing a multiplicity of inner boxes unified by straight and arched silvery lines and rows of sparkling chrome-plated screws. *Ice Palace I*, composed of 230 Plexiglas cubes, was as intricate as a nineteenth-century crystal palace. This new glinting, glimmering sculpture was her attempt at capturing constantly changing reflections—and she began calling herself an architect of reflection. She referred to the materials as "mentalities" and considered them expressions of mental clarity. "I accept that matter is crystallized thought," she said in an interview with her friend Dido Smith. By the mid-1960s, she believed that she was creating on a higher level, reducing her vocabulary to two notes—horizontals and verticals—and expressing illusion, spirit, or the fourth dimension. "The new materials were made for me," she declared during the 1967 panel discussion. "This is the first time I'll dare to admit that the time and I have become one." As her work became more spare and orderly, she felt an impulse to rid herself of the associations inherent in her numerous folk-art collections, and she began to sell them off.

Her experiments with clear Plexiglas, Lucite, and other synthetic materials were shown for the first time at Pace in 1968. Hilton Kramer raved about the new creations, noting their "unembellished syntax and cool, detached glamour." For him they indicated "the final transformation of the romantic architecture of the 1950s, with its Expressionist chiaroscuro, into a stunning Constructivist clarity." But Louise eventually felt restrained by having to send maquettes away to be fabricated into multiples by others,

a process that took months. Once when Arnold Glimcher was at her house, she picked up a little box she had designed with curved elliptical forms in it and asked him to order her twenty of them, some smaller and some the same size. When they arrived from the factory, Glimcher helped her tape them together into a box grid with masking tape and indicate with a black felt marker where each screw would go. "And we sent that miserable taped-up thing with all these little black dots on it to St. Louis, and it came back this glittering, perfect, stainless-steel screw-in piece," Glimcher recalled. Once the plastic constructions were completed, they were impossible to alter; furthermore, because of cost and technology constraints, they were difficult to enlarge. The work in synthetics, with its emphasis on analysis and control, was also essentially alien to her stronger feeling for intuition and impulse.

By the late 1960s, the ornate iron grill doors of her SoHo establishment were repainted black as she once again returned to working primarily in black wood. Her new black wooden walls, displayed at Pace in 1969, exuded energy, force, and innovation. The show included *Night-Focus-Dawn*, a restrained and elegant play of tall, narrow boxes, half hiding the deeper shadowy interiors which contained machine-made curves, triangles, and squares repeated rhythmically throughout. She also broke up the flat wall image and explored new ways to arrange boxes, placing them at right angles and in zigzag patterns.

In October 1969 it became a cause célèbre when Louise was omitted from the Metropolitan Museum's huge review of painting and sculpture from 1940 to the present, which included forty-three artists in scores of galleries. The show was organized by Henry Geldzahler, the museum's first contemporary curator, and the selections were highly controversial. Some observers felt that being an independent, outspoken, and ostentatious female had not helped Nevelson's cause. Despite the greater simplification and clarity of her recent sculptures, particularly the plastics, her work was criticized for its emotionalism by critics and curators adhering to the minimalist aesthetic. Others, notably those in the "formalist" establishment, were discomforted by her inability to adhere to certain conventions, such as the strict separation of wall-mounted painting and three-dimensional sculpture. During the next few years Louise became outspoken in her criticism of influential members of the art establishment who disliked her work, calling them destructive to creativity. When she was on a panel with critic Clem-

ent Greenberg and he remarked that American contemporary sculpture was not on a par with its painting, she responded with an angry outburst.

Actually, the only woman in the Metropolitan show was Helen Frankenthaler, and on the day of the opening the fifteen hundred guests were picketed by the Art Workers' Coalition protesting the show's white-male bias. But Louise, buoyed by her Whitney retrospective and other recent achievements and honors, was more or less immune to the conspicuous critical slap. She had other allies in the museum world, like Dorothy Miller, with whom she traveled that year to an opening an exhibition of her work at the Rijksmuseum Kröller-Müller Museum in Otterlo, Holland. A few months later, when her black wood wall *Nightsphere-Light* (1969), which stretched an incredible forty-seven feet, was installed at the Juilliard School, she blithely remarked, "I used to feel like Little Orphan Annie. But I'm so pleased by all this today that I feel like Alice in Wonderland."

Empress of Modern Art

I dared to look
I like what I see
Good i good i good i
for me

—*LOUISE NEVELSON*

SHORTLY AFTER Arnold Glimcher began to represent Louise's work, he asked her to experiment with metal sculptures for public places, even though in the 1940s she had vehemently rejected metalworking techniques as too masculine. Glimcher recognized the growing American market for monumental outdoor sculpture, and he was aggressively going after these commissions for Pace artists. Convinced that such projects would extend her career, he remembered telling Louise that since she "had always created such extraordinary atmospheres inside, it would be a great challenge for her to move outside," and he offered to pay the cost of her experiments. If they did not work out, the sculpture would be destroyed, and she would not owe him anything. Although she had already cast a few wooden pieces in bronze with, for the most part, unsatisfactory results, she accepted his offer as long as she was not required to produce a commissioned piece.

258 In 1965 she went to St. Louis to work with a metal fabricator

on lightweight, flexible, enameled aluminum sculptures. They were shown at Pace the next year in a gallery decorated with artificial grass and large potted plants; the catalog portrayed her sculptures as if they were in the gardens of Versailles. Regardless of whether she knew working in metal would lead to creating in the round again (she had recently said she had no desire to compose outside the enclosed box), the pieces were an important shift in direction, indicating both a degree of suggestibility and the appeal of experimentation and surprise, which would also become apparent in her subsequent embrace of plastics.

These first experiments in metal had a beneficial impact on her ongoing constructions in wood as well. She was preparing psychologically to undertake an ambitious challenge: the creation of a massive wall from a hundred boxes. After they arrived from a carpenter, their presence overpowered her, and she was unable to go near them for months: "I saw them in their black totality, and I became frightened. My energy, as good as it was, was overcome. So I locked the door in the studio, and if I needed something, such as a hammer, I let my assistant get it." Then she went to St. Louis, where the demands of the aluminum forced her to simplify her vocabulary of shapes. On the return flight, she suddenly understood that the key to composing the great wall was simplification—an emphasis on reductive forms and rhythmic repetition. After almost a year of gestation, the concave, 28-by-14-foot black wall, *Homage to the World* (1966), was completed in a week. Her use of similar-sized slats in a hundred slightly varying arrangements was enhanced by the addition of thirty rounded objects containing circular forms, which were clustered near the center. Louise's intuitive flash resulted in a series of sparer, more elegant wooden walls, which stretched as long as fifty feet. If an artist is "very well integrated," he or she "can put a thousand pieces together," she later declared.

The distance between New York and St. Louis made it difficult for her to go back and forth often. Glimcher arranged for her to visit Lippincott, Inc., a small metal fabricator in North Haven, Connecticut, which had just opened. At first she was intimidated by the prospect of working with Cor-ten steel, a durable outdoor metal, imagining that the cold, hard steel, which was hoisted by heavy cranes, would be repellent to the touch. She worked in wood intuitively; now she had to present the metalworkers with preparatory sketches or, more often, models made of painted wood with

gray cardboard or black Plexiglas indicating the main support posts. She returned regularly to North Haven to supervise the progress of the early Cor-ten pieces at critical times and to ask for minimal changes. The first works, completed in the late 1960s, were relatively formal and mechanical; they had rectangular grids and were close approximations of her walls, the main difference being the larger size and emphasis on silhouette rather than on interiority.

In time she learned to work alongside the metalworkers, whom she found to be genial, perceptive, and willing to spot-weld as long as her stamina held out. Wearing a hardhat and some exotic robe, she quietly but firmly addressed the men in endearments as she asked them to move a few tons of steel an inch this way or that. Don Lippincott, the owner, who described her later work as more "collaborative and impromptu," observed that she was the only artist who worked there that way, requiring no layout and less cutting than usual. Lippincott's technology eventually impressed her, and she marveled that a machine could produce a half circle of steel in a matter of minutes. "She used the cranes and those guys the way someone uses a paintbrush," Arnold Glimcher remarked. Eventually she did away with the familiar grid structure and offered freestanding forms—box interiors, now inflated—as outdoor presences. The scavenger in her was attracted to the asymmetrical metal fragments discarded in creating other sculptors' works, and before long she was being provided with truckloads of scrap from commercial metalworking factories. Her *Seventh Decade Garden*, exhibited at Pace in the spring of 1971, consisted of an orchard of ten spirited, black aluminum "trees," made of both existing scraps and designed forms rapidly welded together in two days.

In North Haven she often worked on a piece twelve feet high, a comfortable scale for her, which was then enlarged and reduced, resulting in three sculptures twelve, two and a half, and thirty-five feet high, but rarely without further adjustments. "When a maquette is enlarged, there are different considerations, and I never merely enlarge. I rethink and add and change edges and thickness of forms as well as adding new pieces. My works are always in process until they are installed, and even then I've made changes," she explained in spring 1977 when an exhibition was situated at the Neuberger Museum at the State University of New York in Purchase. She executed last-minute changes even as a huge sculp-

ture was about to be trucked to its location. As she returned to her old working habits, she decided that steel was as malleable as Salvador Dali's melted watch in *The Persistence of Memory*, as supple as butter, as pliable as a satin ribbon. "Now that was a breakthrough; it took me right out into the open. There had been the principle of the enclosed box, the principle of the shadow boxed in; with the mirror, the principle of the reflection boxed in. Now I'm boxing in the outdoors."

At first Louise refused to take commissions, "because she never wanted to work for anyone," Glimcher explained. Eventually, she relented but claimed, with an edge of defensiveness, that she refused more commissions than she accepted, that she had never allowed an architect to restrict her, and that she had never been restrained by agreements made at corporate meetings. On occasions when she went ahead and created a full-sized commissioned piece before submitting a model for preliminary approval, Pace was forced to order a reduced replica from the finished sculpture to present to the buyer. Even this degree of patronage made her uncomfortable. In later years she defiantly and disingenuously proclaimed, "If I have work, [collectors] should be damn glad to get it, and if they don't like it, the hell with them. Other people will. And if they don't and I can get along, so who cares."

Be that as it may, her first placement of a Cor-ten sculpture, *Atmosphere and Environment X* was commissioned by Princeton University in 1969. During the next decade, when many public agencies allocated small percentages of their construction funds to art, Louise became one of the most frequently commissioned sculptors in America and monumental Nevelson works appeared from coast to coast. The serene totems and great white moon of *Bicentennial Dawn* (1976) were placed behind glass in the lobby of the Philadelphia Federal Courthouse on Independence Mall for the nation's two hundredth birthday gala; composed of free-standing wood units of machined scraps, the structure appeared inspired by her metal work. In 1977–78, after the City of New York donated the land and Chase Manhattan Bank along with several other corporations agreed to donate the sculptures, Louise transformed triangular Legion Memorial Square at the intersection of Maiden Lane and Liberty and William streets in lower Manhattan into Louise Nevelson Plaza. When she had first looked down on the vestpocket park from the window of a nearby skyscraper, she decided to place the sculptures on stilts so that they would "float like flags,"

and the seven black steel sculptures—entitled *Shadows and Flags*—rose as high as seventy-two feet. For an artist whose eyes and spirit had feasted on the city for more than half a century, the taut curves, points, poles, and tense suspended shapes of the sculptures expressed the synergism of her own sensibility and that of the metropolis.

"Working in the open is especially difficult as you are in competition with the scale of the universe," Louise explained. She disliked placing her sculptures informally in naturalistic settings, preferring a formal garden, courtyard, or other structured setting. She found the spare desert landscape of Arizona ideal for *Atmosphere and Environment XIII* (1972), a geometric grid containing playful half- and quarter-circles. When she went to Scottsdale to plan the installation, she instantly decided to "frame the space" and place the sculpture in the center of a plaza, in a pool with fountains: "Now, if I were going to place a piece where that kind of control couldn't exist, I would talk to the architect or the landscape architect to change things so that it was not just left savage." Unpainted Cor-ten steel often developed a natural rusty patina outdoors, which eventually became a matte blackish brown, a shade Louise once described as a "found color" but then rejected because she did not want "a natural thing." Although the titles of her earlier sculptures were romantic allusions to gardens, she had never been genuinely fond of nature, as the parody of a garden behind her Thirtieth Street house demonstrated. In childhood she had been repelled by nature's uncontrolled abundance, and many years later, when she arrived in Texas on a lecture trip and "saw green, it almost killed me," she admitted to sculptor Richard Stankiewicz.

Many of Louise's critics were disappointed in her metal constructions and disparaged them as conventional, mannered, inauthentic, and even as displaying poor workmanship. Several critics, including Hilton Kramer and Dore Ashton, assumed that she was attracted to metal by the expectation of greater financial rewards and wider public acclaim. Ashton particularly disliked the new direction, believing that Louise's work was never meant to be translated into monumental pieces. But Louise, ignoring her bad press, claimed that "working in metal has allowed me to fulfill myself as an environmental architect." She was willing to abandon, at least for the time being, the intimacy, mystery, delicacy, and texture she evoked in black wood for the opportunity to push

her imagination and inventiveness onto a grand scale. By the end of the 1970s, no public sculpture except Alexander Calder's and Henry Moore's was as popular as hers, and Kramer observed facetiously that the entire country was turning into "one big Nevelson sculpture garden." Her celebrity grew, and her face became as familiar as Picasso's.

During the last two decades of her life, Louise dramatized her appearance more than ever. In the past she had shunned designer's labels, declaring proudly that she created her own designs; to be truly an art, she explained, haute couture had to be an expression of the wearer's personality and attuned to her milieu. Once when Glimcher was shopping at Arnold Scaasi's Fifth Avenue couture house, he invited the designer to accompany him to the Whitney Museum, where Louise was installing an exhibition. Scaasi was astonished and amused to find the sculptor wearing a floor-length sable coat and peaked fake-fur hat over a pair of blue jeans and a work shirt. Looking at her sculpture scattered about, he remarked on how much she had produced during her long career. "I have so much to do, I don't have time to die," she replied.

Although it was near closing time, Scaasi invited her back to his salon, where be began to bring out tailored black wool suits that he assumed were appropriate for a seventy-year-old woman. Finally she remarked that she was not "the Scarsdale matron type." He remembered replying: "You are absolutely right. You are the empress of art—we must dress you as the empress of art." "Now you've got it," she agreed. Rapport established, he brought out rich brocades, silks, and velvets. Before long he would design her an evening gown from a geometric pattern of cut black velvet backed by black satin that resembled a Nevelson creation. Subsequent evening outfits made use of black tulle, black sequins, black lace, and other opulent materials.

Scaasi, the son of a Montreal furrier, who created his surname by spelling his original name backward, believed, like Louise, that no woman should enter a room without making as "extraordinary" a first impression as possible. Louise, who regarded herself as one of her own creations, was one of a very small number of his customers whose urge for self-expression was stronger than their concern for appropriateness. Louise never complained of feeling overdressed, only underdressed. She collaborated with Scaasi on her wardrobe, but he set the limits. "She might say 'I want this,'

and I would say 'No, I think we've gone far enough, dear,' and she appreciated that. She came to me because I was not going to make her look foolish." In the years to come, she would travel uptown on short notice to Scaasi's salon, the last custom design house in New York, to order outfits for openings and trips. He understood that each visit was like a voyage for which she must be in the right mood. During the last decades of her life, his lavish, attention-getting clothing helped her feel like the beauty she had been. Once after someone toasted her by saying that she had been one of the most beautiful women he had ever seen, Louise stood up, smiled, and said: "I used to be a young beauty, and now I'm an old beauty." And when *Women's Wear Daily*, the newspaper of the fashion industry, labeled her a "Beautiful Person," she began signing her autograph "from Beautiful Louise Nevelson."

Some of Scaasi's clothes, which cost thousands of dollars, were given to her, and he, an avid art collector, was given several Nevelson assemblages. He escorted her to social events, such as a costume party at the Metropolitan Museum in 1976—she had begun donating her Oriental robes and designer gowns to the museum's costume institute—where she wore a short Scaasi black velvet jacket appliquéd with pink flowers and a long, full black satin skirt. The next year she appeared on the international best-dressed list, which amused and pleased her. She had absorbed her mother's love of adornment and display, and perhaps she sensed that her selection would have gratified Annie Berliawsky, whose greatest pleasure had been dressing up her pretty daughters. Like her mother, she took great pleasure in what she considered a female right to self-indulgence and extravagance. She acquired a great number of semiprecious, showy necklaces, earrings, bracelets, brooches, and belts and a number of fur coats—raccoon, red fox, Russian crown sable, Empress chinchilla—which she liked to spread out on the floor and furniture in her bedroom. In 1986, when she bought the sable, she asked Arnold Glimcher, "Why shouldn't I have that? I always wanted that."

Yet she never allowed herself to become a slave of the fashion industry. Her clothing was loose, and she did not wear high heels because she liked to take "great strides." When she dined at the White House in 1977 at a state dinner for Prime Minister Pierre Trudeau of Canada, one of her dinner partners, a newspaper publisher from Iowa, observed that she resembled "some ancient gypsy who'd wandered from her wagon into the glitter of the State Dining Room." She took to wearing a Moroccan chieftain's coat or a

fringed and feathered African ceremonial robe. She liked to mix prints and patterns as well as styles—a mink-trimmed purple snakeskin jacket with denim work clothes, a gold lamé skirt with a lumberjack shirt. She dressed in layers—a silk jersey Scaasi jumpsuit as long johns ("the most expensive underwear that anyone has ever worn," Scaasi proclaimed with exasperation) under an evening gown—for warmth. And she continued to favor dramatic headgear. One day she spotted some enormous black straw hats in Scaasi's salon and insisted on wearing one to a Metropolitan Museum opening with a black tulle coat; she also wore a ten-gallon cowboy hat or a velvet jockey cap with formal evening clothes. "I'm what you call a real collage," she commented. She dressed the same way she assembled her sculptures—spontaneously and elegantly—often ignoring a new outfit for a year until the right moment came to put it on, much the way she waited to place an interesting piece of wood. She cared meticulously for her vast wardrobe, which she organized by color in black steel lockers, and she wore favorite items for years. "I realized that she was not an ordinary person—that she was a unique creature who dressed in a kind of environment," Scaasi said.

In the early 1970s some feminists criticized Louise's emphasis on ostentation as denigrating her seriousness and that of other women artists. "I am happy in beautiful clothes, wonderful jewelry, I am constantly creating—why should I stop myself?" she replied. Extravagant clothing gave her such a lift, she admitted, that she used to work in Oriental robes "so that every day was an unfolding for me of some sort." But she spoke out publicly on behalf of women's liberation, even though, in her seventies, she felt that men were finally treating her as an equal. "I am a woman's libber because I believe that while a woman's mind is different from a man's mind, a woman's mind is certainly equal to a man's," she said. She went on to describe the socially defined feminine mentality as more positive than the male and speculated that creativity might actually be feminine in nature. Noting that women artists had traditionally done portraiture and illustration, where technique was more important than freewheeling inventiveness, she recalled that most of her difficulties as an artist had arisen from social expectations. By the end of the decade, she had become a role model for younger women artists; in 1979 she was the New York Feminist Art Institute's guest of honor at a benefit held under a huge black Nevelson relief at the World Trade Center.

Louise considered "singlemindedness, concentration, and ab-

sorption in one's work" not masculine attributes but hallmarks of individual self-development. She insisted that everything about her was feminine, explaining that she experienced the feminine principle as feeling that resisted regimentation, and she worked in a feminine manner: "A man simply couldn't use the means of, say, fingerwork to produce my small pieces. They are like needle-work. . . . Men don't work this way, they become too affixed, too involved with the craft or technique. They wouldn't putter, so to speak, as I do with these things. The dips and cracks and detail fascinate me. My whole life is in [my work], and my whole life is feminine." After Dorothy Dehner's second husband died on Thanks-giving, 1974, Louise spent a day with her. "I've had fame, but you've had love, and you've had it twice," Louise remarked to her. Dorothy found herself wondering if Louise had ever been in love. Yet Louise angrily rejected the idea, once suggested to her by a professor's wife, that she was unfulfilled as a woman. She turned the question on her questioner, implying that individuals rarely develop their entire potential and rejecting the idea of a limiting female role: "You are a woman, and you fulfill yourself."

Yet when she was seventy-six, she took the drastic step of having her heavy breasts surgically reduced in size to give her more physical freedom and a more youthful figure. The operation symbolized her rejection of what she called her "mother body" and indicated her determination to recreate her appearance. She avoided a facelift, however, and other than false eyelashes, she wore little makeup, observing that it made an older face look em-balmed. The omnipresent bandanna, which dramatized her hand-some bone structure, was the look Princess Norina Matchabelli had affected in the 1920s. As if to compensate for her hidden hair, Louise sometimes glued several pairs of eyelashes together, be-cause they gave an aging face "emphasis" and made her feel like "a playgirl." "If I looked too refined and said 'fuck it,' they wouldn't quite understand. Looking as I do I can say it." She liked to shock admirers who insincerely fawned over her. Once, when a man greeted her effusively, she turned to him icily and said, "Do I know you?" When he attempted to answer, she asked, "Did you ever sleep with me?" When he mumbled in embarrassment that he had not, she replied that then he did not know her very well.

With her muscular strength added to her dominant personality and the weight of her seventy-odd years, the more flamboyant feminine attire sometimes made her appear like a female imper-

sonator, particularly when she smoked slender Schimmelpennick cigars and offered her roughened workingman's hand to shake. Her extreme attire may also have been an attempt to compensate for her lack of traditional femininity. The inner depths of her boxes and her enfolding walls had been perceived as essentially womanly, but it became difficult to ascribe old notions about female sensibility to the assertive metal sculptures. Most of the time her long robes made her seem immensely powerful, like an ancient queen, while her bizarre combinations sometimes suggested the deviant force of a madwoman or a witch.

It was at this time that she finally became celebrated as a personality in the mass media. She had always relished seeing her name in print, and in the 1930s and 1940s had saved even routine listings of her exhibits. Hubert Crehan observed that by the 1950s she was "a set designer, in the wings when she would prefer to be in the limelight, behind the footlights," receiving the ovations of thousands of people. "I wanted it, and I wanted it badly," she said in 1964. "I didn't want art on any level but a grand scale." She invited attention by being glamorous, photogenic, and quotable, even to the point of providing a favorite recipe or listing her choices for the world's sexiest women (Golda Meir, Greta Garbo, Indira Gandhi, Billie Jean King), appearing on Dick Cavett's talk show, and allowing white spring coats to be photographed in her studio for *Vogue*.

Before long her name had become so familiar that *The New Yorker* published a cartoon of a sleepy man opening a cluttered medicine cabinet and remarking: "What's this Louise Nevelson doing in my medicine chest?" Her image inspired a young playwright to title a play *Dawn's Wedding Chapel*, a choreographer to create a dance inspired by one of her sculptures, and imitators to attempt to duplicate her constructions. She generously used her name to benefit causes and donated works of art to raise money for the National Welfare Rights Organization, the Martin Luther King Foundation, the United Jewish Appeal, the Merce Cunningham Dance Foundation, George McGovern's presidential campaign, and other charities and causes.

When Richard Avedon photographed her for *Vogue* in a photo session complete with Bach, caviar, champagne, and Greek cherry pastry, she admitted to those present: "When I'm the star, I never get bored." She remarked another time that she was having the best time of her life because of her long-awaited financial, psychic,

and aesthetic freedom. "I've waited all my life for this moment," she said. "I can't afford to drop dead." Observing that fame could be as dangerous as failure if it pulled you away from your center, she believed she had been ready for it when it arrived. Like a great actress, she knew how to make a dramatic entrance, and as photographers surrounded her with flashing cameras during an opening in 1977, a reporter noted that she resembled "a breathtaking luna moth being stalked by an avid throng of butterfly collectors."

In 1979 the Farnsworth Museum in Rockland opened its first Nevelson exhibition and held a homecoming luncheon for four hundred townspeople in her honor. The city council proclaimed Louise Nevelson Day, the mayor gave her a symbolic key to the city, flags were hoisted along Main Street, and the *Courier-Gazette* published a "Welcome Home" editorial. Most appropriately of all, people collected debris for her to which they attached little notes. Her old friend Rufus Foshee of nearby Camden suggested facetiously that all her walls be lined up along Main Street for one day to create an enormous environment and help her exorcise her hostility toward Rockland. But the relationship with her hometown continued to be ambivalent on both sides. Although a Maine art critic had earnestly attempted to explain the black wall that once stood in the lobby of the Thorndike Hotel, most townspeople disparaged it. They also disapproved of her life-style (when an old classmate complimented her on her costume, she remarked that it was in amazingly good shape since she had slept, worked, and vomited in it) and resented her criticism of them (she was quoted as saying that her schoolmates were dowdy and the town conventional). Louise found yet another reason for resentment: the management of the Samoset Hotel had destroyed a large wooden sculpture by Maine artist Bernard Langlois. To show her disapproval she refused to stay at the hotel, which she had frequented after Nate sold the Thorndike. Despite Nate's efforts, plans never materialized for a Nevelson sculpture on the grounds of the public library or even a modern-art wing for the William A. Farnsworth Art Museum.

In New York, however, the 1979–1980 season became a year-long eightieth birthday celebration in her honor. The Municipal Art Society turned a large fund-raising award dinner into a birthday party at which Mayor Edward Koch presented her with a cake—she refused to blow out the candles fearing bad luck—and danced with her to the song "Louise." Another Whitney Museum

retrospective opened in May, where parts of seven large black, white, and gold environments from 1955 to 1961 were condensed into four rooms. Awards and honorary degrees continued to pour in: after being elected to the elite fifty-member American Academy of Arts and Letters, taking the chair originally held by the sculptor Augustus Saint-Gaudens, she was awarded the academy's gold medal for sculpture in 1983. Two years later she was presented with a National Medal of the Arts from President Reagan and received an honorary degree from Harvard. Gradually her old bitterness was eradicated, or at least eased.

Despite her life as a celebrity, Louise usually retired early in her fourth-floor bedroom and awoke at three or four o'clock in the morning, read and mused for a few hours, then went to one of her studios. As she grew older, she depended more heavily on assistants, even though she still had extraordinary creative bursts. In 1972 Bill Katz suggested sculptor Cletus Johnson as an assistant. She gave him an apartment in 31 Spring Street, and he enjoyed observing her well-honed aesthetic instincts and the way she moved around the studio like a dancer. He scouted the streets to satisfy her appetite for raw materials, particularly in Chinatown, where wooden crates from Hong Kong could be found. While Louise was composing, he worked at her side, drilling, nailing, hefting heavy pieces. At the end of the day his sense of accomplishment was due to his feeling "really a part" of her creative work. He stayed off and on for a little over a year, until the intensity of the life exhausted him. Gregory Hull, who assisted her during the last two years of her life, was eventually allowed to suggest where an element could be added, although he was careful to say that Nevelson always executed "the master stroke."

After a day in the studio, Louise liked to have a massage or soak in a hot tub with bubbles, scented salts, and a whirlpool attachment. She had a tough peasant body, friends observed, although she suffered episodes of back pain and dizziness. Sometimes she relaxed by listening to records, especially arias by Maria Callas. She rarely cooked, except to improvise with found food from the refrigerator, creating thick sandwiches and omelets that had an abundance of onions and garlic. She liked rye bread, herring, pastrami, sour pickles, pickled green tomatoes, and other ethnic foods from downtown delicatessens and ordered blinis and caviar when she dined uptown at the Russian Tea Room. Often she and Diana

ate in neighborhood restaurants; other times they invited friends for dinner. There were moments when Louise still became depressed and complained, "I only see black," and drank herself into oblivion; but as her energies diminished and her hangovers intensified, this happened less and less often.

She continued to astonish many people with her relentless productivity, inventiveness, and energy. The Pace Gallery, which exhibited her new work every two years or so, in 1974 showed collages and "end of day" black wood pieces, like the exquisite, small *Dark Ellipse*, produced in polyester resin in an edition of 125, and the elegant wall, *End of Day Nightscape*, made of typeboxes. Her 1976 exhibition was clearly reminiscent of earlier ones: an upstairs gallery held a selection of black assemblages called "Moon Garden + Two" including rounded free-standing barrels from which sharp vertical sticks radiated out, while a downstairs room contained "Dawn's Presence—Two," a group with more delicate and placid white wall reliefs. In 1977–78 Pace presented large, powerful black sculptures in the "Zag" series, which broke up her usual even perimeter for a sculptural silhouette.

She had gradually acquired more space to work in as the owner of the flower shop in her building died, the candy store went out of business, and she bought an adjoining property on Mott Street with an eleven-car garage for a large studio. She now had a maze of some twenty rooms connected by doors, staircases, and narrow passageways—in effect a multilevel, dimly lit, live-in sculpture. Black or white floors and ceilings and track lighting set off her work, which shared space with a few pieces of furniture, like an Oriental rug or an antique wood chest. Still a compulsive arranger, she habitually removed objects from closets and cabinets—bowls, silver, pewter, china, crystal, porcelain, even worn striped croquet balls—and placed them on view for a while. She also enjoyed the sight of her long-haired black cats perching gracefully amid the display that she was constantly moving, replacing, adjusting, shifting. "At three in the morning when she got up, she moved furniture around in her room," Diana MacKown recalled. "She liked to do that. That was her life."

Louise did not find her busy household her ideal living space, however. She talked about designing a house on the Upper East Side which would be even more of a live-in sculpture: windows would be spaces in the metal façade, floors and ceilings would be mirrors and illuminated glass, and a curved wall would encircle

the interior. "If you're living with that kind of harmony, something in the mind unfolds," she explained. But it remained a dream house. In the mid-1960s, fascinated by the miniature castle in the stage set of Edward Albee's play *Tiny Alice*, she had talked with Albee about the relationship between the dramatic performance "and molecular structure—everything being part of something larger and smaller than itself against the theory of the finite universe." She was, Albee felt, one of the few people who understood the play. A few years later she began to create with actual dollhouses and peaked-roof structures; the resulting three dozen small black *Dream House*s were encrusted with geometric shapes and characterized by half-open or half-closed windows and doors.

As she continued to invent in black wood, she assembled a large walk-in box called *Mrs. N's Palace*, after the name given her by the neighborhood children. Its shadowy interior was reflected in a black-mirrored tile floor, and it was layered inside and out with a dense veneer of quintessential Nevelson images. Old and new elements of her rich, mysterious, nightmarish vocabulary were suspended from the ceiling; others poked out from the walls. In a deeply personal metaphor, *Palace*'s walls were windowless, and light entered only through the door or artificially from within. When the enclosure was exhibited at Pace in 1977, it evoked strong emotions and various evaluations; a number of art critics saw it as a review and summation of her work during the past quarter-century. To others it was a mausoleum—an interesting reaction, since it had been created soon after the death of her sister Lillian in late 1976. Others saw in it a womb, a vault, the unconscious, or the influence of Kurt Schwitters's *Merzbau*, the Temple of Dendur, or a hut from Joseph Conrad's *Heart of Darkness*. It was actually oddly similar to a hermit's driftwood shack she had seen on Monhegan Island off the Maine coast more than forty years earlier which had excited her more than the European art she had recently seen in the Louvre.

"I feel the *Palace* is both highly sophisticated and highly primitive, and there, I feel, is the meeting place of genius and insanity," she announced. "Insanity has something to do with the primal, and I don't make much distinction between primal and sophisticated." Another time she called it "a night palace that I hope is gay . . . where you eat caviar, drink champagne, all the things you don't do by day." Edward Albee found the assemblage immensely exciting because it revealed to him that her entire body

of work "was part of a larger universal piece"; the only way to understand her sculpture was to be completely surrounded by all of it. At first Louise wanted to ask a million dollars for *Mrs. N's Palace*, but when a German museum made an offer, she decided to give it to the Metropolitan for its new wing of modern art, because she wanted it to remain in America.

She was offered a chance to design a chapel, like her own great-uncle, who was said to have decorated the ceiling of a Russian church. She had been very disappointed when the symbolic white sanctuary, "Dawn's Wedding Feast," was dismantled in 1960; now she could create an actual chapel that would remain intact. When the Reverend Ralph Peterson of St. Peter's Lutheran church in midtown Manhattan first visited her, along with the architect and the chairman of the church's building committee, Louise joked that she hoped he had a lot of money in his briefcase. Peterson shrugged and observed that money was merely paper, and the two felt an immediate rapport. At first they argued about the meaning of "being religious," but within an hour they understood each other; he realized that she had "an orthodox soul" and was profoundly religious in a "pretheological way." Furthermore, he added, she had a "prophetic insight into the nature of reality" as well as an understanding of what he called the "fallenness of the world." Their initial agreement included her acknowledgment that in her design of the tiny chapel in the shape of an asymmetrical polygon, she would adapt her aesthetic concept to respect its functional purpose.

A debate arose among the congregation about whether art should be separate from theology or its servant; there was concern because Louise was both Jewish and not "religious" in any conventional sense. Peterson, however, was firmly convinced of the existence of "visual spirituality"; he found many theologians too word-oriented and literal-minded. The only time he and Louise disagreed was over the design of the gold wood cross. He preferred an early iconlike version, she a more abstract rendition. They finally agreed to attach the first cross to the priest's vestment and use the second over the altar. The Erol Beker Chapel of the Good Shepherd, dedicated in 1976, subtly and successfully evoked Christian imagery. Its flat white paint suggested the austere white wooden Protestant churches of New England; three suspended columns, which swayed slightly but perceptively in air currents, implied the spirituality of the Trinity; five white wall reliefs represented the twelve apostles and other theological symbols. One

of the reliefs, *Sky Vestment-Trinity*, resolved the sculptor's characteristic energy with a sense of exultation. When Nevelson posed for formal photographs in the chapel, she wore elaborate robes and a huge golden medallion around her neck, as though she were herself the Queen of Heaven.

During the winter of 1982–83, her tall, slender *Cascades Perpendiculars* series on display at Pace made use of the fire-damaged remants of an organ from the old church of St. Mark's-in-the-Bowery, which had burned down. Arnold Glimcher and others considered this her best work in a decade; the all-black, human-size personages suggested an outpouring of ecstatic energy and coiled strength as well as tender delicacy. Her 1985 Pace exhibition astonished observers by its innovations. "Nothing is unshakable; a grande dame can also be a gypsy," Patricia Phillips wrote in *Artforum*, referring to the "tornado-like animation" of her work. Another critic found that "[*Mirror-Shadow* (1985)] makes it possible to begin to grasp the enormity of the material and spiritual worlds and the possible connections between them." *Women Artists News* said it was as if "the innards of the boxes have burst out," referring to Louise's subsequent gravity-defying constructions with drainage pipes and split truck tires placed on a diagonal axis. Despite her chronological age, Louise was working at the height of her powers. Although she indulged in luxuries, they did not equal the joy of work. "What you make yourself and what you buy are not related," she observed in 1986. "I'm glad I'm alive to do this."

Nate Berliawsky had gradually become prouder of his sister's accomplishments, even though she embarrassed him somewhat by being a publicity seeker. In 1974 he decided to transform the dining room of the Thorndike, now a third-class residential hotel, into a Louise Nevelson Room to display her paintings and sculptures. When the room was to be opened, Louise hired a chauffeured Cadillac—"the biggest car Rockland had seen since Eisenhower came through," according to one resident—for the drive to Maine, even though it meant turning down a subsequent invitation to a Nelson Rockefeller party for Henry Kissinger. Nate held a champagne reception, to which Louise wore her ruffled black tulle Scaasi decorated with red, yellow, and white polka dots, and felt amply rewarded for his years of loyalty.

When Nate developed cancer of the colon, Louise helped get him admitted to Memorial Sloan-Kettering Cancer Center in New York; and after she aided a fund-raising drive by donating works

of sculpture, the Louise Nevelson Laboratory for Cancer Immunobiology was established there. Nate's cancer was arrested, but he died of heart failure in the summer of 1980. Louise went to Maine for the funeral in Rockland's tiny Adas Yeshron Synagogue to say goodbye to the man with whom she had had the longest and undoubtedly the most gratifying relationship of her life.

Her relationships with other relatives were not as successful. Over the decades, tension with the Mildwoffs had grown. Although Ben often sympathized with her plight, he was sometimes impatient and dictatorial. Louise had also long been angry about what she perceived to be his insensitivity toward her youngest sister, to whom she spoke almost daily on the telephone. In the spring of 1962, after Lillian had urged her husband to finish paying Mike for some of his sculpture which they had acquired, Ben exploded. How could he afford the sculpture when she spent all his money on jewelry? he shouted, and told her to pay Mike herself. "I've seen this scene for thirty years," Mike, who happened to be present, wrote his mother. "I can recall the grand old days when Ben could muster up a storm of indignation, scream and shout, break the dishes, overturn the table, slam the door." Louise increasingly resented feeling indebted to her brother-in-law. Instead of acknowledging any gratitude to him for his help over the years, she credited herself with establishing him as a collector. The autumn after the incident Mike reported, she repaid a loan of $6,463, and their relationship reached the breaking point. Mildwoff visited her studio periodically to try to become involved with her work; one day, after he attempted to tell her how to hammer correctly, she furiously ordered him to leave the house and vowed never to speak to him again.

An argument arose later over the ownership of a Nevelson wall in the Mildwoffs' West Eleventh Street brownstone. Ben was convinced he had bought it, but he lacked written proof; apparently the money that he had given Louise had been a gift in her eyes, payment in his. Two days before Christmas of 1968, Lillian sent her sister a registered letter after learning that, unable to confront them herself, Louise planned to send Diana MacKown in a van to collect the art.

> Ben will not allow Dian [sic] to decide what was paid for and what was not. Ben is perfectly willing that you, yourself, come and whatever you think we did not pay for,

you can gladly take with you. This is the way it will have to be Louise, since I too, want to live with some measure of peace.

<div style="text-align: right;">Sister Lillian</div>

Two years later, the dispute remained unsettled, and it almost came to a lawsuit. Finally it was decided that Louise would construct two walls from the one in question—one for the Mildwoffs, one for herself. But this did not defuse the situation. After Louise returned a reassembled wall with certain elements missing, Ben claimed she had "destroyed" the original work. "I was very upset, but my wife didn't want me to do anything about it," he recalled. "She thought it was a terrible thing that Louise had done."

In the mid-1970s, after Lillian developed cancer, Louise visited her in the hospital, but she refused to acknowledge Ben, and when Lillian died in late December 1976, she did not attend her funeral. She blamed Ben for Lillian's death, although others observed that she herself had contributed to her sister's unhappiness. Mildwoff continued to admire Louise and her work—even leaving a complimentary note for her at Pace in 1983—but she held tenaciously to her grudge against him. "Artists are brave, and she was brave," acknowledged Ben, who long ago had abandoned his early aspiration to become an artist.

Louise often said that no one in the family had helped her, when in fact her needs were so urgent and overwhelming that no one could possibly help her enough. Perhaps as a reaction to the inability of many women to take credit for their own achievements, she found it necessary to feel completely responsible for hers. "I'm not even grateful to some people who might think they have helped me," she informed Diana in the 1970s. "This is my life, and I don't permit people to intrude." Louise also told interviewers that she had lived alone for many years, as if Diana did not exist. At a wedding party for her granddaughter Neith, she remarked in her son's presence that nobody had ever helped her. "If no one ever helped you, I don't know what the hell I've been doing," Mike retorted. "I stand alone," she replied. "You are weak, and you need help from people, but I don't need help from people." Mike became so agitated that he experienced chest pains and difficulty breathing; fearing he was having a heart attack, he lay down on a bed. Louise turned on one of her granddaughters and blamed the girl for causing her father's collapse.

A few years after Mike's second marrige broke up in 1969, he took a European vacation with his two younger daughters. On that trip he met a young Dutch woman, Marianne, whom he later married despite family disapproval over the large age difference. He continued to sculpt and occasionally exhibit and became an avid member of a shooting club near his home. Although his mother appeared to like the idea of his being a strong personality, in reality she hated his lack of deference toward her, and their relationship deteriorated. On her eighty-second birthday he sent her a dozen roses; when he asked if she had received them, she replied that Arnold Glimcher had sent her eighty-two roses. "I've tried for many years to have her respect," he once said sadly. "She's very disappointed in me." She would agree to meet him at a party, not show up, and explain later that he had "represented" her. Eventually he caught on. In February 1985, when Pace gave Louise a dinner party at the Four Seasons in honor of her latest show, Mike turned down the invitation.

She kept up friendships with a few women she had known for many decades, such as Dorothy Miller, Dorothy Dehner, and Emily Genauer, and she telephoned, traveled, and celebrated birthdays and other occasions with them. One evening when Genauer was shocked by Louise's confession that she had never been to Greece, Louise suggested they depart for Athens the next day. They did so, accompanied by Diana, and toured the remains of ancient temples and statuary, but the sculpture did not have the power to profoundly affect Louise's aesthetic the way that of the Mayans had done. She also maintained a warm friendship with Barbaralee Diamonstein, an arts administrator and writer, who over the years interviewed her many times for magazines and television. Louise came to depend on her advice, though when Barbaralee advised her against going to an exploitative event, Louise often went anyway—as if still making up for the years of neglect—and in turn offered the younger woman her own "metaphysical musings."

She often celebrated holidays with William Katz, Edward Albee, and a number of their friends. "Everyone was attracted to Louise because of her energy," Katz explained. Katz also took delight in her speech, which he described as "a heady stream of sequiturs and non sequiturs," and in her ability to have fun. She used to end long telephone conversations with him by saying: "You know, we've had a wonderful time so far, but I think *this* year, we're *really* going to have a good time." He had introduced her to Jasper Johns, who made the rare gesture of throwing a seventieth

birthday party for her at his studio. Louise also got to know composer John Cage and dancer Merce Cunningham during the three summers in the 1970s when she rented a Japanese-style house overlooking the Hudson in Stony Point, New York. Cage said they never talked about their work, but he felt a creative bond with her. "I accept noises, and she accepts old pieces of wood," he explained, describing her work as "music theater." Yet all the friendships seemed limited in their intimacy, and she remained essentially a loner. Albee, who called her "a mother–peasant creature–witch–dear friend–lady," thought she "told half-truths to most people." He observed that she was most interested in her own perceptions, and her conversation was "a sharing of what was going on in her head, it didn't want response, and her questions more often than not were rhetorical." Increasingly, she perceived people as multiple extensions of herself, like the reflections of her image repeated in the mirrors on opposite walls in a bar she once frequented.

When at an opening Louise encountered an artist with whom she had once been close, she would warmly introduce the old friend around and often sit and talk with him or her, holding hands as if to offer strength and encouragement, as if no time or neglect had come between them. "I believe you're good," she might remark, using endearments, especially when she was unable to remember the individual's name. But afterward she would rarely telephone, return telephone calls, or respond to invitations. Despite her public appearances, Louise went "more into herself" as she aged, according to Diana, who became fiercely protective, shielding her from those she thought might waste her time. Old friends, family members, and others complained that Diana, who was in charge of the appointment book, intercepted telephone calls and letters. This may have been true in some instances, but Diana was often unable to explain to callers that she had indeed given Louise the message: "In some cases she didn't want to see certain people anymore. Along with everything else, I was like a bouncer." She accompanied Louise almost everywhere, her plump, blond looks a physical counterpoint to the sculptor's taller, exotic presence. In the early 1970s, as she began to interview, photograph and film Louise, the two set up Iron Crystal Films, under whose auspices Diana produced a poetic twenty-eight-minute film, *Geometry + Magic*. In 1976 she published tape-recorded recollections entitled *Dawns + Dusks*.

In the spring of 1957, Louise had written a poem about the relationship of herself and her projected image. Acknowledging the

aesthetic vision always in her mind's eye, the poem related it to her personal image:

O doesn't remember not knowing about O . . .
In the beginning O had eyes wide open . . .
O had no need to search for O
O's first conscious awareness was "Birth to a New Image"
What a dream for the then little O!
Little O grew bigger and bigger.
The dream became clearer and clearer
One day O was full grown and so was O's Image.
O knows who O is and O knows who the Image is.
A Love-marriage between O and the Image.
Sometimes they may not agree.
Sometimes O gets ahead of the Image.
Sometimes the Image gets ahead of O.
But never to [sic] far from each other.
O and the Image have their eyes wide open
and are seeing very well through to Immortality
How Wonderful!

Masquerading as a grand lady seemed more than ever a way to protect her inner image. "I have a feeling maybe my appearance is deceptive," she admitted to Diana. "Because if you're going to put on a show like I do, they don't know beneath that façade there's something else. Why should I be naked before everyone?" She intimated that her need for a fabricated persona sprang from the effort of inwardly sustaining her youthful belief in herself and fearing she would be unable to handle as her due the praise and plaudits from the social elite and art establishment. "If you walk a tightrope and you don't know the technique, you fall off," she said. Edward Albee described Nevelson at the end of her life as a consummate actress who created "a three-dimensional persona that talked and moved" which was "a good stand-in" for herself as well as an object of her own amusement.

The persona was an assertive mask impossible to ignore. As she aged, Louise believed that without her regalia and reputation she would be unnoticed and unloved. "I want people to enjoy something, not just an old hag," she once remarked. "It isn't just the work, but what you put in the work, and who you are, and how you present things and so on and so forth, and it all adds up." Considering her genuine achievements as an artist, this suggests a lingering shyness and insecurity. One morning before she was

interviewed for an article on aging and creativity, she dressed in a plunging gold lamé blouse, slit black satin pants, and black lace stockings. Proud of the fact that she could still dazzle people despite her years of "drinking, fucking, and screwing," she mused aloud that perhaps those activities had not been bad for her after all. "If I look like this at eighty-three, work like a horse, don't eat right, don't sleep right, get drunk and everything else, you can imagine what I must have looked like at fifteen," she boasted. "Now I can command anything. I can command *anything* I want. I can command any goddamn thing I want from anybody."

But posturing did not always bring her the power and adulation she craved. Her exaggerated appearance seemed "grotesque" to some of her friends, who observed that her words seemed to come from behind a mask. "She has what I call a plastic face," said Peter Busa. "She gives you a plastic answer, which is not there. It's amorphous." At times her audacious public voice, which applauded her own egotism, independence, and originality, seemed false and strained. Maintaining the persona took a certain physical and psychic effort and strain, and she complained that a trip uptown took all day because of the necessity "to dress." On the rare occasions that John Cage got a glimpse of her without makeup and costume, he complimented her on the beauty of her unadorned face. At such times she appeared to be smaller, friendlier, informal and natural. "Louise said she didn't want a comfortable chair in the house, but once people were there she gave a great deal of herself to everybody," Diana explained. "She liked to pretend she was Miss Tiger, but she was really a pussycat underneath."

Louise, like Marcel Proust and a number of other gifted people, advocated the artist's right to be supremely self-centered. Starting in the 1920s with her admiration for Krishnamurti's teachings about the individual's need to be centered, she spent many years trying to justify egotism for the sake of art. She overcompensated in her effort first to bring it off and then to justify it. When she was on a panel at Mount Holyoke College in the late 1950s, she had defended the abstract expressionists for signing their paintings with large, assertive signatures on the front of their canvases. If she were a teacher of young children, she said, she would have each one write his or her name a thousand times a day on the blackboard to teach a strong sense of self. "If I'm selfish, I regret that I'm not more selfish," she stated in old age, while one of her

creative friends explained it was *art* that was demanding, not the artist.

Inevitably her claim to egocentricity left little room for the egos of others. But if she was unintentionally hurtful to those closest to her, she was not deliberately destructive toward other artists. "Her nature is rather selfless, insofar as an artist can be selfless and still have the drive to be a good artist," Dorothy Miller believed. "She had to fight for her work, but it didn't involve sticking a knife into another artist."

In later years she had to suppress many memories "because," she said, "I've destroyed so much"—an extraordinary admission from one who had created so prolifically. "If I had looked back, I would have destroyed myself," she concluded. Sometimes she deliberately tried to hide behavior she found impossible to forget or deny, such as her failed motherhood or her sexual promiscuity. Unable or unwilling to confront certain conflicts or disturbing facts, or even to tolerate friction around her, she allowed things to penetrate her consciousness only to a point. Being introspective, going "way down," was discomfiting: "It's a place of ill-at-ease." When her friend Lucille Beards suggested that she might have erred in some way, Louise declared, "We don't make mistakes—we live!"

She was aware that her repressions gave her a clear and uncluttered mind, free of what she called "splinters"; she compared forgetting to cleaning her mind with silver polish and rags "to keep it shiny." It was a cleansing she found essential for creation, as it provided her with a rich inventory of half-remembered emotions and experiences. "I have been able to make myself more comfortable by reorienting a thought or whatever to suit my kind of thinking," she said. "A truth isn't a truth to me, a lie isn't a lie. If I were to accept academically these words and what they stand for, it would kill me immediately. If a so-called lie will be a tool for me to fulfill myself, I'll use it and have no morals about it. And if a so-called truth can destroy me, the hell with it."

Her hubris and inability or disinclination to adjust to ordinary reality made her existence difficult. "Napoleon said you stoop to conquer, and I said my legs wouldn't give," she explained. Describing her life as "tough," she rejected the notion of happiness altogether, rationalizing that it lacked form. With her outsized ability for suffering, she paid for false starts and setbacks with black depressions and burning rages, regarding her pain as the price to be paid for ignoring convention, as if self-sacrifice were a

form of redemption. But she usually harnessed her anger in the studio, where she denied ever being discouraged by her work—"never for one day."

Private myths fortified her immense self-confidence. She regarded herself as a royal princess born in humble circumstances who was fated to find the right psychic and physical setting for herself, like a piece of wood awaiting recognition and transformation by the right placement. Once in the 1950s she said matter-of-factly to Marcia Clapp and her husband Jovan de Rocco, "I am America's greatest living sculptor." On another occasion she claimed that she "always got raves" from critics. In old age she liked to recall times when others had confirmed her conviction that she was "original." One of these occasions was in 1958, when her old professor Hans Hofmann was dining at the Mildwoffs with Mark Rothko and Clement Greenberg. Hofmann had finally given up his Provincetown school, and Louise remarked that he must be glad to be able to paint full time; but, as she told it, he merely gestured toward an early black wall of hers and replied, "You're an original—I haven't found myself."

Order—mental and personal as well as aesthetic—remained essential to her. Indeed, creation meant searching for "more aware order, like a great symphony where there was nothing left out." On the domestic level, she regarded a cluttered closet or a disordered studio as a form of "constipation." Her need for absolute order was reflected in her relationships with others. "I imagine I was kept in my compartment like everyone else was—in my Nevelson box," reflected Edward Albee. She acknowledged that her insistence on neatness was linked to a controlling impulse, associating "a place that is orderly around me" with "somehow controlling that space." Orderliness kept practical matters and time-consuming miscalculations from infringing on her studio hours. The sense of regimentation, like the use of geometric structures in her assemblages, provided a stability that allowed her intuition and impulses to roam freely.

After denying important influences on her work for many years, Louise finally acknowledged the inevitable impact of her era and environs on her visual imagination. Although she boasted of her uniqueness and inventiveness, she understood their limits. "Now we can afford to have just so much originality, for if we indulged ourselves in total originality, we would go insane," she

explained in a speech at the MacDowell Colony in 1969. Her inspirations and influences were, in fact, numerous and varied; what was significant was her selection, absorption, interpretation, and empowering of them with her intense emotions and vivid imagination. Throughout her long career, observers detected influences ranging from Russian altar screens to African and pre-Columbian art to modern American technology. But she considered herself a genuinely American artist, referring to herself as "Miss America," and she transplanted cubism with her own twist into the tradition of American sculpture.

Manhattan, her chosen setting, continually revealed itself to her as a huge, changeable sculpture and infused her with imagery and inspiration. In December 1972, when the monumental *Night Presence IV* was installed at Fifth Avenue and Sixtieth Street, she called it a Christmas gift to the city which had given so abundantly to her. She had watched the Empire State and other skyscrapers go up and seen innumerable buildings demolished. The shifting urban silhouette was to her a stimulating embodiment of energy in space, which in 1956 she had described as a new sculptural awareness: "I would say that if our time has made a contribution . . . it would be in t employment of the space concept—Space in and around t object, having its own energy and intelligence."

When she was driven around the metropolis, often in a chauffeured limousine or by Diana in a black Ford station wagon named Black Beauty, Louise enjoyed the human tideline of graffiti, marveled at the way the sunset transformed restaurant windows into molten gold, and saw red traffic lights at night as "burning roses." She liked to watch the infinitely variable play of sunlight and moonlight in the hundreds of windows on the handsome old school building just across Mott Street. Although it had been a sight she hoped to feast on visually for the rest of her life, she took it philosophically when the building was demolished in 1973; characteristically, she raided its wreckage for debris to alchemize into art. She was fascinated by the crisscrossed structures of railway bridges, regarded gritty subway columns as "grand and glorious," even evoking them in her slender black-encrusted totems, and acknowledged that her huge black wood wall relief *Sky Gate—New York*, commissioned by the World Trade Center, was a direct interpretation of the city skyline. Although she traveled throughout the world with her exhibitions, she felt she did not need to leave home for inspiration: "All I need is to feel New York coming through the wall."

In her mind, inventive fantasy remained far superior to unembellished facts; in 1954 she had quoted William Blake to the effect that "he who does not imagine in stronger and better lineaments, and in stronger and better light than his perishing mortal eye can see, does not imagine at all." She revealed that the griffins in *Winged City* represented the flight of the imagination. She insisted that the sculpture be placed on a pedestal precisely forty-two inches from the floor to imply flight. When describing it, she emphasized the importance of imagination: "All our heritage through the ages, expressed in literature, spiritual messages, mythology, the visual arts, has been winged, has had flight, expressed from multiple directions, all going to just that one place. Some call that God. . . . I believe totally and completely that we are forever aware of flight in our very being."

She remained scornful of literal reality. When an observer commented on her use of a toilet seat in a golden wall, she said perversely that the Madonna's halo could be viewed as a toilet seat and her own gilded object an abstract image. Sometimes she declared before audiences that her sculpture was not black, not wood. When challenged, she once replied: "If you see a woman on the street and describe her as 'a female in a dress' instead of 'a dream,' then she has missed the boat. . . . If you look at a piece of sculpture and say it's black and wood instead of 'a dream,' then I have missed the boat."

Near the end of her life, Nevelson's metaphysical sense of the insubstantiality of objective reality deepened. In 1954 she had articulated the idea to a group of women artists by describing how she saw a room completely differently by entering it through different doors. "My search for the absolute led me to consciousness of relativity," she said to Colette Roberts in the 1960s. Another time she explained that "a flicker" in Einstein's consciousness, presumably about the scientific approach to relativity, "dovetailed with a flicker in mine." Her dismissal of what normally passed for reality also indicated her obsession with her own half-conscious imaginative reality, which in turn gave rise to her mysticism and romanticism.

She indicated that a sense of disability motivated her search for revelation. "If you accept the world three-dimensionally, it's a tough racket because you get banged every second, every pore of your body is banged, and you are black and blue all over," she once said. Her indifference to practicality sometimes made her work more arduous. "She loved certain things because of their

shapes and textures, and she didn't care if it was oak and you couldn't hammer it—or [she would] spend three hours with one nail trying to get through the goddamned thing," Diana recalled. As she experienced an exciting and gratifying imaginative reality, actual events outside the studio seemed "almost accidental." Gesturing to a blurred reflection of a window on a glossy black tabletop one dark, rainy afternoon, she observed that it was "a million times more beautiful" than the window itself: "Illusion permits anything, reality stops everything."

Since she believed that reality was illusory, she regarded the individual as someone who, like a motion-picture camera, viewed a world of his or her own making. In 1968 she had explained to Colette Roberts that her only reason for living was to follow the vital direction of her own sensibility: "Something grows in you, and you project it." In an experience common to most artists, she felt driven to understand and then relate to others by projecting her awareness through her work into the visual world. Making sculpture was "the best way I knew to project how I was feeling about everything in the world." By the end of her life, she believed she had bridged the distance between objective reality and her private imagination, that she could even go back and forth easily between them—an experience that had at last given her personal stability: "I don't care where you take me, I feel very comfortable," she said at the age of eighty. She had finally attained what she had only dreamed was possible, while her imagination was enriched by a lifetime of experience. "My life gets richer every day," she said. She had gotten as close to the meaning of life as humanly possible, she believed, and was moving into the mirror of ultimate understanding: "I'm just about seeing myself in the mirror."

As she grew older, Louise appeared to have little faith in anything except her own compulsive, solipsistic activity. She found it immensely satisfying to work with assertive verticals, limitless horizontals, fluctuating light, shadow, and reflection, variable grains, ages, and thicknesses of wood. "When you use a vertical line or a horizontal line, or a texture or the way the shadow falls on a thinner piece or a heavier piece [it] satisfies something in the soul," she had explained in 1963. Her hours in her studio remained a daily rebirth in a heightened state, "walking in and out of green pastures." Bypassing the persona, she offered her most intimate and naked self to the world through her work. In 1977, receiving her honorary degree at Harvard, she said that art "gives me my

world, it gives me my sanity, it gives me my beauty, and it gives me my life."

In the summer of her eighty-eighth year, Louise rented a week-end house in Westhampton, Long Island, where she sunbathed, dipped in the swimming pool, consumed banana milkshakes, and worked on collages with wood fragments, twigs, sandpaper, clothespins, and other objects. She was "radiant and beautiful," in the eyes of Bill Katz, who, along with the sculptor Marisol and her dog, arrived late one evening and found her waiting up for them. That summer, however, she had a premonition of death—she dreamed that she was covered with layers of earth. She asked Arnold Glimcher, who was staying in East Hampton, to tell her about the deaths of his mother, Eva, and Jean Dubuffet. Glimcher explained that Dubuffet's death was willful because the elderly artist, who suffered from emphysema, stopped taking oxygen. As he recounted the event, he noticed that "it was as if she were taking notes on how to die." He became alarmed, because she had never before taken such an obvious interest in death. Two years earlier she had insisted, "I'm not afraid of dying, because I've done so much on this earth." Once she said that she wanted to be reincarnated as an American Indian; another time she admitted she would rather live again as herself, because of the artist's rare degree of personal freedom. Although she remained optimistic about art and the artist's imagination, she was "intellectually completely nihilistic," according to Glimcher. "She felt that mortality negated the meaning of life."

In September 1987, she was in high spirits when she showed a *New Yorker* writer the roses blooming in her makeshift rooftop garden. But shortly afterward she checked into Doctors Hospital for an examination because of a painful case of shingles and a general feeling of malaise. At the end of the month, an X ray indicated a shadow on a lung, and physicians diagnosed lung cancer—the same disease that had taken her mother's life. She had feared cancer because it had also stricken her brother and her youngest sister. For a few days she debated whether or not to allow surgery that would remove half her lung and probably prolong her life. "What am I to do—die or try to live?" she mused to Glimcher from her hospital bed, adding that she still had a lot of work she wanted to do. "When you're my age, all you have is your life." Her doctors felt she had the physical and mental health of a sixty-five-

year-old, and she decided to go ahead with the operation. The night before the surgery, she was serene and remarked that her life had been "more than I ever could have hoped for." She came through the operation well, and tests indicated that the cancer had not spread to other organs of her body. She believed she had survived a great crisis and had more years to live. Speaking very slowly and softly to assorted friends and family members, she whispered that she hoped scientists and intellectuals would never unlock the mysteries of the universe, because from them emerged the joyous impulse to create art.

In October and November she gained enough strength to do a little work, but she did not regain her old vigor and continued to speak in a whisper. One night, dining with Diana and the Glimchers at the Chanterelle restaurant to celebrate her recovery, she had no appetite and appeared thin and fragile. She talked about traveling to St. Martin, where she had spent the previous Christmas. After she and Diana arrived on the island in late December, William Katz, who was already there, went to visit them. He did not know about her operation and was surprised to find her very weak and resting on her bed; she spoke to him about euthanasia as it was practiced in Holland and about her dislike of the rocky terrain around the isolated guest house, which reminded her of Maine. "She was very, very, very quiet—kind of serenely quiet," he recalled. He wondered what was wrong, and finally Diana told him about the cancerous "spot" on Louise's lung. As Louise's condition rapidly worsened, arrangements were made to take her immediately back to New York, where she went directly from the airport to Doctors Hospital.

She was transferred to Mount Sinai Hospital, a teaching and research facility, where in January doctors discovered a cerebellar tumor; the cancer had metastasized after all. The prescribed treatment was radiation, which had harsh side effects but might give her another year. Again, she decided to fight for her life, but the radiation "totally drained her, and we thought she was dying by the day," Glimcher remembered. Friends hung art posters in her hospital room, and Diana brought paper, glue, wood, and other materials in a futile attempt to interest her in working. Once when someone held up a piece of wood for her to see, Louise opened her eyes and looked at it with such desire—"as if she were looking at a gorgeous man"—that her visitors burst out laughing. Dignified and stoic, Louise wanted no one outside her immediate circle of

friends and family to know she was seriously ill, and she insisted that her name be taken off her door and replaced by the word "Occupant." She would have preferred to drop dead in her studio— and she intended to give the world that impression.

When her youngest granddaughter, Maria, who had visited her in Westhampton the previous summer, learned that she was ill, she traveled from Philadelphia every weekend to be with her. Louise had always had mixed feelings about being a grandmother and a great-grandmother; she disliked being called Grandma and referred to herself as "Old Lady Lou" on postcards to her younger granddaughters in the 1960s. During those years, she visited the girls a few times a year, bringing them beautiful dolls and other gifts. Sometimes she aroused their jealousy by buying one an extravagant gift and not the other; when Mike explained this to her, she replied that she wanted each girl to have the experience of feeling special. When Maria was eighteen, Louise sponsored her debut at the annual International Debutante Ball, bought her a ruffled, childish dress, and hired a limousine to take herself and Maria, Diana and Diana's niece, and the girls' escorts to the ball. Maria was dimly aware of the fact that her grandmother was wearing a see-through black lace skirt without any underwear, which she later explained as an expression of her grandmother's resentment of society. Although Maria wanted to remain in New York after the ball to attend other parties, she felt unwelcome at the Spring Street house and returned dejectedly to Connecticut. Louise frequently found being with her granddaughters emotionally draining; if she thought one or another of them seemed troubled, she offered to send her to a psychiatrist. She had also provided each one with a small trust fund. "So I fulfilled my duties to nature, which I don't believe in anyway," she remarked to a *New York Post* reporter in 1977.

By February 1988 Louise had virtually stopped speaking. Glimcher asked her in Yiddish if her head was strong, if she could understand everything, if she was silent because she wished to be, and she nodded yes to each. She had never had much faith in spoken language; deliberately going mute had been her instinctive response to grief when her father emigrated to America. After the radiation treatments were completed, her doctors asked her if she wanted to go home, and she nodded yes. In mid-March, as she steadily weakened, she was provided with round-the-clock nursing care. As she lay with her eyes closed, people took turns holding her

hand; she still had a strong grip, and if they expressed an endear-
ment, she squeezed their hands in response. Mike's visits partic-
ularly pleased her; on one occasion he brought her a spring bouquet
of daffodils, which he carefully placed where she could see them.
As her condition deteriorated, Mike and his wife began to stay
overnight. "It was long and painful, yet she held onto me and did
not want to go," he said.

Ten days before Louise died, Diana telephoned the other grand-
daughters to ask them to come to New York because their grand-
mother had only hours to live. When Neith arrived, Louise was
drifting in and out of a coma, but she grasped Neith's hand so
tightly that her thumb made a bruise on her wrist. At the end,
morphine was no longer effective, and Louise suffered excruciating
pain in her head. "I think she was shocked at how long it took to
die," Glimcher said. The day before she finally did, she was
writhing in pain. At last she spoke: "Let me go, let me go." She
died on Sunday evening, April 17, 1988, after her relatives had left.
Her body was taken to the funeral home next door, and the fol-
lowing day it was cremated. Louise had never wanted a funeral,
an event she had always regarded as a grotesque ritual, so plans
were made for an eventual memorial service.

Her will, drawn up in 1974, left everything in her $1.8 million
estate to Mike. He spent the summer going through his mother's
possessions, cataloging and photographing her work, dealing with
appraisers, and moving items out of her house, including twenty-
five terra-cotta sculptures and other works of art, which Diana
claimed belonged to her. Mike and his lawyer maintained that the
items and the remainder of Louise's output were owned by Sculpt-
otek Inc., a corporation established by him and Arnold Glimcher
in 1976 to manage Louise's personal finances and business affairs.
Mike also disputed the legitimacy of two documents Louise signed
in 1985 and 1986 giving Diana the works of art and the right to
sell reproductions of the terra-cottas. During Louise's final illness,
old animosities between Mike and Diana had intensified. Two days
after his mother's death, Mike had the entrance connecting Louise's
living quarters with Diana's apartment in 31 Spring Street sealed
with a metal door, and he changed the lock on 29 Spring Street.
While Diana and her lawyers were indicating that she wanted to
be recompensed for her services to Louise, even threatening a pal-
imony claim and suggesting that Sculptotek was set up to evade
taxes, Mike described the actions as attempted blackmail. As at-

torneys attempted to work out a settlement, Louise's unburied ashes remained in Mike's possession amid arguments over their final resting place.

After Louise's 1967 retrospective at the Whitney Museum, she had given the museum $350,000 worth of art—an unusually generous gift from an artist, but she felt it gave her the space to create more. "When I see all the work I've done, it scares me that one person could have ever done it," she said at the time. "So it's just as well that it's kind of spread around." In the early 1970s, she gave the museum additional gifts, making it one of the largest repositories of her work. In 1985 she donated twenty-five sculptures and collages, worth more than $5 million, to the Metropolitan Museum of Art and museums in Chicago, Minneapolis, Los Angeles, Boston, London, and Paris. It was unusual for an artist to give away so many works of art during a lifetime, but Louise was extremely prolific and generous with her work. Observing that Mark Rothko had allowed little of his work to be sold before his death, she pointed to the burden his huge estate had imposed upon his children. In her case, it was expected that Sculptotek, which reportedly owned $100 million worth of sculpture at her death, would continue as always to handle her estate. Meanwhile, prices continued to escalate, and Sotheby's sold *Dawn's Wedding Chapel I* of 1959 for $253,000.

On an unseasonably warm, overcast October day, six months after Louise's death, the memorial service was held in the Medieval Sculpture Hall of the Metropolitan Museum. Although distant in every sense from the provincial town of her birth, it was an appropriate setting. It was the beauty of gold-embroidered robes at the Metropolitan that had helped bring her back to art, and it was to the Met that she had donated *Mrs. N's Palace.* She had sketched there as an art student, warmed herself in its galleries during times of struggle, and appeared at its openings in full regalia. On the day of the service, a soft light streamed down from high windows. An arrangement of white flowers had been placed in front of a large, ornate gilded iron altar screen from seventeenth-century Spain. Surrounding statuary depicted eagles and Madonnas. At noon more than two hundred and fifty family members and friends, including museum directors and leading art critics and curators, were greeted by the Glimchers and Mike and his wife, Marianne, as they took their places on chairs set up on the stone floor. As the service began, a quintet played selections of classical music. Wil-

liam Lieberman, the museum's director of twentieth-century art, was the first to offer fond personal reminiscences and homage to her originality. He was followed by Arnold Glimcher, Hilton Kramer, Barbaralee Diamonstein, and Edward Albee. It was evident that Louise had finally triumphed on her own terms. Her tenacious pursuit of her independence, at whatever the cost, has resulted in the enduring and honored expression of her ephemeral imaginative truth. At the end, having been caught up again in a sense of her aliveness, the mourners quickly dispersed.

Notes and Sources

LN Papers, AAA—Louise Nevelson Papers, Archives of American Art, Smithsonian Institution. Unless otherwise noted, all letters quoted are in this collection.

1: LOUISE BERLIAWSKY

5

Other sources than those cited for material about Nevelson's family background and early years in America include Mrs. Bronislava Barban, Leah Bergren, George Berkley, Gregoire Berliawski, Lillian Berliawsky, Alex Berljawsky, Edna Wardwell Clements, Ida Dondis, E. Allen Gordon, Elaine Kahner, and Anita Berliawsky Weinstein.

13

"I often hear the remark": Louise Nevelson, "Art at the Flatbush Boys Club," *Flatbush Magazine*, June 1935, p. 3.

16

"toward which their gaze": Irving Howe, *World of Our Fathers* (New York: Harcourt Brace Jovanovich, 1976), p. 57.

17

"as closely as herring": Sholom Aleichem, *From the Fair: The Autobiography of Sholom Aleichem* (New York: Viking, 1985).

17

"took her face from Heaven": Natalie S. Bober, *Breaking Tradition: The Story of Louise Nevelson* (New York: Atheneum, 1984), p. 9.

18

Pereyaslav: In an alien registration form filed in November 1940, Isaac stated he was born in "Pereislow, Poltawe, Russia"; common usage translates this to Pereyaslav, province of Poltava.

18

Nachman: The boy's grammar-school records in America vary the month and year, some saying 1897. His naturalization papers state he was born in 1896, probably because he enlisted in the U.S. Navy when he was underage. He later settled on the year 1898, the date on his tombstone.

18

"built for greatness": LN to author, September 5, 1986.

22

"a living presence of a people": LN, "One Lives a Life," 1965, LN Papers, AAA.

22

"The eye, of all the senses": LN to Louise E. Rago, July 1958 and February 1959, "Why People Create: Visit with Sculptress Louise Nevelson," LN Papers, AAA, p. 3.

22

"to enslave him in labor": Diana MacKown, *Dawns + Dusks: Taped Conversations with Diana MacKown* (New York: Charles Scribner's Sons, 1976), p. 6.

25

"If you tried to break in": W. R. Kalloch to author, October 28, 1986.

25

"Although nothing had been done": Abram Chasins to author, March 5, 1983.

27

"When he came home": MacKown, *Dawns*, p. 10.

27

"too exciting": Felicia Roosevelt, *Doers and Dowagers* (New York: Doubleday & Co., 1975), p. 179.

28

"a piece of genius": LN to author, October 13, 1982.

29

"a fire in his eye": Mike Nevelson to author, September 19, 1984.

29

"While I loved my mother": LN to author, October 13, 1982.

30

"the most beautiful woman on earth": Lynn Gilbert and Gaylen Moore, *Particular Passions: Talks with Women Who Have Shaped Our Times* (New York: Clarkson N. Potter, 1981), p. 81.

30

"that was her art": Roosevelt, *Doers*, p. 180.

30

"My mother wanted us to dress like queens": LN to author, October 13, 1982.

32

"My mother was sickly": LN to author, October 13, 1982.

32

"heart and soul": Joan Galway, "Monumental Work with Thanks to No One," *Washington Post*, November 10, 1985.

33

"I was determined to open": MacKown, *Dawns*, pp. 10–13.

33

The bedbug story was passed by Edna Wardwell Clements, whose father was a spar maker and whose mother ran a boardinghouse.

34

who liked to describe the way: Mike Nevelson to author, September 19, 1984.

35

"dogmatic teaching": LN, "Boys Club," p. 3.

35

"I wasn't a great reader": Eleanor Munro, *Originals: American Women Artists* (New York: Simon & Schuster, 1979), p. 139.

35

"O God, I could be bounded": *Hamlet*, Act II, scene ii.

36

"In some ways, all my life": LN to Dorothy Seckler, May–June 1964, Oral History Program, AAA.

36

"If you *have* a grandiose concept": LN to Dorothy Seckler, January 14, 1965, Oral History Program, AAA.

36

"Because already I must have felt": LN to Arnold Glimcher, January 30, 1973, Oral History Program, AAA.

37

"Her handwriting is commonplace": Ernest Bloch diary, August 8, 1933, pp. 90–92.

37

"make a name for herself": Edgar Crockett to Laurie Wilson, July 15, 1976, in *Louise Nevelson: Iconograpy and Sources* (Ph.D. dissertation, City University of New York, 1978), p. 54.

38

"It's the quickest way of communicating": MacKown, *Dawns*, p. 14.

38

"to be engaged with the esthetics of self": Harold Rosenberg, "Is There a Jewish Art?," *Commentary*, July 1966, pp. 57–58.

39

"I could see the shade": LN in *Four Sculptors*, a film by Richard Stankiewicz and Carol Howard (1973).

39

"too many leaves": Robert Indiana to author, May 14, 1988.

40

"Now I didn't say I was intelligent": LN to author, March 16, 1983.

41

The younger girl was Grace Cutting.

41

"the physical is the geography": MacKown, *Dawns*, p.13.

41

"We all kind of looked up to her": Florence Flynn Snow to author, July 15, 1982.

42

"If you make people understand the irony": Gregory McDonald, "She Takes the Commonplace and Exalts It," *Boston Sunday Globe*, September 10, 1967, p. 24.

43

"I never even wanted that": LN to author, October 13, 1982.

43

"a certain power": LN to Louise Rago, February 1959, LN Papers, AAA.

43

"And while the horse wasn't like": MacKown, *Dawns*, pp. 15, 18.

44

"I'd rather steal than beg": LN to author, March 16, 1983.

44

"He spoke of her being beautiful": Abram Chasins to author, March 5, 1983.

45

"She *knew* she was made": Abram Chasins to author, March 5, 1983.

45

"almost Prussian": Corinne Nevelson to author, April 13, 1988.

46

Charles was born in 1882 according to his 1906 naturalization papers. The year of his birth appeared as 1883 in the 1910 census, 1886 on his 1920 marriage license, and 1888 on his death certificate.

46

"whole ambition in life": Mike Nevelson to author, July 27, 1984.

46

This version of the meeting of Louise and Charles is based on LN's statements to the author and others and Laurie Wilson's interviews with Lillian Mildwoff and Nate Berliawsky. Corinne Nevelson was never told about an earlier meeting between Bernard and Louise; her parents told her that Charles met Louise after inquiring about a family with whom to celebrate a Jewish holiday while in Maine on business.

47

"Bernard had an enormous influence": Abram Chasins to author, February 26, 1983.

47

"I was overwhelmed": "The World of New York," *New York Times Magazine*, May 18, 1986, p. 102.

47

"I had made up my mind": LN to author, March 16, 1983.

48

"The other girls would sleep": Emmett Meara, "Sculptor Louise Nevelson Resents Ostracism in Rockland," *Bangor Daily News*, June 6, 1978.

48

"I would have *died*": LN to author, October 13, 1982.

48

Gershwin was a song plugger at Remick's, a Tin Pan Alley publisher, and the next year published the song "Swanee." Rodgers and Hart, whom Louise did not remember meeting, published their first collaboration in 1919. Chasins went on to graduate from the Juilliard School of Music and become a professional pianist, composer, and music director of radio station WQXR in New York City.

48

"wasn't that kind of gal": Abram Chasins to author, March 5, 1983.

48

"So much of her energy": Abram Chasins to author, March 5, 1983.

48

"play": Bill Marvel, "Louise Nevelson: Lady of Action, Shaper of Wood," *National Observer*, 1973, p. 18.

49

"My mother and father": LN to author, March 16, 1983.

49

"very much": LN to author, March 16, 1983.

49

"great quiet wisdom": LN to author, October 13, 1982.

49

"Her mother thought": Celia Scheidlinger to author, January 18, 1984.

49

"dried-up old maids": Meara, "Sculptor Louise Nevelson."

50

"I obviously recognized that he had quality": Roosevelt, *Doers*, p. 181.

50

"stuffy, pompous, and mannered": Abram Chasins to author, February 26, 1983.

50

"not in any sense scholarly": Corinne Nevelson to author, April 13, 1988.

51

"I probably gave him more credit": Roosevelt, *Doers*, p. 181.

51

"celebrated": LN to author, March 16, 1983.

51
"I thought he could go halfway": LN to author, October 13, 1982.
52
"gorgeous": Anita Berliawsky Weinstein to author, October 11, 1983.
52
"inner being": LN to author, September 5, 1986.
52
"I thought of myself": Eleanor Vincent, *Minnesota Daily*, November 21, 1973.
52
"was probably good": LN to author, October 13, 1982.
52
"It was only because I had so little confidence": Gilbert and Moore, *Particular Passions*, p. 75.
53
"to spend time in an antiworld": Munro, *Originals*, p. 26.

2: YOUNG MRS. NEVELSON

Sources other than those cited include Sylvia Nevelson Price, Larry Campbell, Stewart Klonis, Sally Avery, and Lillian O'Linsey Kiesler.

55
"the ladies who wore white gloves": LN to author, April 24, 1982.
55
"a mulatto": LN to author, September 5, 1986.
56
"I even played a little bridge": LN to author, March 16, 1983.
56
"another mind has left": LN to Dorothy Seckler, January 14, 1965, Oral History Program, AAA.
57
"I wasn't equipped": LN to author, March 16, 1983.
57
"They are, I think, kinder": Ibid.
57
"I dreaded it": Mike Nevelson to author, July 27, 1984.
57
"I don't think I gave him": LN to Dorothy Seckler, May–June 1964, Oral History Program, AAA.
57
"was practicing on the floor": Corinne Nevelson to author, April 13, 1988.
58
"How can anyone": LN to author, March 16, 1983.
59
"I saw her as a girl who wanted to sing": Abram Chasins to author, March 5, 1983.
60
LN told Laurie Wilson that the lessons lasted for a few months in 1926; the author's evidence suggests that the lessons were earlier.
60
"I think that the single element": Theresa Bernstein to author, October 29, 1982.
60
"a column of vibrating development": Ibid.
61
"He was of the nineteenth century": Mike Nevelson to author, July 27, 1984.
61
"Charles was always talking to me": Ibid.

62

"tried to restrain her": Anita Berliawsky Weinstein to author, July 22, 1982.

62

"her frustration and her loss": Abram Chasins to author, March 5, 1983.

62

"I was never married in the true soul sense": Diana MacKown, *Dawns + Dusks: Taped Conversations with Diana MacKown* (New York: Charles Scribner's Sons, 1976), p. 37.

62

"She had a blotting-paper memory": Corinne Nevelson to author, April 13, 1988.

62

"There's so much of you that has to compromise": LN to author, March 10, 1983.

62

"I learned that marriage": Arnold Glimcher, *Louise Nevelson* (New York: E. P. Dutton & Co., 1972), p. 20.

62

"My father was insecure": Mike Nevelson to author, July 27, 1984.

63

"very proud": Abram Chasins to author, March 5, 1983.

63

"Well, she's from the country": Mike Nevelson to author, September 19, 1984.

63

"I was kept in a highly nervous state": MacKown, *Dawns*, p. 37.

64

"her eagerness, her glowing enthusiasm": Abram Chasins to author, March 5, 1983.

64

"not for that": Mike Nevelson to author, July 9, 1985.

64

"I remember that she was screaming": Mike Nevelson to author, February 20, 1985.

64

LN said she attended the Browne Art School in Boothbay Harbor; however, the Browne Art Class was in Provincetown, Massachusetts, where, in July 1930, she stayed at Seascape House. She may have been referring to Edwin L. Brown, a teacher of landscape painting at a Boothbay Harbor summer art school at the time.

65

"a new determination in her": Abram Chasins to author, March 5, 1983.

65

"played the game of being a roué": Mike Nevelson to author, July 27, 1984.

65

"We were sympathetic with her": Anita Berliawsky Weinstein to author, July 22, 1982.

66

The school became the American Laboratory Theatre.

66

"to waken the authority of instinct and intuition": Speech at Independent Theatres dinner, "Princess Matchabelli Speaks for the International Theatre Arts Institute," October 3, 1926, Frederick Kiesler Papers, AAA.

66

"gorgeous": LN to author, March 16, 1983.

66

"copious notebooks": Mike Nevelson to author, July 27, 1984.

66

"fourth dimension": "Audience Are Actors in Newest Theatre," *New York Evening Post*, March 13, 1926.

66

"peace between the storms": LN to Dorothy Seckler, May 6, 1964, Oral History Program, AAA.

67
 "just *loved* beautiful women": LN to author, September 5, 1986.
67
 "electric affinities": Lillian O'Linsey Kiesler to author, March 3, 1984.
67
 "beautiful young man": LN to author, September 5, 1986.
67
 "I saw a vision": MacKown, *Dawns*, p. 35.
67
 "steam": LN to author, September 5, 1986.
68
 "You're moved": LN to Richard Stankiewicz, 1973, Oral History Program, AAA.
68
 "big trunks of stock certificates": Mike Nevelson to author, February 20, 1985.
69
 "And then I knew": MacKown, *Dawns*, p. 37.
69
 "Her contempt for conventional taste": Dorothy Seckler, "The Artist Speaks: Louise Nevelson," *Art in America*, January–February 1967, p. 33.
69
 "pushed into it": LN to Tal Streeter, November 25, 1959, LN Papers, AAA, p. 2.
69
 "No longer am I waiting": LN Papers, AAA, no date.
70
 "I had always identified with cubism": MacKown, *Dawns*, p. 68.
70
 "everybody called us communists": Dorothy Dehner to author, November 30, 1982.
70
 "There's a certain kind of energy": Louis Botto, "Work in Progress: Louise Nevelson," *Intellectual Digest*, April 1972, p. 6.
70
 "a freak": LN to Arnold Glimcher, January 30, 1973, Oral History Program, AAA.
71
 "smiling and full of laughter": Ivan Donovetsky to author, August 4, 1983.
71
 "marvelous beige outfit": Lillian Mildwoff Berliawsky to author, July 28, 1982.
71
 "fit right in": Elenore Lust to author, March 20, 1986.
71
 "to tighten up": Dorothy Dehner to author, November 30, 1982.
72
 "admired her tremendously": Frances Avery to author, September 24, 1983.
72
 "a little affair": LN to author, March 16, 1983.
72
 "magnificent grapes": Letter from Kenneth Hays Miller to LN, February 7, 1931.
73
 "that utilizes as many of the five senses": Kimon Nicolaides, *The Natural Way to Draw* (Boston: Houghton Mifflin, 1941), p. 3.
73
 "the best": LN to author, September 5, 1986.
73
 "I didn't have to measure": MacKown, *Dawns*, p. 119.
73
 "gave me a kind of strength": LN to Tal Streeter, November 25, 1959, LN Papers, AAA, p. 6.

73

"The sooner you make your first five thousand": Nicolaides, *Natural Way*, p. 3.
73

"about ten thousand drawings": LN to Arlene Jacobowitz, May 3, 1965, Brooklyn Museum Library.
73

"to break an image or create one": LN to Tal Streeter, November 25, 1959, LN Papers, AAA, p. 6.
74

"exaggerated": Maude Riley, "57th Street Review: A Sculptor's Portraits," *Art Digest*, November 15, 1943.
74

"cubism as a kind of basic grammar": Glenn Wessels, "Hofmann Students Dossier," scrapbook compiled by William Seitz, 1963, Museum of Modern Art Library.
74

"With the acceptance of the Theory": Hans Hofmann, "Art in America," *Art Digest*, August 1930, p. 27.
75

"went wild": Vaclav Vytlacil to author, January 29, 1983.
75

"Everyone was talking": Glimcher, *Nevelson*, p. 32.
75

"I knew I had it": LN, "Nevelson on Nevelson," *ARTnews*, November 1972.
75

"But there is a world": LN to author, March 16, 1983.
76

"I soon realized": MacKown, *Dawns*, p. 31.
76

"I decided not to break the bond": LN to author, February 22, 1984.
76

"Remember 1931": Letter from Mike Nevelson to LN, September 4, 1954.
76

"unprepossessing": Corinne Nevelson to author, April 13, 1988.
77

"So she said to me": LN to author, September 5, 1986.
77

"The Great Beyond is calling me": no date, LN Papers, AAA.
77

"wanted a wife": Anita Berliawsky Weinstein to author, July 22, 1982.
78

"Mother, don't go!": LN to Edith Meyer, May 13, 1975. The late Ms. Meyer was an editor for *Vogue*.
78

"a place of prodigious eating": Joseph Hergesheimer, *Berlin* (New York: Knopf, 1931), p. 51.
79

"in Pan-Germanism the saviour": Eugen Diesel, *Germany and the Germans* (New York: Macmillan, 1931).
79

"I had to pass Hitler's house": LN to author, September 5, 1986.
80

Lillian Mildwoff and Anita Weinstein told Laurie Wilson in July 1976 that Hoffman asked LN to leave his school because she would never be an artist. LN denied this to the author, and others said it seemed out of character for Hofmann. It also seems incompatible with his subsequent praise of her work when she studied with him in New York.
80

"creativ": Harold Rosenberg, "Teaching of Hans Hofmann," *Arts Magazine*, December 1970, p. 17.

80

"absolute faith in art": Ludwig Sander, "Hofmann Students Dossier," scrapbook compiled by William Seitz, 1963, Museum of Modern Art Library.

80

"carefully and exhaustively specific": Glenn Wessels, "Hofmann Students Dossier," scrapbook compiled by William Seitz, 1963, Museum of Modern Art Library.

81

"the push and pull": MacKown, *Dawns*, p. 44.

81

"You are depriving": MacKown, *Dawns*, p. 46.

81

"And when I got to Europe": LN to Edith Meyer, May 13, 1975.

81

"desperately": LN to author, September 5, 1986.

81

"two-gun Mike": Letter from Mike Nevelson to LN, December 12, 1931.

81

"because times are hard": Letter from Mike Nevelson to LN, no date.

82

"Dear Lou": Letter from Mike Nevelson to LN, December 12, 1931.

82

"To me it was a tragic house": Mike Nevelson to author, July 27, 1984.

82

"I hope you come back soon": Letter from Mike Nevelson to LN, April 24, 1932.

83

"adored her": Maude Cabot Morgan to author, December 12, 1983.

83

"I had nothing": LN to author, October 13, 1982.

84

"I was too serious": LN to author, September 5, 1986.

84

"All of a sudden": LN to Edith Meyer, May 13, 1975.

84

"a tall, attractive man": LN to author, September 5, 1986.

84

"a palace": LN to Barbara Braun, 1982, Oral History Program, AAA.

85

"I immediately identified with the power": LN, "Nevelson on Nevelson," *ARTnews*, November 1972.

85

"When I was a student": LN to author, September 5, 1986.

85

"Now, according to metaphysics": MacKown, *Dawns*, p. 44.

85

"When I found cubism": Barbaralee Diamonstein, "Louise Nevelson at 75," *ARTnews*, October 1974, pp. 48–49.

85

"You state that you expect": Letter from Mike Nevelson to LN, June 14, 1932.

86

"Must it always be cold": LN Papers, AAA. These Hôtel Scribe writings remain undated or misdated. MacKown's *Dawns + Dusks* suggests that they were written during her second trip to Europe in 1932.

87

On one of her summer trips to Europe: Louise and Diana MacKown maintained that this trip took place in 1932. Céline's correspondence and his biographers, however, place it in 1934. According to Corinne Nevelson, LN traveled to Europe with Lion Feuchtwanger after a lecture trip on March 2, 1933, but this cannot be confirmed.

87

"I liked him because he was neurotic": LN to author, September 5, 1986.

87

"Nothing on earth would appease him": MacKown, *Dawns*, p. 50.

87

"By now you must have been married": Letter from Louis-Ferdinand Céline to LN, no date.

88

"I think that at that moment": MacKown, *Dawns*, p. 49.

88

"already doing what Hofmann was talking about": George McNeil to author, February 18, 1984.

88

"the nude figure broken up": LN to author, September 5, 1986.

89

"she pulled up the shades": Marjorie Eaton to author, September 15, 1982.

90

"very frail, poetic-looking blond child": Corinne Nevelson to author, April 13, 1988.

90

"very painful": Marjorie Eaton to author, September 15, 1982.

90

"the thrill of his life": Mike Nevelson to author, February 20, 1985.

90

"Never loved, she says": Ernest Bloch diary, August 5, 1933, p. 107.

91

"She was coming out of her shell": Marjorie Eaton to author, September 15, 1982.

91

"felt he was a failure": Mike Nevelson to author, February 20, 1985.

91

"lived on the dream of past glory": Corinne Nevelson to author, April 13, 1988.

91

"gentlemen do not divorce ladies": Mike Nevelson to author, July 9, 1985.

92

"I'm the type that if I'm going to have art": LN to author, March 16, 1983.

92

"The world is built for one": LN Papers, AAA, no date.

92

"I wanted freedom": LN to author, March 16, 1983.

92

"imprisonment": MacKown, *Dawns*, p. 37.

92

"For me, life couldn't be a complement of master and slave": LN, "Nevelson on Nevelson," *ARTnews*, November 1972.

3: THE DEPRESSION YEARS

93

"to get the artists off my neck": Dorothy Miller to author, February 10, 1984.

94

"I was always high": LN to Katherine P. Rouse, October 21, 1963, LN Papers, AAA.

94

"at the top of a steel staircase": Diego Rivera, *Portrait of America* (Covici, Friede, 1934), as quoted in Bertram D. Wolfe, *Diego Rivera: His Life and Times* (New York: Alfred A. Knopf, 1939).

94

"absolutely fell in love with Louise": Marjorie Eaton to author, September 15, 1982.

94

"If a man's a genius": Anna Walinska to author, January 2, 1982.

95

Two portraits, both titled *Rivera* and exhibited at the Nierendorf Gallery in 1943, are attributed to 1932, although several sources, including LN, indicated that she first met Diego in 1933. Various reasons have been given for the earlier dates; Diego's longtime assistant, Lucienne Bloch, stated that it was a deliberate effort to conceal the intimate nature of Louise's relationship with Diego. More likely, they were inaccurately dated several years after they were painted.

95

"as if we'd known each other": Marjorie Eaton to author, September 15, 1982.

95

That summer she revealed: Ernest Bloch diary, August 6, 1933, p. 103.

95

"She would get up early": Marjorie Eaton to author, September 15, 1982.

96

"I was young": David Margolis to author, March 3, 1984.

96

"I never liked the confines": LN to Edith Meyer, May 13, 1975.

96

"It isn't promiscuous": LN to author, March 16, 1983.

97

"very little": LN to author, October 13, 1983. This was confirmed by Lucienne Bloch and Stephen Dimitroff, assistants to Rivera that summer.

97

"worked and studied with Diego Rivera": *New York Evening Journal*, March 28, 1935.

97

"And when I got there": LN to author, March 16, 1983.

98

"gets out a cigar": Ernest Bloch diary, August 6, 1933, p. 104.

98

"He didn't live in the present": LN to author, September 5, 1986.

98

"I thought he might have found": Colette Roberts, *Nevelson* (Paris: Editions Georges Fall, 1964), p. 16.

98

"I thought I could be as good": LN to author, March 16, 1983.

98

"I had my future in front of me": LN to author, September 5, 1986.

98

"a very beautiful girl": Ernest Bloch diary, July 28, 1933, p. 74.

99

"I tell her my troubles": Ernest Bloch diary, August 5, 1933, pp. 84–92.

99

fluchtig is translated as fugitive, hasty.

100

"She changes practically in front of me": Ernest Bloch diary, August 6, 1933, pp. 102–111.

101

"knew my harmony was different": "Total Nevelson," *Boston*, June 1967, p. 29.

101

"realistic sentiment": Sam Hunter, *Modern American Painting and Sculpture* (New York: Dell Publishing Co., 1959), p. 163.

102

"grand and glorious": LN to Arnold Glimcher, January 30, 1973, Oral History Program, AAA.

102

"I would go in the subways": LN, "Nevelson on Nevelson," *ARTnews*, November 1972.

102

"terrifically talented": Chaim Gross to author, January 13, 1983, and January 17, 1984.

103

"to really see what each side said": Diana MacKown, *Dawns + Dusks: Taped Conversations with Diana MacKown* (New York: Charles Scribner's Sons, 1976), p. 59.

103

"very exaggerated": Chaim Gross to author, January 13, 1983.

104

She also made sculptures with stars, such as the bronze *Woman with a Star on Her Head* (c. 1948).

104

"The subject is poised": "The Birth of a Painting (Picture Happy)," May 31, 1953, LN Papers, AAA.

105

"on the other side": LN to Barbara Braun, 1983, Oral History Program, AAA.

105

"Each of us only has a certain time": "Notes on Discussion of Sculpture Today by Sculptors," February 27, 1954, Federation of Modern Painters and Sculptors Papers, AAA.

106

"dance was *carrying* America": MacKown, *Dawns*, pp. 67–68.

106

She and a number of assistants created the costumes and set for the Opera Theatre of St. Louis's production of the opera *Orfeo et Euridice* in June 1984.

106

"I felt a body discipline": Roberts, *Nevelson*, p. 70.

107

"tight and frightened": Roberta B. Gratz, *New York Post*, March 8, 1967, p. 47.

107

"when the body lets go": Blanche Howard, *Dance of the Self* (New York: Simon & Schuster, 1974), p. 14.

107

"I went again": Joan Galway, "Monumental Work with Thanks to No One," *Washington Post*, November 10, 1985.

107

"had an interesting body": Laurie Wilson, *Louise Nevelson: Iconography and Sources* (Ph.D. dissertation, City University of New York, 1978), p. 142.

107

"I didn't get the inner dance": MacKown, *Dawns*, p. 65–67.

108

"Dance made me realize": Arnold Glimcher, *Louise Nevelson* (New York: E. P. Dutton & Co., 1972), pp. 41–42.

108

"to solve the plastic problem": Roberts, *Nevelson*, p. 70.

108

"Isadora Duncan said that": Roy Bogartz, " 'I Don't Want to Waste Time,' Says Louise Nevelson at 70," *New York Times Magazine*, January 24, 1971, p. 12.

108

LN actually began to work under the forerunner of the WPA, a program run by the Temporary Emergency Relief Administration.

108
"saved a whole generation": Ibram Lassaw to author, February 10, 1983.
109
"a dark, rather handsome-looking woman": Joseph Solman to author, January 12, 1983.
110
"I won't call it teaching": "Art at the Flatbush Boys Club," *Flatbush Magazine*, June 1935, p. 3.
110
On a 1968 WPA questionnaire Louise denied that she had to make regular submissions to the government, but her son recalled that she turned in a piece of art every six weeks.
110
"prima donnas": Francis O'Connor, editor, *The New Deal Art Projects: An Anthology of Memoirs* (Washington, D.C.: Smithsonian Institution Press, 1972), p. 235.
111
"cuts and slashes into her creations": *Art Digest*, October 1, 1941.
111
"heretical": LN to Richard Stankiewicz, 1973, Oral History Program, AAA.
111
"For example, one arm of a figure": Emily Genauer, *New York World Telegram*, September 12, 1936.
112
"sculptural midwife": Abram Schlemowitz to author, May 24, 1984.
112
"colored white-pink": LN to author, September 5, 1986.
112
"so social in theme": Howard Devree, *New York Times*, June 21, 1936.
113
"physical energy that wanted to push": Panel discussion, "An Evening with Louise Nevelson," moderated by Harold Weston, February 28, 1967, Harold Weston Papers, AAA.
113
"You weigh it a little bit": LN to Barbaralee Diamonstein, "Nevelson: Maquettes for Monumental Sculpture," May 2–June 27, 1980, Pace Gallery catalog.
113
"Zorach did the elephant": Dream Journal, April 28 and 30, 1936, LN Papers, AAA. Zorach refers to sculptor William Zorach, a fine-arts juror for the WPA whom she knew. He gave her a pencil drawing, possibly a portrait of her, dated June 6, 1937.
113
"there was a subterranean world": LN to Katherine Rouse, October 21, 1963, LN Papers, AAA.
113
"My head is in a whirl": "The Birth of a Painting (Picture Happy)," May 31, 1953, LN Papers, AAA.
114
LN's guilt over not going to her son's bar mitzvah led her to tell people in later years that he had the ceremony at Temple Emanu-El.
114
"you will be doing pretty well": Letter from Mike Nevelson to LN, March 13, 1935.
114
"Nevelson doesn't deserve any 'sympathy' ": Letter from Mike Nevelson to LN, June 19, 1935.
115
"Sometimes": Mike Nevelson to author, February 11, 1985.
116
"A piece of wire": Letter from Mike Nevelson to Vivien Raynor, May 16, 1967.

116

He had begun to drink, smoke and fight: Mike Nevelson to author, July 9, 1985.

118

"On many occasions I tried": Peter Grippe to author, August 5, 1983.

118

"When the Sculptors Guild started": LN to author, September 5, 1986.

118

"flash thinking": Cindy Nemser, *Art Talk: Conversations with Twelve Women Artists* (New York: Charles Scribner's Sons, 1975), p. 59.

118

"I hate the word *intellect*": MacKown, *Dawns*, p. 119.

118

"She was intensely interested": Letter from Mike Nevelson to Vivien Raynor, May 5, 1967.

119

"we assumed she was a bourgeois girl": Peter Grippe to author, August 5, 1983.

119

"had to have a double life": Alice Neel to author, September 25, 1983.

119

"Gramma just said": Letter from Mike Nevelson to LN, January 24, 1934.

119

"Oh, that's Louise Nevelson": Dorothy Dehner to author, November 19, 1982.

119

"Now that you have a son": Letter from Mike Nevelson to LN, April 19, 1935.

120

"The other night at El Morocco": Lee Leary, "Manhattan Merriment," *Turf & Tanbark*, December 1, 1937, p. 20.

120

"grusome": Dream Journal, May 8 and 9, 1936, LN Papers, AAA.

121

"an innocent": MacKown, *Dawns*, p. 39.

121

He wrote the *Sun* "ten thousand letters," according to an article in the December 30, 1941 issue of the *New York Herald Tribune*. It reported that he also created about five thousand paintings, two hundred musical compositions, and three hundred volumes of writing.

121

As reprinted in the March 25, 1963 issue of *Newsweek*, his four-by-six-inch calling card said, in part: "Louis Michel Eilshemius, M.A., Educator, Ex-Actor, Amateur All Round Doctor, Mesmerist-Prophet and Mystic, Reader of Hands and Faces, Linguist of Five Languages, Graphologist, Dramatist (7 works), Short Story Writer and Novelettes (26 works), Humorist Galore, Ex-Mimic, Animal Voices and Humans, Ex–All Round Athletic Sportsman (to 1889), Universal Supreme Critic, Ex–Don Giovanni, Designer of Jewelry, etc., Spiritist, Spirit-Painter Supreme, Best Marksman to 1881, Ex–Chess and Billiard Player to 1909, Scientist Supreme, all ologies, Ex–Fancy Amateur Dancer, the most rapid master creator in 3 Arts, Most Wonder and Diverse painter of nude groups in the world."

121

"Every time she went up there": Corinne Nevelson to author, April 13, 1988.

122

"Even his awkwardness": John I. H. Baur, editor, *New Art in America: Fifty Painters of the 20th Century*, Greenwich, Ct.: N.Y. Graphic Society and New York: Praeger Publishers, 1957. pp. 32–34.

122

"I have lived with my Eilshemius": Graham Gallery catalog, January 1961.

122

"Eilshemius was born to be a great artist": LN, "Nevelson on Nevelson," *ARTnews*, November 1972.

122

"Always there is a consciousness": Balin/Traube Gallery catalog, 1963.
123

"the slot-machine king of New England": Lillian Mildwoff Berliawsky to author, July 28, 1982.
123

"racketeer": George Berkley to author, September 19, 1985.
123

"As one merchant explained to me": Letter from Mike Nevelson to LN, January 18, 1962.
124

Nate used to remind his father that he was losing money on these taxable properties, but years later Nate himself gave away many of them to their occupants.
124

"really had only one love, Mama": Letter from Mike Nevelson to LN, March 1, 1962.
125

"I'd rather steal than work": Robert Newman, "Adventurous Sculptress," *Newsweek*, November 9, 1959, p. 119.
125

"economics": LN to author, September 5, 1986.
126

"Louise did everything a woman would do": Peter Busa to author, July 12, 1983.
126

"Fucking, dear, fucking": Alice Neel to author, September 25, 1983.

4: A PROMISING SCULPTOR

127

"to us art is an adventure": Letter from Mark Rothko and Adolph Gottlieb to Edward Alden Jewell, *New York Times*, June 7, 1943.
128

"well off the beaten track": Carlyle Burroughs, *New York Herald Tribune*, September 28, 1941, p. 9.
128

"Somehow she wasn't embraced": Jimmy Ernst to author, October 24, 1983.
129

"the essence of the modern age": Barbara Rose, *American Art Since 1900* (New York: Praeger Publishers, 1975), p. 133.
129

"on a silver platter": Diana MacKown, *Dawns + Dusks: Taped Conversations with Diana MacKown* (New York: Charles Scribner's Sons, 1976), pp. 87–90.
129

"When you go to Paris": Fred Ferretti, "Arts and Politics Create a New Cultural Center," *New York Times*, November 5, 1977, p. 23.
130

"The word 'torch' ": LN to Arnold Glimcher, January 30, 1973, Oral History Program, AAA.
130

"closer to the feminine": MacKown, *Dawns*, p. 81.
130

"If Rockefeller signs a check": Lily Ente to author, January 14, 1984.
130

"warmed himself with his own self-esteem": Ibram Lassaw to author, February 10, 1983.
130

"They were discussing art": LN to author, September 5, 1986.

131

"I needed my full consciousness": LN, "Nevelson on Nevelson," *ARTnews*, November 1972.

131

"I never got caught [up]": LN to Tal Streeter, November 25, 1959, LN Papers, AAA, p. 2.

131

"no one could claim it but me": LN speech, Nassau County Museum, February 23, 1983.

131

"which cannot be said": "Sculptors," *New York Times*, March 10, 1940.

131

"art is a stream": Agnes Adams, "Behind a One-Woman Art Show: Louise Nedelson's [sic] Revolt as a Pampered Wife," *New York Post*, October 16, 1941, p. 3.

132

"knew the name, the telephone number": Corinne Nevelson to author, November 13, 1988.

132

"I was desperate": LN to author, September 5, 1986.

132

"He thought nothing of spending": Ibid.

133

"a man of taste": Ibid.

133

"It's love that dominates": Maude Riley, "The *Digest* Interviews: Karl Nierendorf," *Art Digest*, February 1, 1944.

133

"are really good friends": Letter from Karl Nierendorf to LN, September 9, 1941.

133

"He improvised all the time": Hildegard Bachert to author, April 26, 1988.

133

"rare combination": Peyton Boswell, "Nierendorf: Scholar-Dealer," *Art Digest*, November 1, 1947.

134

"the strong, expressive things of life": Riley, "Nierendorf."

134

"to bring interesting people in": Letter from Karl Nierendorf to LN, September 9, 1941.

135

"Miss Nevelson injects": Carlyle Burroughs, *New York Herald Tribune*, September 28, 1941, p. 5.

135

"with a shrewd eye for tensions": "Louise Nevelson, Sculptor," *Art Digest*, October 15, 1942, p. 18.

136

"I don't care how strong": LN to Arlene Jacobowitz, May 3, 1965, Brooklyn Museum Library.

136

"I saw *darkness*": MacKown, *Dawns*, p. 76.

137

"infantile and hysterical attitude": Letter from Mike Nevelson to LN, August 29, 1941.

137

"did not overestimate a bit": Letter from Charles Nevelson to LN, undated.

137

"it is a good portion": Letter from Mike Nevelson to LN, January 27, 1941.

138

"until the war is won": Letter from Mike Nevelson to LN, October 24, 1942.

138
"It was lovely of you": Letter from Thomas McPhail to LN, January 25, 1943.
139
"My intention at the time": LN to Richard Stankiewicz, 1973, Oral History Program, AAA.
139
"I wanted great enclosure": LN to Dorothy Seckler, May–June 1964, LN Papers, AAA.
139
"a place of great secrecy": MacKown, *Dawns*, p. 16.
139
"the drinking period": LN to author, September 5, 1986.
139
"to be a good girl": Letter from Mike Nevelson to LN, June 16, 1943.
140
"like needles are going through you": LN to Arlene Jacobowitz, May 3, 1965, Brooklyn Museum Library.
140
"in some way my thinking": Panel discussion, "An Evening with Louise Nevelson," moderated by Harold Weston, February 28, 1967, Harold Weston Papers, AAA.
141
"full charge of managing": Statement from Joe Milone to LN, November 14, 1942.
141
"festive as a Christmas tree": *Time*, January 4, 1943, p. 39.
142
"It could only have been created": Lou Nappi, "Great Contribution to Surrealist Art, Says Noted Woman Sculptor of Joe Milone's Odd Shoe-Shine Box," *Corriere d'America*, January 10, 1943, p. 18.
142
Peggy Guggenheim's sculpture collection, much of which LN presumably saw, included work by Arp, Archipenko, Brancusi, Lipchitz, and Giacometti.
142
"to install these amazing pictures and carvings": Henry McBride, *New York Sun*, October 1943.
143
"She liked the idea": Jimmy Ernst to author, October 24, 1983.
143
"We learned the artist is a woman": "Art Notes," *Cue*, October 4, 1941.
143
Max Ernst visited the artists' studios to make the final choices, sometimes returning several times; one of the artists, Dorothea Tanning, became his next wife.
144
"This is logical": Henry McBride, *New York Sun*, January 9, 1943.
144
"quite refreshing": MacKown, *Dawns*, pp. 87–90.
146
"the injustices of relationships": MacKown, *Dawns*, p. 81.
146
"And I suppose I transferred": LN to Dorothy Seckler, May–June 1964, Oral History Program, AAA.
146
"I'd be defeated right away": Martin Friedman, *Nevelson: Wood Sculptures* (Nevelson: E. P. Dutton, 1973), p. 9.
147
"After a while they were giving her everything": Sidney Geist to author, June 21, 1983.

147
"wedgie": LN to author, September 5, 1986.
147
"refugees from a lumberyard": Jimmy Ernst, *A Not-So-Still Life* (New York: St. Martin's/Marek, 1984), pp. 242–43.
147
"a marvelous scene": Jimmy Ernst to author, December 16, 1982.
147
"decidedly a happening": Jimmy Ernst to author, October 24, 1983.
148
"strewn with a strange conglomeration": Edward A. Jewell, "Louise Nevelson," *New York Times*, April 18, 1943, p. 8.
148
"pranks": Maude Riley, "Irrepressible Nevelson," *Art Digest*, April 15, 1943, p. 18.
149
"It was like a psychic operation": LN to Arnold Glimcher, January 30, 1973, Oral History Program, AAA.
149
"My money earned from 1941": Letter from Mike Nevelson to LN, June 20, 1943.
150
"high strung and frantic": Letter from Mike Nevelson to LN, October 2, 1943.
150
"grand": Letter from Charles Nevelson to LN, November 18, 1943.
150
"timeless blue void": Letter from Mike Nevelson to LN, May 11, 1944.
151
Her work reminded John Stroup: "Tunnard and Nevelson," *Art Digest*, November 14, 1944, p. 14.
152
"I was the smart one": Anita Berliawsky Weinstein to author, July 22, 1982.
153
"I want to go to New York": Letter from Mike Nevelson to LN, February 28, 1952.
153
"she would drink whisky": Marjorie Eaton to author, September 15, 1982.
153
"I've never been fat": LN to Edith Meyer, May 13, 1975.
154
"Having an affair": LN to author, October 13, 1982.
154
"I've had moments in bed": Elizabeth Fisher, "The Woman as Artist: Louise Nevelson," *Aphra*, Spring 1970, p. 41
154
"all barriers [were] down": MacKown, *Dawns*, pp. 40, 42.
154
"impassive indifference": Ernest Bloch diary, August 5, 1933, p. 109.
155
"aura of interesting inner violence": Fritz Low to author, March 9, 1983.
155
"We talked very excitedly": Sidney Geist to author, June 21, 1983.
155
"Every time I see you with Ralph": Letter from Mike Nevelson to LN, September 5, 1947.
155
"a sort of modern Turner": Grace Glueck, "The Artists' Artists," *ARTnews*, November 1982, p. 97.

156

"We are both growing older, darling": Letter from Mike Nevelson to LN, January 1, 1944.

157

"a male with my own personality": Mike Nevelson to author, September 19, 1984.

157

"Just to mention his mother": Sidney Geist to author, June 21, 1983.

158

In the 1947 Whitney annual she exhibited *Earth Woman*.

158

In 1952 Guenther Reinhardt published *Crime Without Punishment: The Secret Soviet Terror Against America,* published by Hermitage House, New York, in which he accused Nierendorf of secretly being a communist and a Soviet agent and suggested that he was murdered, but no hard evidence has emerged. Nierendorf's nephew, Florian Karsh, told the author that he was stricken at a party given by a German actress while telling how Paul Klee's widow had dropped dead when her son, a prisoner of war, had suddenly returned home.

158

"He came back and said": Dorothy Dehner to author, January 31, 1983.

159

Laurie Wilson noted that Nierendorf bought a piece of her work, but gave no details.

5: LADY LOU

161

"Male artists in America": Lily Ente to author, January 14, 1984.

161

Among the Russian-Jewish artists she knew were Ahron Ben Shmuel and Ben-Zion (Weinman).

161

"pretty good friends": LN to author, September 5, 1986.

161

"no matter what she does": Katherine Kuh to author, March 14, 1986.

162

"she was very ambitious": Hans Sahl to author, February 25, 1984.

162

"all full of shit": Jimmy Ernst to author, October 24, 1983.

162

"a little breakdown": LN to Edith Meyer, May 13, 1975.

162

"I tried too hard and overlooked by grace": LN Papers, AAA, No date.

162

"Like a plant": Dido Smith, "The Ceramic Workshop," *Ceramic Workshop,* June 1954.

163

"extremely strong": Olive Plunkett Rose to author, April 27, 1983.

163

"With Louise you had to sense intimacy": Dorothy Dehner to author, November 30, 1982.

163

"To be yourself": "Notes on Discussion of Sculpture Today by Sculptors," February 27, 1954, Federation of Modern Painters and Sculptors Papers, AAA.

163

"very exciting": Lily Ente to author, January 14, 1984.

164

"Fucking, of course": Ilse Getz to author, November 16, 1987.

164

"Then someone's boyfriend showed up": Worden Day to Rosalyn Drexler, manuscript dated January 29, 1973.

164

"I guess that you need me there": Letter from Anita Berliawsky Weinstein to LN, August 25, 1951.

164

"growing doubles": drinks

165

"modernism": Letter from Mike Nevelson to LN, August 12, 1952.

165

"refusing, at personal cost, to jump": Letter from Mike Nevelson to William Zorach, February 24, 1952, Library of Congress Manuscript Collection.

165

"I thought that by negating myself": LN to author, September 5, 1986.

165

"Louise said, 'I'll say goodbye' ": Corinne Nevelson to author, April 13, 1988.

166

"John is working hard": Letter from LN to Mike Nevelson, January 13, 1952, Nevelson Archives, The William A. Farnsworth Library and Art Museum.

166

"would take almost anything": Mike Nevelson to author, September 19, 1984.

166

"The actual world is too much": "Notes on Discussion of Sculpture."

166

"great shocks on a great scale": LN to Arlene Jacobowitz, May 3, 1965, Brooklyn Museum Library.

166

"horrid gagging cough": Letter from Mike Nevelson to LN, June 10, 1951.

166

"I have moved Joe in": Letter from LN to Mike Nevelson, January 13, 1952, Nevelson Archives, The William A. Farnsworth Library and Art Museum.

167

"took care of her": Marjorie Eaton to author, February 12, 1983.

167

"It's a romantic story": Elisabeth Model to author, November 16, 1983.

168

"I wasn't feeling very well": LN to Richard Stankiewicz, 1973, Oral History Program, AAA.

168

"an amicable person": Letter from Sahl Swarz to author, January 24, 1988.

168

"good but not exceptional": Ibid.

168

"I always felt, when these people": LN to author, September 5, 1986.

168

"immediately responsive to the creative impulse": Dido Smith, "Ceramic Workshop."

168

Laurie Wilson figured that Louise created almost ninety pieces in terra cotta and stone from June 1948 to May 1950.

169

"You might think it's a mad vitality": Sidney Geist to author, June 21, 1983.

169

"in the nature of static mobiles": LN manuscript, November 29, 1955, LN Papers, AAA.

169

Originally a painted terra-cotta piece, *Mountain Woman* was cast in aluminum in 1947.

169
No description of LN's visit to Rivera has yet turned up.
169
"a rare ether": Arnold Glimcher, *Louise Nevelson* (New York: E. P. Dutton & Co., 1972), p. 197.
170
"This was a world of forces": Colette Roberts, *Nevelson* (Paris: Editions Georges Fall, 1964).
170
"the great Mexican primitives": Letter from Max Weber to LN, October 7, 1950.
170
"splendid work": Letter from Max Weber to LN, February 12, 1951.
170
"I know well that you are imbued": Letter from Max Weber to LN, April 2, 1952.
171
"In nature they seemed": LN to author, September 5, 1986.
171
"every time I took a breath": Ibid.
172
"thus disturbing or reaccenting the etch": Una Johnson, *Louise Nevelson Prints and Drawings, 1953–1966* (New York: Shorewood Publications, 1967).
172
"I sort of felt my way": Balin-Traube Gallery catalog, December 1963.
172
In later years Grippe was resentful of LN, charging that she had not paid for her plates and materials. Her records reveal otherwise—in 1952 alone she wrote checks to him for more than $75.
172
"She thought it was kind of wonderful": Dorothy Dehner to author, November 30, 1982.
172
"My God, what energy!": Letter from Alan Gussow to author, March 24, 1983.
173
"I've waited": Donald Mavros to author, August 12, 1986.
173
"I know that your work is sound": Letter from Mike Nevelson to LN, June 10, 1951.
173
"Most of t men were fags": Letter from LN to Mike Nevelson, January 13, 1952, Nevelson Archives, The William A. Farnsworth Library and Art Museum.
174
"the most fantastic": Corinne Nevelson to author, October 10, 1988.
174
"no one could, quite": LN to author, March 16, 1983.
174
"As for t Audubon": Letter from LN to Mike Nevelson, January 13, 1952, Nevelson Archives, The William A. Farnsworth Library and Art Museum.
174
The groups included Artists Equity, American Abstract Artists, New York Society of Women Artists, League of Present-Day Artists, Silvermine Guild of Artists, New York Society of Ceramic Arts, National Association of Women Artists, and the Creative Arts Associates.
174
"They will roll out the red carpet": Lily Landis to author, February 13, 1987.
175
"very, very beautiful": Ibid.

175

"to be at the center of a moment of largesse": Sidney Geist to author, June 21, 1983.

175

"I'm beginning to agree with you": Letter from Mike Nevelson to LN, May 1, 1953.

175

"She was indefatigable": Letter from Hubert Crehan to author, December 1, 1983.

176

"As you know I am showing": Letter from LN to Mike Nevelson, January 13, 1952, Nevelson Archives, The William A. Farnsworth Library and Art Museum.

176

"completely out of place": Sidney Geist, "Fifty-seventh Street: Women Sculptors," *Art Digest*, March 1, 1953, p. 18.

176

"in a few years [you] will be universally hailed": Letter from Mike Nevelson to LN, June 13, 1953.

176

"abstract conformism": Hans Sahl to author, February 25, 1984.

176

"to be seen": Will Barnet to author, November 17, 1982.

177

"The question arises whether modern art": "The Crisis of Form in Modern Art," Four O'Clock Forum program, March 14, 1954.

178

"[Miss Clapp] led the way": "Tensed Up," *New Yorker*, August 14, 1954.

178

"a stupid waste of time": Letter from Mike Nevelson to LN, February 2, 1949.

179

Among them were Martin and Madeline Schonberger, who bought a bronze *Child* for $200. That same year she had sold to Flora and Eugene Morrell of New York City a painted plaster *Mother and Child* for $125, and two paintings, *Flowers in Her Hair*, for $175, and *Crown on Her Head*, for $165. The ACA Gallery had acquired two sculptures, the wooden *Seated Woman* and the bronze *Position*, for $90 and $75. Harry Pildes had bought a 1949 oil painting of a young girl for $160. The Mildwoffs had six drawings and six oils, including portraits of family members, and sculptures in a variety of materials. Nate owned a number of oils and at least one sculpture.

179

"I hate the word 'compromise' ": "Notes on Discussion of Sculpture."

179

"a little spending money": Letter from Nate Berliawsky to LN, December 9, 1953.

179

"more commonplace": Ernest Bloch diary, August 5, 1933, p. 88.

180

"The whole art world": Ben Mildwoff to author, January 20, 1983.

180

An undated list in LN's hand notes that the Mildwoffs owned the paintings *Ben*, 1931, *Steven*, 1941, *Susan* and *Lady with Animal*, both of 1946, and the undated *Horse in the Sky;* a 1941 bronze, *Dancing Lady*, and two terra-cottas, *Rhythm* and *Earth Bust* of 1950.

180

"a roll of hundred-dollar bills": Letter from Hubert Crehan to author, December 3, 1983.

180

"If it's worth that much": Corinne Nevelson to author, November 23, 1988.

180

"I'll eat my hat": Letter from Mike Nevelson to LN, September 10, 1953.

180
"gimmick": Letter from Mike Nevelson to LN, October 8, 1953.
181
"Really, the prime thing": LN to Louise Rago, February 1959, LN Papers, AAA.
182
"a love affair": Letter from Hubert Crehan to author, December 3, 1983.
182
"adds up to Structure, Technique, Material": Essay, LN Papers, AAA, no date.
183
"a desperate experience": Letter from Mike Nevelson to LN, March 18, 1954.
183
"it seems to be more likely": Letter from LN to Dorothy Adlow, 1956, LN Papers, AAA.
183
"you enhance them": Diane MacKown, *Dawns + Dusks: Taped Conversations with Diana MacKown* (New York: Charles Scribner's Sons, 1976), p. 83.
184
"We were both artists": Alfred Van Loen to author, February 27, 1983.
184
"permanent and unrelieved twilight": Hilton Kramer, Introduction to *Nevelson's World* by Jean Lipman (New York: Hudson Hills Press, 1983), p. 10.
184
"neatly arranged stacks of black-stained wood": Roberts, *Nevelson*, p. 23.
185
"It is grave": LN Papers, AAA, undated.
185
Ancient City: Arnold Glimcher in *Louise Nevelson* and Jean Lipman in *Nevelson's World* call it *Ancient City* and date it 1945. A piece of the same name was in LN's 1944 show at the Nierendorf Gallery. Laurie Wilson in her dissertation calls the sculpture *Winged City* and dates it 1954–55. In any event, the circular form and rounded object appeared in earlier pieces, like 1944's *Three Four Time.*
186
"Not that the thing has to look like it": LN to author, September 5, 1986.
186
"speak to me": Ibid.
186
"I have never used language": LN to Barbara Braun, 1983, Oral History Program, AAA.
186
Louise Bourgeois designed the set for Erick Hawkins's 1952 *Bridegroom of the Moon.*
187
"The Bride of the Black Moon": "A Fairy Tale," LN Papers, AAA, 1955.
187
"Bride of the black moon is me": LN to author, September 5, 1986.
187
"phantom images": Laurie Wilson, *Louise Nevelson: Iconography and Sources* (Ph.D. dissertation, City University of New York, 1978), p. 187.
187
"a spacious, gracious, harmonious home": LN Papers, AAA, undated.
188
"How happy your mother would have been": Anna Walinska to author, January 4, 1983.
188
"I suspect that her psyche": Letter from Hubert Crehan to author, January 26, 1984.
188
"romantic, not elegiac": Dore Ashton to author, February 13, 1987.

188

"black creates harmony": "Weird Woodwork of Lunar World," *Life*, March 24, 1958, p. 77.

188

"I just feel *looking* at it": MacKown, *Dawns*, p. 125.

189

"For me black isn't black": LN to Arnold Glimcher, January 30, 1983, Oral History Program, AAA.

189

"not wood, not black": Letter from Hubert Crehan to author, October 18, 1983.

189

"as if they were Gertrude Stein": Sidney Geist to author, June 21, 1983.

189

"an extraordinary person": Richard Roberts to author, August 20, 1984.

6: QUEEN OF THE BLACK BLACK

190

"You can only conceive of drives": Diana MacKown, *Dawns & Dusks: Taped Conversations with Diana MacKown* (New York: Charles Scribner's Sons, 1976), p. 154.

190

"There have been moments": Henry L. Seldes, "Enchanted Forest of Nevelson Wood Sculptures," *Los Angeles Times*, February 10, 1974, p. 61.

191

"to rest": Mary Shore to author, November 20, 1988.

191

LN, in turn, recommended Daniel Schneider, the author of *Psychoanalysis and the Artist*, to Mary Shore.

191

LN paid Bergler $500 in early 1962.

191

"Look, Dr. Bergler": LN to author, September 5, 1986.

191

"And I thought": Katherine P. Rouse, January 26, 1963, LN Collection, AAA.

191

"the achievement of Unity": Colette Roberts, *Nevelson* (Paris: Editions Georges Fall, 1964), p. 31.

192

"This is the common denominator!": Donald Mavros to author, August 12, 1986.

192

"Imagine that son-of-a-bitch": Ibid.

192

"I'm a queen to myself": Eleanor Munro, *Originals: American Women Artists* (New York: Simon & Schuster, 1979), p. 131

193

"Queen of the black black": Signed poem in LN's hand, 1957, LN Papers, AAA.

194

"it is true that you are not isolated": LN to Arlene Jacobowitz, May 3, 1965, Brooklyn Museum Library.

194

LB's 1953 show was named "Garden at Night," and LN's 1958 show was called "Moon Garden + One."

195

"The two sort of make a total being": LN to Arlene Jacobowitz, May 3, 1965, Brooklyn Museum Library.

195

"crossed that bridge": MacKown, *Dawns*, p. 128.

195

Laurie Wilson pointed out that *Wedding Bridge* and *Black Wedding Cake* were listed in the press release but were not pictured in the installation photograph or included in the subsequent gallery list.

195

"I can't come out in the open": LN to Dorothy Seckler, May–June 1964, Oral History Program, AAA.

195

"There's something more private": LN to Arlene Jacobowitz, May 3, 1965, Brooklyn Museum Library.

195

In her 1955 show, small pieces were placed on wooden crates with slatted backs removed and the box pedestals became part of the sculpture.

196

"She had this power": Tom Kendall to author, January 26, 1983.

196

"terra firma": Lynn Gilbert and Gaylen Moore, *Particular Passions: Talks with Women Who Have Shaped Our Times* (New York: Clarkson N. Potter, 1981), p. 75.

196

"When we look at the early paintings": "Sculpture Today," *The Whitney Review*, 1961–62, Whitney Museum of American Art.

196

"I never know my next move": "One Woman's World," *Time*, February 3, 1958, p. 58.

196

"like sinners crowding the antechambers": Roberts, *Nevelson*, p. 30.

197

"reserve of forms": Roberts, *Nevelson*, p. 23.

197

"touched, fondled, caressed, even kicked": "Total Nevelson," *Boston Magazine*, June 1967, p. 29.

197

"some of it screams back": MacKown, *Dawns*, p. 81.

197

"they will see it for what it is": LN to Arlene Jacobowitz, May 3, 1965, Brooklyn Museum Library.

197

"And so why shouldn't these": LN to Dorothy Seckler, May–June 1964, Oral History Program, AAA.

197

"a sculptural act": *Nevelson at Purchase: The Metal Sculptures*, May 8–September 1, 1977, Neuberger Museum, State University of New York, Purchase.

197

"because it had everything that I understood": LN to Arnold Glimcher, January 30, 1973, Oral History Program, AAA.

197

"I have never seen anyone": Anna Walinska to author, January 4, 1983.

198

"A white lace curtain": LN, "Nevelson on Nevelson," *ARTnews*, November 1972.

198

"The one establishes the artist's affinities": Hilton Kramer, "The Sculpture of Louise Nevelson," *Arts*, June 1958, p. 26.

198

"If [Nevelson] had to be placed": John Canaday, "Louise Nevelson and the Rule Book," *New York Times*, April 6, 1969, section 2, p. 25.

199

"That's all there is, my dear": Florence Nevelson to author, November 5, 1988.

200

"He might be wildly drunk one day": Tom Kendall to author, January 26, 1983.

201

"While Teddy was making outrageous statements": Donald Mavros to author, August 12, 1986.

201

"whimsical willfulness": Dorothy Dehner to author, January 31, 1983.

201

"I thought everyone wanted a show": LN to author, September 5, 1986.

201

"would have poisoned me": Mike Nevelson to author, September 19, 1984.

202

"What I do, actually, is the judgment": Robert Newman, "Adventurous Sculptress," *Newsweek*, November 9, 1959, p. 119.

202

"This is the best piece": Worden Day to author, October 10, 1982.

202

"I don't mean that it was outright theft": Tom Kendall to author, January 26, 1983.

203

"sorcerer's apprentices": Roberts, *Nevelson*, p. 11.

203

"Well, Sarah Bernhardt": Georgette Michaud Hillard to author, May 30, 1986.

203

"If you served Louise Nevelson": Donald Mavros to author, October 22, 1986.

203

"There was a certain joy": Tom Kendall to author, June 8, 1986.

203

"Suppose I want to work today": LN to Edith Meyer, May 13, 1975.

204

"everything is clean": LN to Katherine Rouse, October 21, 1963, LN Papers, AAA.

204

"I must be able to see!": Roberts, *Nevelson*, p. 22.

204

"This is nothing": Letter from Colette Roberts to Alfred Barr, March 14, 1957.

205

"I just thought, This work": Dorothy Dehner to author, November 30, 1982.

205

"a somewhat worn shawl": Letter from Nancy Russell to author, June 8, 1989.

205

"just enough for the sleep": Roberts, *Nevelson*, p. 22.

205

"I'd rather work twenty-four hours": LN to Katherine Rouse, October 21, 1963, LN Papers, AAA.

206

"magic power": Letter from Georges Mathieu to author, December 27, 1983.

206

"There is no place to live": Exhibition catalog, Galerie Daniel Cordier, Paris, 1960.

206

"She was gleaming in a jellied mask": Letter from Hubert Crehan to author, October 1, 1983.

207

"I'm ready for a hot romance": Letter from Hubert Crehan to author, November 7, 1983.

207

"It was Louise with snowflakes": Letter from Hubert Crehan to author, October 18, 1983.

207

"She was interested in the 'line' ": Ibid.

207
"I felt that Louise's ambition": Letter from Hubert Crehan to author, November 7, 1983.
208
"I hand over the torch to you": Letter from Hubert Crehan to author, October 15, 1983.
208
"great vitality": MacKown, *Dawns*, p. 162.
208
"It was the first time": Panel discussion, "An Evening with Louise Nevelson," moderated by Harold Weston, February 28, 1967, Harold Weston Papers, AAA.
208
"Everything has to fit together": *Time*, February 3, 1958, p. 58.
208
"Slowly, majestically, she stripped": Roberts, *Nevelson*, p. 25.
209
"This is the universe": *Time*, February 3, 1958, p. 58.
209
"On entering the gallery": Emily Genauer, "Abstract Art with Meaning: Another World," *New York Herald Tribune*, January 12, 1958, section 2, p. 14.
209
"fleeting": LN to Dorothy Seckler, May–June 1964, Oral History Program, AAA.
210
"I used shadow": "An Evening with Lousie Nevelson."
210
"a plastic embodiment of pure shadow": Hilton Kramer, "Month in Review," *Arts*, January 1957, p. 47.
210
"transfixed": Dido Smith to author, March 4, 1984.
210
"At that time, if I'd had a city block": MacKown, *Dawns*, p. 128.
210
"dwarfed": Letter from Hubert Crehan to author, October 18, 1983.
211
"an action painter with solids": Sidney Tillim, "Month in Review," *Arts*, February 1963, p. 40.
211
"Far from being an eccentric": Hilton Kramer, "The Sculpture of Louise Nevelson," *Arts*, June 1958, pp. 26–29.
211
"I love you": Hilton Kramer at Louise Nevelson memorial service, October 17, 1988.
211
"a sorceress in her den": "Weird Woodwork of Lunar World," *Life*, p. 77.
211
"Although I don't really think you're a witch": Letter from Robert Rosenblum to LN, March 25, 1958.
211
"a very new kind of feeling": Ibram Lassaw to author, February 10, 1983.
212
"Several times we took a work": Dorothy Miller to Paul Cummings, April 1971, Oral History Program, AAA.
212
"very hard up": Ibid.
212
Afterward Duchamp, along with a French art critic and their wives, went to visit LN. Because of language difficulties, Duchamp mistakenly thought that she asked for his opinion of a wall; as he launched into a critique, she interrupted and

told him pointedly that she had *not* asked for his viewpoint. Nonetheless, they became friends.

212

"a total surprise": Dorothy Miller to author, March 15, 1983.

212

"We were all just completely bowled over": Dorothy Miller to Paul Cummings, April 1971, Oral History Program, AAA.

213

"This is America, and I will write a poem to the savage": LN, "Nevelson on Nevelson," *ARTnews*, November 1972.

214

Other artists in the Martha Jackson Gallery included James Brooks, Willem de Kooning, Arshile Gorky, Marsden Hartley, Paul Jenkins, Barbara Hepworth, Sam France, Morris Louis, Lee Krasner, and Alfred Jensen.

214

"atmosphere of a loser": Harry Rand, *The Martha Jackson Memorial Collection* (Washington, D.C.: Smithsonian Institution, 1985), p. 6.

214

"surprisingly naive remarks": Dorothy Miller to author, March 15, 1983.

214

"As far as owing anything": Letter from Colette Roberts to LN, May 11, 1960.

214

"She believed in women": David Anderson to author, September 17, 1986.

215

"If you have to have some $": Letter from David Anderson to LN, May 22, 1959.

215

"happy and whole": Letter from Mike Nevelson to LN, August 16, 1959.

216

"Once again Louise Nevelson": Dore Ashton, "Art: Worlds of Fantasy—Louise Nevelson's Sculpture at Jackson Gallery," *New York Times*, October 29, 1959, p. 44.

216

"bled out the blacks": Dore Ashton, "Art," *Arts & Architecture*, December 1959, p. 7.

216

Nevelson's records show that she gave them an eight-piece gold construction.

216

"a quarter of a million bucks": Robert Newman, "Adventurous Sculptress," *Newsweek*, November 9, 1959.

217

"How can you live with all this crap?": Howard Lipman to author, September 30, 1988. Over the years the Lipmans bought three Nevelson walls for themselves, including a gold one; a black one, dated 1957, had been displayed in the Thorndike Hotel. Another wall, *Dawn's Wedding Chapel II*, was bought to give to the Whitney, and another to donate to Lincoln Center.

217

"I am very excited to see what you conjure": Letter from Emily Hall Tremaine to LN, July 15, 1959.

217

"one of the great sculptors": Letter from Martha Jackson to Daniel Cordier, December 14, 1959.

217

"He wants WALLS": Letter from Martha Jackson to LN, June 5, 1960.

218

"Louise! All those who count": Letter from Colette Roberts to LN, July 16 (1960?).

218

"It's too late": Elisabeth Model to author, November 16, 1983.

218

"squatted over a tub": Letter from Hubert Crehan to author, October 23, 1983. Actually it was a common practice for male sculptors to urinate on bronzes in order to get a softer patina, and Louise used to urinate on hers as well.

219

"second generation": William Agee, "The New American Painting and Sculpture: The First Generation," Museum of Modern Art, Summer 1969. He grouped her with painters Ellsworth Kelly, Kenneth Noland, and Frank Stella as well as sculptors Isamu Noguchi, Richard Lippold, and Richard Stankiewicz.

219

"Fuck these Philistines!": Rufus Foshee to author, October 28, 1986.

219

"Every now and then she would raise her voice": Corinne Nevelson to author, November 13, 1988.

220

A one-woman show was in late October at the Martha Jackson Gallery, and another was a retrospective at the David Herbert Gallery in January 1960.

220

"She didn't bother to say yes or no": Dorothy Miller to author, March 15, 1983.

220

"This was here, and that was there": Bobby Buecker to author, April 6, 1983.

220

"People think black is the only mysterious color": Newman, "Adventurous Sculptress."

220

"I promised Dorothy Miller": LN to Tal Streeter, November 25, 1959, LN Papers, AAA.

221

"What did Kandinsky": Anna Walinska to author, Janurary 4, 1983.

221

"has a grandfather": Jean Arp, "Nevelson," *XXe Siècle*, March 1960.

222

"It's appropriate that an artist": Robert Melville, "Exhibitions: The Venice Biennale," *Architecture Review*, October 1962, p. 285.

222

"The word scavenger is really a resurrection": George Rickey, "Presentation to Louise Nevelson of the Gold Medal for Sculpture," American Academy and Institute of Arts and Letters, 1983.

222

"empires": Dorothy Seckler, "The Artist Speaks: Louise Nevelson," *Art in America*, January/February 1967, p. 33.

222

"The baroque finery": Dore Ashton, "U.S.A.: Louise Nevelson," *Cimaise*, April/June 1960, p. 26.

222

"succumbed to an artist's iron will": Thomas Hess, "U.S. Art: Notes from 1960," *ARTnews*, January 1960, p. 25.

222

"something that was beginning again": LN to Arlene Jacobowitz, May 3, 1965, Brooklyn Museum Library.

222

"to break it": Donald Mavros to author, August 12, 1986.

222

"Maybe sometimes we become too introverted": LN to Arlene Jacobowitz, May 3, 1965, Brooklyn Museum Library.

223

"It was a kind of wish fulfillment": MacKown, *Dawns*, pp. 137, 144.

223

"never looked lovelier": Steve Barrie, "Steve's Own Corner," Provincetown, Massachusetts, newspaper [title unknown], March 10, 1960. Among the guests

were Mark Rothko, David Smith, Hubert Crehan, and Hildegarde, a singer in the Plaza's Persian Room.

7: NEVELSON

224

"One of the most striking developments": Robert Coates, *New Yorker*, December 12, 1960.

224

"Could there be a more dramatic representation": Stanley Burke, "A New Discipline," *ARTnews*, Summer 1960, p. 45.

225

"time, form, color, light": John Canaday, "Whither Art?," *New York Times*, March 26, 1961, p. 15.

225

"leaves a consciousness": LN to Richard Stankiewicz, 1973, Oral History Program, AAA.

225

"I think this is the richest time": John Canaday, "Whither Art?," *New York Times*, March 26, 1961, p. 15.

225

When LN called on O'Keeffe in 1971, it was evident that O'Keeffe did not know Nevelson's name or work. In 1983 the work of the two "independents" was exhibited together at the Nassau County Museum of Fine Art.

226

"Out of the studios in the spring of 1960": Colette Roberts, *Nevelson* (Paris: Editions Georges Fall, 1964), p. 30.

226

"An artist who is crystallized": Martha Jackson Gallery press release, 1961.

227

"a touch of brassiness": Roberts, *Nevelson*, p. 32.

227

"When you acquire a big wall": Letter from LN to Seymour Knox, September 14, 1962. In the same letter she said that she had sold a wall for $100,000 to The Buffalo Fine Arts Academy in 1962.

228

"I'd rather have a living child": Letter from Mike Nevelson to LN, March 10, 1960.

229

"too intuitive, too personal": Robert Coates, "The Art Galleries," *New Yorker*, December 5, 1964, p. 160.

229

"constantly fighting": David Anderson to author, March 1, 1987.

229

"How did you let Martha do that?": Tom Kendall to author, January 26, 1983.

229

"to try to resolve some pieces": David Anderson to author, September 17, 1986.

230

"to put up a pretty good wall": Tom Kendall to author, January 26, 1983.

230

"I seemed to be on auction": Arnold Glimcher, *Louise Nevelson* (New York: E. P. Dutton & Co., 1976) p. 116.

230

"spirit": Letter from Tom Kendall to Elliot Sachs, March 23, 1962.

230

"high level of accomplishment": Letter from Martha Jackson to LN, January 12, 1967.

230
"great deal of feeling": LN to Harry Rand, May 15, 1981, as quoted in Harry Rand, *The Martha Jackson Memorial Collection* (Washington, D.C.: Smithsonian Institution, 1985), p. 28.

231
"although he was Jewish": Tom Kendall to author, January 26, 1983.

231
"advisor and spiritual comforter": *Samuel R. Kurzman and Rose Kurzman, Plaintiffs,* v. *Louise Nevelson, Defendant,* draft deposition, August 23, 1963, Supreme Court of New York.

232
"I'm going to make a million": Tom Kendall to author, January 26, 1983.

232
"people who didn't speak the same language": Hilton Kramer to author, April 8, 1988.

232
"future looks golden": "All That Glitters," *Time,* August 31, 1962, p. 40.

232
"Sun Son Sun Son": LN Papers, AAA.

233
"completely amenable": Dorothy Miller to Paul Cummings, April 1971, Oral History Program, AAA.

233
"starlets at Cannes": John Ashbery, *International Herald Tribune,* June 13, 1962.

233
"commandeer": Dorothy Miller to Paul Cummings, April 1971, Oral History Program, AAA.

233
"had no language except Italian": Ibid.

234
"wonderfully appreciative": Ibid.

235
"mother-son sculpture relationship": Letter from Mike Nevelson to LN, October 1, 1961.

235
"fancy house": Letter from Mike Nevelson to LN, September 26, 1962.

235
"not clear as to the relationship": Letter from Mike Nevelson to Elliot Sachs, January 27, 1963.

235
"desperate": Mike Nevelson to author, December 7, 1988.

237
"a little on the crude side": Sidney Janis to author, February 1, 1983.

237
"Not an excursion into a Nevelson 'Elsewhere' ": Roberts, *Nevelson,* p. 79.

237
"rather sparse and sedate": Hilton Kramer, "Art," *Nation,* January 26, 1963, p. 78.

237
"being more reasonable": Sidney Tillim, *Arts,* February 1963.

237
From 1964–69, LN gave him etchings, sculptures, drawings in lieu of fees, according to documents among the Harris Steinberg papers at the AAA.

238
"completely unfair": Letter from Harris Steinberg to Ralph Colin, March 18, 1963.

238
"practically incapable of functioning": Mike Nevelson to author, September 19, 1984.

238

"I just wanted to die": LN to Molly Haskell, 1975, Oral History Program, AAA.

239

"to accomplish finishes": June Wayne to author, May 14, 1988.

239

"the most abstract": Una Johnson, *Louise Nevelson Prints and Drawings, 1953–1966* (New York: Shorewood Publications, 1967).

239

"I went to the telephone": LN to Molly Haskell, 1975, Oral History Program, AAA.

240

"she was very intelligent and fair": Lily Landis to author, February 13, 1987.

240

"a Living Force": Artists Equity newsletter, April 1963.

241

"So I'm an idiot": LN to Edith Meyer, May 13, 1975.

241

"where to speak out": Will Barnet to author, November 17, 1982.

241

"I'd love to come to Boston": Arnold Glimcher to author, February 28, 1986.

241

Eva Glimcher acquired one of LN's gold walls.

242

"was a bit depressed": Arnold Glimcher to author, February 28, 1986.

242

"my favorite sculptor": Letter from Arnold Glimcher to LN, December 20, 1962.

242

"king of the art world": Cynthia Saltzman, "The Go-Between," *Wall Street Journal*, July 31, 1981, p. 1.

242

"the most important thing": Arnold Glimcher to author, July 28, 1988.

242

"I did not take a single piece": Ibid.

243

"fits me like a glove": LN to Edith Meyer, May 13, 1975.

243

"You're just my little lover boy too": Arnold Glimcher to author, February 28, 1986.

243

"sometimes played as if she didn't understand": Arnold Glimcher to author, July 28, 1988.

243

"I'm a partner of Louise Nevelson": Mike Nevelson to author, July 27, 1984.

244

"of late her artistic development": Robert Coates, *New Yorker*, December 5, 1964.

244

"I took the back out of the box": LN to Richard Stankiewicz, 1973, Oral History Program, AAA.

244

"tearing down that imprisoning wall": Emily Genauer, "Rouault as Mirror and Prophet," *New York Herald Tribune Magazine*, November 22, 1964, p. 37. From time to time Nevelson would be accused of mannerism, or using deliberate stylistic effects lacking genuine emotional content, often when her prolific output seemed to cast doubt on the sincerity of each work.

244

"Only yesterday, Louise Nevelson": John Canaday, "Art: Sculptures by Louise Nevelson," *New York Times*, November 21, 1964.

245

"one of the hottest young dealer partnerships": Grace Glueck, "A New Breed Is Dealing in Art," *New York Times*, December 16, 1968, p. 58.

245

Two black walls were sold to the List family—one in 1963 and *Homage for Six Million I* in 1964. Other collectors included Joseph Hirshhorn, Stanley Marcus, and Mrs. Otto Preminger.

245

"I enjoy the fact that a woman artist": Ann Holmes, "For Nevelson, It's Not the Medium, But What You 'See,'" *Houston Chronicle*, October 23, 1969.

246

"Ted?": Donald Mavros to author, August 12, 1986.

246

"She felt really alone": Ibid.

246

"She cast him out": Tom Kendall to author, January 26, 1983.

247

"to go in the corner and draw": Diana MacKown to author, June 28, 1988.

247

"When it started it seemed": Ibid.

247

By 1988, Diana was getting a salary of $250 a week.

247

"fairy godmother": Neith Nevelson to author, July 24, 1984.

249

"a cathouse": Ibid.

249

"displaced in a formal society": Neith Nevelson to author, July 23, 1984.

249

"She would call me in the morning": LN to author, October 13, 1982.

250

"tend to clutter and become outgrown": Holmes, "For Nevelson."

250

"He's got it": Mike Nevelson to author, February 20, 1985.

250

"smiled like a goddess": Lillian Kiesler to author, March 3, 1984.

250

"They think they're so big": Neith Nevelson to author, July 24, 1984.

251

"I couldn't live with myself": LN to author, March 16, 1983.

251

"good friends": Diana MacKown to author, June 28, 1988.

251

"I have given long and careful consideration": Letter from LN to Jack Gordon, January 14, 1967, Whitney Museum library.

252

"She said, 'Why don't you'": Arnold Glimcher to author, July 28, 1988.

252

"she was so much more vigorous": Howard Lipman to author, September 30, 1988.

253

"I never underestimate one's appearance": LN to Edith Meyer, May 13, 1975.

253

"Louise has a person in her mind": Donald Mavros to author, August 12, 1986.

253

"bird of paradise": Arnold Glimcher to author, September 25, 1988.

253

"Nevelson is the work": Arnold Glimcher to author, February 2, 1986.

253

"like a mirror": LN to Katherine Rouse, October 21, 1963, LN Papers, AAA.

253

"I feel this is the first time": Lisa Hammel, "Louise Nevelson Has Plan for Living: A House That Is One Large Sculpture," *New York Times*, April 28, 1967, p. 45.

254

"romantic concept that an artist can't": Panel discussion, "An Evening with Louise Nevelson," moderated by Harold Weston, February 28, 1967, Harold Weston Papers, AAA.

254

"If someone asked me": Mary Sullivan, "Louise Nevelson, One of the Art World's Most Noted," *Rockland* [Maine] *Courier-Gazette*, March 20, 1976, p. 3.

254

Other artists elected that year were Josef Albers, Federico Castellon, Dorothea Greenbaum, William Gropper, Gyorgy Kepes, Mark Rothko, and Saul Steinberg.

254

"able to grasp anything": LN to Ilya Bolotowsky, October 27, 1960, Oral History Program, AAA.

254

"I love horses and carriages": "An Evening with Louise Nevelson."

255

"revealed a new Nevelson": Dorothy Seckler, "The Artist Speaks: Louise Nevelson," *Art in America*, January–February 1967, p. 32.

255

"mentalities": "An Evening with Louise Nevelson."

255

"I accept that matter is crystallized thought": Dido Smith, "Louise Nevelson," *Craft Horizons*, May–June 1967, p. 74.

255

"The new materials were made for me": "An Evening with Louise Nevelson."

255

"unembellished syntax and cool, detached glamour": Hilton Kramer, "A Triumph of Constructivism," *New York Times*, January 28, 1968, p. 31.

256

"And we sent that miserable taped-up thing": Arnold Glimcher to author, July 28, 1988.

257

"I used to feel like Little Orphan Annie": Grace Glueck, "Juilliard Unveils a Wall Sculptured by Nevelson," *New York Times*, December 19, 1969.

8: EMPRESS OF MODERN ART

258

"had always created such extraordinary atmospheres": Arnold Glimcher to author, July 28, 1988.

258

Some soft-edged elements previously cast by the Martha Jackson Gallery were screwed into crisp-edge bronze boxes provided by the Pace Gallery, creating a bronze wall which is occasionally exhibited in the sculpture garden at the Whitney Museum.

259

"I saw them in their black totality": "An Evening with Louise Nevelson" moderated by Harold Weston, February 25, 1967, Harold Weston Papers, AAA.

259

Another time she suggested that it was a conversation about Isadora Duncan and understatement which made her understand how to start. The larger *Homage to Six Million I* (1964) consisted of fewer, larger boxes.

260

"collaborative and impromptu": Don Lippincott to author, July 15, 1988.

260

"She used the cranes": Arnold Glimcher to author, July 28, 1988.

260

"When a maquette is enlarged": *Nevelson at Purchase: The Metal Sculptures,*

May 8–September 1, 1977, Neuberger Museum, State University of New York at Purchase.
261
"Now that was a breakthrough": Dorothy Seckler, "The Artist Speaks: Louise Nevelson," *Art in America*, January–February 1967, p. 33.
261
"because she never wanted to work for anyone": Arnold Glimcher to author, July 28, 1988.
261
"If I have work": LN to author, September 5, 1986.
261
"float like flags": *New York Times*, August 5, 1977, p. 3.
262
"Working in the open is especially difficult": *Nevelson at Purchase*.
262
"frame the space": LN to Arnold Glimcher, March 3, 1976, "Louise Nevelson Remembered," Pace Gallery catalog, March 31–April 29, 1989.
262
"found color": Arnold Glimcher, *Louise Nevelson* (New York: E. P. Dutton & Co., 1976), p. 166.
262
"saw green, it almost killed me": LN to Richard Stankiewicz, 1973, Oral History Program, AAA.
262
"working in metal had allowed me": *Nevelson at Purchase*.
263
"one big Nevelson sculpture garden": Hilton Kramer, "Art: A Nevelson Made to Last," *New York Times*, December 9, 1977, p. 17.
263
"I have so much to do": Arnold Scaasi to author, April 10, 1983.
264
"I used to be a young beauty": William Katz to author, October 5, 1988.
264
"Why shouldn't I have that?" Arnold Glimcher to author, February 28, 1986.
264
"some ancient gypsy": John McCormally, "Memo from Mac," *Hawk Eye*, Burlington, Iowa, February 25, 1977.
265
"I'm what you call a real collage": LN to Edith Meyer, May 13, 1975.
265
"I realized that she was not an ordinary person": Arnold Scaasi to author, April 10, 1983.
265
"I am happy in beautiful clothes": Barbara Rose, "The Individualist," *Vogue*, June 1976, p. 124.
265
"so that every day": Beverly Grunwald, "Getting Around," *Women's Wear Daily*, November 18, 1976.
265
"I am a women's libber": Henry Seldes, "Enchanted Forest of Nevelson Wood Sculpture," *Los Angeles Times*, February 10, 1974.
265
"Singlemindedness, concentration": LN, "Do Your Own Work," *ARTnews*, January 1971.
266
"A man simply couldn't use the means": LN, "Nevelson on Nevelson," *ARTnews*, November 1972.
266
"I've had fame, but you've had love": Dorothy Dehner to author, November 30, 1982.

266

"You are a woman, and you fulfill yourself": LN, "Nevelson on Nevelson, *ART-news*, November 1972.
266

"If I looked too refined": LN to Edith Meyer, May 13, 1975.
266

"Do I know you?": Glimcher, *Nevelson*, p. 135.
267

"a set designer": Letter from Hubert Crehan to author, October 18, 1983.
267

"I wanted it": *Vogue*, February 1, 1964.
267

"When I'm the star": LN to Edith Meyer, May 13, 1975.
268

"I've waited all my life": Elizabeth Fisher, "The Woman as Artist: Louise Nevelson," *Aphra*, Spring 1970, p. 42.
269

"the master stroke": Gregory Hull to author, October 18, 1988. Katz brought her a number of other helpers, such as Rusty Walles and Robert Hardiman.
270

"I only see black": Mike Nevelson to author, July 9, 1985.
270

"At three in the morning": Diana MacKown to author, June 28, 1988.
271

"If you're living with that kind": Jane Kay, "Artist's House Will Use New Metals and Plastics," *Christian Science Monitor*, June 2, 1967, p. 16.
271

"and molecular structure": Edward Albee to author, August 8, 1988.
271

"I feel the *Palace* is both highly sophisticated": Eleanor Munro, *Originals: American Women Artists* (New York: Simon & Schuster, 1979), p. 138.
271

"a night palace that I hope is gay": Jerry Tallmer, "Louise Nevelson Non-Stop," *New York Post*, November 30, 1977, p. 30.
272

"was part of a larger universal piece": Edward Albee to author, August 8, 1988.
272

"being religious": The Rev. Ralph Peterson to author, May 15, 1988.
272

The first time she used Christian symbols probably was in 1942 when she contributed a sculpture called *His Story* to a show of Christ figures at the Puma Gallery.
273

"Nothing is unshakable": Patricia C. Phillips, "Reviews," *Artforum*, Summer 1985, p. 104.
273

"[*Mirror-Shadows* (1985)] makes it possible": R. H. Cohen, "New Edition," *Artforum*, January 1987, p. 72.
273

"the innards of the boxes have burst out": Kathleen Paradiso, "Exhibitions," *Women Artist News*, Winter 1986–87, p. 21.
273

"What you make yourself": LN to author, September 5, 1986.
273

"the biggest car Rockland had seen": Brian Hardin to author, October 12, 1983.
274

"I've seen this scene for thirty years": Letter from Mike Nevelson to author, April 23, 1962.
274

"Ben will not allow": Letter from Lillian Mildwoff to LN, December 23, 1968.

275

"I was very upset": Ben Mildwoff to author, January 20, 1983.

275

"I'm not even grateful to some people": Diana MacKown, *Dawns + Dusks: Taped Conversations with Diana MacKown* (New York: Charles Scribner's Sons, 1976), p. 137.

275

"If no one ever helped you": Mike Nevelson to author, July 27, 1984.

276

"I've tried for many years": Ibid.

276

"Everyone was attracted to Louise": William Katz to author, October 5, 1988.

276

"a heady stream": William Katz, "Louise Nevelson Remembered," Pace Gallery catalog, March 31–April 29, 1989.

277

"I accept noises": John Cage to author, January 30, 1988.

277

"a mother–peasant creature": Edward Albee to author, August 8, 1988.

277

"I believe you're good": David Margolis to author, March 3, 1984.

277

"more into herself": Diana MacKown to author, June 28, 1988.

277

"In some cases she didn't want": Ibid.

278

"O doesn't remember not knowing": March 26, 1957, LN Papers, AAA. This poem, like others, exists in several versions.

278

"I have a feeling maybe my appearance": MacKown, *Dawns*, p. 187.

278

"If you walk a tightrope": LN to author, March 16, 1983.

278

"a three-dimensional persona": Edward Albee to author, August 8, 1988.

278

"I want people to enjoy something": S. B. Conroy, "Nevelson at 80," *Horizon*, March 1980, p. 62.

278

"It isn't just the work": LN to author, March 16, 1983.

279

"The drinking, fucking, and screwing": LN to author, August 15, 1982.

279

"If I look like this at eighty-three": LN to author, March 16, 1983.

279

"She has what I call a plastic face": Peter Busa to author, July 12, 1983.

279

"Louise said she didn't want a comfortable chair": Diana MacKown to author, June 28, 1988.

279

"If I'm selfish": LN to author, September 5, 1986.

280

"Her nature is rather selfless": Dorothy Miller to author, March 15, 1983.

280

"because I've destroyed so much": WNET-TV documentary film, "Nevelson in Process," 1977, produced and directed by Jill Godmilow and Susan Fanshel.

280

"way down": LN to Richard Stankiewicz, 1973, Oral History Program, AAA.

280

"We don't make mistakes": Lucille Beards to author, February 5, 1987.

280

"A truth isn't a truth to me": MacKown, *Dawns*, p. 122.

280

"Napoleon said you stoop to conquer": LN to author, March 16, 1983.

280

"tough": LN to author, October 13, 1982.

281

"never, for one day": LN to author, March 16, 1983.

281

"I am America's greatest living sculptor": Letter from Jovan de Rocco to author, July 14, 1986.

281

"always got raves": LN to author, September 5, 1986.

281

"You're an original": Ibid.

281

"more aware order": LN to Dorothy Seckler, January 14, 1965, Oral History Program, AAA.

281

"I imagine I was kept in my compartment": Edward Albee to author, August 8, 1988.

281

"a place that is orderly around me": LN to Richard Stankiewicz, 1973, Oral History Program, AAA.

281

"Now we can afford to have": Speech, awards ceremony, MacDowell Colony, August 24, 1969.

282

"Miss America": John Dalmos, "An Artist's Hideaway," *Rockland County Journal-News*, December 6, 1976.

282

"I would say that if our time": Dorothy Adlow, "American Art of the 20th Century," *Christian Science Monitor*, October 27, 1956, p. 4.

282

"burning roses": Lucille Beards to author, February 5, 1987.

282

"All I need is to feel": John Russell, "Despite Serious Ills, City Keeps Chin Up," *New York Times*, July 5, 1976, p. 17.

283

"he who does not imagine": Manuscript, 1954, LN Papers, AAA.

283

"All our heritage through the ages": Manuscript, LN Papers, AAA.

283

"If you see a woman on the street": Jack Tucker, *Detroit Free Press*, September 1966.

283

"My search for the absolute": Colette Roberts, *Nevelson* (Paris: Editions Georges Fall, 1964), p. 70.

283

"a flicker": Dorothy Seckler, "The Artist Speaks: Louise Nevelson," *Art in America*, January–February 1967, p. 33.

283

"If you accept the world three-dimensionally": Barbaralee Diamonstein, "New York's Art World: The Reminiscences of Louise Nevelson," Oral History Research Office, Columbia University, 1977.

283

"She loved certain things": Diana MacKown to author, June 28, 1988.

284

"almost accidental": LN to Richard Stankiewicz, 1973, Oral History Program, AAA.

284
"a million times more beautiful": LN to author, September 5, 1986.

284
"Illusion permits anything": Glimcher, *Louise Nevelson*, p. 65.

284
"Something grows in you": Speech, February 23, 1983, Nassau County Museum of Art.

284
"the best way I knew": LN to Barbaralee Diamonstein, "Nevelson: Maquettes for Monumental Sculpture," Pace Gallery catalog, May 2–27, 1980.

284
"I don't care where you take me": LN to author, October 13, 1982.

284
"My life gets richer every day": LN to author, September 5, 1986.

284
"I'm just about seeing myself": Speech, February 23, 1983, Nassau County Museum of Art.

284
"When you use a vertical line": LN to Katherine Rouse, October 21, 1963, Oral History Program, AAA.

284
"walking in and out of green pastures": WNET-TV documentary film, "Nevelson in Process."

284
"gives me my world": Speech, March 31, 1977, Harvard University.

285
"radiant and beautiful": William Katz to author, October 5, 1988.

285
"it was as if she were taking notes": Arnold Glimcher to author, July 28, 1988.

285
"I'm not afraid of dying": LN to author, September 5, 1986.

285
"intellectually completely nihilistic": Arnold Glimcher to author, July 28, 1988.

285
"What am I to do": Ibid.

286
"She was very, very, very quiet": William Katz to author, October 5, 1988.

286
"totally drained her": Arnold Glimcher to author, July 28, 1988.

286
"as if she were looking at a gorgeous man": Maria Nevelson to author, October 19, 1988.

287
"So I fulfilled my duties to nature": Jerry Tallmer, "Louise Nevelson Non-Stop," *New York Post*, November 30, 1977.

288
"It was long and painful": Letter from Mike Nevelson to author, May 21, 1988.

288
"I think she was shocked": Arnold Glimcher to author, July 28, 1988.

289
"When I see all the work I've done": LN to Colette Roberts, 1968, Oral History Program, AAA.

Selected Bibliography

There is a large body of newspaper and magazine reviews of Nevelson's work, beginning in the 1930s, on which I have drawn. I will not attempt to list all of them here because they are far too numerous; many others are cited in Notes and Sources.

The earliest reviews of Nevelson's work were by Emily Genauer in the *New York World Tribune* and Howard Devree, Carlyle Burroughs, and Edward Alden Jewell in *The New York Times;* starting in the 1950s, Dore Ashton, Hilton Kramer, John Canaday, and John Russell reviewed her work for the *Times.*

Among the most provocative and regular reviewers for art magazines were Maude Riley, Dorothy Seckler, Dido Smith, Una Johnson, Sidney Geist, Sidney Tillim, Robert Rosenblum, and Barbaralee Diamonstein.

Notable critics for general-circulation magazines include Dorothy Seiberling in *Life*, Robert Coates in *The New Yorker*, Robert Newman in *Newsweek*, and Robert Hughes in *Time.*

In addition, Laurie Wilson's Ph.D. dissertation, *Louise Nevelson: Iconography and Sources*, completed in 1978, is a significant contribution.

I also relied upon film and oral-history sources, which include contributions by Ilya Bolotowsky, Barbara Braun, Barbaralee Diamonstein, Arnold Glimcher, Molly Haskell, Arlene Jacobowitz, Edith Meyer, Dorothy Miller, Louise Rago, Colette Roberts, Katherine Rouse, Dorothy Seckler, Richard Stankiewicz, Tal Streeter, and Harold Weston.

Perhaps the most valuable source is *Dawns + Dusks: Taped Conversations with*

Diana MacKown, published in 1976, compiled by Nevelson's friend and assistant of twenty-five years.

BOOKS

Lynn Gilbert and Gaylen Moore, *Particular Passions: Talks with Women Who Have Shaped Our Times*. New York: Clarkson N. Potter, 1981.

Arnold Glimcher, *Louise Nevelson*. New York: Praeger Publishers, Inc., 1972; revised edition, New York: E. P. Dutton & Co., 1976.

Jean Lipman, *Nevelson's World*, introduction by Hilton Kramer. New York: Hudson Hills Press in association with the Whitney Museum of American Art, 1983.

Diana MacKown, editor, *Dawns + Dusks: Taped Conversations with Diana MacKown*. New York: Charles Scribner's Sons, 1976.

Eleanor Munro, *Originals: American Women Artists*. New York: Simon & Schuster, 1979.

Cindy Nemser, *Art Talk: Conversations with Twelve Women Artists*. New York: Scribner's, 1975.

Colette Roberts, *Nevelson*. Paris: Editions Georges Fall, 1964.

Felicia Roosevelt, *Doers and Dowagers*. New York: Doubleday & Co., 1975.

Wilson, Laurie, *Louise Nevelson: Iconography and Sources*. New York and London, Garland Publishing, 1981.

EXHIBITION CATALOGS

Brooklyn Museum and Shorewood Publications, New York, 1967, *Louise Nevelson Prints and Drawings, 1953–1966*, text by Una E. Johnson, 1967.

William A. Farnsworth Library and Art Museum, Rockland, Maine, *Louise Nevelson*, 1979.

Martha Jackson Gallery, New York, *Nevelson*, 1961.

Museum of Fine Arts, Houston, *Louise Nevelson*, 1969.

Nassau County Museum of Fine Art, Roslyn Harbor, New York, *Nevelson and O'Keeffe: Independents of the Twentieth Century*, 1983.

Neuberger Museum, State University of New York at Purchase, *Nevelson at Purchase: The Metal Sculptures*, May 8–September 1, 1977.

Pace Gallery, New York, *Nevelson*, 1964.

——. *Nevelson: Maquettes for Monumental Sculpture*, interview by Barbaralee Diamonstein and essay by David Shirey, May 2–June 27, 1980.

——. *Nevelson: Recent Wood Sculpture*, 1969.

——. *Louise Nevelson Remembered*, March 31–April 29, 1989.

Walker Art Center, Minneapolis, with E. P. Dutton & Co., *Nevelson: Wood Sculptures*, essay by Martin Friedman, 1973.

Whitney Museum of American Art, Fairfield County, *Louise Nevelson*, January 7–March 11, 1987.

Whitney Museum of American Art, New York, with Clarkson N. Potter, Inc. *Louise Nevelson: Atmospheres and Environments*, introduction by Edward Albee, 1980.

Whitney Museum of American Art, New York, with Praeger Publishers, *Louise Nevelson*, Introduction by John Gordon, 1967.

PERIODICALS

Jean Arp, "Louise Nevelson," *XXe Siècle*, June 1960.

Dore Ashton, "U.S.A.: Louise Nevelson," *Cimaise*, April–June 1960.

Arnold Glimcher, "Nevelson: How She Lives, Works, Thinks," *ARTnews*, November 1972.

Hilton Kramer, "The Sculpture of Louise Nevelson," *Arts*, June 1958.

Louise Nevelson, "Art at the Flatbush Boys Club," *Flatbush Magazine*, June 1935.

Louise Nevelson, "Nevelson on Nevelson," *ARTnews*, November 1972.

Dorothy Seckler, "The Artist Speaks: Louise Nevelson," *Art in America*, January–February 1967.

Dido Smith, "Louise Nevelson," *Craft Horizons*, May–June 1967.

Selected Public Installations

Atmosphere and Environment XII, 1970
Fairmont Park, Philadelphia, Pennsylvania

Atmosphere and Environment XIII: Windows to the West, 1972
Scottsdale, Arizona

Bicentennial Dawn, 1976
Bryne-Green Federal Courthouse, Philadelphia, Pennsylvania

Celebration, 1976–77
Pepsico Inc., Purchase, New York

Chapel of the Good Shepherd, 1977
St. Peter's Lutheran Church, Citicorp Center, New York, New York

Dawn's Column, 1972–73
Binghamton Civic Center, Binghamton, New York

Dawn's Forest, 1985–86
Georgia Pacific Center, Atlanta, Georgia

Dawn's Shadows, 1982
Madison Plaza, Chicago, Illinois

Night Presence IV, 1972
Park Avenue, New York, New York

Night Sail, 1983–84
Crocker Center, Los Angeles, California

Nightwave Moon, 1984
Kentucky Center for the Arts, Louisville, Kentucky

Shadows and Flags, 1978
Louise Nevelson Plaza, New York, New York

Sky Covenant, 1973
Temple Israel, Boston, Massachusetts

Sky Gate—New York, 1978
World Trade Center, New York, New York

Sky Landscape, 1982–83
American Medical Association, Chicago, Illinois

Sky Landscape II, 1979
Federated Department Stores, Cincinnati, Ohio

Sky Tree, 1977
Embarcadero Center, San Francisco, California

Summer Night Tree, 1977–78
Jackson, Michigan

Transparent Horizon, 1975
Massachusetts Institute of Technology, Cambridge, Massachusetts

Trilogy, 1979
Bendix Corporation, Southfield, Michigan

Untitled, 1982
American Medical Association, Washington, D.C.

Voyage I, 1980 (replicated)
Hallmark Center, Kansas City, Kansas
University of Iowa, Iowa City, Iowa

Selected Public Collections

Albany Mall Project, Albany, New York
The Albright-Knox Art Gallery, Buffalo, New York
Allentown Art Museum, Allentown, Pennsylvania
City of Binghamton, New York
Birmingham Museum of Art, Birmingham, Alabama
Museum of Boymans van Beuningen, Rotterdam, The Netherlands
Brandeis University, Waltham, Massachusetts
Carnegie Institute of the Arts, Pittsburgh, Pennsylvania
Arts Club of Chicago, Chicago, Illinois
Chrysler Museum, Norfolk, Virginia
City Art Museum, St. Louis, Missouri
Cleveland Museum of Art, Cleveland, Ohio
Corcoran Gallery of Art, Washington, D.C.
Dallas Museum of Art, Dallas, Texas
Delaware Art Museum, Wilmington, Delaware
Detroit Institute of Arts, Detroit, Michigan
Musée de Grenoble, Grenoble, France
Grey Art Gallery, New York University, New York, New York
The Solomon R. Guggenheim Museum, New York, New York
The High Museum of Art, Atlanta, Georgia
Hirshhorn Museum and Sculpture Garden, Washington, D.C.

Hospital Corporation of America, Chicago, Illinois
Indiana University, Bloomington, Indiana
Israel Museum, Jerusalem, Israel
Jewish Museum, New York, New York
Juilliard School of Music, New York, New York
Rijksmuseum Kröller-Müller, Otterlo, The Netherlands
Krannert Art Museum, University of Illinois, Champaign, Illinois
Nordjyllands Kunstmuseum, Aalogorg, Denmark
La Jolla Museum of Contemporary Art, La Jolla, California
Los Angeles County Museum of Art, Los Angeles, California
Louisiana Museum, Humlebaek, Denmark
Ludwig Museum, Cologne, Germany
The Metropolitan Museum of Art, New York, New York
Minnesota Museum of Art, Minneapolis, Minnesota
The Montreal Museum of Fine Arts, Quebec, Canada
Musée des Arts Moderns, Paris, France
Museum of Modern Art, New York, New York
The Nelson-Atkins Museum of Art, Kansas City, Missouri
Newark Museum, Newark, New Jersey
New Orleans Museum of Art, New Orleans, Louisiana
North Carolina Museum of Art, Raleigh, North Carolina
Norton Simon Museum of Art, Pasadena, California
Pennsylvania Academy of the Fine Arts, Philadelphia, Pennsylvania
Phoenix Art Museum, Phoenix, Arizona
Princeton University Art Museum, Princeton, New Jersey
Queens College, New York, New York
Rhode Island School of Design, Providence, Rhode Island
Riverside Museum, New York, New York
Scottish National Gallery of Modern Art, Edinburgh, Scotland
The Tate Gallery, London, England
University of Nebraska, Lincoln, Nebraska
University of Texas, Austin, Texas
Walker Art Center, Minneapolis, Minnesota
The Whitney Museum of American Art, New York, New York
Yale University, New Haven, Connecticut

Index